Rock 'n' Roll

Origins & Innovators

Second Edition

Timothy Jones

Jim McIntosh

Kendall Hunt publishing company

Ronnie Wood

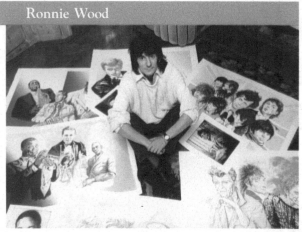
© Getty Images

Ronnie Wood Biography

Ronnie Wood was born in Middlesex, England, into a musical and artistic family. Before beginning his musical career he received formal art training at Ealing College of Art in London. As his musical career with the Jeff Beck Group, the Faces and the Rolling Stones progressed, Ronnie continued his painting and drawing, his subjects ranging from musicians he admired, knew and sometimes played with, to family and close friends, and, of course, the self-portrait.

Throughout the years the artist and the musician have been inseparable. It is as natural to find him with a pencil as with a guitar, drawing portraits of contemporaries and finding inspiration from his musical influences. In America in the early 1980s Ronnie produced his first prints—three woodcuts and a series of monotypes. At that time he was not yet an experienced printmaker so it was with great enthusiasm that he seized upon it. In 1987 he had the opportunity to spend several months working in a professional printmaking studio in England. Since then he has devoted a considerable amount of time to printmaking and has produced a number of images using various techniques—etching, drypoint, screenprint and digital.

Over the years his work has been widely exhibited. In 1996 he had a retrospective exhibition at the Museum of Modern Art in São Paulo, Brazil. He has had numerous one-man exhibitions in North and South America, in the Far East and throughout Europe.

Cover image courtesy of Ron Wood of the Rolling Stones

Kendall Hunt
publishing company

www.kendallhunt.com
Send all inquiries to:
4050 Westmark Drive
Dubuque, IA 52004-1840

Contents

Foreword

Well kids, here it is! The fundamental nuts and bolts of rock and roll history. "Nuts and bolts" because chances are slim that you're going to learn it all in a semester, at least at the current rate. The good news: Everything you need to know, and everything you thought you knew is in here! (Well, pretty much.) Easy enough, the basics are in this book; all laid out in a framework that's actually easy to understand and fun . . . really! The rest is up to you to get out there and find out for yourself. You'll find that much of what you're looking for is in the music itself.

Surprisingly, your individual estimation of rock and roll and what it means may change once you've found out where it actually comes from. Beginning with America and slavery, significant historical events, economics, and politics—rock and roll itself is a history book in song form. You just have to be conscious enough to read between the lines.

Pretty much, the same old song.

Enjoy!
Ronnie Vannucci, The Killers

Ronnie Vannucci

Photo by Torey Mundkowsky

Rock 'n' Roll: Its Origins & Innovators is a book designed specifically for high school, college and university "music appreciation" style courses. It is by no means intended to be a comprehensive history of rock music, nor a detailed study of every major artist that contributed to the development of rock and roll. It is rather, an "appetizer."

For several years Jim McIntosh and I have used a variety of books to cover the information that students in a "music appreciation" environment need to know about popular music. Most of the books on the market that we have used are excellent, detailed and comprehensive, but they have one major flaw for our purpose: We simply cannot cover the amount of material and information provided in these books in a single semester, and we feel we are shortchanging our students by skipping large sections in these books. The solution was to pull all of the information that we believe best educates students to the overall history of rock and roll and compile that into a functional, easy to navigate text.

This book is a selection of key artists, groups, industry figures and events that have instrumentally shaped the world of rock and roll, providing the student with a broad understanding of a variety of areas on this subject. The text discusses many major artists and bands along with references to cultural, social and political implications, record companies, producers and music industry icons and other relevant facts. The information is presented in a "bare bones" style, cutting to the main contributing aspects of each area in an effort to give the student more knowledge in a one-semester course.

This book's structure allows for the presentation of one hundred percent of the material in one semester. Each chapter, arranged in an approximate chronological order, contains carefully selected facts and highlights representative of the particular genre, artist and group, with recommended listening examples that reinforce the information set forth.

Photographs and points of trivia are supplied to aid both the retention and recollection of information and to inspire the learning process within the student. Some chapters also provide other artists of note, further reading and Web site resources for a more in-depth study of a particular area of interest. We feel that the artists and information presented in this book give the best overall introduction to rock and roll as a whole and will provide a greater appreciation and understanding of the music for the typical student today when given the parameters of such a short teaching period.

Our goal is for every student not only to gain an understanding about the origins of rock and roll music, but to be challenged to think about the significance of where the music they choose to listen to came from, and how that music has impacted several generations.

— Dr. Timothy Jones

Acknowledgments

Thanks to:

Our friends and families, Ann McIntosh, Julia Mink, Carol Cali, Luke Kestner, Anthony King, Bradford Malbon, Jeremy Meronuck, Merietta Oviatt, Peter Rice, Jason Slaughter, Alex Stopa, Adam Walton and Farah Zolgar, Dean Jeffrey Koep, Ph.D, Dean Gronemeier, J.D., DMA, Chair Jonathan Good and all who have supported this endeavor.

Special Thanks to:

Jamie, Tyrone, Jo and Ronnie Wood, Ronnie Vannucci, Angela Lampe, Amanda Smith, Lara McCombie, Lindsay Wubben, Melaney Jones, Raylin, Carter and Cooper Jones, Christine Wilhelm, Samantha Smith, and Kendall/Hunt Publishing.

Copy Editing for the 2014 revision:

Thomas Johnson. Thomas is an experienced English teacher and has a particular interest in popular culture. His passion for rock 'n' roll and talent with modern linguistics have brought a greater clarity to subsequent editions.

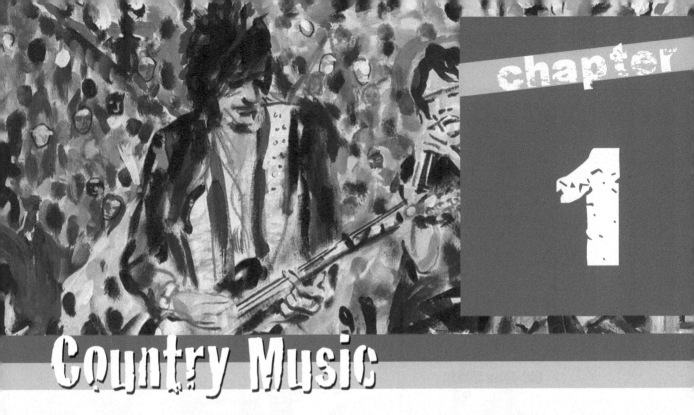

Country Music

The Beginnings of Country Music

Country music is essentially a North American form of music that, just like rock and roll, combines many eras, styles and sub-genres. When we use the classification "country music," we are usually generalizing to describe a variety of musical styles that are sometimes as different as classical music and the blues. The primary reason for such diversity is that influences on the beginnings of country music came from various cultures and parts of the world. These different cultures, however, had one thing in common: The music they brought with them was in every case the music of the common working class people. It consisted of folk music that carried stories and legends of their ancestors, dance music and songs of the homeland, music that unified people living in similar circumstances and songs with a patriotic flair. All of these genres and styles were thrown into the melting pot in North America during the eighteenth and nineteenth centuries and emerged as country music.

The four most significant stylistic influences on early country music are:
1. Folk ballads and fiddle tunes, primarily from Britain and Ireland
2. American popular songs of the 1800s
3. Blues of the southern blacks
4. Southern religious music

The instruments used in the evolving country styles were generally instruments of the string family and were not electronically amplified.

There are four main instruments, coupled with styles found in early country music:
1. The fiddle, from Britain (with influences from Ireland and Europe)
2. The guitar, from Spain
3. The mandolin, from Italy
4. The banjo, from West Africa

Singers became involved with many forms of country music, but they didn't really come to the forefront until the 1940s. The instruments themselves were usually the focus of the music. As country music evolved, performers invented microphones, amplifiers and pick-ups. The possibility to make records became a reality; and the piano, accordion, steel guitar, and bass, along with brass and reed instruments diversified the music.

The early country music performers emerged from the working class, drawing on work songs and music about the hardships of the land for their inspiration. They were usually reasonably skilled musicians, but in most cases, self-taught. These artists carried the traditions and stories of their ancestors in song and would share them through their performances. When singing became popular in country music, the singers clearly pronounced and sometimes spoke the lyrics so that the listener could understand the stories. They would draw on themes and topics that the common man could easily understand and present them with sincerity. Therefore, telling a story through the music became very important to country music. Dance music was also prevalent and popular, but apart from a "caller" to instruct the dancers, this form of country music usually contained no melodic vocals.

Old-Time Music

The basis of old-time music consists mostly of Celtic influences from the folk music of England, Scotland and Ireland that made their way to North America in the seventeen hundreds and eighteen hundreds. There is also some influence from other European countries and from Africa that all combined and evolved into American (Appalachian)

Eck Robertson

Eck Robertson made the first country recording in 1922.

© John Cohen/Getty Images

"Hillbilly" music. The music primarily uses string instruments and often accompanies square dancing, flatfoot dancing, clogging and dances associated with jigs and reels. Some famous old-time musicians include "Uncle" Dave Macon, Dock Boggs, Darby and Tarlton, the Fruit Jar Guzzlers, Bascom Lamar Lunsford "Minstrel of the Appalachians," Charlie Poole, Fiddlin' John Carson, the Skillet Lickers, and Eck Robertson. Pete Seeger and the New Lost City Ramblers (NLCR) preserved the old-time style in the 1940s, and in the 1950s, the Weavers and the Kingston Trio carried on the tradition.

The First Country Recording

The first country commercial recording was an old-time hillbilly song titled "Sally Goodin'," recorded in 1922 by Alexander "Eck" Robertson (November 20, 1887–February 15, 1975). His musical career spanned eight decades, and many consider Robertson one of America's legendary folk fiddle players. He was a skilled musician who would often play tunes in second or third position, a practice more commonly found in classical music. He also had the ability to make the fiddle speak in an almost human voice. By using a "trick" attachment from the fiddle to his mouth, he would play and talk at the same time, giving the impression of words coming from the fiddle itself.

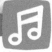

Recommended Listening

- Sally Goodin' (performed by Eck Robertson)
- Any traditional old-time, or Celtic, song that demonstrates the fiddle in the folk style. The Irish band, the Chieftains, demonstrates excellent renditions of traditional Irish tunes with well-produced recordings.

Jimmie Rodgers, the Father of Country Music

Jimmie Rodgers was born on September 8, 1897 in Meridian, Mississippi. Many affectionately know him as the "Father of Country Music." When he was fourteen, Rodgers began working on the railroad and learned the blues from his black coworkers. He performed recreationally during these early years until a tuberculosis diagnosis in 1924 forced him to quit work. At this time he decided to focus his attention on a career in music. By 1927 Rodgers had become exceedingly popular with a unique style of music that was a blend of blues, Appalachian ballads, spirituals and yodeling. He enjoyed success as a performer through radio broadcasts, in live performances and as a recording artist. Between 1927 and 1933, Rodgers recorded 110 sides for the Victor label and appeared in a short film for Columbia titled The Singing Brakeman, which became one of his nicknames, along with "America's Blue Yodeler."

Rodger's first thirteen recordings were called "blue yodels" and were numbered 1–13, which he later re-named with official titles. They all featured Rodger's playing guitar and singing in his self-developed style. With no precedent of any standard country style, Rodgers shaped country music for future generations more significantly than anyone else until the 1950s, and his legacy

Jimmie Rodgers

The father of country music, Jimmie Rodgers

© Michael Ochs Archives/Getty Images

as a great innovator has had a lasting impact on many country artists, both past and present. With no official category in which to place his music, many labeled Rodgers a folk-blues artist, and it wasn't until after his death that his music was associated with the hillbilly style. Jimmie Rodgers died of tuberculosis on May 26, 1933, from tuberculosis only two days after his final recording session. The basis of Jimmie Rodgers' style is largely the blues "call and response" style and is usually in a loose 12-bar form that makes use of the Appalachian yodel in between verses. He accompanies himself on guitar using a strong rhythm influenced by the blues guitarists that he listened to during his days as a railroad brakeman. Rodgers was one of the first three artists inducted into the Country Music Hall of Fame in 1961. He also was in the first group of inductees to the Rock and Roll Hall of Fame in 1986 and was inducted into the Songwriters Hall of Fame, 1970.

Influential Songs

- In the Jailhouse Now
- Pistol Packin' Papa
- The 13 "Blue Yodels"
 Blue Yodel No. 1 (T for Texas)
 Blue Yodel No. 2 (My Lovin' Gal, Lucille)
 Blue Yodel No. 3 (Evening Sun Yodel)
 Blue Yodel No. 4 (California Blues)
 Blue Yodel No. 5 (It's Raining Here)
 Blue Yodel No. 6 (She Left Me This Mornin')
 Blue Yodel No. 7 (Anniversary Blue Yodel)
 Blue Yodel No. 8 (Mule Skinner Blues)
 Blue Yodel No. 9 (Standin' On the Corner)
 Blue Yodel No. 10 (Ground Hog Rootin' in My Backyard)"
 Blue Yodel No. 11 (I've Got a Gal)
 Blue Yodel No. 12 (Barefoot Blues)
 Jimmie Rodger's Last Blue Yodel (The Women Make a Fool Out of Me)

Recommended Listening

- Blue Yodel No. 1 (T for Texas)
- In the Jailhouse Now
- Pistol Packin' Papa

Trivia

- Famous jazz trumpeter Louis Armstrong (Satchmo) played on "Blue Yodel No. 9."

- In 1978, the United States Postal Service issued a 13-cent commemorative stamp honoring Rodgers.

- Tuberculosis so ravaged Rodgers that they had to set up a cot in the studio for his last recording session.

- Ernest Tubb made his first recordings for RCA-Victor using Jimmie Rodgers' guitar.

Cajun and Zydeco

Cajun and zydeco music have had a significant influence on county music and rock and roll with styles that developed in French Louisiana from the music of the Creoles in the late 1800s. The term "zydeco" derives from *les haricots* (French for "the beans"). The early zydeco style tended to feature the fiddle and later the accordion (of German heritage) and washboard with the standard guitar, bass guitar, drums, horns and keyboards utilized for accompaniment. Many consider "Paper in My Shoe," by Boozoo Chavis, the

first real zydeco song, and that "My Toot Toot," by Rockin' Sidney, brought the music into the mainstream. Cajun music took on the influence of jazz with the early lyrics all sung in Cajun French. The first Cajun recording, "Allons à Lafayette" (Let's go to Lafayette) made in 1928, was by Joe Falcon and Cleoma Breaux. A rejuvenated interest has existed in both Cajun and zydeco music since 1964 when the Newport Folk Festival incorporated these styles into its lineup. A good example of how zydeco and Cajun merged with country music, especially bluegrass, is with the fictitious band The Soggy Bottom Boys' "I'm a Man of Constant Sorrow" from the 2000 movie O Brother, Where Art Thou?

Recommended Listening

- Paper in My Shoe, by Boozoo Chavis
- My Toot Toot, by Rockin' Sidney
- Allons à Lafayette, by Joe Falcon and Cleoma Breaux
- I'm a Man of Constant Sorrow, from the movie soundtrack for O Brother, Where Art Thou?

Trivia

- The band named the Foggy Mountain Boys inspired the name for the fictional band The Soggy Bottom Boys.

Bluegrass

Bluegrass is a fast mandolin, banjo, and fiddle-based music popularized by Bill Monroe and by Flatt and Scruggs.

William (Bill) Smith Monroe (September 13, 1911–September 9, 1996) developed the style of music known as bluegrass, which takes its name from his band, The Blue Grass Boys. Monroe's performing career spanned sixty years as a singer, instrumentalist, composer and bandleader. He primarily played the banjo and mandolin, and his most well-known song is "Blue Moon of Kentucky," which is Kentucky's official state bluegrass song famously covered by both Elvis Presley and Patsy Cline. Many often refer to Monroe as "the father of bluegrass." He was inducted into the Country Music Hall of Fame in 1970, the International Bluegrass Music Hall of Honor in 1991 and the Rock and Roll Hall of Fame in 1997.

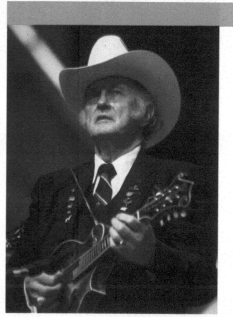

© AP/Wide World Photos

Bill Monroe

Bill Monroe was one of the most significant innovators of the bluegrass style.

- Blue Moon of Kentucky
- Molly and Tenbrooks
- My Rose of Old Kentucky

Lester Flatt (June 19, 1914–May 11, 1979), Earl Scruggs (January 6, 1924–March 28, 2012), and the Foggy Mountain Boys were an influential bluegrass band who enjoyed popularity throughout the 1940s, 1950s and 1960s. Best known for his banjo playing, Scruggs honed his style while working in Bill Monroe's band. Flatt's vocals and contributions to song writing gave them a very progressive sound. The movie *Bonnie and Clyde* used their instrumental "Foggy Mountain Breakdown" in the car chase, which won them two Grammy Awards. In 1955 they became members of the Grand Ole Opry, and in 1963 had their only #1 charting song with "The Ballad of Jed Clampett," which later became the theme song for the *Beverly Hillbillies* television series.

Flatt and Scruggs

Lester Flatt, Earl Scruggs, and the Foggy Mountain Boys

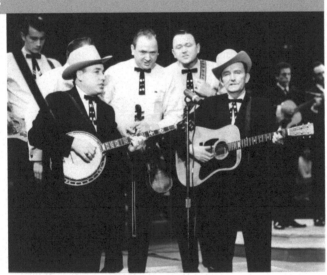

© AP/Wide World Photos

- The Ballad of Jed Clampett
- Foggy Mountain Breakdown
- Martha White Jingle

The Carter Family

The Carter family band consisted of Alvin Pleasant (A. P) Carter (December 15, 1891–November 7, 1960), his wife Sara Dougherty Carter (July 21, 1898–January 8, 1979) and his sister-in-law Maybelle Addington Carter (May 10, 1909–October 23, 1978). They

were one of the first influential country music groups and were particularly important to the bluegrass style. They generally performed Anglo-American songs in three-part harmony with a distinguishable accompaniment of guitar (Maybelle) and autoharp (Sara). The Carters recorded for a variety of labels beginning in 1927 and also reached a wide audience through a series of radio shows. Their music was an inspiration during the 1930s and 1940s, and in the 1960s folk revival it was revitalized with successful artists such as the Kingston Trio, Bob Dylan, Woodie Guthrie and Bill Monroe crediting the Carter family with influencing their music. In the 1960s, Maybelle toured and recorded with her daughters Anita, June and Helen, as did A. P and Sara with their children Joe and Janette. The Carter family was inducted into the Country Music Hall of Fame in 1970.

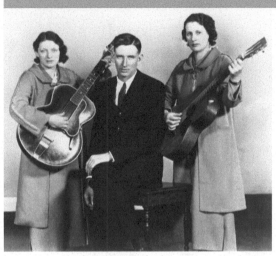

The Carter Family

The Carter family: Maybelle Carter, A. P Carter and Sara Carter. Country music's first family.

© Michael Ochs Archives/Stringer/Getty Images

Recommended Listening

- Can the Circle Be Unbroken
- Wildwood Flower
- Keep On the Sunny Side
- Little Darling, Pal of Mine

Trivia

- The U.S. Postal Service issued a commemorative stamp with the Carters image in 1993.

- June Carter (daughter of Maybelle) was the girl Johnny Cash pursued for more than ten years, finally marrying her in 1968. They remained together for 35 years and died within 4 months of each other in 2003.

- The album *Can the Circle Be Unbroken: Country Music's First Family* (released in 1935) received a Grammy lifetime achievement award in 1999.

Honky-Tonk

Honky-tonk music, which has its roots in ragtime and boogie woogie, has had the greatest influence on country music as a whole. It embraces the spirit of dancing, drinking, loving and, of course, losing the one you love. The term honky-tonk describes two things: a piano style of music that closely resembles ragtime, although more rhythmically based due to the

Ernest Tubb

Ernest Tubb was the first person to play electric guitar on the Grand Ole Opry.

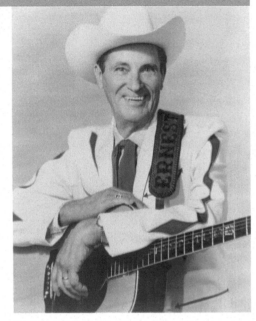

© Michael Ochs Archives/Stringer/Getty Images

Fats Domino

Fats Domino brought the honky-tonk sound into rock and roll.

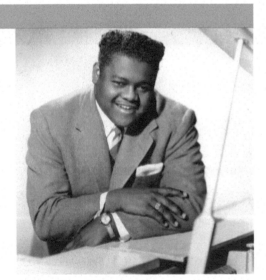

© AP/Wide World Photos

poor tuning of the pianos in the bars where the music was played, and the name of the bars themselves. Honky-tonks were usually working class hangouts for men that sometimes housed prostitution as well. The music influenced the evolution of boogie-woogie, which in turn influenced early rock musicians like Little Richard and Antoine "Fats" Domino.

In the 1940s, Ernest Tubb (February 9, 1914–September 6, 1984) (the "Texas Troubadour") took the honky-tonk sound to Nashville and was the first country artist to play electric guitar on the *Grand Ole Opry*. Rockabilly music of the 1950s carries the traits of honky-tonk, as do many of the mainstream modern country artists. Fats Domino (February 26, 1928–October 24, 2017) made honky-tonk the core element of his rock and roll style in the mid 1950s with "Blueberry Hill," which, incidentally, Gene Autry originally recorded in 1941 and Glen Miller made popular (also in 1941) before it was an international rock and roll hit for Domino in 1956. In the 1980s and 1990s artists like Dwight Yoakum, George Strait, Garth Brooks, Clint Black, Shania Twain and Faith Hill effectively created a slick, produced form of honky-tonk with rock and roll style bands.

 Recommended Listening

- Sweet Thang, by Ernest Tubb and Loretta Lynn
- I'm Walking the Floor Over You, by Ernest Tubb
- Blueberry Hill, by Fats Domino
- Little Red Shoes, by Loretta Lynn and Jack White (from the album *Van Lear Rose*)

Western

Western encompasses traditional Western cowboy campfire ballads and Hollywood cowboy music made famous by Roy Rogers, The Sons of the Pioneers and Gene Autry.

Leonard Franklin Slye, aka Roy Rogers (November 5, 1911–July 6, 1998), was a singer and cowboy actor. He and his third wife Dale Evans (October 31, 1912–February 7, 2001), his golden palomino Trigger and his German shepherd Bullet were featured in over one hundred movies as well as on the *Roy Rogers TV Show*. Together they brought commercial country music to prime time America. Through Roy's movies, the world became acquainted with Western music and an attitude that carried its influence right through to the British invasion and the Beatles. Roy and Dale were inducted into the Western Performers Hall of Fame at the National Cowboy & Western Heritage Museum in Oklahoma City, Oklahoma, in 1976. Roy was inducted again as a member of The Sons of the Pioneers in 1995. Roy was also elected twice to the Country Music Hall of Fame, first as a member of The Sons of the Pioneers in 1980 and then as a soloist in 1988. His career theme song was "Happy Trails" sung with Dale Evans. Van Halen and Quicksilver Messenger Service have covered this song, and Janis Joplin sent it as a birthday greeting to John Lennon in 1970.

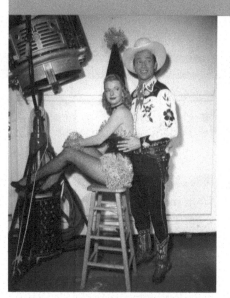

Roy Rogers

Hundreds of western movies featured Roy Rogers and Dale Evans.

© AP/Wide World Photos

The Sons of the Pioneers were an American "cowboy singing group" founded in 1933 by Roy Rogers. They remained popular into the 1950s and in 1977 the Smithsonian designated them "national treasures." The group continues to perform today with various country musicians.

Orvon Gene Autry (September 29, 1907–October 2, 1998) was an American performer who gained fame as "The Singing Cowboy" on the radio, in the movies and on television. People generally recognize "Back in the Saddle Again" as his biggest hit and signature song. Gene Autry's music is typical of the swinging, light-themed cowboy music with chorus and string orchestra heard in the movies during the 1930s and 1940s. Gene Autry is the only celebrity to have five stars on the Hollywood Walk of Fame, one in each of the five categories: motion pictures, radio, television, live theatre, and recording. Autry also created the Cowboy Code, sometimes known as the Cowboy Commandments:

Gene Autry

Gene Autry, the singing cowboy

1. The Cowboy must never shoot first, hit a smaller man, or take unfair advantage.
2. He must never go back on his word, or a trust confided in him.
3. He must always tell the truth.

© Herbert Dorfman/Contributor/Getty Images

4. He must be gentle with children, the elderly, and animals.
5. He must not advocate or possess racially or religiously intolerant ideas.
6. He must help people in distress.
7. He must be a good worker.
8. He must keep himself clean in thought, speech, action, and personal habits.
9. He must respect women, parents, and his nation's laws.
10. The Cowboy is a patriot.

Recommended Listening

- Happy Trails, by Roy Rogers and Dale Evans
- Back in the Saddle Again, by Gene Autry

Western Swing

Western Swing, originating in Texas and Oklahoma and popularized by Bob Wills, is an extension of Western music with a sophisticated dance feel. The new Fender Telecaster guitars, a big drum beat and dance style became the Western Swing signature sound.

Milton Brown formed the Musical Brownies (with Bob Wills) as the first true Western Swing band in 1932. The band made use of jazz improvisation in country music creating a move back to instrumental country and contributed over one hundred recordings during their developing years (1934–1936). After Bob Wills left the group, Brown died tragically in 1936, leaving Wills to finish establishing the Western swing style singlehandedly.

Bob Wills

Bob Wills was one of the founding icons of Western swing (with fiddle).

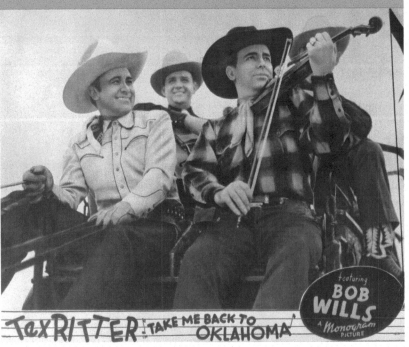

© Michael Ochs Archives/Getty Images

James Robert (Bob) Wills (March 6, 1905–May 13, 1975) was an American country musician, songwriter and big band leader. Using jazz sophistication, pop music and blues influence, plus improvised scats and wisecrack commentary by Wills, his band became the first supergroup of the genre. Will's band, The Texas Playboys, used horns, reed instruments, banjo upright bass, drums, fiddles, steel guitar and a vocalist. Wills' 1938 recording of "Ida Red" served as a model for Chuck Berry's later version of the same song, "Maybelline." In 1940 "New San Antonio Rose" sold a million records and became the signature song of the Texas Playboys.

Recommended Listening

- Taking Off, by Milton Brown and the Musical Brownies
- San Antonio Rose, by Bob Wills & His Texas Playboys

Trivia

- Wills suffered a terrible stroke in 1973 after the first day of recording the album *For The Last Time*, and his band finished the project on his behalf. Wills remained in a coma until his death in 1975.

- Merle Haggard, involved in the development of the Bakersfield Sound and Outlaw Country, contributed vocals to the *For The Last Time* version of "San Antonio Rose."

The Grand Ole Opry

"The Grand Ole Opry, to a country singer, is what Yankee Stadium is to a baseball player; Broadway to an actor. It's the top of the ladder, the top of the mountain. You don't just play the Opry; you live it."

— **Bill Anderson, one of country music's greatest songwriters**

The Grand Ole Opry is the longest running weekly radio show in history and has aired from 1927 without missing a single week. People know *The Opry* for hosting the greatest country music artists, and its guests view it a great honor and confirmation of their merit in the industry. The WSM radio station went live in October of 1925 from the fifth floor of the National Life building in Nashville with Jack Keefe as the announcer. In November George Hay, known as the "Solemn Old Judge," began to present his hillbilly program on the station. Audiences knew the program as WSM Barndance until one Saturday night in 1927 when Hay made the following statement: "For the past hour, we have been listening to music taken largely from the Grand Opera, but from now on we will present the Grand Ole Opry." This name took hold, and they have called the show *The Grand Ole Opry* ever since.

As the show grew in popularity, *The Opry* needed a bigger venue and was moved to several different Nashville venues, including The Belcourt Theatre (known then as the Hillsboro Theatre), the Dixie Tabernacle and the War Memorial Auditorium before settling

into the Ryman Auditorium (formally the Union Tabernacle) in 1943. The show changed the Ryman Auditorium name to Grand Old Opry House in 1963. In 1974, it made its final move, nine miles from downtown Nashville, into a brand new complex built specifically for the *The Opry*; again they called it the Grand Old Opry House.

The six-foot circle of dark, oak wood in the Opry House stage is a cut from the stage of *The Opry*'s famous former home, the Ryman Auditorium. This circle gives newcomers and veterans alike the opportunity to perform on the same spot that once supported Jimmie Rodgers, Hank Williams, Ernest Tubb, Patsy Cline and others.

Until 1938, *The Grand Ole Opry* had focused primarily on instrumental performances, and singers were always subordinate to the band. That changed when a young Roy Acuff joined the cast and sang "The Great Speckled Bird." From that performance a new avenue opened that brought attention to the country singers at the *The Opry* thanks to Roy Acuff.

Although performance guidelines are fairly liberal at the *The Opry* today, performers must adhere to one rule, George D. Hay's first commandment: "Keep 'er down to Earth, boys!"

Opry Trivia

"When Bob Wills went on the Grand Ole Opry he was already a huge star in Texas but not so much in Nashville . . . Bob went onstage with his cigar in his mouth. They told him not to smoke on the stage, and he walked off again. So far as I know, that was his one and only appearance on the Opry."

— Willie Nelson, 1988

"The band kicked off a song, and I tried to take the microphone off the stand. In my nervous frenzy, I couldn't get it off. That was enough to make me explode in a fit of anger. I took the mike stand, threw it down, then dragged it along the edge of the stage. There were fifty-two lights, and I wanted to break all fifty-two, which I did."

— Johnny Cash, on the night he was asked not to return to *The Grand Ole Opry*, 1993

Roy Acuff, the King of Country Music

Born in Tennessee on September 15, 1903, Roy Acuff took an instant attraction to music, initially learning to play the harmonica. He also emerged as a talented athlete, particularly in baseball. He seemed likely to join the New York Yankees in 1929, but unfortunately he suffered from sunstroke and a nervous breakdown that prevented him from being eligible for the draft. During his recovery, he learned to play the fiddle and turned increasingly towards country music. He became well known for his fiddle playing during the 1930s, which attracted music talent scouts and recording opportunities. In 1937, he made his debut at *The Grand Ole Opry* singing "The Great Speckled Bird" (recorded in 1936), which was the first time a vocalist had appeared on *The Opry*. The theme of the song's lyrics comes from the Bible passage Jeremiah 12:9, and *The Opry* allowed the song for that reason. Until this time, lyrics were seen to degrade the wholesome nature of country music, but Acuff knew that a religious theme could not be rejected as it actually elevated the moral value of the song.

In 1942, Acuff and Fred Rose (who was one of the first three artists inducted into the Country Music Hall of Fame in 1961) founded the Acuff-Rose publication company. This was the first major country music publishing house in the United States. Roy Acuff was at

Roy Acuff (singing with fiddle) was the biggest star of *The Grand Ole Opry* in the 1940s and 1950s.

© *AP/Wide World Photos*

the height of his popularity in the 1940s, even running for governor of Tennessee in 1944 and 1948. During this decade he wrote and recorded many of his most successful songs, made a number of movies and became recognized as the biggest star of *Opry* history. He is credited with forming the bridge between country rural string bands and modern era star singers backed by fully amplified bands. He was the first living artist to become inducted into the Country Music Hall of Fame in 1962, and his plaque describes him as "The King of Country Music." Acuff died on November 23, 1992.

Recommended Listening

- Great Speckled Bird
- Wabash Cannonball

Trivia

- Roy Acuff originally recorded the song "House of the Rising Sun" on November 3, 1938, which is the first known commercial recording of the song. (The British band The Animals took the song to international fame.)

- Received the Kennedy Center Honors award in 1991

Hank Williams, the Most Influential Country Artist of All Time

Hiram "Hank" King Williams, known as a great American country music singer, guitarist and songwriter, was born on September 17, 1923 in Georgiana, Alabama. His career began in southern Alabama learning guitar from his aunt and local musicians, writing songs and working his way into the mainstream through such radio shows as the *Louisiana Hayride* and *The Grand Ole Opry*. He made his career in country music performing and recording with his band The Drifting Cowboys from 1939 until his death in 1953. Roy Acuff and southern gospel music influenced Williams, and he drew heavily on black music to develop his style. Fred Rose signed him in 1946 to Acuff-Rose Publications, became his manager and he helped him record and edit songs.

Hank Williams ushered country music into the modern era and his music had an immediate influence on folk and rock music. Williams had a decisive sincerity to his music, which mirrored his genuine life struggles in marriage, personal tragedy and depression. Many still consider his singing style a major influence on today's country artists, and his songs are standard repertoire in all genres of popular music. Unfortunately, Hank Williams' battle with alcoholism eventually ruined his career. He was fired from numerous shows including *The Grand Ole Opry* for his heavy drinking. Hank Williams died on January 1, 1953 in the back of the Cadillac that was taking him overnight to his next show. He was only 29 years old. Williams was one of the first three artists inducted into the country music hall of fame in 1961. He was inducted into the Rock and Roll Hall of Fame in 1987, and his debut *Opry* performance made him the first artist to receive six encores on the show.

Hank Williams

Hank Williams was the most influential country music artist.

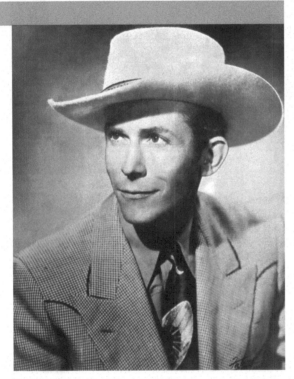

© Blank Archives/Contributor/Getty Images

Recommended Listening

- Lovesick Blues
- Move It On Over
- Your Cheatin' Heart
- Hey Good Lookin'
- Cold, Cold Heart

Trivia

- Hank Williams had eleven #1 hit songs during his career.

- His son Hank Williams Jr., his daughter Jett Williams and his grandchildren Hank Williams III, Holly Williams and Hilary Williams are all professional singers.

- "Cold, Cold Heart" was covered by Tony Bennett in 1951 and reached #1 on the pop charts.

- Many people attribute Hank's alcoholism to his severe back pain stemming from having spina bifida as a child.

- Almost a decade before rockabilly set in, Hank Williams was playing a similar style that was way ahead of its time.

- Following the recording of "Lovesick Blues" in 1946, Hank's management thought the song was a waste of time and money and believed it would damage his career more than help it. Hank was persistent that the song had potential. It was eventually released in 1949, topped the charts (his first #1 hit) and brought Hank an invitation to perform on *The Grand Ole Opry*. Sometimes the artist does know best!

Nashville Sound (1950s and Beyond)

The Nashville sound overtook honky-tonk in the late 1950s and early 1960s as the most popular form of country music. Created to win back the youth audience that was turning to rock and roll, record companies RCA Victor and Columbia, and manager/producers such as Steve Sholes and Chet Atkins (among others), formulated a produced "pop" version of country music. With crooning lead vocals, string instruments and a 1950s pop sound, artists like Jim Reeves, Floyd Cramer and Patsy Cline climbed to the top of the charts and attracted a whole new generation of fans and country artists. The record companies strictly controlled this successful formula and gave very little latitude for artists to expand their ideas beyond what "fit the mold." These tight reins sparked controversy among country artists and spawned both the "Bakersfield Sound" and "Outlaw Country" as a reaction against the Nashville sound. Artists like Tammy Wynette (the "first lady of country music"), Charlie Rich, Eddy Arnold, Conway Twitty, and Charlie Pride fell into the Nashville sound, as did Elvis Presley with his song "Suspicious Minds."

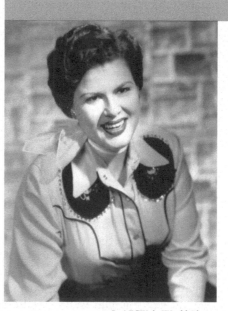

Patsy Cline

Patsy Cline popularized the now famous "Crazy" written by Willie Nelson.

© AP/Wide World Photos

Recommended Listening

- Crazy, by Patsy Cline
- Make the World Go Away, by Eddy Arnold
- Kiss an Angel Good Mornin', by Charley Pride
- The Most Beautiful Girl, by Charlie Rich
- Slow Hand, by Conway Twitty

Trivia

- The irony behind "Crazy" becoming a huge Nashville Sound hit was that the composer, Willie Nelson, was one of the founders of Outlaw Country, a direct reaction against the Nashville Sound!
- Chet Atkins once described the Nashville sound as "the sound of money."

Outlaw Country

Outlaw Country became famous in the 1970s through the music of Waylon Jennings, Willie Nelson, Billy Joe Shaver, David Allan Coe, Jerry Jeff Walker, Mickey Newbury, Kris Kristofferson, Johnny Cash and Hank Williams, Jr. The movement's objective was for its members to become self-declared "outlaws" as a reaction against the Nashville sound, developed by record producers like Chet Atkins. Outlaw Country also aimed to restore the raw foundation and life back into country music. The songs were about drinking, drugs, hardworking men and honky-tonk heroes. The music had more of a rock and roll lineup and sound, and there were no strings in the background.

The Highwaymen—Waylon Jennings, Willie Nelson, Kris Kristofferson, and Johnny Cash

Waylon Jennings (June 15, 1937 – February 13, 2002) befriended Buddy Holly during his 1958 radio show. After becoming friends, Waylon became the temporary bass player for Holly's band, the Crickets, playing with the rock and roller on his final tour. Jennings had scheduled a seat on the flight that ended in Holly's tragic death in early 1959, but he gave it up at the last minute to the Big Bopper (J. P. Richardson), who was suffering from a cold. After Jennings gave up his seat, Holly jokingly told him, "I hope your ole bus freezes up!" Jennings shot back facetiously, "I hope your damn plane crashes!" These words haunted him for years. Jennings had a hit with "The Good Ol' Boys," the theme for the television series *The Dukes of Hazzard* in the late 1970s; he was also the narrator's voice on the show.

Willie Nelson (born April 29, 1933) is one of the most significant figures in modern country music and was instrumental in breaking the Nashville recording establishment's hold over country music. He has had success with songs like "Crazy," which was a major hit for Patsy Cline, "On the Road Again," "To All the Girls I've Loved Before" (with Julio Iglesias) and "Shotgun Willie." Nelson named his guitar "Trigger" after Roy Rogers' horse and is the advisory board co-chair of NORML (National Organization for the Reform of Marijuana Laws). He has numerous Grammy, CMA and American Music awards, and has collaborated with artists in nearly every genre of music.

Billy Joe Shaver (August 16, 1939–October 28, 2020), is a prolific songwriter contributing many hit songs to albums by other Outlaw Country artists, most notably his song "Live Forever" performed by the Highwaymen. His 1973 album *Old Five and Dimers Like Me* is his most notable record and a classic in the Outlaw Country genre. On April 3, 2007, the 66 year old Shaver surrendered himself at the McLennan County Jail in Waco, TX after shooting a man in the face during an altercation outside a Lorena bar on March 31, 2007. During the exchange Shaver was heard asking the man "Where do you want it?" before firing, then exclaiming "No one tells me to shut up!" His colleagues have dubbed him the unofficial poet laureate of Texas.

Recommended Listening

- Highwayman

Other Significant Country Artists

- Patsy Cline
- The Judds
- Dolly Parton
- Glen Campbell
- George Jones
- Tammy Wynette
- Kenny Rogers

- Loretta Lynn
- Randy Travis
- Tanya Tucker
- Reba McEntire
- Garth Brooks
- Toby Keith
- Merle Haggard

Early Blues

What Is Blues Music?

Blues music is best described as an African folk music harmonized with Western chords that was largely created by slaves transported to the United States. We can define blues music as having its foundation firmly rooted in African rhythm, melody and song structure, but the harmonic, or chordal elements, come from European, mostly religious, music. It is possible to trace rough forms of the blues to the beginning of the slave trade (1619) in the New England area of North America, but it flourished and has generally been associated with the Southern United States, especially the Delta region. When the *Codes Noir* of 1724 officially outlawed traditional African music, dancing and drumming, the blues began to emerge and develop. At this time, performing the blues was largely a mental escape and a release from the terrible conditions in which African Americans lived.

With emancipation in 1863, blues musicians became more visible and performed publicly to make a living. One could hear the blues from the street corners, in bars and juke joints, on trains, plantations and in brothels. The rambling (traveling) bluesmen helped spread the blues beyond the immediate South and Delta region, and sparked interest in the blues as an entertaining form of music. By c.1912, the most common blues form, the 12-bar blues, had become established, and the name or title "blues" had become commonly used as the defining term for this, the first true American music. Prior to this definition, people described the blues simply as folk music. By this time there were several established blues styles including spirituals, the ragged piano blues, Delta blues (or Deep South style) and country blues. Slide and finger picking on the guitar became an identifying feature with the blues, and various forms of showmanship were integral to the blues artist's survival.

Instrumentation

Vocal singing supported predominantly by acoustic guitar is the most common instrumentation found in early blues music. A variety of homemade imitations of both guitar and banjo style instruments were also prevalent.

Musical Styles That Evolved from African Music in America Influencing the Blues

The most common styles evolving directly from African music are work songs, field hollers, spirituals, rags, boat songs, shouts and rambles. Slaves used music to accompany nearly every part of the day, and the various styles that evolved were usually a result of the type of work and the region where they lived. These songs relieved the toil of labor, brought rhythm to their work and eased the soul. Spiritual and gospel music were a direct result of traditional African music, and in addition to lifting one's spirit, they influenced the development of the blues.

Relevance to Rock and Roll

The blues is the most significant influence on the development of rock and roll and every sub-genre of rock and roll. In the 1960s, a massive blues revival ignited widespread interest in the blues, and it has remained the core influence for many of the world's finest rock musicians. The blues scale and chord structure can be found throughout rock and roll's history and provides the foundation for the most basic forms of rock to the most complex.

Rhythm

Rhythm in blues music comes directly from African traditions. According to ethnomusicologist A. M. Jones, rhythm plays an integral role in all activities of daily life in Africa. People feel, function and communicate in rhythm to give energy to work and effortlessly pass the workday, for religious ceremonies, and for entertainment and dance. Blues musicians often adopt traditional drumming rhythms to blues vocal lines on the guitar strings and fingerboards and sometimes on the actual body of the guitar. African rhythms are generally more involved and complex than most Western rhythms as they make use of syncopation, cross rhythms and polyrhythm (multiple rhythms occurring at the same time).

Recommended Listening

- Traditional African style music that makes use of syncopation, cross rhythms, polyrhythms and a variety of drums

Melody

Most melodies found in the blues come from slave work songs and dance songs, or their creation is due to the influence of Southern religious music. "Blue notes" usually augmented these melodies. These are notes lower in pitch than normally expected in Western music. As the blues became standardized, blue notes began to affect common degrees in a given scale. The blues scale is derived from the Western major scale, but uses the inflection of a flatted third, a flatted fifth and a flatted seventh. It appears frequently in all forms of the blues and in rock and roll. (A "*b*" represents a flatted note in written music.)

Western major scale:	1	2	3	4	5	6	7	8
	C	D	E	F	G	A	B	C
Major scale with blue notes:	1	2	b3	4	b5	6	b7	8
	C	D	Eb	F	Gb	A	Bb	C
Basic blues scale:	1		b3	4	b5	5	b7	8
	C		Eb	F	Gb	G	Bb	C

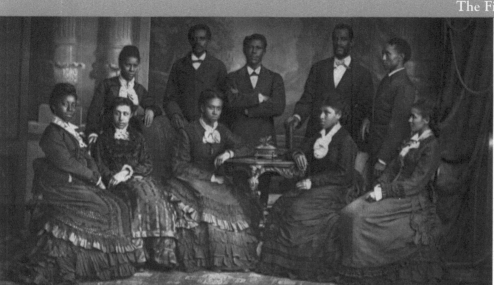

The Fisk Jubilee Singers

The Fisk Jubilee Singers are one of the earliest and finest examples of spiritual style music; the group still performs today.

Courtesy of the Library of Congress

The Spiritual

The spiritual is fundamentally a church, or sacred, form of music generally associated with the Deep South. The traditional African call and response style commonly used in the spiritual was the principal influence on the chord structure for the developing blues form. The spiritual is still in existence today both in church music and in popular entertainment.

The Fisk Jubilee Singers are a choral group formed in 1871 by Fisk University in Nashville for the primary purpose of fundraising. Fisk University was founded as a college for freed slaves, opening about six months after the end of the Civil War. In their earliest formation, the Jubilee Singers included nine performers, which broke down to two vocal quartets and a pianist. Their repertoire consisted of spirituals, anthems, popular ballads and operatic arrangements. They are responsible for the popularization of African-American music throughout the United States and abroad. In the early1870s the Jubilee Singers toured extensively as the first spiritual/gospel choir of significance, including two European tours, and performed at the White House for President Grant. They raised enough money from their early tours to build Jubilee Hall (dedicated 1876) and to ensure the university's financial stability.

One of the most famous spiritual songs of the early spiritual era is "Swing Low, Sweet Chariot," a song composed by Wallis Willis c.1862. He sent it to the Jubilee Singers and the Library of Congress now preserves their version in its historic recordings. The performance of "Swing Low, Sweet Chariot" is typically in a "call and response" style, which is a device heard in nearly all early blues. The PBS award-winning television documentary series *The American Experience* featured the Fisk Jubilee Singers in the program *Jubilee Singers: Sacrifice and Glory* in 1999. In 2000, the Fisk Jubilee Singers were inducted into the Gospel Music Hall of Fame, and in 2006 they received a star on the Music City Walk of Fame.

Recommended Listening

- Swing Low, Sweet Chariot
- The Fisk Jubilee Singers version can be found on: *Fisk Jubilee Singers Vol. 1, 1909–1911* original cylinder recordings re-mastered to CD

Blues Form / Structure

The blues began with no particular form. What the artist needed to say governed its length, and a change in harmony took place only when necessary. The 12-bar form and basic chord structure evolved due to the spiritual's influence, but by c. 1910–1912 the 12-bar form had become standardized among most blues musicians.

Standard 12-Bar Blues Form (shown in the key of C)

The basic chord structure for the 12-bar blues is based on three chords. If you refer back to the blues scale, you will notice that the chords come from the 1st, 4th, and 5th scale degrees. The "7" attached to the chords implies that the blue note on the 7th degree is required.

			C7		C7		C7		C7		
		F7		F7		C7		C7			
		G7		G7		C7		C7			

Publishing the Blues

William Handy

William Christopher (W.C.) Handy was born in Florence, Alabama, in 1873 and died in New York in 1958. He played piano, guitar and cornet, was a singer and arranged and composed music. Handy received little formal training in music, but he was exposed to spirituals, folksongs, light classics and ragtime while growing up. In the late 1890s, he toured the U.S., Canada, Mexico and Cuba with the band Mahara's Mistrels. In the years from 1903–1911, Handy became intimately acquainted with the blues form and style and spent 1903–1906 in the Mississippi Delta region leading the Knights of Pythias band. In 1909, Handy wrote a ragtime style song called "Mr. Crump" for mayoral candidate Mr. E. H. Crump. The name was soon changed to "Memphis Blues" and was officially published in 1912. (George A. Norton later added words.) We generally credit W.C. Handy with being the first person to publish a blues composition even though two

W.C. Handy

W.C. Handy is credited as one of the first people to supply print music for blues songs and also publish the term "Blues" in the title (c. 1912).

© Bettmann/Contributor/Getty Images

other pieces ("Baby Seals Blues" and "Dallas Blues") were released just before Handy's due to last minute publishing disputes. He moved to New York in 1918 and began to focus on arranging and publishing music exclusively. There is a movie based on Handy's life starring Nat 'King' Cole called *St. Louis Blues* (released in 1958), and in 1969, the United States released a postage stamp celebrating him. The prestigious annual awards that recognize achievements in blues music are called "Handys" in his honor.

Recommended Listening

- Memphis Blues (Mr. Crump), published in 1912
- Yellow Dog Blues, published in 1914
- St Louis Blues, published in 1914
- Beale Street Blues, published in 1916

First Recorded Blues

Mamie Smith

Mamie Smith, born in 1883 (died in 1946), was an African-American vaudeville singer, dancer and entertainer who also made several films. Smith received her lucky break when popular singer Sophie Tucker suddenly fell ill and could not sing for a commerical recording on February 14, 1920. The producer, who had already paid for the session, was persuaded to allow Mamie Smith to step in and cover the vocals. Literally, the rest is history! Although considered more of a jazz singer than a blues singer, Smith has the credit for making the first real "race record." The recording for the Okeh label was "Crazy Blues," made in August 1920. Her 1920s recordings opened the door for other African-Americans, particularly blues artists, to record and sell their music.

You can find "Crazy Blues" on the albums *Mamie Smith Vol. 1 (1920–1921),* and *Crazy Blues: the Best of Mamie Smith.*

Mamie Smith

Mamie Smith opened the door for African-American blues musicians to record their music.

© *Hulton Archive/Getty Images*

Recommended Listening

- Crazy Blues

Father of the
Delta Blues

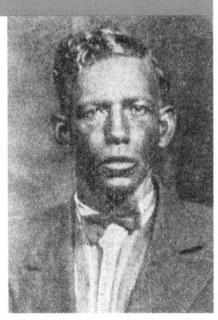

© *Hulton Archive/Getty Images*

Classic Delta Blues

Born in 1891 (died 1934), Charley (Charlie) Patton was the first great Delta blues man. He brought slide guitar to a position of prominence in Delta blues and inspired many future bluesmen, including Howlin' Wolf, Robert Johnson, Muddy Waters, John Lee Hooker and Elmore James. Patton is one of the most influential artists in blues history and can be considered an early "rock and roller." Decades before Jimi Hendrix, he played the guitar between his knees, behind his back, with his teeth and he would drum on the back of the guitar. His guitar style was percussive and raw, which matched his coarse earthy voice and reflected hard times and hard living. Audiences also knew him to "pop" his bass strings forty years before funk bass players did the same. Patton lived the life of a blues man, drinking and smoking excessively, womanizing, spending time in jail and traveling (rambling) constantly. Charley Patton was a star, a genuine celebrity around Mississippi plantations in the 1920s. He was inducted into the Blues Foundation's Hall of Fame in 1980.

Recommended Listening

- Down the Dirt Road Blues
- Mississippi Bo Weavil Blues
- Pony Blues
- 34 Blues

Trivia

- Charley Patton had his throat slashed in a 1930 brawl, from which he recovered.
- Patton claimed to have had eight wives.

Country / Folk Blues

Blind Lemon Jefferson

Blind Lemon Jefferson was born sometime between 1893 and 1897 and died under mysterious circumstances in December 1929. A true bluesman, inspired by field hollers and work song rhythms, Jefferson composed all of his own music. He recorded spirituals under the pseudonym Deacon L. J. Bates and performed mostly on the streets and in brothels. Jefferson was the first musician to significantly bring prominence to the country, or Texas, blues and was also the most successful artist to record in this style. He made seventy-nine records for Paramount and a handful for other labels. Jefferson used a busy accompanying style of guitar playing and sang in a high-pitched voice that influenced such artists as Leadbelly, Louis Armstrong and Lightnin' Hopkins. Bob Dylan covered Jefferson's "See That My Grave Is Kept Clean" on his debut album, and Jefferson's music is featured in the 2007 film *Black Snake Moan*. Blind Lemon Jefferson was inducted into the Blues Foundation's Hall of Fame in 1980.

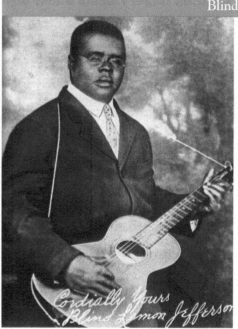

Blind Lemon Jefferson

Founder of the Texas blues sound.

© GAB Archive/Contributor/Getty Images

Recommended Listening

- Black Snake Moan
- Match Box Blues
- See That My Grave Is Kept Clean
- Penitentiary Blues

Trivia

- The theories surrounding Jefferson's mysterious death range from stories of a heart attack and a jealous lover poisoning his coffee to freezing to death when abandoned in the snow after an argument with his guide.

12 String Finger Picking Guitar Style

Blind Willie McTell

Blind Willie McTell, born William Samuel McTier (McTear) in 1901 (some sources say 1898), and was either blind from birth or lost his sight at a young age. Through his career McTell earned the status as one of the most accomplished 12-string guitarists and lyrical storytellers in blues history. Documentation exists that Blind Willie used an elegant slide and finger picking style giving the impression that more than one guitarist was playing. He recorded under a series of pseudonyms to avoid contractual obligations to only one record company. He recorded as "Blind Sammie" for Columbia, "Georgia Bill" for Okeh, "Red Hot Willie Glaze" (or "Hot Shot Willie") for Bluebird and "Blind Willie" for Vocalion. Blind Willie also became a knowledgeable blues music theorist, both reading and writing music in Braille. "Statesboro Blues" is McTell's most celebrated blues, covered by many rock artists during the 1960s blues revival, but the Allman Brothers and Taj Mahal particularly made it famous. Blind Willie McTell left the music scene later in his life to become a preacher, but he still recorded intermittently until his death in 1959. He was inducted into the Blues Foundation's Hall of Fame in 1981.

Blind Willie McTell

Blind Willie McTell was hailed as one of the great early finger picking and 12-string blues guitarists.

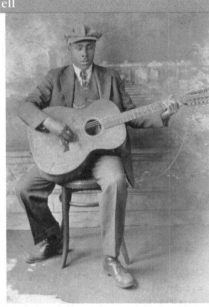

© Michael Ochs Archives/Getty Images

Recommended Listening

- Statesboro Blues
- Broke Down Engine Blues
- Southern Can is Mine

Trivia

- The "Blind Willie Blues Festival" in Thomson, GA, received its name in McTell's honor.

Slide Guitar Style

Blind Willie Johnson

Blind Willie Johnson was born in 1897, although some sources have him born as late as 1902. He lost his sight in late childhood when his stepmother, in an argument with his father, accidentally threw lye into his eyes. (Lye is a caustic solution made from ashes used in making glass and soap and in certain food preparations.) Best known as a gospel-blues

artist, many regard him as one of the greatest bottleneck slide guitarists. Johnson usually played slide with his pocketknife instead of a bottle. He had an extraordinarily deep voice, with a distinct guttural tone heard on many of his recordings. Johnson's guitar playing has a strong, heavy emphasis on rhythm. He often used an open D tuning, playing single-note melodies, while using his slide and strumming a bass line with his thumb. His slide guitar playing influenced many people but particularly the future "King of the slide guitar," Elmore James. As his career progressed, Johnson decided that he didn't want to be a bluesman because his religious beliefs caused conflict with many of the blues themes. To overcome this problem he became a Baptist preacher and began singing the Gospel and interpreting spirituals. In 1949 his house caught fire, and after sleeping in the damp, damaged house, he contracted pneumonia and died shortly thereafter. His death has poor documentation and could

Blind Willie Johnson

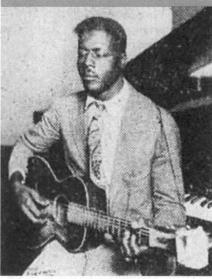

One of the greatest slide guitarists was Blind Willie Johnson.

© Michael Ochs Archives/Getty Images

have taken place any time between 1945–1950, although the actual date is most likely 1949. Johnson was inducted into the Blues Foundation's Hall of Fame in 1999.

Recommended Listening

- Dark was the Night, Cold was the Ground
- Keep Your Lamp Trimmed and Burning
- I Know His Blood Can Make Me Whole
- John the Revelator

Trivia

- Several popular artists have covered Johnson's music including Led Zeppelin, Beck, Depeche Mode, John Mellencamp and the White Stripes (all of whom covered "John the Revelator").

- According to Samuel Charters (a respected and reliable blues historian), Johnson's house caught fire in 1949. After extinguishing the flames, the family spent the night back in the house on wet bedding. In the morning, Johnson was ill and died some two weeks later of pneumonia.

- You can hear Johnson's wife, Angeline Robinson, singing in the background on many of his later recordings.

Crossroads: The Legendary Story of Robert Johnson

The story . . . Robert Johnson was a young black man living on a plantation in rural Mississippi. Branded with a burning desire to become a great blues musician, he received instruction to take his guitar to a crossroad near Dockery's plantation at midnight. There, a large black man (the Devil) met him, took his guitar, tuned it and handed it back to him in exchange for his soul. Within less than a year's time Robert Johnson became the king of the Delta blues singers, able to play, sing and create the greatest blues anyone had ever heard.

Robert Johnson

Robert Johnson was the most important blues musician who ever lived

—Eric Clapton

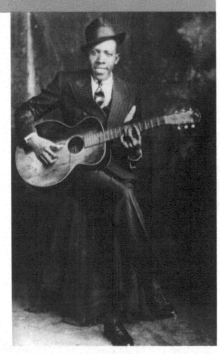

Robert Johnson Studio Portrait
Hooks Bros., Memphis, circa 1935. © 1989
Delta Haze Corporation. All Rights Reserved.
Used By Permission.

Robert Johnson, born in 1911, was in all probability the greatest and most influential of the early blues musicians. His life and the now legendary story epitomize the blues in every way. Johnson's music is derived from all of the blues myths and styles, and his lyrical interpretations could make an audience cry. He played guitar with deep soul and passion. He would often play a bass line, boogie-woogie style chords and slide guitar fills all at the same time while spicing his songs up with sparse finger picked lines. Johnson recorded only 29 songs in his lifetime in just five sessions in 1936 and 1937. His songs generally express dark themes, such as sexual innuendo, paranoia and representations of demonic possession. Robert Johnson was inducted into the Blues Foundation's Hall of Fame in 1980 and the Rock and Roll Hall of Fame in 1986.

The titles and lyrics of many of his recorded songs relate to the famous deal of selling his soul to the devil. Johnson's ability to impress his female audience led to his death in 1938 when a jealous husband (or another girlfriend) in Mississippi poisoned him. As a guitarist Johnson was more advanced than his peers and could give the impression of three guitarists playing at one time. Despite his untimely death at age 27, he was influential in the post-war 1940s Chicago blues scene. He inspired musicians like Muddy Waters and Elmore James and also 1960s rock musicians like Keith Richards, Eric Clapton and Jimmy Page.

Guitar Spotlight

Robert Johnson stands out as the greatest Mississippi/Delta Blues guitarist. Though he recorded during 1936 and 1937, no one has surpassed his playing the Mississippi Delta blues style. Johnson played bass parts, chordal and lead/slide parts simultaneously while singing. He also employed elements of classical music (contrary motion, counterpoint, etc.) and elements of jazz.

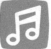

Recommended Listening

- Sweet Home Chicago
- Cross Road Blues
- Rambling On My Mind

- Dust My Broom
- Stop Breakin' Down Blues
- Hellhound On My Trail

Trivia

- The legend of Robert Johnson is the basis for the movie *Crossroads* starring Ralph Macchio (the karate kid) and guitarist Steve Vai.

- Elvis Presley died on the same day as Robert Johnson (August 16) 39 years later.

- In 1994 the U.S. Post Office issued a stamp in his honor.

- *Rolling Stone* magazine listed Johnson at number five in their list of the 100 greatest guitarists of all time.

- Eric Clapton released an album in tribute of Robert Johnson in 2004 titled *Me and Mr. Johnson*.

Big Bill Broonzy

Big Bill Broonzy (William Lee Conley Broonsey) is said to have been born June 26, 1893. (More likely it was 1898, which his twin sister confirmed, but possibly it was 1901 according to the U.S. census of 1930!) It's likely that Broonzy lied about his age to obtain work, get into the military or to bring credibility to his blues history. From 1912 to 1917, Broonzy worked as an itinerant preacher. He served in the U.S. army from 1918 to 1919 and finally moved to Chicago around 1924. He had a very successful musical career and was the best-selling "race record" blues artist on the Vocalion label. He was one of the first blues singers to use a small instrumental group (drums and acoustic bass with horns or harmonica), which served as a stepping stone to the true electrified Chicago sound of the 1940s. In December 1938, Big Bill Broonzy was one of the principal

© *Gerrit Schilip/Contributor/Getty Images*

Big Bill Broonzy

Big Bill Broonzy was one of the first blues musicians to make a successful transition from the South to the Chicago blues scene.

solo performers in John Hammond's first "From Spirituals to Swing" concerts held at Carnegie Hall in New York City. Broonzy was a stand-in for Robert Johnson, who was murdered a few months earlier. He toured Europe many times from 1951 until his death (from throat cancer) in August 1958 and was a major influence on Muddy Waters and Memphis Slim. Big Bill Broonzy was inducted into the Blues Foundation's Hall of Fame in 1980.

Recommended Listening

- Good Liquor's Gonna Carry Me Down
- Black Brown and White
- Key to the Highway
- The Glory of Love
- John Henry

Trivia

- Not realizing he had a song in the second half of the "From Spirituals to Swing" concert, Broonzy left Carnegie Hall at intermission and caught a bus home.
- In 1908 he made himself a violin and a guitar out of cigar boxes.

Lead Belly

Huddie William Ledbetter, known as Lead Belly (January 20, 1888 – December 6, 1949), was one of the greatest folklorists in American history. He is often recognized for his contributions to blues music, but in actuality he was well versed in the blues, spirituals, reels, cowboy songs, folk ballads and prison hollers. In early 1917 he was Blind Lemon Jefferson's guide and protégé. Unfortunately, his temper often got him into trouble leading to several terms of incarceration in Southern penitentiaries. In 1917, he was charged with murder and in 1930 attempted murder. Fortunately for Lead Belly, he composed songs for the Governors of Texas and Louisiana appealing to their sense of compassion and was, in both cases, pardoned and made a free man. John and Alan Lomax who were in need of Lead Belly's expertise to locate many original artists and contributors to early American music in Texas, Louisiana and similar areas supported his 1935 (2^{nd}) pardon. Lead Belly was in many ways released to the care of the Lomax's to assist their work for the Library of Congress documenting America's history of song.

Through John and Alan Lomax, Lead Belly moved to New York and became friends with Woody Guthrie and Pete Seeger performing on and off with them for the last 15 years of his life. Lead Belly became known as the "King of the 12 String Guitar," and was famous for his percussive guitar playing, powerful voice and many indigenous recordings made for the Library of Congress. Considered a master singere, Lead Belly's songs such as "Rock Island Line," "Goodnight, Irene," "The Midnight Special" and "Cotton Fields" became standards for folk and blues musicians alike, and even propelled other artists into stardom. The folk group the Weavers released a version of "Goodnight Irene" in 1950 (just after Lead Belly's death) that hit #1 on the Billboard "Best Seller" charts selling over 2 million records. "Where Did You Sleep Last Night," a song that had evolved from a traditional work song to a rough published version in 1917 (Cecil Clark), and then popularized by Lead Belly in the early 1940s, was one of his signature songs carrying a dark and somber sound (minor blues). And, it is Lead Belly's version that inspired Kurt Cobain and Nirvana to cover the song for their 1993 MTV Unplugged appearance and subsequent release that made it to #63 on the Billboard charts. There are now more than 35 cover recordings of the

song released by well-known artists ranging from Bill Monroe, Joan Baez, Dolly Parton, and the Oakridge Boys through to the Grateful Dead.

Lead belly spent most of his life in poverty and passed away in 1949 from Lou Gehrig's disease. He is forever immortalized in the work and recordings of the many musicians he inspired and in the archives of the songs he collected and recorded for the Library of Congress.

Other Important Early Blues Artists

- Barbecue Bob
- Blind Blake
- Sleepy John Estes
- Blind Boy Fuller
- Son House
- Peg Leg Howell
- Mississippi John Hurt
- Tommy Johnson
- Memphis Minnie
- Little Brother Montgomery
- Ma Rainey
- Tampa Red
- Bessie Smith
- Washboard Sam
- Ethel Waters
- Peetie Wheatstraw
- Sonny Boy Williamson I

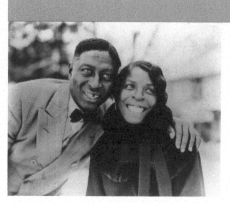

Lead Belly

Lead Belly and his Wife Martha in 1935

© MPI/Stringer/Getty Images

Electrifying the Blues

What Is the Difference between the Early Blues and the Chicago Blues?

Essentially, the early blues is a country or rural blues performed acoustically and usually by a single artist. The basis of the urban electric blues is primarily a Chicago style blues, influenced by the city's factories and general hustle and bustle of the busy city streets. Most importantly, the Chicago sound's definition comes from the electric guitar and the addition of other instruments (piano, bass, harmonica and drums) in the form of a supporting band. When the blues went electric, it opened a whole new genre of music. To define this urban blues from its parent, the early blues, people began to call it Rhythm and Blues, or "R & B," and they modernized the style by using a riff based (or stop time) feel.

Migration North

From 1910 to 1930, the blues came north with the migration of many African Americans from the South for work prospects in Chicago and Detroit. This brought the blues to larger populations and opened up the possibility for the production and sale of records. Chicago's Maxwell Street Market thrived with the blues and African heritage, and many credit it as the birthplace of R & B.

Introduction of the Electric Guitar

The need to create an easily amplified guitar that could project above a band or a noisy club became a reality during the 1920s and 1930s. As with any new invention, the first attempts had their flaws, but they certainly moved in the right direction. The first successful electric guitars were of the Hawaiian (or laptop) style and made by the Rickenbacker (in 1932) and Gibson (in 1935) companies. Gibson also built an electric Spanish style (hollow body) guitar that featured f-holes, a maple body and a mahogany neck. This is most likely the type of guitar that Chicago blues musicians used in the 1940s. The first commercially manufactured solid body electric guitar was the Fender broadcaster (later renamed the 'telecaster'),

designed by Leo Fender and introduced in 1950. The Stratocaster, released in 1954, improved on the broadcaster with its three pickups, a tremolo arm ("whammy bar") system for vibrato effects and a double cutaway where the body joined the neck to allow easier access to the upper frets. Additionally, Fender developed the first commercial electric bass, the Precision Bass, in 1951. Gibson's answer to Fender was with the "Les Paul" model, a semi-hollow body guitar released in 1952. These instruments revolutionized the guitar world and provided the fundamental sound that would ultimately shape rock and roll.

Race Records

We refer to many of the blues artists as releasing "race records." The term race record was a general musical trade designation for African-American recorded music on any label that had the expectation of the majority of sales to the African-American community.

Chess Records

Chess Records was one of the most important record companies associated with the blues and the development of rock and roll emerging out of post-WWII Chicago. In 1947, Leonard Chess (March 12, 1917–October 16, 1969) invested in an upstart record company called Aristocrat Records owned by two brothers, Charles and Evelyn Aron and their partners. By 1948, Leonard Chess had bought out all of the shareholders except Evelyn Aron. In 1950, Phil Chess (March 27, 1921–October 18, 2016) joined Leonard, and they finally bought out Evelyn Aron. The Chess brothers then took control as the sole owners of the record company. Leo and Phil promptly changed the name from Aristocrat to Chess and proceeded to build one of America's most famous and influential record companies. They recorded many of the greatest blues artists and early rock musicians throughout the 1950s and 1960s, often launching their careers. The Chess brothers are largely responsible for extending the popularity of the blues to a national and international level. Leonard Chess' son, Marshall, kept the family tradition alive as founder and manager of "Rolling Stones Records," the Rolling Stones' variety label. Marshall produced several albums for the Stones from 1970–1977. He went on to form "Sunflower Records" in 2000 with his son, Jamal. Sunflower is the leading independant Latin music label.

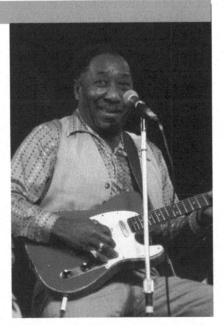

Muddy Waters

The father of the Chicago Rhythm and Blues was Muddy Waters.

© *Richard E. Aaron/Contributor/Getty Images*

Muddy Waters

McKinley Morganfield (Muddy Waters) was born April 4, 1915 in Rolling Fork, Mississippi. (The PBS series *American Masters* dates his birth as 1913.) He learned to play the harmonica when he was five years old, and in his early teens he cut his teeth performing in Mississippi Delta clubs alongside his mentors. Waters picked up the guitar at age seventeen and by imitating Robert Johnson and Son House became a skilled guitarist and singer. In 1940, he moved to St. Louis and spent three years playing for the Silas Green tent show. Alan Lomax, on behalf of the Library of Congress, recorded him in 1941 and 1942. In 1943, Waters migrated to Chicago and began playing the Chicago clubs. In 1944, in order to be heard over the noise of the Chicago bars, he became one of the first blues

musicians to play electric guitar. He worked six days a week as a truck driver and played in the blues clubs every night. Big Bill Broonzy, who was the leading bluesman in Chicago until 1950, helped elevate him to the top of the Chicago blues scene. Muddy Waters scored several hits in the 1950s recording for the Chess brothers, and his popularity spread as far as England. In the 1960s and 1970s, Waters reached a broad rock audience with such albums as *Muddy Waters at Newport* (1960), *Fathers and Sons* (1962) and *They Call Me Muddy Waters* (1971). He continued to record and perform throughout the 1970s to wide acclaim, performing for the last time in an Eric Clapton concert in 1982. Waters died peacefully in his sleep on April 30, 1983. Muddy Waters became known as the father of Chicago rhythm and blues because of the significance of his using a rhythm section and electric instruments.

Recommended Listening

- I Can't Be Satisfied
- Rollin' Stone
- I Just Wanna Make Love to You
- (I'm Your) Hoochie Coochie Man
- Got My Mojo Working

Awards

- Blues Foundation Hall of Fame, 1980
- Rock and Roll Hall of Fame, 1987
- Won six Grammy Awards between 1971 and 1979
- Grammy Lifetime Achievement Award, 1992
- Grammy Hall of Fame, 1998

Trivia

- The Rolling Stones named themselves after Muddy Waters' 1950 song, "Rollin' Stone."

- Muddy Waters apparently earned his nickname from his grandmother. She called him Muddy Waters because of the mud puddles near the Mississippi River he played in as a child.

Willie Dixon

Willie Dixon was born on July 1, 1915 and grew up in Vicksburg, on the edge of the Mississippi River. Dixon had a close relationship with music from a young age singing in his church choir and the gospel group The Union Jubilee Singers. Dixon moved to Chicago in 1936 with aspirations of becoming a heavyweight boxer. His fighting career was cut short after only four fights due to money disputes with his manager, and he decided at that time to focus his attention on music. Dixon formed a number of successful bands in the late 1930s and early 1940s including the Five Breezes, the Four Jumps of Jive and the Big Three Trio (credited with bringing harmonization to the blues). When Dixon began working full time for the Chess recording studios in 1951 his career really took off. He became the driving force behind many

Willie Dixon

Willie Dixon, an influential blues songwriter, producer and bassist.

© Paul Natkin/Contributor/Getty Images

successes at Chess through his talents as a songwriter, arranger, bassist, producer, and talent scout. He appeared on many of Chuck Berry's early recordings, providing the link between the blues and the birth of rock 'n' roll. Dixon also composed and produced music for many films including *The Color of Money* and *La Bamba*. Dixon was the founder of the Blues Heaven Foundation that provides protection for the estates of past blues artists and inspiration and educational funding for music students. The organization is now housed in the original Chess recording studios (purchased through the foundation in 1997). Willie Dixon is responsible for promoting the careers of such musicians as Muddy Waters, Howlin' Wolf, Buddy Guy, Bo Diddley and Chuck Berry. Many groups have recorded and performed his songs, including the Doors, the Rolling Stones, Cream, The Allman Brothers, Led Zeppelin, Jimi Hendrix and others. Willie Dixon died on January 29, 1992 in Burbank, California. He was one of the greatest contributors to recorded blues music via his own body of work and through launching the careers of some of the best blues and rock musicians. He wrote or contributed to many songs that have put some of rock and roll's greatest musicians' careers on the map.

Recommended Listening

- Spoonful
- Back Door Man
- Walking the Blues
- Little Red Rooster
- Hoochie Coochie Man
- I Just Want to Make Love to You

Awards

- Blues Foundation Hall of Fame, 1980
- Rock and Roll Hall of Fame, 1994
- Grammy Award for Best Traditional Blues Recording, 1989

Trivia

- Willie Dixon won the Golden Gloves heavyweight boxing title in 1937.
- He resisted the World War II draft and was imprisoned for ten months.

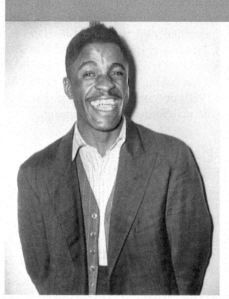

Sonny Boy Williamson I & II

left: Sonny Boy Williamson I (John Lee Williamson), *right:* Sonny Boy Williamson II (Aleck 'Rice' Miller)

© Hulton Archive/Stringer/Getty Images

© Michael Ochs Archives/Getty Images

The Harmonica

The harmonica, or "harp" as it is commonly called in the blues, came to prominence in the Chicago R & B bands of the 1940s and 1950s, but was in sporadic use for many years with the early rural and Delta blues. Some of the harp players that became popular included Little Walter, Muddy Waters, Junior Wells, Howlin' Wolf, Slim Harpo and Sonny Boy Williamson I and II. These innovators of the harp inspired artists like Paul Butterfield, Taj Mahal, John Lennon, Mick Jagger, Bob Dylan, Brice Springsteen and Bono to play and further the harmonica in the rock and roll genre.

Who's Who with Sonny Boy Williamson I and II?

John Lee Williamson was the first and original 'Sonny Boy.' He was born June 1, 1914 and grew up teaching himself to play the harp from recordings before moving to Chicago to perform and record from 1937 through 1948. Williamson, often called "the father of modern blues harp," popularized the harp for the first time in an urban blues setting. His first commercial recording, released in 1937, was *Good Morning, Little School Girl*, followed by a string of country style blues records. He helped make the harp a front line instrument in Chicago blues bands and created a bridge between country and modern blues. In June of 1948, his career was cut short when he was tragically beaten to death as he left a Chicago nightclub.

Sonny Boy Williamson II (Aleck 'Rice' Miller) was born in Glendora, Mississippi sometime between 1897 and 1912; his gravestone says March 11, 1908. Some sources say he kept his background a mystery because he was an escaped convict, which would explain the many aliases he used and his constant need to move from place to place, but no one really knows. He did, however, work with Robert Johnson, Robert Lockwood Jr. and Elmore James in the 1930s who undoubtedly influenced his musical development. He was also one of the earliest proponents of amplifying the harmonica by hooking up a mike to a jukebox or a car radio. By 1941 he had assumed the name Sonny Boy Williamson, who was already a popular recording artist, to ensure the success of the radio show *King Biscuit Time*, of which he became the star. *King Biscuit Time*, broadcasting from Helena, Arkansas, was the

first live blues radio show to hit the American airwaves. Miller had the right sound and style for the show and, consequently, became far more popular than the original Sonny Boy Williamson. Even though he didn't record commercially until 1951, Miller later recorded with major rock artists like the Animals, Eric Clapton and Jimmy Page, and also with blues artists including Muddy Waters, Elmore James and Buddy Guy. He taught Howlin' Wolf to play the harp and also helped B. B. King get his first paying gig. Miller was certainly one of the best harp players of the 1940s, 1950s and 1960s despite his shady past. He claimed to his death, in May of 1965, to be the first only and real Sonny Boy Williamson.

Trivia

- The Who performed Rice Miller's song "Eyesight to the Blind" in their rock opera Tommy. It is the only song in that opus not written by The Who.
- Some characterized Miller by a hip-flask of whiskey, a pistol, a knife, a foul mouth and a short temper.
- Sonny Boy I recorded over 120 songs for RCA from 1937 to 1947.
- Sonny Boy I's "Good Morning Little School Girl" was covered by the Grateful Dead, the Yardbirds, Taj Mahal, Rod Stewart and Muddy Waters, among others.

Recommended Listening

Sonny Boy I
- Good Morning Little School Girl

Sonny Boy II
- Bring it on Home (written by Willie Dixon)
- Eyesight to the Blind
- Don't Start Me to Talkin'

Howlin' Wolf

Chester Arthur "Howlin' Wolf" Burnett (June 10, 1910–January 10, 1976) was an influential blues singer, songwriter, guitarist and harmonica player. He learned the rudiments of playing guitar through Charley Patton, modeled his harmonica playing after Rice Miller (Sonny Boy Williamson II) and sang with a deep scratchy voice. In 1948 he moved to West Memphis and became a favorite in the local clubs. At the urging of Ike Turner, Sam Phillips recorded him for Chess Records (at the soon to become Sun studio). When he moved to Chicago in 1953, he teamed up with Willie Dixon and recorded directly for Chess. Unlike many of his fellow blues artists, Howlin' Wolf achieved significant financial success due largely to his ability to avoid the pitfalls of alcohol, gambling, and "loose

women." Howlin' Wolf's unique sound proved to be a major influence on such future rockers as the Rolling Stones, Eric Clapton and Led Zeppelin. Howlin' Wolf was inducted into the Blues Foundation Hall of Fame in 1980 and the Rock and Roll Hall of Fame in 1991.

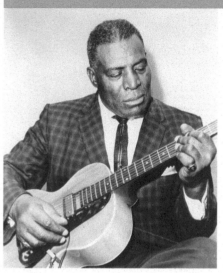

© *Michael Ochs Archives/Stringer/Getty Images*

Howlin' Wolf

Howlin' Wolf was one of the most important transitional early blues to Chicago blues artists.

Recommended Listening

- The Killing Floor
- Smokestack Lightnin'
- Howlin' Wolf
- How Many More Years
- Little Red Rooster

Trivia

- The Howlin' Wolf Blues Festival takes place each year in West Point, Mississippi.

- Sam Cooke, the Doors and the Rolling Stones covered Howlin' Wolf's "Little Red Rooster," and Led Zeppelin and the Doors covered "Killing Floor."

- In 1994, a U.S. postage stamp was issued to honor Howlin' Wolf.

John Lee Hooker

John Lee Hooker was born near Clarksdale, Mississippi, on August 22, 1917, to a sharecropper family. His stepfather, Will Moore, taught him how to play guitar, and in his teens Hooker encountered such blues legends as Charley Patton, Blind Lemon Jefferson and Blind Blake, who passed the blues traditions on to him. In 1943, he moved to Detroit, where a local record storeowner discovered him and helped him get his music recorded. By 1949, Hooker had scored his first number-one hit and million-seller, "Boogie Chillun'," distributed by

John Lee Hooker

John Lee Hooker was one of the last links to the blues of the Deep South.

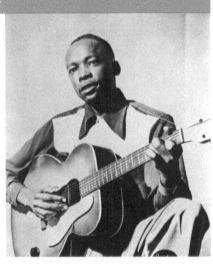

© *Michael Ochs Archives/Stringer/Getty Images*

Modern Records. Some describe his guitar playing as bearing similarities to the boogie-woogie piano style. This, along with his half-spoken approach to singing, became his trademark. During the 1950s and 1960s, Vee Jay Records released more than one hundred of Hooker's songs. He also recorded for the Chess, Riverside, United and Atco labels. The music industry "rediscovered" Hooker in 1989, giving him the first of five Grammy awards for his album *The Healer*, followed by *Mr. Lucky* (1991), *Boom Boom* (1993), *Chill Out* (1995) and *Don't Look Back* (1997). These albums also brought collaborations between Hooker and rock musicians Van Morrison, Canned Heat, George Thorogood, Carlos Santana, Bonnie Raitt, Los Lobos, Ry Cooder and Ike Turner. In the 1990s, his influence contributed to a booming interest in the blues and many considered him one of the last links to the blues of the Deep South. John Lee Hooker died on June 21, 2001.

Recommended Listening

- Boogie Chillun'
- Boom Boom
- The Healer
- Don't Look Back

Awards

- Blues Foundation Hall of Fame, 1980
- Inducted into the Rock and Roll Hall of Fame, 1991
- Star on Hollywood Walk of Fame, 1997
- Rhythm and Blues Foundation Lifetime Achievement Award, 1999
- Lifetime Achievement Grammy Award, 2000

Trivia

- John Lee Hooker had a cameo role in the 1980 *Blues Brothers* movie

- On November 14, 1998 "John Lee Hooker Lane" was dedicated in his honor in Clarksdale, MS.

- According to his daughter, John Lee Hooker could not read or write.

Albert King

Albert King was born in Indianola, Mississippi, on April 25, 1923. He learned to play the blues on homemade cigar box guitars and diddley-bows (one string guitars) until he got his first real guitar in 1942. As a left-handed guitarist King turned over a right-handed guitar without restringing it, which seemed to help his unique style of bending notes. King's first recordings, "Bad Luck Blues" in 1953, followed by "I'm a Lonely Man" in 1959, made in Chicago and St. Louis, respectively, achieved little impact. His first hit on the rhythm and blues charts came in 1961 with "Don't Throw Your Love on Me Too Strong," but it wasn't until 1966, when he signed with Stax Records, that he produced his most famous recordings. In 1967 he recorded "Born Under A Bad Sign" and became one of the first major blues guitarists to successfully cross over into modern soul music. In 1970 he released *Blues For Elvis: Albert King Does The King's Thing*, a tribute collection of Elvis Presley material. King was also one of the first blues guitarists to record with a symphony orchestra. Albert King stayed fairly true to the traditional blues style, remaining relatively uninfluenced by more recent trends. He was inducted into the Blues Foundation Hall of Fame in 1983 and died of a heart attack on December 21, 1992, just before commencing a European tour.

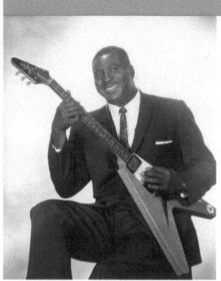

Albert King

Albert King played a flying V guitar upside down with right-handed set-up.

© *Michael Ochs Archives/Stringer/Getty Images*

Recommended Listening

- Don't Throw Your Love On Me Too Strong
- Bad Luck Blues
- Born Under a Bad Sign
- The Hunter
- Cold Feet

Trivia

- On February 1, 1968, Albert King shared the bill with John Mayall and Jimi Hendrix for the opening night of San Francisco's Fillmore Auditorium.

- King actually recorded the album *In Session* (released in 1999) in 1983 with Stevie Ray Vaughan.

B. B. King

B. B. King, the King of the blues

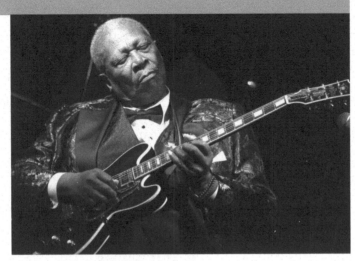

© Astrid Stawiarz/Stringer/Getty Images

B. B. King

Riley "Blues Boy" King was born on a cotton plantation in Itta Bena, Mississippi on September 16, 1925. In 1946 he moved to Memphis to work with his cousin Bukka White. He stayed there until 1948, when he appeared on Sonny Boy Williamson's radio show. That appearance led to a steady gig and a radio show of his own where he broadcast as Beale Street Blues Boy (shortened to Blues Boy, then to B. B). Audiences know King for his single-note solos, left hand vi- brato and the hollow body Gibson guitar, named Lucille, which carries his signature sound. He bends notes at the fret board to give the impression of the slide style, and when he stops singing, Lucille takes over. King began recording in 1949 when he signed with RPM records (including subsidiaries Kent and Crown), and he recorded with them until 1962. His first hit, "Three O'Clock Blues," topped the rhythm and blues charts for five weeks in 1951. Dissatisfied with royalty rates and songwriting cred- its, King signed with ABC-Paramount in 1962 receiving much greater public exposure, which included high-profile gigs such as opening for the Rolling Stones in 1969. He recorded "When Love Comes to Town" in 1988 with U2 for their *Rattle and Hum* album and won Grammy Awards for the albums *Live at the Apollo* in 1991 and *Blues Summit* in 1993. In 2000, he released *Riding with the King* (with Eric Clapton), earning his first plat- inum selling album. B.B. King was for many the most significant artist in blues history. He passed away on May 1, 2015 at a hospital in Las Vegas, Nevada.

Guitar Spotlight

B. B. King, aka The King of the Blues, has a very identifiable sound. King developed his vibrato (shaking the strings) to sound like a slide guitar vibrato. This gives King's vibrato a unique and powerful sound unlike any other player. King's main influences were T. Bone Walker and jazz guitarist Charlie Christian. This may explain why King strays from the blues scale and outlines the four and five chord of the blues progression at times. King's powerful vibrato, great feel and phrasing have influenced almost everyone that has played post-1950s blues and blues-rock guitar.

Lucille

In the mid-1950s, while B. B. was performing at a dance in Arkansas, a few fans became unruly. Two men got into a fight and knocked over a kerosene stove, setting fire to the hall. B. B. raced outdoors to safety with everyone else then realized that he had left his beloved $30 acoustic guitar inside. He rushed back inside the burning building to retrieve it, narrowly escaping death. When he later found out that the fight had occurred over a woman named Lucille, he decided to give the name to his guitar to remind him never to do a crazy thing like fight over a woman. Ever since, B. B. has named each one of his trademark Gibson guitars Lucille. – From *www.bbking.com*

Recommended Listening

- Rock Me Baby (with Eric Clapton)
- Three O'Clock Blues
- The Thrill Is Gone
- Everyday I Have the Blues
- Why I Sing the Blues
- Payin' the Cost to Be the Boss

Awards

- Blues Foundation Hall of Fame, 1980
- Rock and Roll Hall of Fame, 1987
- Received Honorary Doctorates from Tougaloo, MS College in 1973, Yale 1977, Berklee College of Music 1982, Rhodes College of Memphis 1990, Mississippi Valley State College University in 2002, and Brown University in 2006.

Trivia

- "About 15 times, a lady has said to me 'It's either me or Lucille.' That's why I've had 15 children by 15 women." —B. B. King

- In 1956, B. B. King and his band performed 342 one-night stands. He averaged more than 200 shows annually right into his seventies.

- B. B. owns a chain of "B. B. King's Blues Clubs" in L.A., Memphis, New York and Connecticut.

Bo Diddley

Ellas Otha Bates McDaniel, aka Bo Diddley, was born in McComb, Mississippi, on December 30, 1928. In the mid-1930s his family moved to Chicago where he was exposed to the street-performing blues musicians and the developing Chicago electric blues. By 1951, Diddley was playing regularly in Chicago. In 1955, he signed with Checker (a Chess subsidiary),

Bo Diddley

Bo Diddley with his signature rectangular guitar

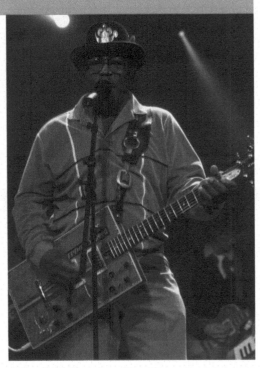

© Ron Galella/Contributor/Getty Images

which brought him almost immediate success. His first release was the eponymous 'Bo Diddley' (with "I'm a Man" on the B side) that demonstrated his unique guitar work on one chord and featured syncopated rhythms taken from traditional African music. This became known around the world as the Bo Diddley beat. One can hear recreations of the Bo Diddley beat on songs like Buddy Holly's "Not Fade Away," Johnny Otis's "Willie and the Hand Jive," the Strange Loves' "I Want Candy," the Who's "Magic Bus" and Bruce Springsteen's "She's the One." Diddley designed and created his own tremolo effect and his rectangular "cigar box" guitar in 1958. He also set up one of the first home recording studios. On the 1988 *Live at the Ritz* album, Diddley includes Rolling Stone Ron Wood. In 1996, he employs both Ron Wood and Keith Richards for *A Man Among Men*. Bo Diddley died on June 2, 2008.

Recommended Listening

- Bo Diddley
- Who Do You Love
- You Don't Love Me

- I'm a Man
- Road Runner

Awards

- Inducted in the Rock and Roll Hall of Fame in 1987
- Rhythm and Blues Foundation Lifetime Achievement Award, 1996
- Blues Foundation Hall of Fame, 2004

The Bo Diddley Beat, a lilting and almost swing clave pattern. The **bolded** capitalized counts are the clave rhythm.

ONE and two **AND** three and **FOUR** and one and **TWO** and **THREE** and four and

Trivia

- Bo Diddley opened for the Clash on their debut U.S. tour in 1979
- Diddley lived in Los Lunas, New Mexico from 1971 to 1978, and for two and a half years he was a deputy sheriff in the Valencia County Citizens' Patrol. During that time he personally purchased and donated three highway patrol pursuit cars.

Freddie King

Freddie King was born Freddie Christian on September 3, 1934, in Gilmer, Texas. After graduating from high school, King performed around the Texas area but decided in 1949 that he could find better opportunities in Chicago. When he arrived in Chicago, Howlin' Wolf took him in and introduced him to Robert Lockwood, Jr., Little Walter and Muddy Waters. Despite being from Texas, King gained recognition as one of the emerging group of Chicago blues artists in the early 1960s. In 1956 he began recording, but he didn't reach critical acclaim until 1960 with the album *Freddie King Sings* (August 29, 1960). This album included the crossover instrumental hit "Hide Away," which climbed to #29 on Billboard's pop charts. Many of King's most successful recordings were instrumentals, and due to the rock edge of his guitar sound, he had great appeal with the rock audiences. He also led the way for the blues-

Freddie King

Freddie King introduced the blues-rock sound.

© Michael Ochs Archives/Getty Images

rock instrumental genre, which would later include such greats as Eric Clapton, Duane Allman, Jimmy Page and Stevie Ray Vaughn. King usually played with a plastic thumb pick and a metal index-finger pick to emphasize his unique sound. His next successful album was *Freddie King Gives You a Bonanza of Instrumentals*. This album displayed his versatility and talent. In 1970, he recorded the album *Getting Ready*, which included the classic "Goin' Down" that revived King's career. This brought invitations to perform at such venues as the Kinetic Circus (Chicago), the Boston Tea Party (Boston), the Grande Ballroom (Detroit) and the Fillmores (East and West). King again achieved success at the end of his career in the rock genre. He became ill with pancreatitis on December 25, 1976, in Dallas and died on December 28. Freddie King was inducted into the Blues Foundation Hall of Fame in 1987, and by proclamation of the Texas Governor, September 3 is officially Freddie King Day.

Recommended Listening

- Hide Away (one of the first important blues-rock instrumentals)
- Goin' Down
- The Stumble
- Sad Nite Owl
- Have You Ever Loved a Woman

Trivia

- Freddie King was a big man, about 6'7" tall, and 300 pounds.
- Early in his career King used a Les Paul Gold top, the loudest guitar of its time; he later switched to a Gibson 345.
- King named "Hide Away" after a popular bar in Chicago.

Other Influential Chicago/Electric Blues Artists

- Bobby Blue Bland
- Paul Butterfield
- Albert Collins
- Arthur Crudup
- Georgia Tom Dorsey
- Champion Jack Dupree
- Buddy Guy
- Lightnin' Hopkins
- Elmore James
- Otis Spann
- Koko Taylor
- Sonny Terry
- Junior Wells

The Forefathers of Rock

It is extremely difficult to pinpoint the very moment that rock and roll officially became a style of music. Therefore, we tend to credit the period of time between 1951 and 1954 as the birth and infancy years of rock and roll. During this time many social elements, important artists, specific songs and a number of musical influences merged and evolved to become rock and roll. The addition of a heavy "back beat" and rock 'n' roll themes of partying, fast cars and girls mixed with the jump blues styles of Louis Jordan and Big Joe Turner are definite precursors to rock and roll.

Many consider Jackie Brenston's 1951 hit "Rocket 88" to be the first actual rock and roll song. Others believe it wasn't until Elvis Presley released "That's Alright Mama" in 1954 that rock and roll was really established. Radio disc jockey Alan Freed helped give an identity to this emerging style when he coined the term "Rock and Roll." By using this term Freed was referring to the electric rhythm and blues (R & B) that he played on his late night radio shows between 1951 and 1954. Credit for the actual musical foundation generally goes to Little Richard and Chuck Berry as the "Fathers of Rock and Roll," a fact rarely disputed. Richard and Berry significantly impacted America with their music and were consistent in their execution of the rock and roll style. Rock and roll's basic ingredients are a blend of rhythm and blues and country music with hints of boogie-woogie and any other style that can spice up the rhythm, groove, melody and harmony, or overall band structure.

The Precursors

"Big Joe" Turner

Joseph Vernon "Big Joe" Turner was born in Kansas City (May 18, 1911–November 24, 1985) and was one of the most influential forefathers of rock and roll. He began his career in cabaret style performing, but established himself quickly as a blues shouter. After an appearance at Carnegie Hall in the 1930s, he gained national acclaim. He is credited with introducing a heavy backbeat to his music that influenced the 1950s rockers. During his career, Turner performed with some of the twentieth century's most famous musicians

Big Joe Turner

Big Joe Turner was a pivotal figure between the swing era and early rock and roll.

© Hulton Archive/Getty Images

including Duke Ellington, Count Basie, Art Tatum, King Curtis, Dizzy Gillespie and Milt Jackson. People generally consider him a blues and swing music singer, but his handful of "pop" style recordings introduced the "rockin' blues" style. Turner's biggest rock 'n' roll hit was with "Shake, Rattle and Roll" in 1954. The song is rife with sexual references and when Bill Haley recorded his version, he had to clean up the lyrics significantly for commercial release. Most importantly, the song uses a 12-bar blues form, a heavy backbeat and a riff-based saxophone solo that is typical of 1950s rock and roll. Turner continued to perform up until his death in 1985 despite continuous health issues. Big Joe was inducted into the Blues Hall of Fame in 1983 and the Rock and Roll Hall of Fame in 1987.

Recommended Listening

- Chains of Love
- Shake, Rattle and Roll
- Flip, Flop, Fly
- Roll 'em Pete
- Corrina, Corrina

Trivia

- Bill Haley and the Comets made Big Joe Turner's "Shake, Rattle and Roll" (written by Jesse Stone under the pseudonym Charles E. Calhoun) internationally famous.
- Turner was one of the featured artists in John Hammond's "Spirituals to Swing" concert at Carnegie Hall in NYC, in 1938.

Louis Jordan

Louis Jordan (July 8, 1908–February 4, 1975) was a popular saxophonist and singer during the 1930s, 1940s and 1950s. In his early career he supported blues singers Ma Rainey, Ida Cox and Bessie Smith and he played in the bands of Louis Armstrong, Clarence Williams, Chick Webb and Ella Fitzgerald. In 1938, Jordan formed his first combo, the Elks

Rendezvous Band, which blended music and comedy. The band changed their name in 1939 to the Tympany Five and enjoyed increasing success on the R&B charts throughout the 1940s. By the mid-1950s, Jordan faded out of prominence as rock 'n' roll artists like Little Richard and Chuck Berry became popular. Jordan's "jump blues" music directly influenced many early rock musicians such as Chuck Berry, Little Richard, Bill Haley, B. B. King and James Brown. And his song "Caldonia" is an excellent example of the jump blues style. The song begins with a boogie-woogie piano introduction and a band shout chorus, and also makes use of "stop-time" and band "kicks" in the choruses. From mid 1946 to 1947, Jordan had five consecutive #1 hit songs and held the #1 place on the R & B charts for forty-four weeks running. Louis Jordan was inducted into the Rock and Roll Hall of Fame in 1987.

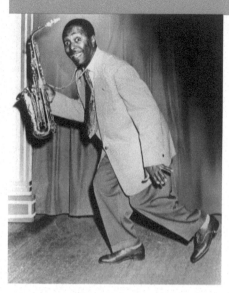

Louis Jordan

Jump blues entertainer Louis Jordan embodied the energy of the incoming rock and roll.

© Michael Ochs Archives/Getty Images

Recommended Listening

- Caldonia
- G.I. Jive
- Let the Good Times Roll
- Saturday Night Fish Fry (Pts. 1 & 2)
- Ain't Nobody Here But Us Chickens
- Choo Choo Ch 'Boogie

Trivia

- The name "Tympany Five" came from Jordan's drummer Walter Martin who often used tympany (usually spelled timpani) drums during performances.

- The Broadway show, *Five Guys Named Moe* was devoted to Jordan's music.

- In the 1940s, Jordan scored a staggering eighteen #1 singles and fifty-four Top Ten placings.

- To this day Louis Jordan ranks as the top African-American recording artist of all time in terms of the total number of weeks at #1. His records spent an incredible total of 113 weeks in the #1 position.

- On two occasions during arguments, Jordan's wife stabbed him, and the second time she nearly killed him.

Jackie Brenston

Jackie Brenston and his Delta Cats (with Ike Turner at the piano) receive credit for the first rock and roll song.

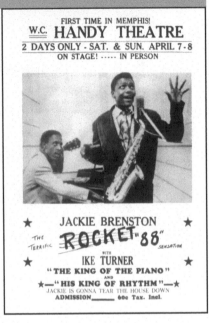

© Michael Ochs Archives/Getty Images

Ike Turner and the Kings of Rhythm, Jackie Brenston and his Delta Cats, and "Rocket 88"

Izear "Ike" Luster Turner (November 5, 1931-December 12, 2007) and his band, the Kings of Rhythm, are probably the most pivotal group in the transition to rock and roll. After a recommendation to future Sun Records founder Sam Phillips, Ike Turner's band began recording and releasing a series of jump blues style songs. Turner's band recorded the song "Rocket 88," which is now credited as the first rock and roll song, in early 1951 on the Chess label with Jackie Brenston, Turner's saxophone player, singing. Phillips made the decision to credit the song to Jackie Brenston and His Delta Cats because he wanted to release another record credited under Turner's name simultaneously. A great example of early guitar distortion is present in the boogie-woogie bass line of the original version of this song. "Rocket 88" achieved instant success, spending five weeks in the #1 spot on the R & B charts, and the unique electric guitar sound on the recording occurs because the amplifier was apparently dropped in the parking lot before the session. Ike Turner went on to a very successful career in the music industry, while Jackie Brenston, who didn't handle fame very well, became an alcoholic and died at the age of 49.

Recommended Listening

- Rocket 88

Awards

- Ike Turner was inducted into the Rock and Roll Hall of Fame in 1991
- Turner was inducted into the Blues Foundation Hall of Fame in 2005
- Star on the Saint Louis Walk of Fame, 2001
- Rocket 88, along with Jackie Brenston, inducted into the classic blues recording section of the Blues Hall of Fame in 1991

Trivia

- In 1991, after a great deal of debate, the Rock and Roll Hall of Fame recognized "Rocket 88" as the first rock and roll song ever recorded.

- General Motors gave Jackie Brenston a Rocket 88 to thank him for the publicity the song generated for the car.

- The piano intro on "Rocket 88" influenced Little Richard to use it on his 1958 hit "Good Golly Miss Molly" and "True Fina Mama."

- Ike Turner claims to have had thirteen marriages. However, his most public (and notorious) marriage and most fruitful musical collaboration was to Tina Turner, whose real name is Anna Mae Bullock.

- Ike was in prison at the time of his induction into the Rock and Roll Hall of Fame, so Tina Turner accepted the award on his behalf.

Other Important Precursors and Songs Influential to Developing Rock and Roll

- Roy Brown—Good Rockin' Tonight
- Ruth "Miss Rhythm" Brown—Teardrops from My Eyes
- Wynonie "Mr. Blues" Harris—All She Wants to Do is Rock
- Jimmy Liggins—Cadillac Boogie
- Joe Liggins—The Honeydripper
- Jimmy Nelson—T-99 Blues

History of the Term "Rock and Roll"

People had used the terms "rock" and "roll" for several hundred years in social settings to describe dancing, sex, shaking things up or simply disturbing the current social climate. These descriptions seem to suit very well how those in favor—and against—rock and roll music perceived its early influence. "Rocking" also appeared in American gospel music as describing a spiritually moving experience that brought one closer to God. "Roll," referring to sex, has appeared in verse and prose by poets and writers as far back as the Middle Ages, as in "had a good *roll* in the hay." The word "rock" took on the same connotation in the 1930s. Common usage of "rock and roll" together began to occur in the early 1920s. Evidence of this appears in 1922 with blues singer Trixie Smith's recording of "My Daddy Rocks Me (With One Steady Roll)" and in 1934 with the Boswell Sisters' "Rock and Roll." The term digressed into frequent use as a double entendre for sex in the 1940s. This is noticeable in the mid-1940s' songs "Rockin' Rollin' Mama," by Buddy Jones, Lil Johnson's "Rock That Thing," Ikey Robinson's "Rock Me Mama" and "Good Rockin' Tonight" by Roy Brown. The term though, did not always represent sex. Swing bands in the 1930s played songs such as "Rockin' in Rhythm" that referred to music with a good solid beat, and rock and roll is still a form of freestyle swing dancing today.

When Alan Freed needed an alternative, but exciting, term to use for the electric rhythm and blues music he was airing on his late night radio programs in the early 1950s, he began to call it rock and roll. At this late hour, Freed could quite liberally play "race music," ordinarily prohibited from popular radio play, to a much wider white audience, which helped bring this music into general popularity by 1954.

Disc jockey Alan
Freed, the man
who coined the
term rock and roll

© Bettmann/Contributor/Getty Images

Alan Freed and the Rock and Roll House Party

Albert "Alan" James Freed (December 15, 1921–January 20, 1965) is the radio DJ who coined the term "rock and roll" as it relates to what we now call rock music. He also significantly popularized the term nationally. Freed began playing R & B in 1951 on the radio from Cleveland's WJW station, calling the show "The Moondog Rock 'n' Roll House Party." In September 1954, he moved to New York's WINS and turned it into a rock and roll station. He moved to his last major station, WABC, in 1958 just prior to the payola investigations that ultimately ended his career. During his heyday, Freed helped manage and promote the careers of many future rock and roll stars, hosted the first stadium-sized rock concerts and brought "race music" into mainstream popularity. He also made a number of TV appearances, and featured in mid-1950s movies such as *Rock Around the Clock, Rock, Rock, Rock, Mr. Rock and Roll, Don't Knock the Rock* and *Go, Johnny Go!* Alan Freed died at the age of 43, suffering from alcoholism following the payola investigations that stripped him of his livelihood during the early 1960s.

The Fathers of Rock and Roll

Little Richard

The self-proclaimed, "architect of rock and roll," Little Richard (Richard Wayne Penniman), was born December 5, 1932 and raised in Macon, Georgia. His fusion of gospel, spirituals, boogie-woogie and blues helped create rock and roll. Little Richard's songs, piano playing and high-energy performances, along with his flamboyant appearance and unique singing style, ensured his place in the development of early rock and roll.

Little Richard grew up firmly rooted in southern gospel music. He sang with the Penniman Singers and Tiny Tots Quartet and began singing gospel music semi-professionally at age ten, performing in local talent shows and spending his spare time learning the techniques of popular Macon piano players. In 1951, Little Richard won a talent contest that gave him a small recording deal with RCA-Victor (through Camden Records), but in 1952, when his father was killed, he became the breadwinner of the family. During this time, he washed dishes in the cafeteria at the Macon bus station and performed with his band The Upsetters at night.

Little Richard recorded for the Peacock label from 1952–1954 without much success. Then, after sending in a demo tape, Specialty Records invited him to sign in February 1955. The first few months with Specialty were somewhat productive, but it wasn't until Little Richard let loose on his song "Tutti Frutti" during a recording session break that producers saw exactly where his talent lay. The lyrics of the song were, of course, too racy for a commercial recording, but the blend of Richard's hard hitting boogie-woogie piano, up tempo gospel vocal lines and signature "whooo" blues hollar had an immediate impact on 1950s popular music. The producer changed the opening line of the first verse, "tutti frutti, good booty," to "tutti frutti, awe rootie" and cleaned up other original lyrics, and recorded the song that same day. "Tutti Frutti" raked in over two hundred thousand sales in the first ten days of its release, propelling Little Richard to overnight success. In the next eighteen months, he

went on to record a string of hit songs for Specialty and two albums that scored high on both the R & B and pop charts. Another great example of Little Richard's work is "Good Golly Miss Molly" where all of the elements of his rock and roll style come out: the strong bluesy piano intro, the straight eighth note groove, the heavy backbeat, the boogie-woogie bass line played by both the bass and the guitar and harmonized by the tenor and baritone saxophones, as well as a stop-time feel in the verses, a powerful vocal style and, of course, his signature "whooo." He borrowed the piano intro from "Rocket 88" (key of Eb) but played his version a major 3rd higher (key of G), creating more intensity and drive.

While on a tour to Australia in 1957, and after a plane scare, Little Richard claimed to have had an epiphany with God. He discarded nearly ten thousand dollars worth of rings and jewelry and claimed "you can't be with God and rock 'n' roll at the same time, God doesn't like that." Since that day, Little Richard has gone in and out of both the rock and roll and preaching the gospel scenes.

Little Richard

The "architect of rock and roll," Little Richard

© Matt Stroshane/Contributor/Getty Images

Since 1955, Little Richard has appeared in many movies, television shows and commercials. He has also personally mentored the early careers of many up and coming stars including James Brown, Billy Preston, Jimi Hendrix, the Beatles and the Rolling Stones and sold over 32 million records by 1968.

Little Richard died on May 9, 2020 after a long battle with bone cancer. He will be remembered and celebrated for time eternal as the original rock 'n' roller in every sense of the term. "Richard truly was the king!" Kelvin Holly, longtime Little Richard band member.

Recommended Listening

- Tutti Frutti
- Good Golly Miss Molly
- Rip It Up
- Lucille
- Long Tall Sally

Awards

- Inducted into the Rock and Roll Hall of Fame in 1986
- Received a star on the Hollywood walk of fame in 1990
- Received the Lifetime Achievement award at the Grammys in 1993
- Received a lifetime achievement award from the Rhythm and Blues Foundation as a Prestigious Pioneer in 1994
- Earned the Award of Merit from the American Music Awards in 1997

Trivia

- Once claimed that "if Elvis is the King of rock and roll, then I must be the Queen of rock and roll"
- Little Richard's father, Charles "Bud" Penniman, was a Seventh Day Adventist preacher who sold moonshine and ran a juke joint on the side.
- Little Richard sang background vocals on the U2-B. B. King song "When Love Comes to Town" in 1989

Chuck Berry

Chuck Berry was born in St. Louis, Missouri on October 18, 1926, and brought up in a middle class area, which allowed him the opportunity to study music. He learned how to perform and play guitar in high school and joined a working club band in 1952. In 1953, Sir John's Trio invited Berry to join. Eventually, due to Chuck's growing popularity, the trio re-named itself the Chuck Berry combo. "Sir John" (Johnnie Johnson) was a great piano player who mentored Chuck Berry's developing style. Berry liked to play his own rockin' style of country and western music and with Johnson's encouragement decided to pursue a career as a full-fledged country artist.

In 1955, on a road trip to Chicago, Chuck Berry became friends with one of his idols in music, Muddy Waters. Waters instructed him to go to Chess Records to present his music, which he did at the first opportunity. The song that inspired Chess to sign Chuck Berry was a bluegrass style country song he had adapted titled "Ida May" (a variation of Gene Autry's "Ida Red"). And, with the help of Willie Dixon, the song received a strong backbeat, was reinforced with a touch of R & B and renamed "Maybelline." It was an instant hit, rising to #5 on the pop charts and #1 on the R & B charts. Berry quickly followed with other hits including "Brown-Eyed Man," "Too Much Monkey Business," "School Days," "Rock and Roll Music," "Sweet Little Sixteen," "Memphis Tennessee," "Roll Over Beethoven!" and "Johnny B. Goode."

Many consider the song "Johnny B. Goode" the coming of age of rock and roll with the now standard verse-chorus lyric format, unforgettable guitar hook and rockin' rhythm section groove that became the classic map for future rock and roll artists to follow. Written in 1955 (although not released until 1958), the song is a dedication to Berry's mentor Johnnie Johnson. The song itself is somewhat autobiographical and still has Berry's country "story" element through each verse. Although Johnnie Johnson played on many of Chuck Berry's recordings, he did not play on "Johnny B. Goode." Berry later wrote a sequel called "Bye Bye Johnny" about how he made it to Chicago to get that famous recording contract.

Chuck Berry

The eternal teenager, Chuck Berry

© Walter McBride/Contributor/Getty Images

As the hits kept coming Chuck Berry toured feverishly, was featured on television shows and in movies, and earned the nickname "the eternal teenager" due to his popularity among white teens across America. Even though Chuck Berry frequented the top of the R & B charts, it wasn't until 1972 that he managed to get a #1 hit on the pop charts. Although a great achievement, the song that put him in the number one spot was, compared with his 1950s masterpieces, a fairly tacky song that appealed to his teenage audience's prurient interest in euphemistic lyrics. Concert goers across the globe chanted that infamous song, "My Ding-a-Ling," for two decades. For his contribution to the founding of rock and roll, Chuck Berry was one of the first inductees of the Rock and Roll Hall of Fame in 1986. Berry's career as an "in-demand artist" continued well in to his 80s, and he toured frequently across the United States. On March 18, 2017, Chuck Berry passed away from a heart attack. He was 90 years old. One of the true pioneers of rock 'n' roll, his music and legacy is forever ingrained in pop culture and history.

Guitar Spotlight

Chuck Berry was the most influential rock and roll guitarist of the 1950s and possibly all of rock history. Berry wrote the rule book on playing rock and roll rhythm guitar, which he got from boogie-woogie piano when he joined the Johnnie Johnson trio. The rhythm Berry plays is the exact rhythm boogie-woogie pianists play with their left hand. The power chord (used in rock and heavy metal) comes from this chord shape, which includes the 1 and 5 of a chord. Berry's classic intros and solos utilize double stops (two string licks). Berry states that jazz guitarist Charlie Christian influenced him, but his double stop playing sounds closer to the right hand of a boogie-woogie pianist (i.e. Johnnie Johnson). One can hear Berry-influenced double stop licks through all of rock from the 1950s to the British invasion, punk rock and heavy metal.

Recommended Listening

- Maybellene (1955)
- Rock and Roll Music (1957)
- School Days (1957)
- Johnny B. Goode (1958)
- Sweet Little Sixteen (1957)

Trivia

- John Lennon once said, "If you tried to give rock and roll another name, you might call it Chuck Berry."

- "My mama said, You and Elvis are pretty good, but you're no Chuck Berry." —Jerry Lee Lewis

- Chuck Berry was born on Goode Avenue in St. Louis (Johnny B. Goode).

- "Johnny B. Goode" is a feature on the Voyager Golden Record as one of three examples of American music.

- John Lennon borrowed a line from Chuck Berry's "You Can't Catch Me" for his song "Come Together." Berry's music publisher subsequently sued him!

- When Keith Richards inducted Chuck Berry into the Rock and Roll Hall of Fame, he said, "It's hard for me to induct Chuck Berry because I lifted every lick he ever played!"

The Million Dollar Quartet and the Emergence of Rockabilly

On December 4, 1956, four superstars of the rock and roll world, Elvis Presley, Johnny Cash, Carl Perkins and Jerry Lee Lewis, met for an impromptu jam session at the Sun recording studios in Memphis, Tennessee.

The stage was set for a landmark recording when studio owner Sam Phillips brought Carl Perkins and his band in for a session to record the song "Matchbox" with rising piano star Jerry Lee Lewis. In the afternoon, with the scheduled session well underway, Elvis Presley (who was then signed to RCA), followed by Johnny Cash, walked into Sun to say hello to Phillips and were invited to listen to the playbacks of the morning session in the control room. Elvis, who was particularly impressed with the recording, went into the main room, sat down at the piano and began playing gospel songs. One thing lead to another and, with the tapes rolling, Elvis Presley, Johnny Cash, Carl Perkins and Jerry Lee Lewis made music history jamming through each others' songs and other standards of the day. Phillips called in a local reporter who captured the famous "Million Dollar Quartet" photograph and ran a promotional article in the paper documenting the occasion the next day.

This famous jam session was locked away in the Sun vault for many years. In 1981, Sun released part of the session on LP in Europe and the complete session worldwide in 1987. They then released a fiftieth anniversary CD edition containing twelve minutes of previously unreleased material in 2006.

The Million Dollar Quartet

The "Million Dollar Quartet" (L-R) Jerry Lee Lewis, Carl Perkins, Elvis Presley and Johnny Cash

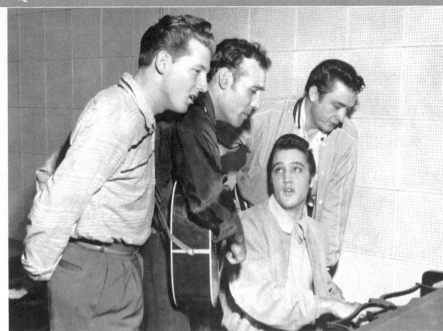

© Michael Ochs Archives/Stringer/Getty images

Sun Records

Sam Phillips officially opened the Sun recording studios in Memphis Tennessee in 1952, and in doing so, helped shape the face of rock and roll. From 1950–1952, before officially becoming Sun, Phillips ran the "Memphis Recording Service," recording artists such as Ike Turner and Jackie Brenston for distribution by the Chess/Checker label. The lineup of artists that came through Sun is a who's who list of 1950s and 1960s rock music. The popularity of rock and roll in white America (and the rest of the world) is largely due to Sam Phillips recording black R & B music with a string of successful artists and with a complete disregard for the social race barriers. Phillips is credited with blurring the color line through his recording and releasing music that demonstrated, to black and white communities, that each other's music was valid. Most artists on the Sun label believed that Phillips was doing more for racial equality in America through music than politicians were able to do in Washington. In addition to the "Million Dollar Quartet," some of the significant artists on the Sun record label were "Big Memphis" Ma Rainey, The Prisonaires, Roy Orbison, Jack Clement (producer), Ray B. Anthony, Charlie Rich, The Four Upsetters and Buddy Blake. In 1969, Phillips sold Sun to the Mercury label, which continued to release the classic Sun recordings of the mid-1950s.

Elvis Presley—See Chapter Six

Carl Perkins

Carl Lee Perkins was born on April 9, 1932, near Tiptonville, Tennessee, to a poor sharecropping family. He grew up listening to black work songs and the blues during the weekdays and white gospel music on Sundays. Perkins diligently studied the music of the bluesmen that his family worked with in the fields, and he practiced using a guitar made for him by his father from a cigar box, broom handle and fence wire. When he was thirteen he won a local talent

contest with a song that he wrote himself called "Movie Magg." This song eventually earned him a record deal with Sun in October 1954, and it was also the first official single released by Sun.

Carl Perkins was quickly becoming one of the top artists for Sam Phillips and toured with his two brothers, Jay and Clayton, as his backing band. He finally hit it big in December 1955 with "Blue Suede Shoes," which topped the country charts and came in at #2 on the pop charts and #3 on the R & B charts. This song was the first million-selling single for the Sun Company.

In March 1956, while on their way to appear on the Perry Como Show in New York, the Perkins brothers were involved in a terrible car accident that seriously injured Clayton and Carl. Clayton developed a brain tumor as a direct result of the crash and died in 1958. Carl never really recovered from this accident and his career began to fade. He never had another hit on the pop charts.

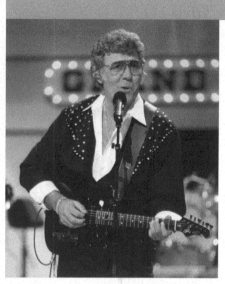

Carl Perkins

Carl Perkins had the first million-selling single for the Sun Company.

© AP/Wide World Photos

Carl left Sun for Columbia at the end of 1958 in hopes of reigniting his career. In 1964 he oversaw and assisted with the recording of five of his songs by the Beatles. He joined his friend Johnny Cash in 1965 as part of his touring band (for ten years), after which he formed the C. P. Express with his two sons, Greg and Stan.

Throughout his career, Carl Perkins has collaborated on projects with many of rock and country music's biggest names, including the Beatles, Eric Clapton, Roy Orbison, Chet Atkins, Travis Tritt, Joan Jett, Charlie Daniels, Paul Simon, John Fogerty, Tom Petty and Bono. He appeared on numerous TV specials and made a cameo appearance in the 1985 movie *Into the Night* alongside David Bowie.

Diagnosed with throat cancer in 1992 and after a series of strokes, Carl Perkins succumbed to the cancer and died on January 19, 1998.

Recommended Listening

- Movie Magg
- Let the Jukebox Keep On Playing
- Blue Suede Shoes
- Matchbox
- Honey Don't
- Everybody's Trying to Be My Baby

Awards

- Inducted into the Rock and Roll Hall of Fame, 1987
- Grammy Hall of Fame Award recipient in 1986
- Carl Perkins' autobiography, *Go, Cat, Go!*, published in 1995

Trivia

- Carl apparently wrote "Blue Suede Shoes" on a potato sack after he witnessed a boy telling his prom date not to "step on his blue suede shoes."
- After Carl's car accident, Sam Phillips bought him a new Cadillac to replace the car destroyed in the wreck.
- Sang the duet "Get It" with Paul McCartney on his 1985 *Tug of War* album.
- Played rhythm guitar on the McCartney/Stevie Wonder hit "Ebony and Ivory."
- Opened and supported the Carl Perkins Center for the Prevention of Child Abuse in 1981.

Johnny Cash

Johnny Cash was born in Kingsland, Arkansas, to a Baptist sharecropping family on February 26, 1932. He lived close to the Perkins family where he developed a boyhood friendship with their son Carl with whom he remained close for the rest of his life. By age twelve, Cash was playing guitar competently and writing his own songs. At fourteen he was entering talent contests and playing at every public event he could. In July 1954, Cash teamed up with Luther Perkins (electric guitar) and Marshall Grant (bass) to form the Tennessee Three. Their attire was plain black as it was the most affordable professional outfit.

In 1954, Cash became friends with Elvis Presley and Scotty Moore who recommended him to Sam Phillips as an artist he ought to sign. Phillips took the advice, and the new "Johnny Cash and the Tennessee Two" recorded a string of successful hits for Sun. The hits began with "Cry, Cry, Cry," which entered the country charts at #6 and ultimately pushed Elvis off the #1 spot in Memphis in the summer of 1955. From mid-1955 to 1958 (when he left Sun), Johnny Cash produced hit songs that consistently reached #1 on the charts. These included such songs as "Folsom Prison Blues," "Get Rhythm," "There You Go," "I Walk the Line" (selling over two million copies), "Ballad of a Teenage Queen" and "Guess Things Happen That Way."

In 1958, Cash signed with Columbia and moved with his family to Ventura, California, where he continued his chart-topping success. In 1960, he hired drummer W. S. Holland as a permanent member of his band. Cash went through a long struggle with drugs and alcohol from 1958 to 1967 that, despite having disastrous results on his personal life and marriage, didn't seem to interfere with his more successful songs and albums. His song "Ring of Fire" hit #1 on both the pop and country charts in 1963, and at this

Johnny Cash

"The Man in Black," Johnny Cash with June Carter Cash

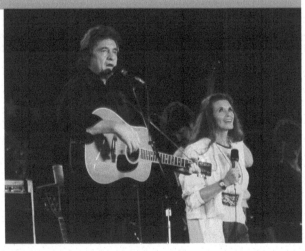

© Ebet Roberts/Contributor/Getty Images

time, Cash's tour schedule included as many as three hundred shows a year. In 1966 his wife Vivian divorced him, allowing him to pursue the woman of his dreams, June Carter (daughter to Maybelle Carter of the famous Carter family country band), whom he married in 1968. Johnny Cash and June Carter-Cash remained together for the rest of Johnny's life. In 1967, he kicked his drug problem, and in 1968 released the million-selling *Live at Folsom Prison* album.

In 1969, *The Johnny Cash Show* aired on ABC. The show was a success, running for two years and receiving high ratings. Throughout the 1970s the hits kept coming and his documentary series *Gospel Road* inspired him to record several Christian albums. In 1985, Cash joined with fellow outlaw country artists Kris Kristofferson, Waylon Jennings and Willie Nelson to form the Highwaymen. The band had three particularly successful albums: *Highwayman* (1985), *Highwayman II* (1990) and *The Road Goes on Forever* (1995). Cash unofficially retired from the music business in 1996, but he made intermittent appearances and recordings that demonstrated his long-lasting contribution to music. In 2001, he again hit the #1 spot on the charts and won a Grammy award with his version of Neil Diamond's "Solitary Man." Johnny Cash died on September 12, 2003, a few short months after June, his wife of thirty-five years, passed away (May 15, 2003). Johnny Cash left a legacy that not many musicians in any field could match.

Recommended Listening

- Cry, Cry, Cry
- I Walk the Line
- Folsom Prison Blues
- Ring of Fire
- Girl from the North Country (with Bob Dylan)
- Solitary Man

Awards

- Inducted into the Country Music Hall of Fame in 1980
- Inducted into the Grammy Hall of Fame in 1986
- Inducted into the Academy of Country Music's Pioneer Award in 1990
- Inducted into the Rock and Roll Hall of Fame in 1992
- Winner of 11 Grammy Awards
- Awarded the National Medal of Arts by George W. Bush in 2001

Trivia

- Cash's personality and his black stage attire earned him his nickname "The Man in Black."

- In 1965, Cash received a fine of $85,000 for smuggling amphetamines over the Mexican border.

- In 1970, Cash performed at the White House for President Nixon. He did not, however, play the two songs Nixon had requested as he apparently couldn't remember them and didn't have time to rehearse his band!

- In the late 1980s he appeared in a number of Western movies and TV shows.

- In 1957, Cash became the first Sun artist to release an LP (long-play) album.

- Cash has over fifteen hundred songs and almost five hundred albums to his credit.

The Story of the Tennessee Two / Three

The Tennessee Two became known primarily as the backing band for Johnny Cash when he rose to popularity in the mid 1950s. When the band first formed, their name was the Tennessee Three, with John Cash on acoustic guitar and vocals, Luther Perkins on electric guitar (no relation to Carl) and Marshall Grant on bass guitar. After auditioning for Sun, Sam Philips recommended the catchier "Johnny" Cash and the Tennessee Two. Luther Perkins is responsible for the freight train signature percussive guitar sound heard on all of Cash's early recordings. In 1960, Cash expanded the band to include drums and hired W. S. "Fluke" Holland, who remained with him through the rest of his career. With the addition of Holland, they were known again as the Tennessee Three. In 1968, Luther Perkins died tragically when his house burned down. Rumors of how the fire started involve suicide and homicide, although it is most likely that Perkins fell asleep in bed with a lit cigarette. Bob Wootton, who also remained with Cash for the rest of his career, replaced Perkins in 1971, and as a tribute to Luther Perkins, the band released an album under their own name called *The Tennessee Three: The Sound Behind Johnny Cash*. In 1980, Marshall Grant left the band as Cash made dramatic changes to his show. The remaining two members of the band held things together for the rest of Cash's touring and recording career and released another tribute album in 2006, titled *The Sound Must Go On*, this time in memory of Johnny Cash.

W.S. Holland: The First Rock and Roll Drummer

Through the early Sun years, drums were not used on recordings or with the touring shows. It wasn't until Carl Perkins recorded "Blue Suede Shoes" in 1955 that drums made an appearance on a Sun rock and roll record. The lucky drummer was W. S. Holland (April 22, 1935–September 23, 2020), who went on to play on every Carl Perkins recording for Sun and also toured extensively with him. Holland was the drummer on the famous "Million Dollar Quartet" session in 1956, and he also recorded with Carl Mann, Rayburn Anthony and Little David Wilkins on the Sun label. He also played on Bob Dylan's "Nashville Skyline." His career with Johnny Cash lasted over forty years, and it was Cash who gave him his title as the father of rock and roll drumming. Obviously, artists such as Little Richard and Chuck Berry were already using drummers, but the Sun studio really propelled rock and roll into national popularity. Thus, when Holland emerged on the scene it was significant; his addition changed the sound of the Sun record releases and rock and roll for the future.

Jerry Lee Lewis

Jerry Lee Lewis, "the Killer," was born on September 29, 1935, in Ferriday, Louisiana. Jerry Lee's interest in music, especially the piano, from a young age encouraged his father to save enough money to buy a family piano that he and his cousins, Mickey Gilley and Jimmy Swaggart (yes! the disgraced TV evangelist), could study and learn to play. Jerry Lee only had a couple of piano lessons before he decided to go it alone and teach himself by listening to his favorite musicians on the radio. In his teens he snuck into Big Haney's House, a blues club in Ferriday, where he would absorb everything the house piano players dished out.

In September 1956, after two failed marriages and expulsion from Bible school, Jerry Lee made the decision to take on the rock and roll world. He drove to Memphis and presented himself at the Sun studios where he refused to leave until they heard his music. Fortunately, Sam Phillips saw the potential in Jerry Lee and signed him to the label immediately. At this point, Sun had just sold Elvis Presley's contract to RCA, and Phillips needed another star to continue Sun's success. Following a moderate regional hit in 1956 with "Crazy Arms," Jerry Lee Lewis had two #1 hits in 1957 with "Whole Lotta Shakin' Goin' On" and "Great Balls of Fire." "Whole Lotta Shakin' Goin' On" was released on March 1, 1957, and remained in the top forty for twenty weeks. It reached #1 on the pop, country and R & B

charts, which is extremely rare, even today. This song was performed up to six or seven times in a show due to its overwhelming popularity.

On December 12, 1957, Jerry married his 13 year old second cousin, Myra Gale Brown, daughter of his cousin and bass player, JW Brown (this was his third marriage). Controversy over this marriage led to the cancellation of his British tour after only three shows and ruined his career in the United States. Lewis went from commanding $10,000 a show to playing beer halls for $200 a night. He managed to salvage his career in Europe in the early 1960s, but it took much longer for his American fans to forgive him.

Jerry Lee went through a series of personal tragedies in the 1960s and 1970s with the deaths of his two sons and more failed marriages. He accidentally shot his bass player at a party in 1976, and in 1979, the IRS audited him and ordered him to pay millions in back taxes. In June 1982, his fourth wife, Jaren Pate, drowned, and in August

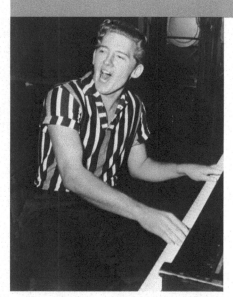

Jerry Lee Lewis

"The Killer," Jerry Lee Lewis

© Bettmann/Contributor/Getty Images

1983, his fifth wife, Shawn Michelle Stevens, was found dead, bruised and bloodied in the bedroom of their Nesbit home. In 1984, Lewis married twenty-one-year-old Kerrie McCarver, his sixth wife (divorced 2005), and married Judith Brown, his 7th wife, in March of 2012.

When the movie *Great Balls of Fire* starring Dennis Quaid was released in 1989, it received mixed reviews (a weak script, but great performance by Quaid). The movie is a watered-down version of Jerry Lee Lewis's rise to fame based on a book by his former wife Myra. He has openly voiced his disapproval of the book and lack of interest in the movie. In the 1990s and early 2000s, Lewis stayed largely out of the limelight, but he had another very successful comeback album in 2006 titled *Last Man Standing*.

Fans consider Jerry Lee Lewis the first wild man of rock and roll. He broke all the rules, didn't care what anybody thought of his actions and wasn't shy about telling producers, record executives, managers and band members exactly what he thought regardless of the consequences. His early career had him marked to overtake Elvis as the king of rock and roll, but his outrageous and reckless lifestyle prevented that from happening. Jerry Lee Lewis is rock and roll in every sense of the term!

Recommended Listening

- Crazy Arms
- Whole Lotta Shakin' Goin' On
- Great Balls of Fire
- High School Confidential
- Breathless

Awards
- Inducted into the Rock and Roll Hall of Fame in 1986
- Member of the Rockabilly Hall of Fame

Trivia

- On his first trip to Nashville in 1954, some record executives liked Lewis's sound but suggested he incorporate the more marketable guitar. Lewis, in his usual unpredictable fashion, apparently told one Nashville producer, "You can take your guitar and ram it up your a**!"

- Nicknamed "The Killer" for his powerful voice and energetic piano playing.

- Lewis has ten gold records to his name.

- Apparently, the Bible school Jerry Lee Lewis was attending in his youth expelled him for breaking into a boogie-woogie version of "My God Is Real."

- He married Jane Mitcham, his second wife, twenty-three days before his divorce from his first wife was final.

- Once he set a piano fire at the end of his show while playing "Great Balls of Fire."

- The theme song "High School Confidential," for the movie of the same name, was almost pulled at the last minute due to the backlash against Jerry Lee's 1957 marriage. The movie's release was delayed by six months and ultimately suffered at the box office.

Elvis Presley

Elvis Presley is the undisputed "king of rock and roll." He conquered the 1950s division of race with his music, appeared in 31 movies, had 30 gold records and sold more than 250 million records during his living career. His fame continued to escalate following his death in 1977 with albums like *Elvis 30 #1 Hits* going triple platinum. Elvis was the consummate performer; he had command over his own performance, his band and his audiences. Elvis Presley's fame during his career and his legacy after death are, to this day, unmatched by any performer.

The Life of Elvis Presley

"God intended for Elvis Presley to do what he did on the face of this earth. That's why he made him so good looking."

— Carl Perkins

1935–1953

Elvis Aaron Presley was born in Tupelo, Mississippi on January 8, 1935 to Gladys and Vernon Presley. Elvis was the second born of identical twins (his twin brother Garon was stillborn) and grew up in a poor working class environment with a strong religious foundation. The influence of gospel music in church and local blues musicians on Beale Street would become a major part of his later musical career.

When he was ten years old, Elvis won second place in a talent contest at the Tupelo "Mississippi-Alabama Fair and Dairy Show" with the song "Old Shep." In September 1956, Elvis performed at the fair again, but this time to thousands of screaming fans and 100 national guardsmen assigned to him for crowd control.

Elvis received his first guitar for Christmas in 1946. He took this guitar everywhere, practicing constantly and transcribing music of every kind from records and the radio. In 1948, his family moved to Memphis where he attended L. C. Humes High School and

Elvis Presley

Elvis Presley playing acoustic guitar

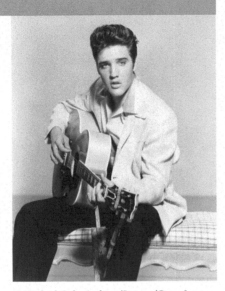

© *Michael Ochs Archives/Stringer/Getty Images*

became friends with Hank Snow's son J. R. Some said that Elvis knew all of Snow's songs and could play them on demand. During his high school years, Elvis would hang out on Beale Street sneaking into blues clubs to study the singing and guitar styles of the blues greats. B. B King recalls talking with Elvis and vouching for him so he could stay and watch his band on many occasions.

After graduating from high school in June 1953, Elvis worked briefly for Parker Machinists, the Precision Tool Company and the Crown Electric Company as a delivery driver. He also made his first visit to Sun record studios to see what his voice sounded like on disc. He recorded "My Happiness" and "That's When Your Heartaches Begin" ($4 bought him two sides). He then presented the recording to his mother as a much belated birthday present. Elvis returned to Sun in January 1954 to make another recording, and this time Sam Phillips was impressed with his unique musical style and image. After a number of unsuccessful experimental recordings, Phillips finally teamed Elvis up with Scotty Moore (lead guitar-December 27, 1931–June 28, 2016) and Bill Black (bass—September 17, 1926–October 21, 1965) who became the foundation of his band for many years. Elvis played rhythm guitar and named the trio The Blue Moon Boys.

Recommended Listening

- My Happiness

1954

On July 5, 1954, Elvis recorded Arthur Crudup's "That's All Right Mama" and Bill Monroe's "Blue Moon of Kentucky." Both songs charted in the South, but "That's All Right Mama" became an overnight regional hit, bringing six thousand advance orders in the first week of radio play. Elvis's follow-up single to "That's All Right Mama" was Roy Brown's "Good Rockin' Tonight," which was also well-received by the public.

Elvis was asked to perform on the prestigious Grand Ole Opry, but was not invited back because they said "he does not perform country music properly." One of the Opry officials advised him not to quit his job driving delivery trucks any time soon! In October, the Louisiana Hayride (the Opry's biggest competitor) recognized the opportunity and signed Elvis to fifty-two consecutive Saturday night appearances. Through the Hayride performances, Elvis met his future manager Colonel Tom Parker.

Recommended Listening

- That's All Right Mama (Memphis regional hit)
- Blue Moon of Kentucky
- Good Rockin' Tonight

1955

In January, Bob Neal became Elvis's manager. He toured Elvis, Scotty and Bill throughout the Southern states with various country artists and added drummer D. J Fontana to the lineup, thus completing Elvis' rock and roll sound. In August he signed Elvis with Hank Snow Attractions where Col. Tom Parker took exclusive control of managing Elvis Presley. On November 21, Parker negotiated a $35,000 buyout for Elvis, moving him from Sun to RCA (Elvis received a $5,000 personal bonus) where his career began to explode on a national and international level.

Young Elvis

Elvis during high school with his record collection

© Bettmann/Contributor/Getty Images

Recommended Listening

- Baby Let's Play House
- I Got a Woman
- Mystery Train
- I Forgot to Remember to Forget (#1 on the country charts)

Colonel Tom Parker

Colonel Tom Parker (AKA Andreas Cornelis van Kuijk) was born in Breda, Netherlands on June 26, 1909. He reportedly arrived in the United States as a stowaway on a ship sometime between the ages of sixteen and eighteen. He served in the U.S. Army for two years (1931–1933), but the Army reported him AWOL for 140 days, after which he was institutionalized for a time. Upon leaving the military, he assumed the name Thomas Parker. He received the unofficial title of Colonel from Governor Jimmy Davis of Louisiana in 1948 as a gesture of thanks after Parker led his political campaign for governor to success (Davis was a former country musician). Mystery and deceit shroud Col. Parker's rise to notoriety as an entertainment manager, although no one can deny his talent for manipulating the music business.

Prior to entering the music business exclusively, Parker worked for traveling circuses, as a dogcatcher, as president of the Tampa humane society and as a pet cemetery proprietor. He became involved with RCA and artist management around 1942. In 1947 he took Eddy Arnold, who dismissed Parker a couple of years later, to the top of the country charts and national fame. He also managed Minnie Pearl and actor Tom Mix before teaming up with Hank Snow to form Hank Snow Attractions. Through Hank Snow, Parker met Elvis Presley and became his manager. Col. Parker made an agreement with RCA and signed Elvis to the famous $35,000 deal that brought the king of rock and roll from Sun to RCA.

When Elvis agreed to sign with Tom Parker, he allowed Parker to give himself a 25 percent commission on every business venture they embarked upon. Later, Parker convinced Elvis to sign over 50 percent of all royalties and profits. By the mid-1970s, Parker was receiving as much as 80 percent of all monies from Elvis' merchandising. Col. Parker was unrelenting with Elvis' touring, recording and movie schedule, keeping the income at a massive and steady flow. His hold on Elvis separated them as friends in the 1970s and played a big part in Elvis' depression and health problems later in life.

Despite Col. Tom Parker's underhanded methods of managing Elvis, he made some smart business moves that changed music management forever. Parker introduced merchandise marketing on an enormous scale by introducing the idea of marketing Elvis to the people who market to the whole nation through national television shows. This created a phenomenon surrounding Elvis that elevated him to superstardom. Parker's only downfall from a business perspective is that he didn't allow Elvis to tour internationally. In fear of being deported, or of Elvis finding a better and more amicable manager, Parker kept Elvis in the United States. When Elvis toured Canada briefly in 1957, Parker did not cross the border.

Elvis tried unsuccessfully to break his association with Tom Parker on a number of occasions, but Parker was always one step ahead. Parker died on January 21, 1997.

1956

Officially now with RCA, 1956 became the most pivotal and monumental year in Elvis' career, musically, in film and in promotion and merchandising.

In January he recorded his first national #1 hit and million-selling single "Heartbreak Hotel." While continuing a busy tour schedule and Louisiana Hayride appearances, Elvis made TV appearances during the year on Jackie Gleason's *Stage Show*, ABC's *Milton Berle Show*, NBC's *Steve Allen Show* and the *Ed Sullivan Show*, where he received an unprecedented $50,000 for three performances. Elvis' first full album, *Elvis Presley*, was released in March, giving him his first Gold record. (The album stayed at #1 for ten weeks.)

In April, Elvis signed a seven-year movie deal with Paramount Pictures, and filming began in August on his first feature, *Love Me Tender*. Originally titled *The Reno Brothers*, the film's title was changed to capitalize on the guaranteed success of the title song. The single also required advance shipping due to overwhelming pre-order sales.

Elvis souvenir merchandise was released in September with more than seventy products ranging from t-shirts, jeans, hats and clothing accessories, to posters, stationary, dolls and toys, and colognes, jewelry and make-up; Elvis lipstick came in tutti frutti red, hound dog orange and heartbreak hotel pink. The *Wall Street Journal* reported that Elvis merchandise reaped $22 million in profits during the first three months of sales.

By the end of 1956, Elvis had five #1 singles, two #1 albums, a movie, multiple television appearances and a massive publicity and merchandise

Elvis in the mid-1950s

Elvis' signature hip gyrations outraged many TV viewers across America

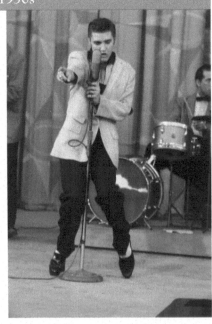

© *Bettmann/Contributor/Getty Images*

campaign. The famous "Million Dollar Quartet" session took place on December 4 with Johnny Cash, Jerry Lee Lewis and Carl Perkins when Elvis returned to Sun to visit Sam Philips. Elvis Presley had officially become the new idol of American teens and a most controversial figure for adults and politicians. His social influence scared them.

Recommended Listening

- Heartbreak Hotel (#1)
- I Want You, I Need You, I Love You (#1)
- Hound Dog and Don't Be Cruel (#1)—quadruple platinum single (only time to happen until We Are The World in 1985)
- Love Me Tender (#1)
- The Million Dollar Quartet (session recordings not released for 20 years)

1957

Elvis made his final appearance of the $50,000 deal on the *Ed Sullivan Show* on January 6 and went straight into production for his next movie, *Loving You*. The filming of *Jailhouse Rock* followed in May. He purchased the Graceland mansion in March where he and his family, including his parents and grandmother, would now reside. Between April and August, Elvis performed three times in Canada. These concerts were the only time in his career that he performed outside of the United States. In December he received notice that the U.S. Government had drafted him for military service in the Army.

Recommended Listening

- All Shook Up (#1)
- Too Much (#1)
- (Let Me Be Your) Teddy Bear (#1)
- Jailhouse Rock (#1)
- Don't (#1)

1958

In early 1958, Col. Parker pushed Elvis to record material for release during his time in the Army. Elvis also made one more movie, *King Creole*, which was hailed as his greatest acting role. In June he made his last recording until 1960. In August, the Army granted Elvis emergency leave when his mother fell suddenly ill. Soon after he arrived home she passed away at age 46, which left Elvis devastated (Elvis was particularly close to his mother). He returned to the Army later that month and served eighteen months in Friedberg Germany (October 1958 to March 1960).

The Presleys

Elvis with his
parents Vernon
and Gladys

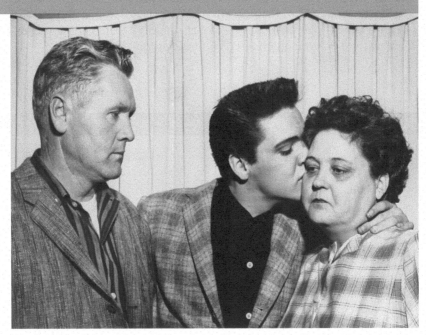

© *Bettmann/Contributor/Getty Images*

Recommended Listening

- Hard Headed Woman (#1)
- One Night
- I Got Stung
- The album *Elvis' Golden Records* (six times platinum)

1959

Col. Parker maintained a steady release of pre-recorded singles and albums while Elvis was serving in the Army. The recordings charted remarkably well, and "A Big Hunk O' Love" hit the top of the billboard charts. Elvis met his future wife Priscilla Beaulieu (born May 24, 1945) while stationed in Friedberg, and they became very good friends.

Recommended Listening

- A Big Hunk O' Love (#1)
- (Now and Then There's) A Fool Such As I
- I Need Your Love Tonight

1960

Elvis returned from Germany in March and wasted no time getting back into the studio and onto the movie set. He entered the charts at #2 with his album *Elvis is Back!* three months before the movie *G.I Blues* opened in theaters. Elvis' album of the same title went straight to #1; this album remained on the charts for 111 weeks.

Recommended Listening

- Stuck On You (#1)
- It's Now or Never (Elvis' best selling single with over 10 million sales in 1960) (#1)
- Are You Lonesome Tonight? (#1)

1961

Elvis's performance to raise money for the USS Arizona Memorial in Hawaii on March 25 became his last live performance until a 1968 TV special. He appeared in four movies this year and continued a rigorous recording schedule. The soundtrack for the movie *Blue Hawaii* was released and stayed in the #1 spot for twenty weeks.

Recommended Listening

- Surrender (#1)
- Little Sister
- (Marie's the Name of) His Latest Flame
- Can't Help Falling in Love

1962

This year brought more movie making and soundtrack albums. Most of the charting singles were a result of their relationship to corresponding movies. In December, Priscilla visited Elvis for Christmas.

Recommended Listening

- Good Luck Charm (#1)
- She's Not You
- Return to Sender

1963

In early 1963, Priscilla moved into Graceland with Elvis and finished her final year of high school in Memphis. In July Elvis began work on the movie and soundtrack for *Viva Las Vegas* co-starring Ann-Margret.

Recommended Listening

■ (You're the) Devil in Disguise

1964

Elvis purchased the "Potomac," Franklin Roosevelt's yacht, for $55,000 and donated it to the St. Jude Children's Research Hospital in Memphis to use for fundraising as they saw fit. The Beatles and British invasion hit the American airwaves with the new face of rock and roll. For Elvis, this confirmed his boredom with his current recording regimen and tacky movie roles.

1965/1966

Elvis made seven more movies in 1965 and 1966; all of them had very short lives at the box office. The soundtracks seemed to hit, make some money and disappear just as quickly. Elvis became more depressed about the state of his unfulfilling career and saw the only true highlight as Priscilla's acceptance to marry him. The album *Roustabout*, however, did chart at #1 during 1965.

Recommended Listening

■ Crying in the Chapel
■ Album *Roustabout*

1967

Elvis bought the 163-acre Circle G ranch in Mississippi in February and finally married Priscilla in a private ceremony at the Aladdin hotel and casino in Las Vegas in May. The gospel album *How Great Thou Art* was released and earned Elvis his first Grammy award. He filmed three more movies this year and appeared in *Speedway* with Nancy Sinatra.

Recommended Listening

■ Album *How Great Thou Art*

1968

Lisa Marie Presley was born on February 1, nine months to the day after Elvis and Priscilla's wedding. More recording and acting continued through the end of June when Elvis filmed his TV show *The '68 Special*. This show was important to Elvis as seven years had passed since he had performed for a live audience. The show was a great success featuring music from his youth, rockabilly days, movies, gospel roots and pop hits. It was essentially the Elvis Presley story, and one of the biggest TV hits of the year. He spent the rest of the year on movie sets and recording.

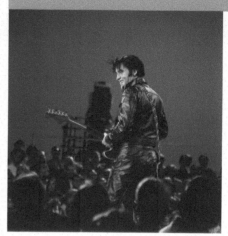

'68 Special

Elvis in his 1968 comeback special

© NBC/Getty Images

1969

Elvis returned to Memphis for two months of recording for the first time since 1955. All other recording to this point took place in Nashville or Hollywood. Two albums and his first #1 hit since 1962 came out of these sessions. (It was also his last #1 pop hit). In March he returned to Hollywood to film *Change of Habit* with Mary Tyler Moore, his last acting role.

At the end of July, Elvis was booked for a four-week, fifty-seven show run at the International Hotel in Las Vegas. The shows broke all Las Vegas attendance records and produced Elvis's first live album, *Elvis in Person at the International Hotel*.

Recommended Listening

- Suspicious Minds (#1)—first #1 hit since 1962
- In the Ghetto
- Don't Cry, Daddy/Rubberneckin'

1970

Elvis returned to Las Vegas for another month long run in January. The event promoters were skeptical as this was the slow season in Las Vegas, but Elvis exceeded his own attendance records from the previous year. In late February, he performed six shows in Houston to a record 207,500 fans. Elvis returned to Vegas in July for more shows and to film *Elvis—That's The Way It Is* for MGM. In September, he hit the road for his first tour since 1957 and met with President Nixon in December at the White House. Some fans claim that this is where Elvis made a deal to fake his death (to come in 1977), to disappear and to become an undercover CIA agent!

Recommended Listening

- The Wonder of You/Mama Liked the Roses
- I Just Can't Help Believin'

1971

Another string of engagements in Las Vegas kicked off the year, followed by recording in Nashville in March, but a bout of Elvis's health issues cut the recordings short. The book *Elvis: A Biography*, considered the first serious look at Elvis' life, was released in October. In June, his childhood home in Tupelo opened as a museum and he received the Bing Crosby Award (later re-named the Lifetime Achievement Award) from the National Academy of Recording Arts and Sciences (the Grammys).

More successful touring, recordings and Las Vegas shows followed, but the lifestyle and pressure became too much for Priscilla who moved out of Graceland at the end of the year.

1972

A grueling tour schedule of extended Las Vegas runs and recording pushed Elvis to the limit, and it began to wear on his health. The gospel album *He Touched Me* won Elvis his second Grammy Award, and MGM filmed a second live movie, *Elvis on Tour*, which won a Golden Globe Award later that year. He recorded and released *Elvis: as Recorded at Madison Square Garden* in only nine days, and continued the touring.

Elvis in 1971

Elvis in Las Vegas during the filming of "The Way It Is" for MGM

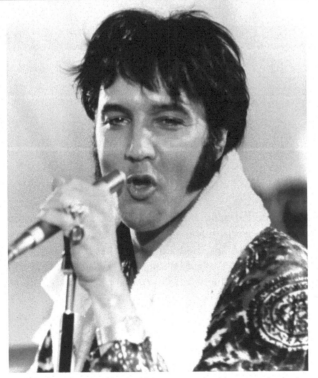

© *Sunset Boulevard/Contributor/Getty Images*

Recommended Listening

- Burning Love (last top 10 single)
- Album *He Touched Me*

1973

Once again Elvis made television history when the *Elvis: Aloha from Hawaii—Via Satellite* special aired to the world. The show attracted a bigger TV audience than man's first walk on the moon! The resulting soundtrack album went straight to #1 and remained on the charts for fifty-two weeks. This was the first #1 album for Elvis since *Roustabout* in 1965. In March, Col. Parker and Elvis sold all royalty rights to the entire Elvis song catalogue to RCA for $5 million.

In August 1973, Elvis and Priscilla became officially divorced. He remained close to her throughout the rest of his life and dedicated all of his spare time to his daughter Lisa Marie. Hospitalized with health problems, Elvis's prescription drug dependency was becoming more and more problematic.

Recommended Listening

- Album *Elvis: Aloha from Hawaii—Via Satellite*

1974

Elvis spent a great deal of time on the road during 1974 playing sold-out stadium concerts and several runs in Las Vegas and Lake Tahoe. One of the concerts recorded in Memphis brought Elvis his third Grammy for the live version of *How Great Thou Art*. In August, Barbara Streisand offered Elvis the male lead in her next movie, *A Star is Born*. Elvis felt excited about the opportunity to act in a serious role, but his health complications prevented him from accepting the offer.

Recommended Listening

- Live version of *How Great Thou Art*

1975

Elvis was hospitalized in early 1975 with serious health problems, but he continued his touring and recording as soon as the hospital discharged him. In August he ended his run

in Las Vegas early and was hospitalized again. He made these performances up in December followed by a New Year's Eve concert in Michigan with over 62,500 fans attending.

1976

Health issues prevented Elvis from leaving his home in early 1976, so RCA set up recording equipment at Graceland. Elvis recorded *From Elvis Presley Boulevard, Memphis, Tennessee*, which went to #1 on the country charts. The stretch of highway in front of Graceland had been re-named "Elvis Presley Boulevard" in 1971. He also managed to record half of the *Moody Blue* album during this time. He spent the rest of the year doing short tours, returning to Graceland to finish *Moody Blue* later in the year. In December, Elvis made his last appearances at the Las Vegas Hilton (formerly the International Hotel).

Recommended Listening

■ *Moody Blue* (#1 on country charts)

1977–August 16, 1977

Elvis tried to fulfill his tour and recording schedule through the first half of 1977, but many dates were cancelled as his health declined dramatically. One last filmed TV special showed the king of rock and roll in a terrible state, but, remarkably, his voice was still strong. His last live performance was in Indianapolis at Indiana's Market Square Arena. After this concert he took a month and a half off to recuperate. In July, three of his friends (members of the Memphis Mafia) published a book titled *Elvis: What Happened?* The book gave scathing accounts of Elvis's private life and personal tragedies. This hurt Elvis deeply at a time when he was most vulnerable.

On August 16, the day before the beginning of his next tour, Elvis Presley passed away from a sudden heart attack. The news of his death spread across the globe in a matter of hours with many stories and rumors about the way he died, the location of his body and the circumstances surrounding his death. What we know for sure is that Elvis ultimately died of heart failure. No drugs of fatal dose appeared in his system (although the years of prescription drug abuse were certainly a factor), nor were there any signs of foul play or suicide.

Elvis Aaron Presley left this earth at the age of forty-two having lived a life that changed the world in which

Priscilla, Lisa-Marie and Elvis

A family portrait of Elvis with his young daughter Lisa-Marie

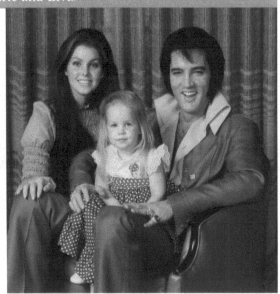

© *Frank Carroll/Sygma/Crobis*

we live. His revolution of, and contribution to, the music industry has allowed rock and roll to become what it is today. Regardless of taste in music, no one can deny the impact, influence and contribution of Elvis Presley and his earned title, the king of rock and roll.

Recommended Listening

- Way Down (#1 on country charts)

All 31 Feature Movies
- 1956 Love Me Tender
- 1957 Loving You, Jailhouse Rock
- 1958 King Creole
- 1960 G.I. Blues, Flaming Star
- 1961 Wild in the Country, Blue Hawaii
- 1962 Follow That Dream, Kid Galahad, Girls! Girls! Girls!
- 1963 It Happened at the World's Fair, Fun in Acapulco
- 1964 Kissin' Cousins, Viva Las Vegas, Roustabout
- 1965 Girl Happy, Tickle Me, Harum Scarum
- 1966 Frankie and Johnny, Paradise, Hawaiian Style, Spinout
- 1967 Easy Come, Easy Go, Double Trouble, Clambake
- 1968 Stay Away, Joe, Speedway, Live a Little, Love a Little
- 1969 Charro!, The Trouble with Girls, Change of Habit

Feature Concert Movie Specials
- 1970 Elvis, That's the Way It Is
- 1972 Elvis On Tour

Influential Songs
- Elvis has 53 singles and 16 extended play singles certified gold or platinum according to RIAA as of January 2005.
- He had 149 singles make it to Billboard's Hot 100 Pop Chart in America; 114 of these reached the top forty, 40 in the top ten, and 18 went to number one.

Influential Albums
- Elvis has 81 albums certified gold or platinum according to RIAA as of January 2005.
- Elvis Presley's records have sold over one billion units worldwide, making him the biggest selling artist in recorded history.
- He has had over 90 charting albums

Awards
- Inducted into the Rock and Roll Hall of Fame in 1986
- Inducted into the Rockabilly Hall of Fame in 1997
- Inducted into the Country Music Hall of Fame in 1998

- Inducted into the Gospel Music Hall of Fame in 2001
- Elvis received fourteen Grammy nominations and won three.
- In 1971, he received the Grammy Lifetime Achievement Award.
- The Grammy Hall of Fame posthumously entered six of Elvis's singles in 1988 for historical significance.
- The United States Junior Chamber of Commerce declared Elvis one of the "top ten young men of the nation" (USA) in 1970.

Trivia

- D.J. Fontana had played as a strip club drummer before becoming the house drummer on the Louisiana Hayride. When Elvis appeared on the show, he began accenting each gyration and dramatic move, and the audience went crazy. He became Elvis's drummer for fourteen years after that performance.

- In 1960, Frank Sinatra featured Elvis on a "welcome home" edition of his show and paid him an unprecedented amount of $125,000.

- From 1969 to 1977, Elvis gave 1,100 concert performances.

1950s Rock and National Popularity

Rock Reaches National Popularity

We generally credit 1954 as the year that rock and roll reached national popularity among both black and white teens in America. Several determining factors met in 1954, and despite much of the older generation rallying against rock music because of its apparent sexual innuendos and power to desegregate among young people, rock 'n' roll hit home with the teenage market and is now here to stay. Influential factors included:

- In 1954, Alan Freed coined the term "Rock 'n' Roll" on his New York radio show, the Rock 'n' Roll House Party, which attracted massive audiences and made him the city's most famous DJ.

- Ten thousand fans attended Alan Freed's first rock 'n' roll show in New Jersey.

- The first successful integrated rock 'n' roll show was staged in Cleveland with The Dominoes and Bill Haley & His Comets.

- Major record companies began to capitalize on white artists covering successful black R&B records.

- In 1954 several songs that defined the rock 'n' roll sound for the rest of the decade and the first half of the 1960s hit the charts. These included "Earth Angel" by the Penguins, "I've Got a Woman" by Ray Charles and "Tipitina" by Professor Longhair. Big Joe Turner and Bill Haley each released "Shake Rattle & Roll," and Ray Charles (with Guitar Slim) released the biggest R&B hit of the year with "Things That I Used to Do."

■ Elvis Presley released his first commercial record "That's All Right, Mama" on July 5 through the Sun Studio in Memphis.

With such suggestive songs as B. B. King's "Whole Lotta Lovin'," the Five Royales' "Too Much Lovin'," Clyde McPhatter & The Drifters' explicit "Honey Love" and "Such A Night," and the Midnighters "Sexy Ways" and "Work With Me Annie" hitting the charts, many communities called for a complete ban on rock 'n' roll. Some states followed this line of thinking and prevented local radio stations from playing rock music they deemed unsuitable.

Evolution of the Charts and the Billboard Hot 100

As television became more affordable for Americans after WWII, radio stations and their disc jockeys started promoting special programs to retain their audiences. The most effective way for them to do this was with a charting system that would update listeners on the most popular music in a given week. Everything from a top five through the top forty seemed to get the attention of young (teen) listeners and record buyers. Initially there were three areas for ranking popular music, especially rock 'n' roll: best sellers in stores, most played by disc jockeys and most played in jukeboxes. By 1954, these charts played an important role in rock 'n' roll record sales and the success of the artists. The most respected and reliable chart didn't appear until August 1958 when *Billboard* magazine first released its "Hot 100." The Hot 100 has since become the benchmark for determining the success of rock and popular artists.

Introduction of 45 Revolutions Per Minute (rpm) Records

Just before 1900 and until the mid-1950s, 78 rpm records were in use and were made from a brittle material commonly referred to as shellac. Each side of a 78 record could hold approximately three minutes of music. The long play (LP) 33⅓ rpm microgroove record and the 45 rpm single and EP record used narrower grooves and a slower rpm for longer playing time. Made largely of vinyl, these records had several advantages over the 78s. The LP could hold up to thirty minutes of music on each side (standard album length was forty-five minutes), and it was cheaper to make and less likely to break or get scratched. The 45 rpm discs came in two formats, the single, which matched the playing time of the 78s, and the Extended Play (EP), which could hold four songs, or a total of ten to fifteen minutes of music. The innovation of vinyl LPs, EPs and singles made the shellac 78 record obsolete overnight! Development of better, cheaper records moved ahead with rock 'n' roll, as did the quality of the recordings. The distribution of singles and LPs also became more widespread as a direct result of the rise in popularity of rock 'n' roll in 1954, and records became available in convenience stores, supermarkets and gas stations.

RCA, Decca, Columbia and Capitol—The "Big Four" record companies

The "big four" record companies that dominated the entertainment industry from the 1940s through the 1950s made it almost impossible for small labels to have a voice or to influence any change in direction in music. The introduction of rock 'n' roll broke the monopoly of these major labels on the industry in the early 1950s. Sun, Chess, Modern, Atlantic and other small record labels saw the value and massive impact that R&B and rock 'n' roll would have on the world and nurtured a new genre and audience that would send music industry profits through the roof. The big four labels initially sided with those rejecting rock 'n' roll, stating that the music was detrimental to American society, sexually fueled and explicit and in many cases the devil's music. They maintained this position until, of course, the mid to late 1950s when they made up the lost ground. They claimed their

portion of this new market that would make them billions and regained their monopoly of the industry. Sponsored radio programs and television then promoted the industry's rock 'n' roll that was appropriate for prime time America and the rest of the world, in many cases using the same artists they had previously condemned. Columbia stayed out of the rock 'n' roll business, choosing to promote classical music and crooners until the mid-1960s, but the other three major labels jumped head first into the new rock 'n' roll industry. To launch their new investments RCA bought Elvis from Sun, Decca picked up both Bill Haley and the Comets and Elvis' UK distribution and Capitol promoted Gene Vincent.

RCA (Radio Corporation of America)

During WWI, General Electric (GE) was asked to form a radio company to support American military correspondence and technology. GE officially formed the Radio Corporation of America in 1919 with Westinghouse producing the equipment. In 1920, Westinghouse and RCA joined forces again to receive the first commercial broadcasting license. In 1929, RCA purchased the Victor Talking Machine Company and began manufacturing radios and phonographs. RCA Victor developed the first 33⅓ rpm "long play" records, and, in 1949, they released the first 45 rpm records.

Decca

The Decca Record Company is a British Record label that formed in 1929 and expanded into the United States market in 1934. The company soon became the second largest record label in the world under the name "The Supreme Record Company." By 1939 there were only two record labels operating in the UK, Decca and EMI (Electric Music Industry). Decca and EMI had bought all of the smaller labels out. Decca dominated the European music industry in every genre, but they almost lost the entire British pop market to EMI through several bad choices in the early 1960s. They refused to sign the Beatles, the Yardbirds and Manfred Mann, but they regained their status when they signed the Rolling Stones in 1963.

Columbia

Columbia Records began distributing and selling Edison phonographs and cylinders in 1891 before signing their own artists and exclusively promoting them from 1901. Columbia introduced the double-sided disc in 1908 but by 1912 stopped making cylinders completely. In 1926, they branched into the jazz genre and, in 1928, country music. In 1931 the UK branch of Columbia merged with the Gramophone Company to form EMI, and in 1938, the American portion of the company merged with CBS and absorbed several other small labels in the process. Columbia dominated the classical and crooner markets well into the 1960s and was innovative in the introduction of stereo recordings.

Capitol

Johnny Mercer (the famous songwriter) and two other music industry friends created the Capitol Record Company in 1940 in Hollywood, California. In 1946 Capitol branched out from the crooner and classic genres into jazz. In the early 1950s they began concentrating on popular music, including rock 'n' roll. In 1955, EMI purchased 96 percent of Capitol, creating a powerful merger. In the 1960s, Capitol (still running independently in the USA) picked up the United States distribution of the Beatles, and, with their subsidiary Tower Records, they dominated the rock genre until the 1970s.

Current Big Four Lineup

For many years, six record labels controlled the music industry (Sony Music, Warner Music Group, BMG Entertainment, Polygram, MCA and EMI Group). However, from 2004, four influential labels dominated the industry:

1. The Universal Music Group who absorbed Decca
2. Sony BMG Entertainment who absorbed Columbia and RCA
3. The EMI Group who absorbed Capitol
4. The Warner Music Group

Between 2011 and 2013 there was a lot of movement in the industry resulting in major mergers and acquisitions of big record labels. The outcome of these changes leaves us now with three major labels who oversee many of the influential record companies.

Here is what the now "Big Three" look like (from https://www.playlistresearch.com/recordlabels.htm March 2022)

Universal Music Group
- Geffen Records
- Interscope Geffen A&M
- Island Def Jam Music Group
- Lost Highway Records
- MCA Nashville
- Mercury Nashville
- Motown Records
- Uni Records
- Universal Music Classics Group
- Universal Records
- Universal Music Enterprises
- Uni Music Latino
- Uni Music South
- Verve Music Group

Warner Music Group
Atlantic Records Group:
- Atlantic Records
- Badboy Records
- Elektra Records
- Lava Records
- Roadrunner Records

Independent Label Group:
- Asylum
- Cordless Recordings
- EastWest

Warner Brothers Records:
- Maverick Records
- Nonesuch

- Reprise Records
- Sire Records
- Warner Bros. Records
- WBR Nashville
- Word Records

Warner Music International:

WMI Word Entertainment:
- Word Distribution
- Word Entertainment
- Word Music
- Word Records

Sony Music Entertainment
- Arista Nashville
- Arista Records
- Bluebird Jazz
- BNA Records Label
- Legacy Recordings
- Provident Label Group
- RCA Records
- RCA Records Label Nashville

- Burgundy Records
- Columbia Nashville
- Columbia Records
- Epic Records
- J Records
- Jive Records
- LaFace Records

- RCA Victor
- Sony BMG Masterworks
- Sony BMG U.S. Latin
- Sony Wonder
- Verity Records
- Winham Hill

Former EMI Group (divided between Universal and Sony)

- Angel Records
- Astralwerks
- Back Porch Records
- Blue Note Records
- Capitol Records
- Caroline Distribution
- EMI Christian Music Group
- EMI CMG Distribution

- EMI Gospel,
- EMI Latin
- Forefront Records
- Higher Octave Music
- Manhattan Records
- Narada
- Sparrow Records
- Virgin Records

Bill Haley

William "Bill" John Clifton Haley (July 6, 1925–February 9, 1981) was the first rock 'n' roll superstar. He began his career as a yodeling cowboy performing up-tempo country music and Western swing with a variety of groups, including the Down Homers, the Range Drifters, the Four Aces of Western Swing and the Saddlemen. In 1951, Haley recorded Jackie Brenston's "Rocket 88," which introduced him to the style of rock 'n' roll. In 1953 he formed Bill Haley and His Comets, abandoning his cowboy roots once and for all. The group's first single, "Crazy Man Crazy," was the first rock 'n' roll song to be a U.S. Top 20 hit; and, in 1954, after signing with the Decca label, the group recorded their two most famous songs, "Rock Around the Clock" and "Shake, Rattle and Roll." "Rock Around the Clock" was initially unsuccessful, but it became a monumental hit in the U.S. and Britain after its inclusion in the controversial 1954 film, *The Blackboard Jungle*. Haley's work in

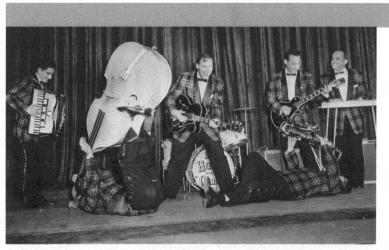

Bill Haley

Bill Haley was the first star of rock 'n' roll.

© *Bettmann/Contributor/Getty Images*

these early years of rock 'n' roll made him a pioneer of the rockabilly style. Between 1954 and 1956, Bill Haley remained the most popular rock 'n' roll artist, and in 1956 and 1957 he had twelve Top Forty hits. He appeared in two movies in 1957: *Rock Around the Clock* and *Don't Knock the Rock*. The younger, slicker Elvis Presley, Jerry Lee Lewis and the other young rockers eventually surpassed Haley, but, because his music retained its universal appeal and he toured constantly, Haley maintained a successful career." Bill Haley died in 1981 after a lengthy battle with alcoholism and a brain tumor. He was posthumously inducted into the Rock and Roll Hall of Fame in 1987.

Recommended Listening

- Rock Around the Clock
- Shake, Rattle and Roll
- Thirteen Women
- See Ya Later Alligator

Trivia

- Bill Haley and His Comets were the first American rock 'n' roll artists to tour the United Kingdom.

- "We steer completely clear of anything suggestive. We take a lot of care with lyrics because we don't want to offend anybody. The music is the main thing and it's just as easy to write acceptable words." —Bill Haley

Buddy Holly

Buddy Holly was a great influence on many future rock stars including the Beatles

© *Michael Ochs Archives/Getty Images*

Buddy Holly

Charles Hardin "Buddy Holly" Holley (September 7, 1936–February 3, 1959) was born and raised in Lubbock, Texas. At the age of thirteen, Holly and his friend Bob Montgomery were playing country music, popular hits and their own creation called "Western Bop" at local clubs. They acquired a booking agent who secured them regular shows and a spot on a local radio station. Their big break came when they were asked to open a show for Bill Haley and His Comets. After the Bill Haley performance Decca Records offered Buddy a recording contract on the condition he return to Texas to continue working on his music skills. Holly took the advice and also put together a backing band called the Crickets. As the group's guitarist and vocalist, Holly recorded "That'll Be the Day" in early 1957, and the song was released on Decca's subsidiary,

the Brunswick label; it hit #1 on the charts. In October 1958, Holly was convinced to leave the Crickets and form a new backing band that included future country great Waylon Jennings on bass. Between August 1957 and August 1958, Holly and the Crickets charted seven Top 40 singles with "Maybe Baby," "Oh Boy!" "Peggy Sue," "Rave On," "It Doesn't Matter Anymore" and "Think It Over." When the Rolling Stones first hit the U.S. singles charts in 1964, it was with Buddy Holly's "Not Fade Away." Apparently this was also the last song that Buddy Holly performed before his fatal plane crash. Buddy Holly's plane crashed near Mason City, Iowa on February 3, 1959, after traveling only eight miles; everyone on board was killed. Buddy Holly pioneered and popularized the standard rock band lineup of two guitars, bass and drums. He was inducted into the Rock and Roll Hall of Fame in the first induction year, 1986.

Recommended Listening

- That'll Be the Day
- Not Fade Away
- Peggy Sue
- Rave On
- Oh Boy!

Trivia

- Buddy Holly was an influence on the Beatles and the Hollies musically and an inspiration for naming their bands.

- A spelling error in a contract listed him as Buddy Holly (instead of Holley). He then adopted this spelling for his professional career. The original spelling of "Holley" is engraved on his headstone.

- Buddy Holly and the Crickets were mistaken for a black rhythm and blues group and booked (from an audition tape) to perform at the Apollo Theater. Although at first the band was booed, by their third day of performing they had become a hit.

- On the original recording, Jerry Allison, the Crickets' drummer, played the "Not Fade Away" rhythm pattern on a cardboard box.

- Holly was one of the first to use advanced studio techniques such as double-tracking.

Eddie Cochran

Despite his very brief career, Eddie Cochran (October 3, 1938–April 17, 1960) still managed to make a mark on rock and roll. Cochran was born in Oklahoma City in 1938, but he spent most of his childhood in Minnesota. As a child, he taught himself how to play blues guitar, and when his family moved to California in 1949, he teamed up with Jerry Capeheart, who co-wrote a number of Cochran's hits, including "Summertime Blues." His first hit singles were in 1957 with "Twenty Flight Rock" and "Sittin' in the Balcony," followed by his most well known song "Summertime Blues" in 1958. Other hits such as "C'mon Everybody,"

Eddie Cochran

Self-taught guitarist Eddie Cochran

© Michael Ochs Archives/Stringer/Getty Images

"Somethin' Else," "Nervous Breakdown" and "Three Stars" helped secure his growing popularity. Cochran was known for his lively stage performance, his proficiency on the guitar and his use of overdubbing to enhance his recordings. Although Cochran had several hits in the United States, he was much more popular in England where he toured extensively. Sadly, Cochran's career was cut short in 1960 when he died in a car crash on the way to the London airport during a tour with Gene Vincent. Eddie Cochran was inducted into the Rock and Roll Hall of Fame in 1987 and the Grammy Hall of Fame and the Rockabilly Hall of Fame in 1999.

Recommended Listening

- Summertime Blues
- Twenty Flight Rock
- Sittin' in the Balcony

Trivia

- Cochran met his primary songwriting partner, Jerry Capeheart, at a music store while he was buying guitar strings.

- Cochran overdubbed his guitar on recordings to create a fuller sound and made use of big open chords well before the "power chord" was a standard tool for guitarists.

- He appeared in the film *The Girl Can't Help It* singing "Twenty Flight Rock."

- Recorded the song "Three Stars" as a tribute to Buddy Holly, Richie Valens and the Big Bopper one year before his own death.

Gene Vincent

Vincent Eugene "Gene Vincent" Craddock (February 11, 1935–October 12, 1971) was a pioneer of the Rockabilly style in the early 1950s. He signed a major record deal with Capital Records in 1956 (largely due to the fact that he sounded like Elvis Presley) and quickly

established a persona of rock 'n' roll rebellion. Like many early rock 'n' rollers, Vincent was heavily influenced by country music. After learning the guitar in his teens, he began to fuse country music and rhythm and blues into his own style. He moved to the UK in 1959, where he stayed for ten years as a popular performer. Although suffering from a serious injury in a car accident in 1960, Vincent remained in demand as an artist throughout the 1960s, especially after listeners began exploring the roots

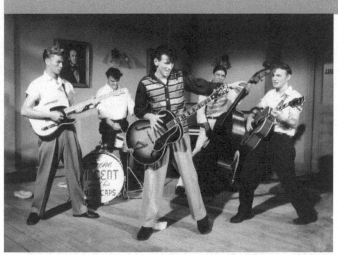

Gene Vincent

Gene Vincent and his Blue Caps

© *Michael Ochs Archives/Getty Images*

of rock music. Gene Vincent and his band the Blue Caps are best remembered for the songs "Be-Bop-A-Lula," "Race with the Devil," "Lotta Lovin'" and "Wear My Ring." He appeared in the movies *The Girl Can't Help It* (1956), *Hot Rod Gang* (1958), *Live It Up!* (1960) and *It's Trad, Dad!* (1962), all of which led to a star on the Hollywood Walk of Fame. Gene Vincent died in 1971 following complications from a bleeding ulcer and a seizure from heavy drinking at only thirty-six years of age. He was inducted into the Rock and Roll Hall of Fame in 1998 for his contributions to the development of rock 'n' roll and rockabilly.

Recommended Listening

- Be-Bop-A-Lula
- Race with the Devil

Trivia

- Vincent was in the same car accident that killed Eddie Cochran in 1960. This marked a brief period in rock 'n' roll where several performers were out of the scene or gone forever: Buddy Holly, Ritchie Valens and the Big Bopper (died in a plane crash); Eddie Cochran (died in a car crash); Elvis Presley (drafted into the army); Little Richard (gave up rock 'n' roll for religion); Carl Perkins (injured severely in a car crash); Jerry Lee Lewis (ousted by booking agents and the public for marrying his thirteen-year-old second cousin); and Chuck Berry (in prison for two years).

The Everly Brothers

Phil and Don
Everly of the pop
vocal duo The
Everly Brothers

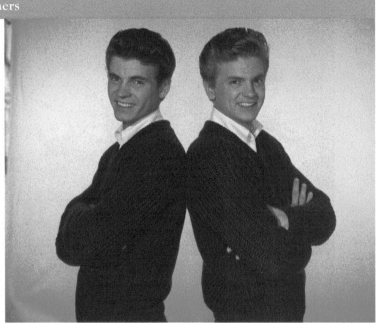

© Michael Levin/Contributor/Getty Images

The Everly Brothers

Don Everly (February 1, 1937–August 22, 2021) and Phil Everly (January 19, 1939–January 3, 2014) came from a musical family that groomed them to be musicians from day one. They initially toured with their parents, who were well-known country musicians (Ike and Margaret Everly), and began to play in their shows. In 1955, as their careers began to unfold, the Everly Brothers moved to Nashville to work as songwriters. In 1957 they had a hit with "Bye Bye Love" (written by Felice and Boudleaux Bryant), which reached #2 on the charts and put them in the spotlight as performers. Their first #1 hit was "Wake up Little Susie," which also hit #1 on the Country & Western and the R&B charts. This was followed by three more #1 hits: "All I Have to Do Is Dream," "Bird Dog" and "Cathy's Clown." The Everlys enjoyed success from 1957 to 1962, when their string of hits abruptly came to a halt. The brothers spent the next ten years continuing to tour despite drug problems and mounting tension between them. They officially parted ways in 1973 after Phil stormed off stage at a concert. The brothers returned to the stage in 1983 for a well-received reunion tour, which the album *Reunion Concert* documented. The Everlys released several albums in the 1980s and 1990s and continue to tour occasionally. Most recently, two musicals were produced inspired by the Everly Brothers' music, *Bye Bye Love: The Everly Brothers Musical* and *Dream, Dream, Dream*. The Everly Brothers' tight vocal harmonies inspired the Beatles, Simon and Garfunkel and other important rock 'n' roll artists. They were inducted into the Rock and Roll Hall of Fame in 1986.

Recommended Listening

- Bye Bye Love
- Wake Up Little Susie

- All I Have to Do Is Dream
- Bird Dog

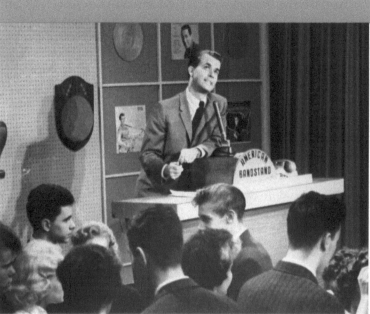

Dick Clark

Dick Clark
hosting American
Bandstand

American Bandstand

American Bandstand was one of the most important TV shows in American history in the promotion of rock 'n' roll entertainment. The show developed at a time when popular entertainers from radio were migrating to the newer medium of television and taking their music to prime time. *American Bandstand* became so popular that a simple thumbs up or down from the host could make or break a career. *Bandstand* first appeared on WFIL-TV in Philadelphia during September 1952 hosted by Bob Horn (at that time called *Bob Horn's Bandstand*). Then a cleancut and well-groomed Dick Clark (November 30, 1929–April 18, 2012) took over as host in 1956 and promoted the show as a teen dance party. Clark had been a radio disc jockey and knew very little about rock 'n' roll before he was the host of *Bandstand*. In August 1957, *American Bandstand* became one of a handful of programs to broadcast nationally and maintained its popularity until 1987. From day one, Clark insisted on racially integrating the show, which helped to promote the growing youth culture in America.

The first national broadcast of *American Bandstand* featured Jerry Lee Lewis with his hit single "Whole Lotta Shakin' Goin' On." To promote good sound and consistency with the broadcasts, all musical guests were instructed to lip-synch their hits, with the only exception being B. B. King. In addition to the Twist, many popular dances were created on *American Bandstand* including the Bunny Hop, the Stroll, the Jerk, the Swim, the Mashed Potato, the Boogaloo, the Pony, the Fly, the Shake and the Hucklebuck. *Bandstand* also introduced popular segments that kept the savvy teen up to date with what was happening each week in entertainment with the Spotlight Dance, Rate-A-Record and the Top 10 Countdown.

American Bandstand was a major source for discovering new rock 'n' roll artists. These included Chubby Checker and "The Twist" sensation; Frankie Avalon, famous for his 1959 #1 hit songs "Venus" and "Why," his thirty-one other charting hits and a TV and film career; Ricky Nelson, who had fifty charting hits and a successful acting career (when Billboard introduced the Hot 100 in 1958, Ricky Nelson's "Poor Little Fool" was the first song to hit #1); and Fabian, whose career as a teen idol was directly developed by Dick Clark himself.

In 1964, the show moved its production to Los Angeles, California and broadcast in full color from 1967. *American Bandstand* ran for a total of thirty years before ABC finally dropped the show in 1987. Through *American Bandstand*, Dick Clark brought a level of respectability to rock 'n' roll, which earned him the nicknames the "Pied Piper of Teenagers" and "America's oldest teenager." Dick Clark was inducted into the Rock and Roll Hall of Fame in 1993.

Recommended Listening

- Venus, Frankie Avalon
- Tiger, Fabian
- Poor Little Fool, Ricky Nelson

Trivia

- In 1956, Bob Horn was arrested for driving under the influence of alcohol in the middle of the TV station's anti-drunk driving campaign. This is when Dick Clark replaced him as the host of *American Bandstand*.

Chubby Checker

Earnest "Chubby Checker" Evans (Born October 3, 1941) has had a successful singing career since 1961 when he revolutionized a dance song craze on Dick Clark's *American Bandstand*. Checker's singing style was greatly influenced by Fats Domino, Jerry Lee Lewis and Elvis Presley, all three of whom he idolized as a teenager. He formed his first vocal group, the Quatrells while he was working as a meat packer for a local butcher and signed a deal with a small record label called Cameo-Parkway Records where he released two singles, "The Class" and "Dancing Dinosaur." Checker became acquainted with Dick Clark through a talent scout and shot to stardom when, with Clark's help, he hit the number one spot on the charts with his version of the Hank Ballard song "The Twist" in 1961. The song was such a success that Checker recorded it again the following year (1962) and hit number one for a second time. Between the two versions, "The Twist" spent a total of nine months on the charts in 1961 and 1962!

"The Twist" also revolutionized rock 'n' roll by giving couples the freedom to break apart on the

Chubby Checker

Conway Twitty, Chubby Checker and Dick Clark do The Twist

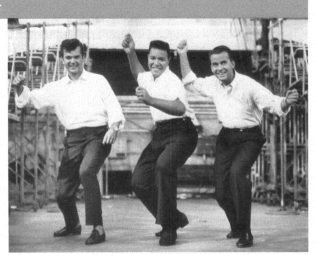

© *Bettmann/Contributor/Getty Images*

dance floor. This idea of dancing unattached to your partner helped market rock 'n' roll dancing on the primetime TV networks. Checker further capitalized on the success of "The Twist" with such songs as "Twistin' U.S.A," "Twist It Up," "Slow Twistin'" and "Let's Twist Again." In addition to "The Twist," Chubby Checker had Top Ten hits in 1961 and 1962 with "Do the Pony," "Limbo Rock" and "Popeye the Hitchhiker." He has sold over 250 million records worldwide and also starred in the movies *Twist Around the Clock* and *Don't Knock the Twist*.

Recommended Listening

- The Twist
- Do the Pony
- Let's Twist Again

Trivia

- The wife of *American Bandstand* host Dick Clark came up with the name "Chubby Checker" as a play on popular singer Fats Domino's name ("Fats" and "Chubby," and "Domino" and "Checker").

- In 1964, Chubby Checker married Rina Lodders, who was Miss World in 1962.

- He was the headlining entertainment act for Superbowl XXII.

- The Twist was so popular that many other artists tried to capitalize on its success with similar songs. These included "The Twist," Ray Anthony; "Twist and Shout," the Isley Brothers; "Twist Polka, Ray Henry; "Twist," Bobby Darin; "Twistin' the Night Away," Sam Cooke; "Twist" the Ventures; "Twistin'," Duane Eddy; and, "Peppermint Twist - part 1," Joey Dee and the Starliters.

Ray Charles

Charles "Ray Charles" Robinson (Sept. 23, 1930–June 10, 2004) was born in Albany, Georgia, and grew up in Greenville, Florida. When he was only six years old, he contracted glaucoma that left him blind within a year. He also began playing piano at this time and developed his own approach to the blues that blended syncopated rhythm and gospel music. In 1945 he moved to Seattle where he played in various jazz combos. He released a minor hit, "Confessin' Blues," in 1949 and was signed to the Atlantic label in 1952 for his creative blues piano playing. In 1955 Ray hit #2 on the R&B charts with "I've Got a Woman" and #1 in 1956 with "Drown in My Own Tears." Between 1957 and 1959 he had several songs make it to both the R&B charts and the pop charts, including "Swannee River Rock" and "What'd I Say." From 1960–1962 Ray had three #1 pop hits with "Georgia On My Mind" (1960), "Hit the Road Jack" (1961) and "I Can't Stop Loving You" (1962). In 1967 he won two Grammys for "Crying Time."

Ray Charles

Rock 'n' roll pianist with soul, Ray Charles

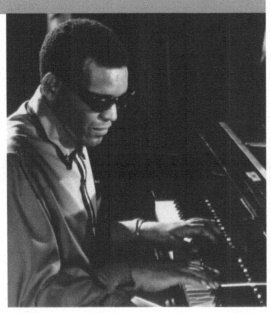

© AP/Wide World Photos

Ray Charles is generally considered an innovator of the rock 'n' roll style and a key transitional figure to the soul genre. Many famous artists cite Charles as an influence, including Quincy Jones, Aretha Franklin, Stevie Wonder, the Righteous Brothers and James Brown. Frank Sinatra was so impressed with Ray Charles that he called him "the only genius in the business." He was inducted into and awarded the Lifetime Achievement Award from the Rhythm & Blues Foundation in 1982 and 1995 respectively and was inducted into the Rock and Roll Hall of Fame in 1986. He has won twelve Grammy awards and a Grammy Lifetime Achievement Award (in 1988). In 1993, he was awarded a Lifetime Achievement Award by the Songwriters Hall of Fame.

Recommended Listening

- I've Got a Woman
- Georgia On My Mind
- Hit the Road Jack
- I Can't Stop Loving You
- The Right Time
- What'd I Say

Trivia

- Ray Charles is the subject of the Academy Award winning movie *Ray*, starring Jamie Foxx.

- "I've Got a Woman" is considered by some to be the first significant soul music song.

- James Brown was once asked what set Ray Charles apart from his peers. "What set him apart?" Brown replied. "He was Ray Charles!"

The Day the Music Died

On February 3, 1959, the small aircraft commissioned to transport Buddy Holly, Ritchie Valens and Jiles Perry Richardson (the Big Bopper) crashed only miles from Mason City, Iowa, after taking off. This tragic accident that that took the lives of three rock 'n' roll greats, as well as the pilot Roger Peterson, has since been dubbed "The Day the Music Died."

Ritchie Valens was only seventeen at the time of his death and was on the verge of

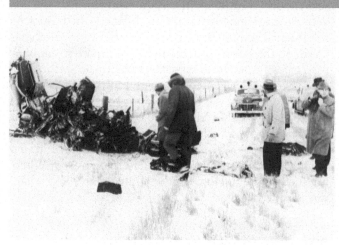

Crash Site

The crash site where the lives of Buddy Holly, Ritchie Valens and the Big Bopper were lost

© Hulton Archive/Getty Images

an extremely successful music career. Just months earlier he had reached #22 on the charts with "La Bamba"; the song would eventually reach #1 years later when Valens' music appeared in the film about his life, *La Bamba*. The Big Bopper was twenty-nine years old at the time of the crash and was a celebrity DJ and rock musician best known for his hit "Chantilly Lace."

Recommended Listening

- La Bamba
- Chantilly Lace

The Payola Investigation of 1959–1960

In 1959 and 1960 the federal government investigated whether DJs were accepting payola that could potentially manipulate the direction of popular music. Payola referred to "pay for play," which means a DJ accepts money or gifts to favor a particular song on the airwaves, therefore increasing its popularity and record sales. Up until 1959, accepting payola was not against the law and was a real part of the entertainment industry. The trouble arose when prominent industry people were found to own stock in an artist, a record company and a radio station or TV network where they could unfairly push their own interests. The investigation scrutinized in detail 207 DJs. Two prominent figures fell into the limelight;

Payola

Alan Freed before being questioned about accepting payola

© Bettmann/Contributor/Getty Images

they were Dick Clark and Alan Freed. Dick Clark cooperated with the investigation and sold enough of his stock in certain areas to satisfy the committee that he could not influence America unfairly (even though he was the host of *American Bandstand* and could give the thumbs up or down on any artist he wanted—including those he managed!). Alan Freed, on the other hand, did not escape quite so easily. With such attention drawn to the payola case, Alan Freed served as a scapegoat for the whole investigation. There is no dispute that Freed accepted payola, hundreds of DJs did, but making him an example was undeserved. Freed was fired from his New York DJ job, lost his license and was basically blackballed from the industry. He was ordered to pay thousands in back taxes and fines and could not find work anywhere. Sadly, the man who coined the term "Rock and Roll" and brought R&B music into the mainstream died in 1965 at the age of forty-three from alcoholism, depression and finding himself in poverty. When all is said and done, rock music was such a powerful force in the United States in the late 1950s that this was just another way to slow things down.

Other Significant Rockabilly Pioneers

Johnny and Dorsey Burnette
Sonny Burgess
Charlie Feathers
Bill Flagg
The Maddox Brothers
Billy Lee Riley
Warren Smith
Gene Summers
Jo Ann Campbell
Wanda Jackson
Alys Lesley
Janis Martin

Folk Music

Folk Music

The best description of folk music is "music by the people, for the people." Traditionally, folk was a kind of music passed on orally through families and generations, rather than music formally composed or written down. The composers of folk music are often anonymous with much of the recorded and published folk music categorized as "traditional." Folk music gets its title from folklore, meaning that the music generally represents common themes, traditions, nostalgia, social topics and community. The music often involves group participation and is rarely about elevating an artist to stardom. The performers are in many cases amateur, and they do not produce the majority of their music to make a profit.

Protest music that introduced political themes, and the folk revival of the 1950s and 1960s, brought folk music into mainstream popularity, but it also provided a vehicle for the music industry to capitalize on this centuries-old form of music. Woody Guthrie, Pete Seeger and their associated groups are the pivotal figures to the folk revival that saw artists like The Kingston Trio, Peter, Paul and Mary, Bob Dylan and Joni Mitchell rise to fame.

Woody Guthrie

Woodrow "Woody" Wilson Guthrie was born on July 14, 1912, in Okemah, Oklahoma. As one of the greatest contributors to American folk music, he mastered the guitar, mandolin, fiddle and harmonica and was also a well known political activist. Growing up in Oklahoma during the "Dust Bowl" era, Woody experienced the dust storms that devastated many of America's prairie lands in the 1930s. Many of his songs and his most popular album, *Dust Bowl Ballads,* reflect the hardships on America's rural working class during that era. Other themes for his music came from spending time with migrants and refugees, which sparked his devotion to radical politics. Woody identified with the ideals of communism, but the Communist Party denied him membership at the close of the 1930s because he would not renounce his religion. The late 1930s and 1940s saw Guthrie perform folk and hillbilly music as a popular radio performer in both Los Angeles and New York.

Woody Guthrie

Political activist
and American
folklore
songwriter,
Woody Guthrie

© John Springer Collection/Contributor/Getty
Images

Woody joined Pete Seeger to form one of America's most popular 1940s folk groups, the Almanac Singers. He also contributed articles to the *Daily Worker* (the newspaper of the Communist Party USA), which resulted in Guthrie being blacklisted in 1950 during the "McCarthy" era. During his life, Woody had three marriages and eight children (including folk singer Arlo Guthrie), and he wrote approximately one thousand songs. On October 3, 1967 he died of Huntington's disease, a genetic nerve disorder that had also claimed the life of his mother. His best-remembered song is "This Land Is Your Land," which is a response to Irving Berlin's "God Bless America." Woody Guthrie and The Almanac Singers were a primary influence on the folk revival of the 1950s and inspired many songwriters with political agendas such as Pete Seeger, Bob Dylan, Joan Baez and, later, Bruce Springsteen.

Recommended Listening

- Talking Dust Bowl Blues
- This Land Is Your Land
- So Long, It's Been Good to Know You
- Grand Coulee Dam
- I Ain't Got No Home

Awards
- Inducted into the Rock and Roll Hall of Fame in 1988
- Received a Grammy Lifetime Achievement Award in 2000

Trivia

- In 1940 Woody Guthrie recorded a ballad called "Tom Joad." This ballad, set to the tune of "John Hardy," summarizes the plot of John Steinbeck's *Grapes of Wrath*. It was so long that he had to record it in two parts.

- Woody's son Arlo went on to become a famous singer and songwriter.

- Each summer in Woody's home town of Okemah, the "Woody Guthrie Folk Festival" celebrates his legacy.

- Woody's guitar carried the slogan "This Machine Kills Fascists."

Pete Seeger

Folk singer, guitarist and banjo player Pete Seeger was born in New York City on May 3, 1919. His father was a musicologist, which inspired his initial interest in folk music. In 1938, he assisted noted folk archivist and field recorder Alan Lomax on his song-collecting trips through the American South. Seeger went on to become one of the most influential American folk singer/songwriters, credited with composing such folk standards as "Where Have All the Flowers Gone," "If I Had a Hammer" and "Turn, Turn, Turn." Influences in the folk revival of the late 1950s and 1960s came from Seeger and Woody Guthrie's group the Almanac singers, formed in 1941, and his own group The Weavers, formed in 1948. In 1942, he married Toshi Ohta who has handled the business side of his career ever since; their marriage has lasted over sixty-five years.

Pete Seeger is one of folk music's most prominent figures

© Andrew Lepley/Contributor/Getty Images

In 1948, Seeger wrote *How To Play the Five String Banjo*, which has become an important instructional manual for many banjo players. In 1950, his group The Weavers had a #1 hit with Leadbelly's "Goodnight Irene," which stayed at #1 for thirteen weeks. Seeger has acted as a very visual political activist since the early 1940s and for a time was a member of the American Communist Party. This association brought him under FBI surveillance a number of times and resulted in his being blacklisted from radio and live performances during the mid-1950s' "McCarthy era." In 1957, Seeger was indicted for contempt of Congress for refusing to name political figures with whom he may have associated. A jury trial convicted him in March 1961 and sentenced him to a year in jail. In 1962, after an appeal process, his conviction was overturned.

Through the ensuing decades, Seeger made valuable contributions to folk music, and he released over one hundred albums. He continued active involvement in environmental issues and authored or co-authored numerous books, articles, banjo methods and musical compositions. Pete Seeger died at the age of 94 on January 27, 2014. He was one of the last significant links to Depression Era America.

Recommended Listening

- We Shall Not be Moved
- Where Have All the Flowers Gone
- If I Had a Hammer
- Guantanamera
- We Shall Overcome
- Turn, Turn, Turn
- Goodnight Irene

Awards

- Pete Seeger received the Grammy Lifetime achievement award in 1993
- Kennedy Center Lifetime Achievement Honor, 1994
- Inducted into the Rock and Roll Hall of Fame in 1996
- Grammy Award for Best Traditional Folk Album, *Pete*, in 1996
- Nominated for the Nobel Peace Prize, 2007

Trivia

- Seeger's half-brother Mike, is a founding member of the New Lost City Ramblers.

- In the early 1960s, Seeger was largely responsible for putting Bob Dylan on the folk music map.

- At the 1965 Newport Folk Festival, Seeger threatened to cut the power when Bob Dylan performed with electric instruments.

- "I still call myself a communist, because communism is no more what Russia made of it than Christianity is what the churches make of it."

The Kingston Trio

The Kingston Trio are responsible for bringing folk music to the university and college campuses. They revolutionized the folk scene by attracting a young audience with chart topping hits nationwide, and they are solely responsible for the introduction of the folk music category adopted by the Grammy Awards. The group was formed in Palo Alto, California, in 1957 by Bob Shane (February 1, 1934-January 26, 2020), Nick Reynolds (July 27, 1933-October 1, 2008) and Dave Guard (October 19, 1934–March 22, 1991). In addition to folk music influences, the trio had a particular interest in calypso music and named their group after the capitol of Jamaica, Kingston. Considered primarily a vocal group, they support their sound with acoustic guitars and a banjo.

Achieving popularity very quickly, the Kingston Trio received an invitation to play at the prestigious "Hungry i" nightclub in San Francisco. This turned into a four-month, standing-room only run. The Trio then recorded their most celebrated song "Tom Dooley," which reached number one on the U.S. charts in the summer of 1958. Also in 1958, their first album, *The Kingston Trio*, reached number one and won them a Grammy Award (in the country music category because no folk category existed). At the end of 1959, the trio had four albums in the top ten and a

The Kingston Trio

The Kingston Trio: Bob Shane (L), Dave Guard (R) and Nick Reynolds (kneeling)

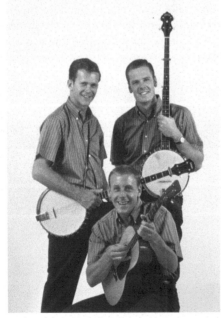

© Bettmann/Contributor/Getty Images

new category, "Folk," created by the Grammy Awards thanks to them. In the first four years, the Kingston trio made ten charting albums, many singles and received a number of Grammy nominations. The trio remained strong on the charts until the arrival of the Beatles in 1964. At that time Capitol records dropped the Kingston Trio from their label to pick up the Beatles. The group continued without Dave Guard who left in 1961, but in 1967 they officially broke up. During 1968 and 1969, Bob Shane reinvented the Kingston Trio and never looked back. For a period of nine years, the group operated as "The New Kingston Trio" until Bob Shane bought the sole rights to use the original name again in 1976. The Kingston Trio is arguably the most important folk group in bringing this music into the popular realm. The original members of the Kingston Trio came together in 1981 to perform a reunion concert that rekindled interest in the group. The Kingston Trio still performs today and is one of the longest standing acts in show business.

The Trio
- Bob Shane 1957–2005
- Nick Reynolds 1957–1967, 1988–1999
- Dave Guard 1957–1961 (reunion concert in 1981)

Other members of the trio included (current lineup then other significant members chronologically):

- George Grove: 1976–present (UNLV Alumni)
- Bill Zorn 1973–1976, 2004–present
- Rick Dougherty 2005–present
- John Stewart 1961–1967
- Pat Horine 1968–1972
- Jim Conner 1968–1972
- Roger Gambill 1973–1985
- Bob Haworth 1985–1988, 1999–2005

Recommended Listening

- Tom Dooley
- M.T.A
- Scotch and Soda
- It Was a Very Good Year
- Greenback Dollar
- The New Frontier

Awards
- Grammy award for best Country and Western performance, 1959
- Grammy award for best Traditional Folk recording, 1960
- Vocal Group Hall of Fame, 2000

Trivia

■ "I like to say I'm not a folksinger, I'm a folks singer."—Bob Shane

■ "The song 'Tom Dooley' has only three verses and two chords on the guitar, and it has sold over ten million copies."—Bob Shane

■ Tom Dooley has as its basis the true story of Thomas C. Dula, a Civil War veteran from North Carolina, tried and convicted in October 1866 of murdering Laura Foster, a young woman with whom he was supposedly intimate. He was hanged in Statesboro, North Carolina on May 1, 1868.—Bob Shane

Peter, Paul and Mary

Peter, Paul and Mary came together to reclaim folk's potency as a social, cultural and political force.

Peter Yarrow (b. May 31, 1938), Noel "Paul" Stookey (b. December 30, 1937) and Mary Travers (November 9, 1936–September 16, 2009) formed the folk group Peter, Paul and Mary (aka "PP&M") in 1961, at the dawn of John F. Kennedy's presidency, with Albert Grossman, the famous manager of Bob Dylan, promoting them. The trio sang about long-deferred issues of social and political injustice and the demand for racial equality. Peter, Paul and Mary made their formal debut at Greenwich Village's "Bitter End" in 1961, and as musical activists they worked to inspire the nation's support of the civil rights movement. Their early career saw them performing on many college campuses around the country and releasing a series of recordings that brought recognition to traditional folk music. The group's self-titled 1962 debut album went straight to #1 and remained in the Billboard Top 10 for ten months. The album actually remained in the Top 20 for two years and on the billboard album charts for three and a half years.

> "We've always been involved with issues that deal with the fundamental human rights of people, whether that means the right to political freedom or the right to breathe air that's clean."
>
> —Mary Travers

In 1963 Peter, Paul and Mary, along with other folk icons, performed at the March on Washington where Dr. Martin Luther King, Jr., gave his "I Have a Dream" speech. In 1969 they had a #1 hit with John Denver's "Leaving On a Jet Plane." Peter, Paul and Mary disbanded in 1970 to pursue solo careers, but they have regrouped several times to perform special concerts and tours. In 1986 PBS made a television special of their twenty-fifth Anniversary Concert. They have also received many awards during their career, including five Grammys, eight gold albums, five platinum albums and thirteen Top 40 hits. Peter, Paul and Mary's music provides a message of humanity, hope and activism.

Recommended Listening

- For Lovin' Me
- If I Had a Hammer
- Puff (The Magic Dragon)

- Blowin' In the Wind
- Leaving On a Jet Plane

Awards
- Inducted into the Vocal Group Hall of Fame in 1999
- Received the Sammy Cahn Lifetime Achievement Award from Songwriters Hall of Fame in 2006

Trivia

- "Blowin' In the Wind" was the fastest selling record ever released by Warner Brothers Records.

- Rumored to be about drugs (marijuana or opium), the song "Puff The Magic Dragon" is actually about losing the innocence of childhood.

- Some folkies accuse "PP&M" of producing concerts and recordings with an overwhelming sameness. One critic reviewed a concert by saying only "See last year's review!"

Joan Baez

Joan Chandos Baez was born in Staten Island, New York, on January 9, 1941, and people know her as much for her political affiliations as her music. After her family settled in Southern California and she was inspired by a Pete Seeger concert in 1957, Baez learned to play guitar and started singing and playing folk music. While attending Boston University in 1958, Baez became politically involved and expressed her views through music in performances at various Cambridge folk clubs. After performing at the 1959 Newport Folk Festival she signed with Vanguard records and released her first album *Joan Baez*, a collection of traditional folk songs, in 1960. During the 1960s, she became an influential voice in the civil rights movement and also began working with Bob Dylan, helping to launch his career; the two had a romantic involvement until 1965. Their relationship provided the material for Baez's 1975 hit, "Diamonds and Rust." Baez performed "We Shall Overcome" at the 1963 civil rights march on Washington and also performed at the Woodstock festival in 1969. Joan

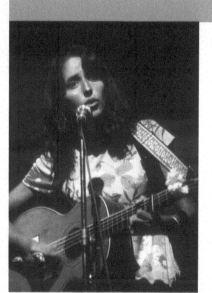

Joan Baez

Folk singer and political activist Joan Baez

© *Michael Ochs/Stringer/Getty Images*

Baez founded several political organizations in the sixties, including the Institute for the Study of Non-violence. Her music took a turn toward "pop" in the 1970s and early 1980s, but after a brief hiatus, Baez returned to music and her folk roots in the 1990s. Although Baez is a songwriter, people know her better as an interpreter of other people's music, especially the music of Pete Seeger, Bob Dylan and Jackson Browne.

Recommended Listening

- There But For Fortune (1964)
- Love Is Just a Four Letter Word (1968)
- The Night They Drove Old Dixie Down (1971)
- Diamonds and Rust (1975)
- Time Is Passing Us By (1976)

Awards
- Joan Baez has received six Grammy nominations
- Received the Grammy Lifetime Achievement Award, 2007
- Received the British Folk Awards, Lifetime Achievement, 2000

Trivia

- Led Zeppelin recorded Baez's song "Babe I'm Gonna Leave You" on their 1969 debut album after hearing her 1962 album *Joan Baez in Concert*.

- Judas Priest covered Baez's "Diamonds & Rust."

- Paul McCartney has stated that Joan Baez's "All My Trials" inspired the Beatles' "I'll Get You."

- Joan Baez cites Elvis Presley as a major early influence on her vocal style.

Other Influential Folk Artists and Groups

- The Almanac Singers
- Gilbert Vandine "Cisco" Houston
- The Limeliters
- Gordon Lightfoot
- Donovan
- Simon and Garfunkel
- The Mamas and the Papas
- Chad Mitchell Trio
- Leadbelly
- The Weavers
- Phil Ochs
- Ramblin' Jack Elliott
- Leonard Cohen
- Paul Simon
- The New Christy Minstrels
- The Byrds
- The New Lost City Ramblers
- Tom Paxton and Martin Carthy

Other Styles Directly Stemming from the Folk Revival of the 1950s and 1960s

Neo-folk music (emerged in the late 1960s, but popular in the 1980s), apocalyptic folk (early 1990s), folk noir (1980s), military pop (1980s).

Bob Dylan

1941–1961

Many consider Robert Allen Zimmerman (aka Bob Dylan) the most influential folk singer/songwriter of the twentieth century. He brought political topics, social commentary, philosophy and literary influences into mainstream music, but he considered himself more of a poet than a musician. His songs from the 1960s became anthems for the anti-war and civil rights movements, and he holds the credit for bringing more intelligent and artistic themes to rock and roll. For over five decades Dylan has maintained a consistent output of music that has evolved with the current music trends.

Robert Allen Zimmerman was born on May 24, 1941, in Duluth, Minnesota, and attended school in nearby Hibbing. Drawn to music from an early age, he spent a great deal of time listening to blues, country and early rock and roll on the radio. While in high school, he formed several bands, including the Shadow Blasters, the Golden Chords and Elston Gunn and His Rock Boppers. These early efforts demonstrated clear influences from Little Richard and Elvis Presley.

In August 1959, Zimmerman enrolled at the University of Minnesota and moved to Minneapolis, where he started listening to and performing American folk music. At this time, he began calling himself Bob Dylan (sometimes Dillon) largely due to his interest in the poetry of Dylan Thomas. Most of his performances took place at coffee houses, and he became involved in the local folk music circuit. Dylan ultimately dropped out of college in his freshman year, but he stayed in Minneapolis until 1961.

1961

In January 1961 Dylan left Minnesota (by way of Highway 61) to move to New York where he spent time visiting his idol Woody Guthrie and establishing himself in the Greenwich Village folk scene. During the year he made several trips to Chicago, Madison and Denver to see Pete Seeger perform and to study the music of Woody Guthrie's long time friend, Ramblin' Jack Elliott. Through this influence, Dylan established his signature performing

style and image with an acoustic guitar and a harmonica. That October, during a session in New York, Bob impressed John Hammond (actually a jazz talent scout), who signed him to Columbia records.

1962

Bob Dylan's first Columbia album, *Bob Dylan* (released March 19, 1962), consisted of folk, blues and gospel material with two of his own songs, "Song to Woody" and "Talkin' New York." This album sold only five thousand copies in its first year, but has since become an essential addition to any fan's collection. In August 1962, Bob legally changed his name to "Bob Dylan" and signed a management contract with Albert Grossman.

Recommended Listening

- Song to Woody—is a tribute to the great folk singer Woody Guthrie and is based on Guthrie's song "1913 Massacre."

1963

At the end of July, Dylan was featured at the Newport Folk Festival in Rhode Island alongside Pete Seeger, Joan Baez and Phil Ochs. The year 1963 was pivotal for civil rights and social upheaval in the United States, and Dylan's appearance at Newport put him in a position of artistic influence and prominence. Joan Baez, who was at this time Dylan's strongest advocate as well as his lover, had a strong position in the protest movement. Their high profile performances together, such as during the March on Washington, where Martin Luther King, Jr., gave his "I Have a Dream" speech, solidified Dylan's importance as a folk artist.

The Freewheelin' Bob Dylan (released on May 27, 1963) introduced the cynical side of Bob Dylan and the controversial character that would provide the basis for his career. The famous album cover captures Dylan walking down Jones Street in New York with his then girlfriend Suze Rotolo. Many of the songs on this album were labelled protest songs, some with a more general theme and others with a specific focus. Dylan's dry sense of humor becomes evident on this album.

By the end of 1963, Dylan had begun to feel manipulated by the folk and protest movements. Following the assassination of JFK, Dylan claimed to see something of himself (and of every man) in assassin Lee Harvey Oswald. JFK's assassination was a devastating blow to Dylan who saw the President as one who could make the changes the United States needed.

Recommended Listening

- Blowin' in the Wind—derived its melody from the traditional slave song "No More Auction Block." The lyrics ask nine questions about life and death, social equality and politics.

- Masters of War—often misquoted as being an "anti-war song." According to Dylan, it is a "pacifist song against war," which is quite different from "anti-war." The lyrics come from what Dylan perceived as a general distaste for Eisenhower's dubbing of the United States becoming a Military-Industrial Complex in his farewell address.
- Oxford Town—is Dylan's cynical account of James Meredith, the first black student to attend the University of Mississippi (October 1962), and his ordeal. The university denied Meredith entrance and federal troops and marshals were necessary to allow him to enter the classroom (citizens of Mississippi had vowed to keep the university segregated). The ensuing riots killed two people and injured forty-eight troops. Thirty marshals received gunshot wounds.

1964

A more sophisticated and politically motivated Bob Dylan recorded *The Times They Are a-Changin'* between August 6 and October 31, 1963 (released on January 13, 1964). His song themes revolved around real life events with a particular focus on the civil rights movement. He also humanized stories of people who embodied the struggles of the times. Dylan had become to many a leader in the protest movement, and his songs consistently hit home.

Bob recorded *Another Side of Bob Dylan* after becoming disenchanted with the protest movement and taking a step back from his political image. He recorded this entire album in one day in June, and it carried a much lighter introspective mood. Dylan had also begun to show signs of poetical influences in his compositions from Jean Rimbaud, Allen Ginsberg and François Villon.

In 1964, Dylan began to play with interviewers who did not really know him or the content of his music. He became almost impossible to interview, and no reporter stood a chance against his wit and intellectual mocking.

Recommended Listening

- The Times They Are A-Changin'—many often view this song as a reflection of the generation gap and the political divide of American culture in the 1960s.
- It Ain't Me, Babe—appears to be a song about spurned love, but upon listening more closely, you can see it is a rejection of Dylan's reputation in the protest movement.

1965

The 1965 album *Bringing It All Back Home* introduced the first recordings that Bob Dylan made with electric instruments, and the single "Subterranean Homesick Blues" clearly demonstrates how Dylan's music reinforced his poetry. This album also ushered in the birth of "folk-rock," a genre and description that Dylan argued did not represent what he was doing as an artist.

In July 1965, "Like A Rolling Stone" was released as a single split onto two sides of the playing disc due to the extended playing time of six minutes. (*Highway 61 Revisited* also featured the song later that year). The single redefined what was currently the industry standard of three minutes to make radio play and the charts. In a 2004 poll, *Rolling Stone Magazine* listed "Like A Rolling Stone" as number one on its list of the five hundred greatest songs of

Young Dylan

Bob Dylan playing
harmonica and
guitar during a
recording session

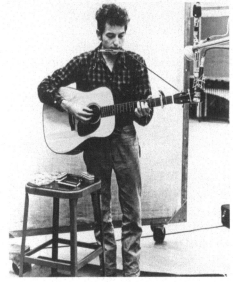

© *Michael Ochs Archives/Stringer/Getty Images*

all time. That same month, while headlining at the Newport Folk Festival, Dylan struck controversy by introducing his electric sound with the Paul Butterfield Blues Band. Due to a mixed reaction from the audience (some of the crowd booed him), he left the stage after only three songs. Four days after this performance, Dylan recorded "Positively 4th Street," a song with spiteful words for the folk community who he felt betrayed him at Newport.

Highway 61 Revisited, released in August, is titled after the road that led from Dylan's hometown in Minnesota to New Orleans.

Highway 61 trivia (from *www.wikipedia.com*): Highway 61, sometimes called the "Blues Highway," stretched from New Orleans through Memphis and from Iowa through Duluth (Dylan's city of birth) to the Canadian border. Blues songs regularly featured the highway, notably Mississippi Fred McDowell's "61 Highway" and James "Son" Thomas's "Highway 61." Bessie Smith met her death in an automobile accident on that roadway; Robert Johnson supposedly sold his soul to the devil at the crossroads of Highway 61 and Highway 49 (itself the subject of a Howlin' Wolf song); Elvis Presley grew up in the housing projects built along it; and the murder of Martin Luther King, Jr. took place at a motel just off Highway 61.

Later in 1965, Dylan met with the Beatles in New York during their third tour of the United States. This meeting marked the beginning of a long friendship and healthy musical rivalry that resulted in both the artist and the band borrowing from one another's styles and a challenge to their audiences to listen more intensely and introspectively.

Recommended Listening

- Subterranean Homesick Blues—demonstrates the influence of beat poetry on Dylan's writing. An innovative film clip accompanies the song with cue cards accenting certain lyrics and offering another meaning to the interpretation of some words. This was Bob Dylan's first single to make the billboard top 40 chart (at #39 in the U.S. and #9 on the UK charts).
- Mr. Tambourine Man—was apparently written about Dylan's friend Bruce Langhorne who appeared as a guest guitarist on many Dylan recordings and who played an oversized tambourine. The Byrds brought the song to prominence when they reached #1 in both the U.S. and UK with their version within months of Dylan's original release.
- Like a Rolling Stone—was released as a single on July 20, 1965 at more than two times the preferred length of songs suitable for radio play. It turned out to be the most successful of Dylan's singles, reaching #2 in the U.S. *Rolling Stone Magazine* voted it the greatest rock song of all time in 2004. Many people often cite it as the pivotal song in the creation of "folk-rock" music.
- Positively 4th Street—is Dylan's reaction to the people who he felt turned their backs on him after his Newport performance.

1966

From October 5, 1965 to March 10, 1966, Dylan intermittently recorded what would become *Blonde on Blonde*, considered the first "double album" in rock music and one of the finest recordings of American popular music. Dylan toured Australia and Europe in the spring of 1966 and split each show into two parts. He would perform solo during the first half, accompanying himself on acoustic guitar and harmonica, and in the second half play electric music with his new backing band The Hawks. When Dylan returned to New York, he faced increasing pressures from his publisher for a finished manuscript of his book, *Tarantula*, and from his manager, Albert Grossman, to fulfill an agreement to tour through the summer and fall and record a new album, among other commitments. Everything was becoming overwhelming, and on July 29, 1966 Dylan crashed his motorcycle and broke his neck. Some fans speculate that the accident was not as serious as reported and that Dylan simply needed an escape route from the red tape and business demands.

May 17, 1966

Dylan had received mixed reactions from audiences about his use of electric instruments, and in a now famous incident while performing in Manchester one fan shouted "Judas!" as he played the electric set. Dylan replied, "I don't believe you . . . you're a liar," turned to the band and shouted, "Play it f***ing loud!" as they broke into "Like a Rolling Stone."

Recommended Listening

- Rainy Day Women #12 & 35—has been the topic of controversy over the true meaning of the lyrics ever since its release. The title and certain lyrics bear resemblance to Proverbs 27:15, and they could describe Dylan's turbulent relationships with several women or mock the fear of hidden drug references in popular music at the time. It is more likely that Dylan is actually conversing with the listener on two levels at the same time: the superficial "everybody must get stoned," relating simply to drug and alcohol use, and more seriously, a political statement of getting stoned by persecution, criticism, and specifically the civil rights movement. Although, 12×35 does equal 420 . . . !!!

1967

Following his motorcycle accident, Dylan retreated to his home in Woodstock, New York, where he spent time with his family and began a new phase of songwriting in his basement and recording at the "Big Pink" where the Hawks lived. The Hawks renamed themselves The Band when they moved on after completing work as Dylan's backing band. In December, he released the album *John Wesley Harding* (eighteen months after *Blonde on Blonde*). It consisted of shorter songs influenced by country music themes and the Bible. The album included

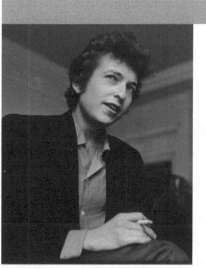

Bob Dylan, 1965

Bob Dylan around the time of the "Don't Look Back" tour

© *Evening Standard/Stringer/Getty Images*

one of his most popular songs, "All Along the Watchtower," which derives its lyrics from the Book of Isaiah (21:5–9 about the fall of Babylon). Dylan said in a 1968 interview that he was now writing shorter lines, with every line meaning something. He wasn't just making up a line to go with a rhyme anymore; each line had to advance the story and bring the song forward.

Recommended Listening

- All Along the Watchtower—This is one of the most covered popular songs of all time. Jimi Hendrix recorded the most inspiring version of the song that even changed the way Dylan approached his own piece. This was also the only song from Hendrix that made the top 40 in the USA during his lifetime. Many other famous artists have released versions of this song including U2, the Dave Matthews Band, Prince, Neil Young, the Grateful Dead, Elton John, Eric Clapton, Lenny Kravitz and Pearl Jam.

1968

Dylan made his first live appearance in over eighteen months at a Woody Guthrie memorial concert at Carnegie Hall in January, 1968, following Guthrie's death on October 3, 1967.

1969

Dylan's next release, *Nashville Skyline*, was a mainstream country record featuring Nashville musicians, very laid back vocals by Dylan, a duet with Johnny Cash, "Girl from the North Country," and the hit single "Lay Lady Lay." At only twenty-seven minutes, this is Dylan's shortest album.

Ken Buttrey (drums on Dylan's Nashville recordings) couldn't find a drum groove that worked on the verses of "Lay Lady Lay," so he asked the producer Bob Johnston and Bob Dylan for suggestions. They responded with "bongos and cowbell," which Ken played to prove they wouldn't really work. The groove turned out to be pretty cool, so they kept it on the track! The drums weren't miked so during the choruses the drums have a very distant sound. The person who held the bongos and cowbell in place while Ken played was Kris Kristofferson, who worked as a janitor in the studio at that point.

Recommended Listening

- Girl from the North Country—first appeared on *The Freewheelin' Bob Dylan*. It re-appeared on this album after an impromptu visit to the studio by Johnny Cash. After the pair recorded more than twenty songs as duets, this song emerged as a good fit for the album.

- Lay, Lady, Lay—was originally intended for the movie soundtrack of *Midnight Cowboy*, but Dylan didn't get the song recorded in time to make the film. Before he recorded it, he had also offered the song to the Everly Brothers when he met them backstage after a show. They misheard him sing the lyric "lay lady lay, lay across my big brass, bed" for "lay lady lay, lay across my big breasts, babe" and declined the song on grounds that they couldn't get away with such risqué lyrics.

1970

Bob Dylan released two albums in 1970: *Self Portrait* and *New Morning*. Greil Marcus of Rolling Stone wrote only the following comment about *Self Portrait*: "What is this s**t?" Dylan claims that *Self Portrait* was not serious, and that he deliberately intended to "get people off my back," to shrug off this "leader of the protest movement" title that had hung over him for a number of years. Ironically, the album still reached #4 in the U.S. and #1 in the UK! A few months later, Dylan released *New Morning*, which many considered a "comeback" to his pre-Nashville form. He finished the album before releasing *Self Portrait* but held back on the release for four months. Several tracks with George Harrison and Charlie Daniels didn't make the final cut; but in the same year Dylan co-wrote "I'd Have You Anytime" with Harrison, which appeared as the opening track on the ex-Beatle's album *All Things Must Pass*.

1970s Dylan

Bob Dylan
in concert

© *Henry Diltz/Contributor/Getty Images*

1971

In November Dylan recorded a series of sessions with Beat poet, and long-time friend, Allen Ginsberg, intended for Ginsberg's *Holy Soul Jelly Roll* album.

1972/1973

In late 1972, Bob Dylan had his first acting experience in the role of "Alias" in *Pat Garrett and Billy the Kid* (released in 1973). He also supplied the songs for the soundtrack, with "Knockin' on Heaven's Door" becoming an international hit. In 1973, Dylan wrote the song "Wallflower" for his friend Doug Sahm's album. Bob's son, Jakob Dylan, named his band the Wallflowers after this song. Dylan also signed with David Geffen's new Asylum label in 1973.

Recommended Listening

- Knockin' On Heaven's Door

1974

Dylan released his first Asylum record *Planet Waves* with two versions of the hit "Forever Young." He rejoined his 1966 band The Hawks (now known as The Band) for this album and tour. A live double album from that tour, *Before the Flood*, was also released. Following his separation from his wife, Dylan recorded another new album entitled *Blood on the Tracks* in September 1974.

Recommended Listening

- Forever Young

FIGURE 9.4

© *David Redfern/Staff/Getty Images*

1975

Blood on the Tracks was released in January and became one of Dylan's most popular albums, and many fans consider this an autobiographical account of his breakup with his wife Sara Lounds (married 1965–1977; broke up in 1974). Jakob Dylan claims that *Blood on the Tracks* reflects conversations between his parents at that time. In mid-1975, Dylan wrote "Hurricane" (released as a single in November) in support of the cause of boxer Rubin "Hurricane" Carter, who Dylan believed was wrongly convicted of a triple murder in Paterson, New Jersey. Dylan presents a somewhat biased perspective of the case in the song to counter the prejudiced trial that Carter received. The publicity from the song raised enough money and attention to bring a new trial, which ironically reconvicted Carter. Carter received parole in 1985, and his conviction was finally overturned in 1988. Carter passed away on April 20, 2014 after a battle with prostate cancer. "Hurricane" represents a brief return to protest songs for Dylan and the influence he could still have with his music.

Recommended Listening

- Hurricane

1976

Dylan's album *Desire*, recorded in mid-1975 and released in January, became his third #1 charting studio album in a row. In November, he appeared on The Band's farewell concert with Joni Mitchell, Muddy Waters, Van Morrison, Eric Clapton, Ronnie Wood and Neil Young, among others. Martin Scorsese filmed the concert and titled it *The Last Waltz*. The film was released in 1978 and it became one of the all-time great rock and roll movies.

1978-Present

Dylan's 1978 album *Street Legal* marks Dylan's transition into Christian music with Biblical themes becoming more prominent. In the late 1970s, Dylan confirmed he had become a born-again Christian. He released two albums of Christian gospel music: *Slow Train Coming* (1979), which won him a Grammy Award as "Best Male Vocalist" for the song "Gotta Serve Somebody," and *Saved* (1980), which audiences did not receive well. Shortly before his December 1980 shooting, John Lennon recorded "Serve Yourself" in response to Dylan's "Gotta Serve Somebody."

In the 1980s the quality of Dylan's recorded work varied, with only one album reaching gold status through the whole decade (*Infidels* in 1983). In 1986 and 1987, he began a working relationship with Tom Petty and The Heartbreakers and toured extensively with them. Dylan toured with The Grateful Dead in 1987 and subsequently released a live album *Dylan & The Dead*. In 1988, Dylan joined Roy Orbison, Jeff Lynne, Tom Petty and George Harrison to form the Traveling Wilburys. Their first album, *Traveling Wilburys Vol. I*, won a Grammy Award in 1989; and, despite Orbison's death in December 1988, the remaining members recorded a second album in May of 1990, *Traveling Wilburys Vol. III*. The Traveling Wilburys Vol. II and IV are both bootleg albums consisting of leftover tracks that didn't make the cut for Volumes I and III, plus several live recordings.

On December 14, 1994, MTV premiered "MTV Unplugged" with Bob Dylan. He then returned to the studio in 1997 to record *Time Out of Mind*, which won him a Grammy for "Album of the Year." That same year, Dylan performed for Pope John Paul II at the World Eucharistic Conference in Bologna, Italy, where the Pope gave a sermon based on Dylan's famous "Blowin' in the Wind." In 1999, Dylan toured with Paul Simon. In 2000, his song "Things Have Changed," composed for the film *Wonder Boys*, won a Golden Globe Award for "Best Original Song" and an Academy Award for "Best Song."

Love and Theft, inspired by historian Eric Lott's book of the same title, was released on 9/11/2001. Reviewers have described it as an album of minstrel style songs of a very personal nature. Dylan is also the producer (under the pseudonym Jack Frost) of this album. In 2006, Dylan entered the charts at #1 with *Modern Times*, his first album to reach that position in thirty years. At sixty-five, Dylan became the oldest living musician to top the Billboard albums chart. *Modern Times* was nominated for three Grammy Awards, won "Best Contemporary Folk/Americana Album" and won "Best Solo Rock Vocal Performance" for "Someday Baby."

In 2009 Dylan released *Together Through Life*, which earned him Grammy nominations for Best Americana Album and Best Rock Vocal Performance for the song "Beyond Here Lies Nothing." His 2012 album, Tempest, received five out of five stars from *Rolling* Stone as one of the most musical albums and also darkest of Dylan's career. "Best of", "Bootleg Series" and "Greatest Hits" records continue to be released with previously unreleased material, but, in 2015, Bob Dylan took a new direction releasing *Shadows in the Night*, an album of jazz standards that topped the UK charts. In May 2016, Dylan released his second, and more refined, jazz album, *Fallen Angels*. Bob Dylan's continued impact on popular music was ratified in June, 2014 when his hand written lyrics for "Like a Rolling Stone" sold at a Sotheby's auction for $2.045 million!

The handwritten lyrics for "The Times They Are A-Changin'" were listed for sale in 2020 for a record 2.2 million. In June, 2020 Dylan released *Rough and Rowdy Days* marking a return to original material and his characteristic poetic lyrics that won him the Nobel Prize for Literature in 2016.

Recommended Listening

- Gotta Serve Somebody (*Slow Train Coming*, 1979)
- Things Have Changed (single, 2000)
- Someday Baby (*Modern Times*, 2006)

Influential Albums

- 1962: *Bob Dylan* reached #13 in the UK.
- 1963: *The Freewheelin' Bob Dylan* went platinum and reached #22 in the USA and #1 in the UK.
- 1964: *The Times They Are a-Changin'* went gold, reached #20 in the USA and #4 in the UK.
- *Another Side of Bob Dylan* went gold, reached #43 in the USA and #8 in the UK.
- 1965: *Bringing It All Back Home* went platinum, reached #6 in the USA and #1 in the UK.
- *Highway 61 Revisited* went platinum, reached #3 in the USA and #4 in the UK.
- 1966: *Blonde on Blonde* went double platinum, reached #9 in the USA and #3 in the UK.
- 1967: *John Wesley Harding* went platinum, reached #2 in the USA and #1 in the UK.
- 1969: *Nashville Skyline* went platinum, reached #3 in the USA and #1 in the UK.
- 1970: *Self Portrait* went gold, reached #4 in the USA and #1 in the UK.
- 1971: *New Morning* went gold, reached #7 in the USA and #1 in the UK.
- 1974: *Planet Waves* went gold, reached #1 in the USA and #7 in the UK.
- 1975: *Blood on the Tracks* went double platinum, reached #1 in the USA and #4 in the UK.
- 1976: *Desire* went double platinum, reached #1 in the USA and #3 in the UK.
- 1979: *Slow Train Coming* went platinum, reached #3 in the USA and #2 in the UK.
- 1999: *Time Out of Mind* went platinum, reached #10 in the USA and #10 in the UK.
- 2001: *Love and Theft* went gold, reached #5 in the USA and #3 in the UK.
- 2006: *Modern Times* went platinum, reached #1 in the USA and #3 in the UK.
- 2009: *Together Through Life*, reached #1 in the USA and UK.
- 2012: *Tempest*, peaked at #3 in the USA and the UK.
- 2015: *Shadows in the Night*, reached #1 in the UK and #7 in the USA.
- 2016: *Fallen Angels*, released May 20, 2016.
- 2020: *Rough and Rowdy Days*.

Compilation Albums

1967: *Bob Dylan's Greatest Hits* went five times platinum

1971: *Bob Dylan's Greatest Hits, Vol II*, went six times platinum

Awards

- Inducted into the Rock and Roll Hall of Fame in 1988
- In January 1990, the French Minister of Culture made Dylan a Commandeur des Arts et des Lettres.
- In 1992, he received the Grammy "Lifetime Achievement Award."
- In 1999, *Time Magazine* included Dylan in its one hundred most influential people of the twentieth century.
- In 2004, he ranked #2 in *Rolling Stone Magazine's* list of "Greatest Artists of All Time," second only to The Beatles.
- In 2007, Dylan received the Prince of Asturia's Award in Arts.
- In 2008, he won a Pulitzer Prize in the Special Awards and Citations category.
- In 2012, Dylan was awarded the Presidential Medal of Freedom.
- In 2013, he was given the highest honor in France with the Chevalier de la Legion d'honneur (Legion of Honour)
- In 2016, Dylan won the Nobel Prize for Literature for his poetic contributions to the American Songbook.

Trivia

- According to John Hammond, Dylan was very difficult to record . . . "Bob popped every p, hissed every s, and habitually wandered off mike. Even more frustrating, he refused to learn from his mistakes!"

- Dylan was booed at the 1965 Newport Folk Festival for using an electric band.

- In June 1986, Dylan secretly married his backup singer Carolyn Dennis. Their daughter, Desiree Gabrielle Dennis-Dylan, was born on January 31, 1986. The couple divorced in October 1992.

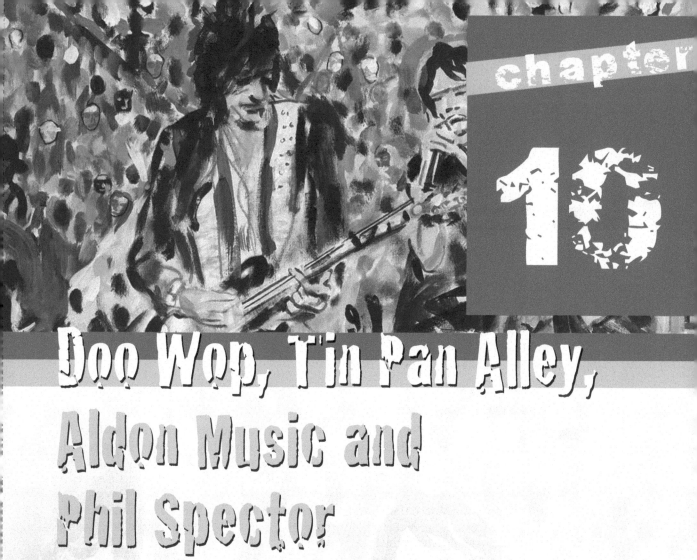

Doo Wop, Tin Pan Alley, Aldon Music and Phil Spector

Doo-Wop

Doo-wop is an unaccompanied style of close-harmony singing by groups of usually four or five members that developed in the late 1940s and thrived in the early 1950s. If instrumental accompaniment was added, it was very much in the background so as not to detract from the voices. The term "doo-wop" itself derives from the ad-lib syllables used while singing the harmony parts. The origins of doo-wop are traceable to nineteenth-century barbershop singing and to the music of such flagship groups as the Ink Spots in the 1930s and the Orioles in the late 1940s. The Orioles were one of the first prominent doo-wop groups, demonstrating their sound in 1948 with the #1 hit "It's Too Soon to Know." From 1948 to 1954, they recorded over 120 sides, hitting the charts with memorable songs such as "Crying in the Chapel" (1953).

In the mid-1950s The Castelles and The Penguins innovated new doo-wop styles, most famously up-tempo doo-wop. The Penguins' "Earth Angel" (recorded in 1954) is an excellent example of the matured popular doo-wop sound. The song "Get a Job" by The Silhouettes (that hit #1 in 1958) is arguably the most successful doo-wop song of all time. This song inspired the early Motown release of The Miracles' "Got a Job" in the same year. Other significant doo-wop groups include The Spaniels, The Moonglows, The 5 Royales, The Turbans, The El Dorados, The Five Satins, The Cadillacs and The Flamingos. In the

late 1950s, Italian doo-wop groups, whose sound and themes were closer to the Tin Pan Alley style, began to have a strong presence on the charts. These groups included Dion and the Belmonts, The Capris, Danny and the Juniors, The Mystics, The Impalas, The Tokens and The Duprees.

Recommended Listening

- Java Jive, the Inkspots, 1940
- It's Too Soon to Know, The Orioles, 1948
- Crying in the Chapel, The Orioles, 1953
- Earth Angel, The Penguins, 1954
- When You Dance, The Turbans, 1955
- In the Still of the Night, The Five Satins, 1956
- Get a Job, The Silhouettes, 1958

Jerry Leiber and Mike Stoller

Jerry Leiber, April 25, 1933–August 22, 2011 (lyricist), and Mike Stoller, born March 13, 1933 (composer), were both born in New York in 1933, but they first met and began working together in Los Angeles in 1950. Together, they have written some of the most significant songs in rock history. In 1951, The Robins (who later became The Coasters) recorded Leiber and Stoller's song "That's What the Good Book Says" for Lester Sill's Modern Records. And by 1953, they had formed their own label, Spark Records. They penned almost every major hit for The Coasters, more than twenty songs for Elvis Presley and girl-group classics such as the Shangri-La's "Leader of the Pack."

When Big Mama Thornton recorded their song "Hound Dog" in 1953, Leiber and Stoller attended the sessions to ensure the quality of the production. They effectively became the producers of their own records. They continued to work directly with their artists, and in doing so pioneered a variety of revolutionary studio techniques. These included altering the speed of a performance after recording it and also splicing together various takes. Future industry giant Phil Spector learned many of his production techniques that would later evolve into the "wall of sound" by watching Leiber and Stoller produce The Drifters. Jerry Leiber once described his own writing style as "playlets," where every member of the group sang the role of an actual character. The duo's compositions were tailor-made for the specific abilities of their artists (a technique mastered by jazz composer Duke Ellington in the 1940s). Leiber and Stoller also state that they wrote records, not songs. More than anyone else, they pioneered the modern concept of the producer of a recorded performance.

Leiber and Stoller wrote a Broadway musical called *Smokey Joe's Café* featuring thirty-nine of their songs. The show debuted in 1994 in Los Angeles and then on Broadway on March 2, 1995, at the Virginia Theatre. It received seven nominations for Tony Awards, and the original Broadway cast soundtrack, *Smokey Joe's Café*, won a Grammy Award in 1995. The Broadway production closed on January 16, 2000, after 2,036 performances, but touring companies still produce the show.

Leiber and Stoller's awards include induction into the Songwriters' Hall of Fame in 1985, the Record Producers' Hall of Fame in 1986, the Rock and Roll Hall of Fame in 1987, an ASCAP Founders' Award in 1991, the Ivor Novella Award from the British Academy of Songwriters in 2000 and the prestigious Johnny Mercer Award, also in 2000.

Recommended Listening

- Hound Dog (Willie Mae "Big Mama" Thornton, Elvis Presley)
- Jailhouse Rock (Elvis Presley)
- Stand By Me (Ben E. King)
- Love Potion #9 (The Clovers)
- Kansas City (Wilbert Harrison)
- On Broadway (The Drifters)
- Spanish Harlem (Ben E. King)
- Searchin' (The Coasters)

The Coasters

Members
- Carl Gardner (vocals; April 29, 1928–June 12, 2011)
- Cornell Gunter (vocals; November 14, 1938–February 27, 1990)
- Billy Guy (vocals; June 20, 1936–November 5, 2002)
- Will "Dub" Jones (vocals; May 14, 1928–January 16, 2000)

The Coasters date back to 1949 when Carl Gardner, Billy Guy, Bobby Nunn and Leon Hughes formed The Robins in Los Angeles. In 1951, they recorded Leiber and Stoller's "That's What the Good Book Says" and in 1954 signed to Leiber and Stoller's label, Spark Records. In the mid-1950s, Nunn and Hughes left the group and were replaced by Cornell Gunter and Will "Dub" Jones. They changed their name to The Coasters and enjoyed a series of successful hits from 1956 to 1961. In 1957, "Searchin'" reached #1 on the R & B charts and #3 on the pop charts, while the flip side, "Young Blood," also made the top ten on both charts. The Coasters were more "rock and roll" than other doo-wop groups, but have remained one of the most influential groups in the style. Leiber and Stoller wrote, produced and arranged most of their songs. Fourteen of the Coasters songs made the R&B charts, and eight also crossed over to the pop charts. The Coasters were inducted into the Rock and Roll Hall of Fame in 1987.

Recommended Listening

- Searchin', 1957
- Young Blood, 1957
- Yakety Yak, 1958
- Charlie Brown, 1958
- Poison Ivy, 1959

The Platters

Members
- Tony Williams (April 15, 1928–August 14, 1992)
- David Lynch (July 3, 1929–January 3, 1981)
- Paul Robi (August 20, 1931–February 1, 1989)
- Herb Reed (August 7, 1931–June 4, 2012)
- Zola Taylor (March 17, 1938–April 30, 2007)

The Platters formed in Los Angeles in 1953 with Tony Williams as the lead singer. Under the direction of Buck Ram, they quickly became one of the most popular doo-wop groups in America. Buck Ram (born Samuel Ram on November 21, 1907, died January 1, 1991) had worked as an arranger for Mills Music, wrote songs, gave voice lessons and managed his own group, The Three Suns, before becoming the manager and producer of The Platters in 1954. He also worked as an arranger for swing band leaders including as Duke Ellington, Tommy Dorsey, Cab Calloway, Glenn Miller and Count Basie.

It was Buck's idea to include Zola Taylor, a woman, which was unusual in doo-wop at that time, but she proved a perfect addition to The Platters' slick sound. In October 1955, "Only You (And You Alone)," composed by Buck Ram, was released on the Mercury label. It soared to #1 on the R&B charts and #5 on the pop charts. The Platters followed up almost immediately with another song written by Buck, "The Great Pretender," in 1956, this time with even more success. "The Great Pretender" was the first #1 pop song for the Platters. In the same year, "My Prayer" became the group's second #1 charting pop song. The Platters then revived some songs from the 1930s and 1940s, including "If I Didn't Care," "I'll Never Smile Again" and "Red Sails In the Sunset," among other songs. These songs inspired the next #1 hit (in 1958), "Twilight Time," a song that Buck had written the lyrics for in 1938 with The Three Suns. Next came a jazz standard by Jerome Kern, "Smoke Gets In Your Eyes," which The Platters recorded in their signature doo-wop style. This also climbed to #1 in 1958.

After their initial success, the group went on to record thirty-three more pop hits on the Mercury label. In 1956, Alan Freed included The Platters performing "Only You" and "The Great Pretender" in his film *Rock Around The Clock*. The heyday for The Platters tapered off by 1962 after ten years of chart topping success. They were inducted into the Rock and Roll Hall of Fame in 1990, the Vocal Hall of Fame in 1998 and continued touring into the twenty-first century.

Recommended Listening

- Only You (And You Alone), 1955
- The Great Pretender, 1956
- My Prayer, 1956
- Twilight Time, 1958
- Smoke Gets In Your Eyes, 1958

The Drifters

Members (as recognized by the Rock and Roll Hall of Fame in 1988)
- Clyde McPhatter (November 15, 1932–June 13, 1972)
- Bill Pinkney (August 15, 1925–July 4, 2007)
- Rudy Lewis (August 23, 1936–May 20, 1967)
- Ben E. King (September 28, 1938–April 30, 2015)
- Charlie Thomas (born April 7, 1937)
- Johnny Moore (December 14, 1934–December 30, 1998)
- Gerhart Thrasher (December 3, 1928–November 1, 1977)

The Drifters have a confusing history in relation to the numerous performers who have passed through the group and all the variations that were operating at the same time, i.e.: The Drifters, Bill Pinkney's Original Drifters and The Second Drifters. They have had twelve different lead singers and two members named Charlie Thomas who were both from Virginia!

The group originated in 1953 with Clyde McPhatter when he left The Dominoes and was under the direction of producers Ahmet Ertegun and Jerry Wexler of Atlantic records. McPhatter formed The Drifters as a business venture with his manager George Treadwell. Each owned 50 percent and employed singers to fill out the ranks of the group as salaried employees. Clyde McPhatter and The Drifters with their doo-wop based sound hit the #1 spot on the R & B charts within months of forming with the song "Money Honey" and then again with "Honey Love." This success catapulted Clyde McPhatter's popularity, and after his departure from the group, they continued to issue albums containing the songs he recorded in the first two years. By late 1954, McPhatter left the group to pursue a solo career and sold his share of Drifters Incorporated to Treadwell. The Drifters had become quite prominent and continued with many hits on the R & B and pop charts throughout the 1950s and the early 1960s.

Just prior to performing at the Apollo theatre in 1958, the entire group quit, unhappy with the low pay and poor working conditions, and new Drifters were recruited. A Harlem group called the Crowns, including singers Ben E. King and Charlie Thomas, were part of this new lineup. It was around this time that Leiber and Stoller assumed control of producing the group. They brought The Drifters into what would become the "Brill Building sound" and pop ballads.

The Drifters are a key link between 1950s rhythm and blues and 1960s soul music. They were an inspiration to Berry Gordy, founder of the Motown label, and his artists. The Drifters epitomized the vocal group sound of the mid-1950s and led the way into the new "pop" sound in music. They acquired much of their material through such songwriters as Lieber and Stoller, Doc Pomus, Mort Shuman, Gerry Goffin and Carole King. Phil Spector, who was playing guitar on sessions for Atlantic in 1963, played guitar on the original recording of "On Broadway." The Drifters were inducted into the Rock and Roll Hall of Fame in 1988 and the Vocal Group Hall of Fame in 1998.

Recommended Listening

- Money, Honey, 1953
- Honey Love, 1954
- There Goes My Baby, 1959
- This Magic Moment, 1960
- Save the Last Dance for Me, 1960
- Some Kind of Wonderful, 1961
- Up On the Roof, 1962
- On Broadway, 1963
- Under the Boardwalk, 1964

Tin Pan Alley

Tin Pan Alley was an area in Manhattan where many of the major music publishers were located from around 1885 to the end of the 1950s. The origin of the name "Tin Pan Alley" is not entirely clear, although a popular belief is that it describes the sound of many pianos playing at the same time, which passersby could hear at street level. Most popular songs were written, sold, and printed in this area, and many famous songwriters and composers got their start in Tin Pan Alley, including Irving Berlin, Jerome Kern, George and Ira Gershwin and Hoagy Carmichael. Aspiring songwriters would show up at one of the Tin Pan Alley publishing houses to play their new songs. If their song was picked up, they often agreed for the publisher not to list them as the composer in order to get cash in hand and their music published. Specific publishers would hire some of the better writers to write for them full time. From 1958 thru 1964, many of the "girl group" songs came from Tin Pan Alley through a new, young generation of writers. The Brill Building (located at 1619 Broadway) is the most famous office building associated with "Tin Pan Alley," and the popular music sound that emerged during its heyday became known as the "Brill Building sound."

Aldon Music Publishing

Aldon Music, formed by Don Kirshner and Al Nevins in 1958, was one of the most successful music publishing companies dominating the teenage pop music scene in the early 1960s. Aldon is famous for its writing partnerships and contribution to the development of the "Brill Building sound."

Kirshner and Nevins set up shop in New York at 1650 Broadway, just down the street from the famous Brill Building. They were largely responsible for what became known as the "Brill Building sound" in the early 1960s, even though their housing was outside of the famous establishment. At this time, the music producers took the reins of the rock and pop music business due to the loss of many rock and roll "heroes" in the late 1950s and an increasing demand for music for America's teenagers.

Connie Francis sung Aldon's first big hit, "Stupid Cupid" (written by Neil Sedaka and Howie Greenfield), which reached #14 on the U.S. and #1 on the UK charts. By 1962 Aldon had a staff of songwriters that included Sedaka/Greenfield, King/Goffin and Mann/Weil, Neil Diamond, Jeff Barry, Ellie Greenwich, Tommy Boyce, Bobby Hart, Andy Kim, Ritchie Adams, Ron Dante, Gene Allan, Toni Wise and others. The writers worked in cubicles, each with an upright piano, on a salary of $150 a week or less (royalties followed for hit songs). They would compose, write lyrics, cut demos and play them for each other at the end of the day, making comments, suggestions and criticisms as they went and ultimately developing that distinct Aldon style. Aldon marketed its catalog to artists, managers and networks to sustain the careers of their best artists. Some of the hits went to the Shirelles, Little Eva, the Drifters, the Ronettes, the Crystals, Tom Jones, Ben E King, the Supremes, Dusty Springfield and the Shangri-Las.

In 1964, Columbia Pictures bought Aldon Music for two million dollars, and Kirshner became president of Screen Gems, the prestigious song publishing wing of Columbia Pictures. Aldon Music placed over two hundred songs on the Top 40 charts during the years of 1958–1963.

Al Nevins

Al Nevins (born Albert Tepper, 1915, Washington, DC, and died January 25, 1965, New York City) was a successful composer, guitarist and recording artist. Nevins had many pre-rock era hits as a member of The Three Suns, a trio that had written and recorded the original version of "Twilight Time" (1944) and had a #1 hit with "Peg 'O My Heart" in

1947. The Three Suns continued to record up to 1965. Don Kirshner approached Nevins and sold him on the idea that publishing new material for teenage record buyers could be an extremely profitable venture. Nevins had a gift for song writing and teaming composers up with the right lyricists. Unfortunately, he suffered a series of major heart attacks in the early 1960s, which ultimately led to his death in 1965.

Recommended Listening

- Twilight Time

Don Kirshner

Don Kirshner (April 17, 1934–January 17, 2011) became known as "the man with the golden ear." He was a friend of Bobby Darin, a then struggling singer-songwriter, and helped him write several songs. Before meeting Al Nevins, he also managed Connie Francis. At only twenty-four years of age, Kirshner conceived and realized the music publishing business Aldon Music. He later moved to Screen Gems Publishing and other television and movie publishing ventures. Kirshner was involved in the creation of the Monkees (1966) and the Archies (1969), and he brought in many of his Aldon songwriters to produce the hit songs for those bands. He formed Don Kirshner Productions in 1972 to produce "Don Kirshner's Rock Concert," a very successful TV show generally considered the predecessor to MTV. At the end of the 1970s, Kirshner began selling off the licensing end of his publishing catalog and retired. In 2007, he was inducted into the Songwriters Hall of Fame with a "Lifetime Achievement Award."

The Aldon Stable of Writers

Howard "Howie" Greenfield
Howie Greenfield (March 15, 1936–March 4, 1986) worked primarily as a songwriting partner with Neil Sedaka, but he also collaborated with Carole King, Helen Miller and Jack Keller. Greenfield and Keller wrote songs used for the TV show *Bewitched*. The songs that Greenfield and Sedaka had hits together with include "Oh! Carol," "Stairway to Heaven" (not the Led Zepplin song!), "Calendar Girl," "Little Devil," "Happy Birthday Sweet Sixteen," "Next Door to an Angel" and "Breaking Up Is Hard to Do" (that sold over twenty-five million copies). In 1991, Howard Greenfield was inducted into the Songwriters Hall of Fame.

Neil Sedaka
Neil Sedaka (born March 13, 1939) studied classical piano and spent time studying at the Julliard School of Music. During high school, he dated songwriter Carole King (then Carole Klein), the subject of his 1959 song "Oh!Carol,' and became friends with Howie Greenfield, Sedaka's lyricist for many years. In 1958, Sedaka joined Al Nevins and Don Kirshner's Aldon music group of songwriters. The next year he signed with RCA as a recording artist and released a number of successful songs. Sedaka's song "Calendar Girl" was released as one of the first Scoptitone (early music video) hits with scenes filmed in Italy of pin-up girls. Scoptitone was a big deal in Europe in the early 1960s, but it failed commercially in the USA. Like many of today's MTV music videos, there are two themes to Scoptitones: They illustrate

the story of the song, and they make it sexy! Since the death of Greenfield in 1986, Sedaka has continued to write hit songs, tour and record on a regular basis. Neil Sedaka was inducted into the Songwriters Hall of Fame in 1983; he has received multiple Grammy Awards with the songs he composed for other artists, six BMI Awards and 52 Gold and Platinum records; and he earned a star on the Hollywood Walk of Fame in 1978.

Recommended Listening

- Oh! Carol
- Calendar Girl
- Happy Birthday Sweet Sixteen
- Breaking Up is Hard to Do

Gerry Goffin and Carole King

The husband and wife songwriting team of Gerry Goffin (February 11, 1939–June 19, 2014) and Carole King (born February 9, 1942) composed for many artists through Aldon Music during the 1960s. Some of their hits included "Up on the Roof" (the Drifters), "One Fine Day" (the Chiffons), "I'm Into Something Good" (Herman's Hermits), "Will You Love Me Tomorrow" (the Shirelles), "Take Good Care of My Baby" (Bobby Vee), "Chains" (the Cookies, and later, the Beatles), "Don't Bring Me Down" (the Animals), "Take a Giant Step" (the Monkees) and "Goin' Back" (the Byrds). Goffin (a lyricist) and King (a pianist) met at Queens College in 1958 and Don Kirshner hired them in 1960. Due to their success, Kirshner formed Dimension Records in 1962 specifically to focus on their songs. In 1968, Goffin and King divorced, but they continued their success individually. King released an album titled *Tapestry*, which stayed at #1 on the charts for fifteen weeks, earning her a Grammy for Album of the Year in 1971. She followed with several other high-charting albums in the 1970s. Gerry Goffin and Carole King were inducted into the Rock and Roll Hall of Fame in 1990.

Recommended Listening

- Up on the Roof (the Drifters)
- I'm Into Something Good (Herman's Hermits)
- Will You Love Me Tomorrow (the Shirelles)
- Chains (the Cookies, or, the Beatles)

Doc Pomus and Mort Shuman

Doc Pomus (born Jerome Solon Felder on June 27, 1925, died March 14, 1991) and Mort Shuman (November 12, 1936–January 2, 1991) are the composers of some of the greatest songs in rock and roll history. These include "This Magic Moment" (the Drifters), "Young Blood" (the Coasters), "Lonely Avenue" (Ray Charles), "There Must Be a Better World Somewhere" (B. B. King), "Turn Me Loose" (Fabian), "Can't Get Used to Losing You"

(Andy Williams) and "Save the Last Dance for Me" (Ben E. King). They also wrote more than twenty songs for Elvis Presley, including "Little Sister," "Surrender" and "Viva Las Vegas." In 1958, Don Kirshner and Al Nevins hired Pomus and Shuman as one of their first and strongest writing teams. Doc Pomus generally wrote the lyrics, and Mort Shuman wrote the music to their songs. In 1964, after the sale of Aldon Music, the writing duo moved to England where they began to spread their working relationships to other writers. In 1965, a bad fall injured Doc Pomus and confined him to a wheelchair for the rest of his life. He retired from composing for ten years but returned to music in the late 1970s to work with Dr. John and B. B. King. In 1992, following his death from lung cancer in 1991, Doc Pomus was inducted posthumously into the Rock and Roll Hall of Fame, adding to his existing inductions into the Songwriters Hall of Fame, the Blues Foundation Hall of Fame and the New York Music Hall of Fame. He was also a founding member of the Rhythm and Blues Foundation. Mort Shuman's later career included writing for the Hollies, Andy Williams and Cilla Black, translating popular French songs and writing for London musicals. He was inducted posthumously into the Songwriters Hall of Fame. Together, Doc Pomus and Mort Shuman's songs have appeared on more than thirty million records.

Recommended Listening

- This Magic Moment (the Drifters)
- Lonely Avenue (Ray Charles)
- Turn Me Loose (Fabian)
- Can't Get Used to Losing You (Andy Williams)
- Little Sister (Elvis)
- Surrender (Elvis)

The Shirelles

Members
- Beverly Lee (born August 3, 1941)
- Shirley Alston Reeves (born June 10, 1941)
- Addie "Micki" Harris (June 10, 1940–June 10, 1982)
- Doris Kenner-Jackson (August 2, 1941–February 4, 2000)

Before becoming a famous vocal pop group, the Shirelles were high school friends who enjoyed singing as a pastime. They got their break when a friend's mother, Florence Greenberg, released their version of "I Met Him on a Sunday," and it became a minor hit. Originally called the Pequellos, they soon changed their name to the more recognizable and stylistically current Shirelles. The girls signed with Decca records briefly in 1958 but switched to Scepter Records in 1959. There, they recorded many hits, beginning with the #1 charting "Will You Love Me Tomorrow" (released in 1960). Florence Greenberg founded and ran Scepter Records to focus on the Shirelles' music. Funds from the original hit "I Met Him On a Sunday" and the sale of her Tiara label enabled the beginning of Scepter records. The Shirelles were the first African American "girl group" with a #1 charting single, and their consistent hits up until 1964 ultimately opened the door for many other girl groups to become successful. They were inducted into the Rock and Roll Hall of Fame in 1996 and are still performing today under the leadership of original member Beverly Lee.

Recommended Listening

- I Met Him On a Sunday, 1958
- Will You Love Me Tomorrow, 1960
- Mama Said, 1961
- Soldier Boy, 1962
- Baby It's You, 1962

The Crystals

Members
- Barbara Alston (December 29, 1943-February 16, 2018) (left the group in late 1964)
- Mary Thomas (born 1946)(left the group in late 1963)
- Dolores "Dee Dee" Kenniebrew(born 1945)
- Myrna Girard (born 1943)(left the group in late 1963)
- Patricia Wright (born 1945)(left the group in late 1964, and Frances Collins replaced her)
- Dolores "La La" Brooks (born 1946)(joined in late 1963)
- Darlene Love and the Blossoms (born July 26, 1941)(recorded by Spector sporadically as the Crystals)

The Crystals formed in 1960 in Brooklyn and were the first group signed by producer Phil Spector to his Philles label (in 1961). Although the girls were only fifteen at the time, they provided Spector with some of his first charting hits as a producer. These included "There's No Other (Like My Baby)" in January 1962, "Uptown" (1962), "Da Doo Ron Ron" (1963) and "Then He Kissed Me" (1963), and their one #1 hit, "He's a Rebel" (1963). Many think Darlene Love and the Blossoms (in L.A.) recorded this song, released by Spector under the Crystals' name.* After great success and five top ten hits in the early sixties, Spector lost interest in the group, and their popularity waned. The Crystals continued as a quartet and then as a trio until 1967 when the group finally broke up. If the British invasion hadn't dominated the music industry so much in the mid-1960s, the Crystals and many of the early 1960s girl groups may have continued their careers more substantially. Since reviving the group in 1971, "Dee Dee" Kenniebrew has led several lineups of the Crystals for over thirty-five years, and they still perform today.

Recommended Listening

- There's No Other (Like My Baby), 1962
- He's a Rebel, 1963
- Then He Kissed Me, 1963
- Uptown, 1962
- Da Do Ron Ron, 1963

* Some girl groups used a variety of singers in the studio in the early 1960s in addition to the publicized or touring lineup. The record companies owned the rights to the names of these groups and chose to record the best voices for lead and backing as necessary on a particular song. This was all part of the experimentation with sound, studio techniques and producing a saleable "product." In most of these cases, the girls' pictures did not appear on the album covers, and the company paid them as "studio musicians."

The Ronettes

Members

- Veronica "Ronnie" Bennett (August 10, 1943–January 12, 2022)
- Estelle Bennett (July 22, 1941–February 11, 2009)
- Nedra Talley (born January 27, 1945)

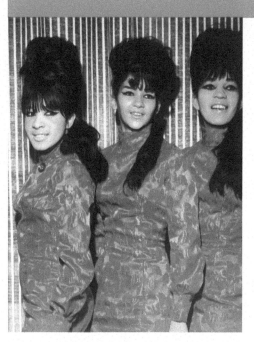

The Ronettes

The first "bad girls" of rock, The Ronettes

The Ronettes (originally called the Darling Sisters), dubbed the first "bad girls" of rock, are one of the most enduring groups of the girl group category. In 1959, Veronica "Ronnie" Bennett (who would marry Phil Spector in 1968 and divorce him in 1974), her sister Estelle Bennett, and their cousin Nedra Talley formed the Ronettes to perform as singers and dancers at the Peppermint Lounge. Legendary disc jockey "Murray the K" (Murray Kaufman) discovered them and gave their career a kick start through his Brooklyn Fox Theater rock and roll revues. The Ronettes released their first single, "You Bet I Would," in 1961 on the Colpix label, co-written by Carole King. After

© GAB Archive/Contributor/Getty Images

nurturing by Phil Spector, the hits began to roll out with "Do I Love You," "Baby I Love You," "The Best Part of Breaking Up," "I Can Hear Music," the Grammy Award-winning "Walking in the Rain" and their biggest hit, "Be My Baby."

When performing in the UK, the Ronettes were the headliners to the Rolling Stones and the Yardbirds supporting acts. In August 1966, the Beatles personally requested that the Ronettes join their final U.S. tour. Unfortunately, by the end of 1966, they had disbanded. Ronnie Spector made a relatively successful attempt at a solo career beginning in the 1970s when she released her 1974 solo single, "Try Some, Buy Some," written and produced by George Harrison (with Harrison, John Lennon, and Ringo Starr in the backing band). She then went on to sing with Alice Cooper and also on Jimi Hendrix's final recording session in August 1970. In 1976, Billy Joel wrote "Say Goodbye to Hollywood" in tribute to her. In 1998, Ronnie Spector and the other Ronettes sued Phil Spector for allegedly cheating them of royalties in the early 1960s, and they won a three million dollar judgment; however, an appeals court later reversed the decision. In 2004, the Ronettes were inducted into the Vocal Group Hall of Fame and then into the Rock and Roll Hall of Fame on March 12, 2007.

Ronnie Spector's latest recording project, *Last of the Rock Stars*, features Dennis Diken (the Smithereens), Nick Zinner (Yeah Yeah Yeahs), Patti Smith, and Keith Richards of the Rolling Stones.

Recommended Listening

- Be My Baby, 1963
- Baby I Love You, 1964
- (The Best Part of) Breaking Up, 1964
- Walking in the Rain, 1964
- Do I Love You, 1964
- Try Some, Buy Some, 1971

Phil Spector

Phil Spector launched his 'wall of sound' concept at only 21 years of age

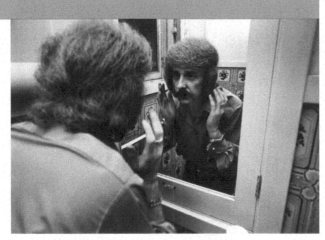

© *Mark S. Wexler/Contributor/Getty Images*

Phil Spector

Harvey Philip (Phil) Spector was born December 26, 1939 in the Bronx, New York, and many refer to him as the greatest producer of rock and roll. While attending Fairfax High School in Los Angeles, Spector learned to play the guitar, piano, drums, bass and French horn. He felt drawn to the local rhythm and blues scene in Los Angeles and studied guitar with Barney Kessel, who encouraged him to get into music production. At age seventeen, Spector joined The Teddy Bears and recorded "To Know Him Is to Love Him." He wrote, arranged and produced the song, which reached #1 on the charts after airing on Dick Clark's *American Bandstand* in 1958. He left The Teddy Bears less than a year later to focus on writing and producing music. In 1960 Spector moved to New York and became an apprentice to Leiber and Stoller, with whom he co-wrote the hit "Spanish Harlem." In 1961 Spector and Lester Sill (January 18, 1918–October 31, 1994) formed Philles (Phil-Les!) Records to capitalize on the Brill Building sound and the Aldon songwriters. In 1962 Spector bought out his partner and became the sole owner. Spector also signed The Crystals and tested his formula for produced, charting acts while working as an independent producer for Atlantic Records and Don Kirshner.

At the age of twenty-one, Spector singlehandedly changed the direction of recording and producing within the music industry when he created his "wall of sound" phenomenon. Spector attributes this discovery to his interest in Richard Wagner's symphonies. The wall of sound concept essentially applies two or more of each instrument to each voice, producing a big and present sound before multi-track recording was available. He often used twenty-four to twenty-five musicians on these tracks, who he referred to as "The Wrecking Crew." He specifically designed the wall of sound to boost the sound quality of his records on jukeboxes and mono record players, and for radio play (mostly AM stations at that time). Spector's other ingenious idea was to put an instrumental on the B-side of his singles to prevent disk jockeys from flipping the record and taking attention away from his "push" side.

Spector is mostly known for his association with the girl group era of the early sixties and as the producer for The Crystals, Darlene Love, Bob B. Soxx and the Blue Jeans and The Ronettes. Between 1960 and 1965, his formula sent twenty-five songs into the top 40. In 1963, Spector co-wrote songs with the Rolling Stones and in 1965, he produced The Righteous Brothers' "You've Lost That Lovin' Feelin'," which immediately went to #1. In 1966, he produced Ike and Tina Turner's "River Deep, Mountain High." Spector considered this his best work, but it failed to chart in the U.S., although it did reach #3 in the UK. A dejected Spector went into retirement until the end of the 1960s. In 1969 Spector began working with the Beatles on post-production for the *Let It Be* album as well as on solo albums for John Lennon and George Harrison. Spector had become quite reclusive and only occasionally took work. His later projects included Cher, Duran Duran, Leonard Cohen, The Ramones' *End Of The Century* (1980), Yoko Ono's *Season of Glass* (1981) and Starsailor's *Silence Is Easy*. He had also been scheduled to work on The Vines' latest album (2003) before his arrest.

Over the years, Spector has had the reputation of having a bad temper, at times even brandishing guns when he didn't get his way (especially with women). On February 3, 2003, police arrested him on suspicion of murder after they found actress Lana Clarkson shot to

death in his mansion. On September 26, 2007, a jury stated that it could not reach a verdict. The judge declared a mistrial, and the murder case against Phil Spector began again in fall 2008. In April 2009, Spector was convicted of murder and sentenced on May 24th to serve 15 years in prison. In January 2021, Phil Spector was transferred in custody from a California Health Care prison facility in Stockton to San Joaquin General Hospital having contracted Covid-19. On January 16, 2021 Spector died from the illness.

Phil Spector won several Grammy Awards, including Album of the Year for the *Concert for Bangla Desh*, co-produced with George Harrison in 1972. He was inducted into Rock and Roll Hall of Fame in 1989 and the Songwriters Hall of Fame in 1997. Spector will be remembered for his genius as a music producer, for advancing the expectations of quality in studio recording and for excellence in the industry. Sadly, as his former wife Ronnie Spector stated "...Phil was not able to live and function outside of the recording studio. Darkness set in. Many lives were damaged."

Recommended Listening

- To Know Him is to Love Him, The Teddy Bears
- He's a Rebel, The Crystals
- Da Doo Ron Ron, The Crystals
- Be My Baby, The Ronettes
- You've Lost That Lovin' Feelin', The Righteous Brothers
- The Long and Winding Road, The Beatles

Trivia

- The title for Spector's first #1 hit, "To Know Him is to Love Him," is the epitaph from his Father's gravestone.

- Someone once asked Spector whether he enjoyed the work of Andrew Lloyd Webber. "Why, yes," he replied. "In fact, I respect his work so much that one day I'd like to set it to music."

- Spector preferred the artistry of singles to albums, describing LPs as "two hits and ten pieces of junk."

- He had a cameo appearance as a drug dealer in the film *Easy Rider* in 1969.

- **Let's Dance the Screw:** In 1962, Lester Sill agreed to sell his share of the Philles label to Phil Spector for $60,000, but Spector refused to pay, claiming that Sill owed him money from back royalties. Sill sued his former partner, demanding all royalties to the next Crystals record as compensation, with which the court agreed. In January 1963, Spector and the Crystals went into the studio to record a song of Spector's called "(Let's Dance) The Screw—Part 1." The chorus consisted of nothing but the word "dance" with Spector singing the line "dance the screw." The B-side, "(Let's Dance) The Screw—Part 2," featured a nearly identical rendition of the song. Lester Sill received a copy of "the next Crystals record" (stamped "D. J. COPY—NOT FOR SALE"). Sill later remarked, "That was Spector saying, 'F*** you, buddy.'"—from *anecdotage.com*

Further Reading
- The Chantels
- The Angels
- The Chiffons
- The Cookies
- The Dixie Cups
- The Shangri-Las
- The Exciters

Surf Music

Surf music began as a transfer of the adrenaline from surfing to music, especially through the electric guitar. The surf style branched into exotic harmonies with vocals inspired by the doo-wop and girl group sound, and themes about surfing, girls, hot rods and the California beach life. The music is not only inherently Californian, but it also evolved completely in southern California before bursting onto a national level with The Beach Boys. The great guitar builder Leo Fender worked closely with many surf artists, especially Dick Dale, and made resulting improvements to his guitars and amplifiers that would further rock music as a whole. With the popularity of Fender's Precision Bass, surf music became one of the first genres to universally adopt the electric bass. A more recent variation of surf music is "surf pop," a vocal-based form that combines surf ballads and "surf rock" and an instrumentally based form of music. The popularity of the movie *Pulp Fiction*, which featured a great deal of surf music, fueled a 1990s revival of surf music.

Dick Dale and the Del-Tones

Dick Dale, "The King of Surf Guitar" (May 4, 1937-March 16, 2019), is the pioneer of surf music. He is one of the most influential guitarists of the early 1960s, and he introduced a new sound concept focusing on a reverberated guitar that later inspired The Beach Boys. Along with his band, the Del-Tones, Dick Dale became an important artist on the West Coast, where he introduced his surf music in the late 1950s. Dale was an expert surfer and he tried to imitate the sounds on his guitar that he heard while riding the waves. In the early 1960s Dale began playing at the Rendezvous Ballroom in Balboa, California, with The Del-Tones to as many as four thousand surf fans. He received national attention with the singles "Let's Go Trippin'" (1961) and "Misirlou" (1962).

Dick Dale was also a consultant to Leo Fender during the development of the Fender reverb unit and Fender showman amplifier, both created in 1960. In 1987 Dale recorded a version of "Pipeline" with blues great Stevie Ray Vaughan for the movie soundtrack *Back to the Beach*, which received a Grammy nomination in 1988. He was also nominated for a

Dick Dale

Dick Dale, the
King of the Surf
Guitar

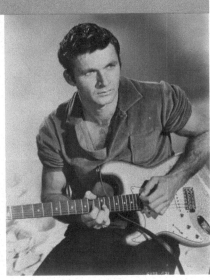

© *Michael Ochs Archives/Getty Images*

Grammy for "Misirlou" in the Quentin Tarantino film *Pulp Fiction* in 1994. Dale's aggressive tremolo style guitar playing has influenced many rock guitarists ranging from metal to punk rock. You can also hear his version of Saint-Saens' "Aquarium" at Space Mountain in Disneyland. In 1981, *Guitar Player* magazine awarded Dale Guitarist of The Year, and he was inducted into "Hollywood Rock Walk of Fame" in 1996.

Guitar Spotlight

Dick Dale, the King of Surf Guitar, has a unique style. Dale plays left-handed, but his guitar is strung upside down. It's as though you took a right-handed guitar and turned it in the opposite direction for a left-handed player without changing the strings. This puts the bass strings closest to the floor. These are the strings Dale plays most of his melodies on. Dale comes from a Greek family and grew up hearing Greek music in the household. Greek music uses the mandolin played with a fast picking technique called a tremolo. Dale uses a similar technique on guitar with a fast picking tremolo while holding notes. He claims the influence of drummer Gene Krupa. This would also influence Dale's picking technique with accents like a drummer playing rolls on a snare drum or tom-tom. Part of Dale's sound comes from the use of a Fender Stratocaster (guitar), Fender amps played very loud and the Fender reverb unit, which Leo Fender developed with Dick Dale's help. Dale would turn his reverb unit up to ten and get a very wet sound. On top of all this, Dick Dale plays very aggressively.

Recommended Listening

- Let's Go Trippin'
- Misirlou
- Jungle Fever
- Secret Surgin' Spot
- Pipeline

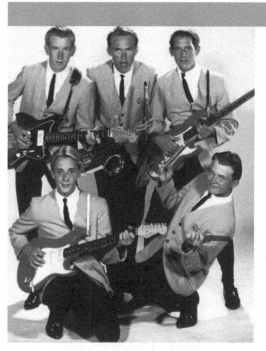

The Surfaris

Surf classic,
"Wipe Out"
was the Surfaris'
biggest hit

© GAB Archive Getty Images

The Surfaris

The Surfaris, formed in 1962, were one of many Californian surf groups popular in the early sixties before the British invasion. The group members were from southern California and part of the original surf culture. The Surfaris were a one-hit-wonder group, known for the instrumental song "Wipe Out" (1963), which became one of the most popular surf songs of the era. In 1965, the group abandoned hot rod and surf songs in favor of a folk rock style. The Surfaris later entered the charts with "Surfer Joe" and "Point Panic." The Surf Music Walk of Fame at Euro Disneyland (1991) and Hollywood's Rock Walk and Museum (1996) include the Surfaris.

Recommended Listening

- Wipe Out
- Surfer Joe
- Point Panic

Jan and Dean

Jan and Dean, (William Jan Berry April 3, 1941–March 26, 2004, Dean Ormsby Torrence born March 10, 1940) were a vocal duo that first achieved national success in the late 1950s prior to the emergence of The Beach Boys. Their first commercial success was with "Jennie Lee" in 1958, a top 10 ode to a local burlesque performer that Berry recorded with his friend Arnie Ginsburg. By May 1959, Ginsberg left the group and Dean Torrence stepped in. Jan and Dean recorded another top ten song, "Baby Talk," which brought them into the

Jan and Dean

Surfboards, girls and hot rods were the subjects of Jan and Dean's music.

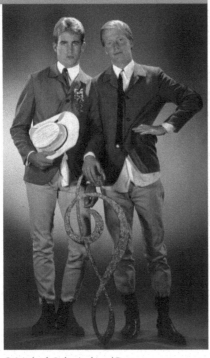

© *Michael Ochs Archives/Getty*

limelight after they appeared on Dick Clark's *American Bandstand*. At this time, many were coming to know Berry as one of the best record producers on the West Coast as well.

In 1961, Jan and Dean signed a deal with Aldon music to write and record six singles with Aldon's West Coast producer Lou Adler. In 1962, they began playing shows with The Beach Boys and collaborated with Brian Wilson on the single "Surf City," which became a national #1 hit in 1963. "Drag City" also made the top 10 in 1963, as did "Dead Man's Curve" and "The Little Old Lady from Pasadena" in 1964. In 1966 Jan Berry received a serious injury when he crashed his new Stingray into the back of a parked truck on a side street in Beverly Hills. His injuries were so bad that paramedics at the scene thought he was dead. Berry was in a deep coma for weeks and underwent several major brain surgeries with very little hope for recovery. With the right side of Jan's body partially paralyzed, the duo made a comeback in 1973 to perform for the first time in seven years.

During the years of Jan Berry's recovery, Dean formed a successful graphics company called Kittyhawk Graphics and created over two hundred album cover designs. This included the artwork for *Pollution*, for which he won a Grammy Award for *Best Album Cover of the Year* in 1972. Jan and Dean had a total of twenty-six charting hits over an eight-year period (1958–1966), and in 1980 the city of L.A. honored them with "Jan and Dean Day."

Recommended Listening

- Jennie Lee
- Baby Talk
- Surf City

- Deadman's Curve
- Little Old Lady from Pasadena

The Beach Boys

Original Members
- Brian Douglas Wilson (born June 20, 1942)
- Carl Dean Wilson (December 21, 1946–February 6, 1998)
- Dennis Carl Wilson (December 4, 1944–December 28, 1983)
- Michael Edward "Mike" Love (born March 15, 1941)
- Alan Charles "Al" Jardine (born September 3, 1942)

The Beach Boys (originally called The Pendletones) were formed in 1961 in the Los Angeles suburb of Hawthorne by the Wilson brothers (Brian, Carl, and Dennis), cousin Mike Love

and friend Al Jardine. Among rock and roll groups of the sixties, The Beach Boys place second only to the Beatles in terms of their overall impact on the top forty charts. Brian Wilson was the group's leader, orchestrating their harmonies, writing the music and producing the recording sessions. The group's first single, "Surfin'," was a limited release that was a hit on the West Coast, and peaked at #75 nationally. Seeing the potential for an untapped market, Murry Wilson, the father of Brian, Carl and Dennis, took it upon himself to manage and promote the boys. Although Murry was instrumental in securing Capitol Records' interest in the boys, his presence and constant interference ultimately damaged the group.

The Beach Boys

The Beach Boys took surf music to national popularity

© Keystone/Stringer/Getty Images

According to Brian, Murry "was a tyrant," quick to offer discouraging criticism and abusing his sons psychologically and physically. Brian comments in his book *Wouldn't It Be Nice* that "playing the piano . . . literally saved my ass. I recall playing one time while my dad flung Dennis against the wall . . . that was just one of many incidents"

In June 1962, The Beach Boys recorded "409" and "Surfin' Safari," which broke into the top 20 and helped secure their Capitol Records deal. Then "Surfin' USA" and "Surfer Girl" both made the top ten on the charts. Surfing, girls and hot rod racing, which created an enticing persona for southern California, were the inspiration for The Beach Boys' songs. From 1962 to 1965, The Beach Boys consistently dominated the charts, having sixteen hit singles and ten studio albums. In 1964, Brian ousted his father as manager after a violent confrontation in the studio. When Murry died of a heart attack in 1973, neither Brian nor Dennis attended the funeral.

In 1964, *The Beach Boys Concert Album* became the first #1 charting album for the group. But, in the midst of touring and continuing success on the charts, Brian Wilson stopped touring with the group, eventually suffering a nervous breakdown in 1965. Brian's mental state further deteriorated through his use of illicit drugs. During this time, Brian confined himself to his home recording studio, working incessantly on applying Phil Spector's wall of sound concept to develop his own multi-tracking and stereo recording technique. His early attempts to produce masterful recordings included "Help Me, Rhonda" and "California Girls" where his attention to detail became evident.

The year 1966 brought with it The Beach Boys' most innovative and influential album, *Pet Sounds*, an album very much ahead of its time. Brian had finally hit what he was striving for after four months working on this recording. In response to this monster album, the Beatles released *Sergeant Pepper's Lonely Hearts Club Band*, an attempt to meet The Beach Boys' level of artistry. Brian rose to the challenge once again with the "pocket symphony" called "Good Vibrations" (he spent six months working just on this song), which catapulted The Beach Boys to the top of the charts. Brian Wilson and Van Dyke Parks then went to work on the album *Smile*, which was even more experimental than *Pet Sounds*. Mike Love and other band members thought *Smile* was too far removed from The Beach Boys' style and halted the release, but they agreed to a watered-down version titled *Smiley*

Smile, which peaked at #41 on the charts. They finally released *Smile* in its entirety in 2004 to critical acclaim, although Mike Love sued Wilson for misappropriating his songs.

During the 1970s, the band toured frequently as interest in their music soared after the release of *Endless Summer*. In 1976, Brian returned to the group and they released the album *15 Big Ones*, which reached #8 on the charts. In 1988, The Beach Boys had their first #1 hit in twenty-two years with "Kokomo" (the B-side is "Tutti Frutti" with guest Little Richard). The band has seen its share of tragedies, which began in 1983 when Dennis Wilson drowned while swimming near Marina Del Ray. Then, in 1998, they lost their finest voice, Carl Wilson, to cancer. Carl received the diagnosis in 1997, but he continued to perform even while receiving chemotherapy. He sat down most of the time, as he needed oxygen after every song.

The Beach Boys have won numerous awards over the years as a group and also as solo artists. In 1974 *Rolling Stone Magazine* elected them Band of the Year. They earned a star on the Hollywood Walk of Fame in 1980, were inducted into the Rock and Roll Hall of Fame in 1988 and received the National Recording Academy of Arts and Sciences Lifetime Achievement Award (NARAS) in 2001.

Recommended Listening

- Surfin' (1961)
- Surfer Girl (1963)
- Surfin' USA (1963)
- I Get Around (1964)

- California Girls (1965)
- Good Vibrations (1966)
- Wouldn't It Be Nice (1966)
- Kokomo (1988)

Trivia

- Brian modeled some of his songs after other well known songs; most famously, "Surfer Girl" shares its rhythm and melody with "When You Wish Upon a Star." Another recognizable tune is "Surfin' USA," which is Brian Wilson's reworking of Chuck Berry's "Sweet Little Sixteen."

- The song "Vegetables" from *Smile*, uses the chewing of vegetables as percussion accompaniment, and features a guest appearance by Paul McCartney on celery!

- Brian Wilson spent most of the years between 1971 and 1975 in bed!

- *Endless Summer* in 1974 was a #1 hit and stayed on the charts for three years.

- In 1968, Dennis Wilson became friends with Charles Manson, let him (and his girls) move into his house and then recorded one of his songs with The Beach Boys. They changed Charles Manson's song, "Cease to Exist" to "Never Learn Not to Love." It appeared as the B-side to "Bluebirds over the Mountain" and on the *20/20* album.

- John Stamos played bongos in The Beach Boys' music video for *Kokomo*.

- A cartoon at this Website documents, and satirizes the outrageous behavior of Murry Wilson in managing his sons:

 http://blog.wfmu.org/freeform/2005/10/im_a_genius_too.html

A Brief Look at the Beach Boy Lawsuits

- The Beach Boys sued Capitol records twice in the late 1960s for unpaid royalties.
- In 1989, Brian recovered ten million dollars lost when he signed his songwriting royalties over to his late father, Murry Wilson, in the 1960s.
- Brian's mother sued publisher HarperCollins for printing that she was a bad mother in the 1991 book, *Wouldn't It Be Nice: My Own Story* written by Brian Wilson.
- In 1992, Mike Love sued Brian Wilson for co-writer credit on several hit songs, including "California Girls," "I Get Around," "Help Me, Rhonda" and others, and won thirteen million dollars for lost royalties.
- The Beach Boys sued Brian in 1997, claiming that false statements made about them in Wilson's autobiography caused them to somehow lose sixteen million dollars in tour revenue.
- In 1999, Mike Love successfully sued Al Jardine for exclusive use of the band's name. Al countersued in 2002 and lost. He then appealed in 2004 and won. He then sued Mike for several million.
- In 2005, Mike sued Brian, claiming Brian "shamelessly misappropriated Mike Love's songs and likeness, The Beach Boys trademark, and the *Smile* album itself."
- In 2006, Mike and Brian sued Allan Gaba and Roy Sciacca for sixty million dollars for allegedly stealing Beach Boys memorabilia sometime before 1994. The court threw the case out.
- In 2022, Brian Wilson's former wife, Marilyn Wilson-Rutherford, sued Brian for 6.7 million dollars after he sold song rights to Universal Music in 2021. The suit comes after Brian offered Rutherford 3.3 million for the sale of those rights, and, after sending her 11 million dollars for the sale other composition rights.

Other Influential Surf Artists and Styles

- **Spy Rock** is a subgenre of surf rock. A great example of this subgenre is the James Bond theme, from the popular series of spy movies, performed by The Ventures.
- **Duane Eddy** is a Grammy Award-winning American guitarist. Inducted into the Rock and Roll Hall of Fame in 1994, he is acclaimed by fans as the most successful rock and roll instrumentalist of all time.
- **The Tornadoes** were the first surf band to receive national airplay with a surf instrumental; the song was "Bustin' Surfboards" in 1962.
- **The Chantays** had a #1 hit with "Pipeline," one of the most widely known surf melodies and rock drum solos in the music's history.
- **Eddie & the Showmen** became popular with the hits "Squad Car" and "Mr. Rebel."
- **The Ventures** hit the charts in 1960 with "Walk Don't Run." They have the most recognition for their covers of TV and movie theme songs such as "Hawaii Five-0," "Batman," "Secret Agent Man" and the James Bond theme. Almost 40 Ventures' albums charted, and seventeen of those hit the Top 40.
- **The Atlantics** were an Australian surf rock band in the early 1960s. They were Australia's most successful surf band with their 1962 classic hit "Bombora."
- Other popular surf era groups include The Dakotas, The Challengers, The Bel-Airs, The Pyramids, Ronny and the Daytonas, The Hondells and The Ripchords.

The British Invasion

"The British Invasion" is the term used to describe the wave of British rock bands that dominated the American music charts primarily from 1964 to 1967. The characteristic sound of the British invasion was a blend of American blues, country and early rock and roll, fused with British pop and skiffle music. There were many British rock bands that became popular throughout the UK and Europe in the early 1960s, but only a handful entered the U.S. charts and had an impact on the direction rock music took in the mid to late 1960s. The first wave of British bands came primarily from Liverpool where the "beat boom" or "beat music" flourished, and then from Manchester, London and the rest of the United Kingdom. The first band to follow the Beatles' success on the American scene was the Dave Clark Five. A steady stream of British rock bands followed, including the Animals, Jethro Tull, the Spencer Davis Group, the Kinks, the Small Faces, Them, the Rolling Stones and The Who. These bands sparked a healthy musical rivalry in the U.S., and the two sides of the Atlantic began to battle for the top chart positions.

Skiffle Music was the British equivalent of rockabilly with influences coming from folk, jazz and blues music. Bands usually performed skiffle music on homemade instruments such as the washboard, tea chest bass, kazoo, cigar-box fiddle, musical saw, acoustic guitar and vocals. Skiffle was also a slang term for "rent party."

The "Mersey Beat" is the sound developed by Liverpool bands that generally featured lead and rhythm guitars, bass and drums. This became the standard core rock and roll lineup for years to come.

DC5

The Dave Clark Five were one of the most successful bands of the early British Invasion

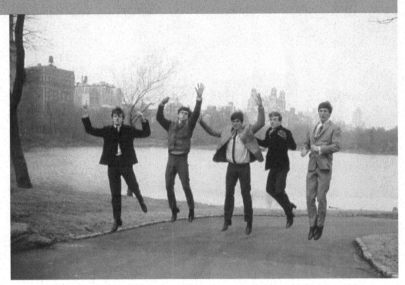

© Bettmann/Contributor/Getty Images

The Dave Clark Five (DC5)

Members
- Dave Clark (born December 15, 1939)—drums
- Mike Smith (December 6, 1943–February 28, 2008)—lead vocals, keys
- Lenny Davidson (born May 30, 1942)—lead guitar
- Rick Huxley (August 5, 1940–February 11, 2013)—bass
- Denis Payton (August 11, 1943–December 17, 2006)—sax, guitar, harmonica

The Dave Clark Five (usually abbreviated to DC5) were a North London beat group that experienced great success in the USA between 1964 and 1967. They were one of the first British bands to tour the USA extensively and had their first charting U.S. hit with "Glad All Over" in April 1964. Their Top Ten hits included "Bits and Pieces," "Can't You See That She's Mine," "Because," "Catch Us If You Can," "Over and Over" and "You Got What It Takes." Following suit with the Beatles, the DC5 released their own film *Catch Us If You Can* in 1965. After six sell out tours of the US, thirteen appearances on the *Ed Sullivan Show*, twenty-two hit records in Britain and twenty-four in America, the group broke up in 1970. They were inducted into the Rock and Roll Hall of Fame in 2008.

Recommended Listening

- Glad All Over
- Catch Us if You Can
- Bits and Pieces
- Over and Over

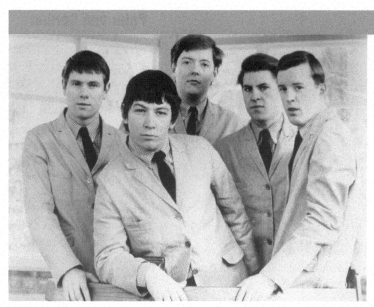

The Animals

Bad boy British rockers, the Animals

© *Bettmann/Contributor/Getty Images*

The Animals

Members
- Eric Burdon (born May 11, 1941)—vocals
- Alan Price (born April 19, 1942)—keyboards
- Chas Chandler (December 18, 1938–July 17, 1996)—bass
- John Steel (born February 4, 1941)—drums
- Hilton Valentine (May 21, 1943–January 29, 2021)—guitar

The Animals began as a jazz trio in 1960, but soon changed their sound to reflect a raw, American blues sound influenced by John Lee Hooker and Ray Charles. With the addition of their lead singer Eric Burdon in 1962, they became one of the premier English rock groups. Burdon was one of the best white R&B singers of the 1960s, and, along with Alan Price's organ playing, gave the Animals their identity. The Animals' signature song, "House of the Rising Sun," was a #1 hit in both England and the USA in 1964. They followed up with Brill Building songs including "We Gotta Get Out of This Place" (1965), "Don't Let Me Be Misunderstood" (1965) and "Inside Looking Out" (1966). The band's strong rock singles and R&B albums secured their impact on America and also an induction to the Rock and Roll Hall of Fame in 1994. From 1967 the Animals went through several personnel changes before disbanding in 1969. Chas Chandler became an entrepreneur and managed Jimi Hendrix in the late 1960s, and Burdon went on to front the first incarnation of the band War.

Recommended Listening

- House of the Rising Sun
- We Gotta Get Out of This Place

Peter and Gordon

Peter and Gordon's hit songs were given to them as gifts from Paul McCartney

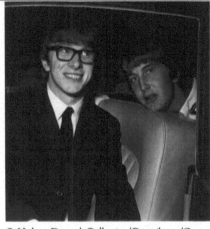

© Hulton-Deutsch Collection/Contributor/Getty Images

Peter and Gordon

Members
- Peter Asher, CBE (born June 22, 1944)
- Gordon Waller (June 4, 1945–July 27, 2009)

Peter and Gordon had a relatively short career as a duo, but a significant one in the British invasion. They hit the ground running in 1964 with "World Without Love," a #1 hit in the UK and the USA. Their quick rise to the top is partially attributed to Peter Asher's sister (the actress Jane Asher) who was dating Paul McCartney. McCartney passed several of his songs to the pair, often written under a pseudonym (Bernard Webb) to see how his songwriting held up on the charts without his name attached. Peter and Gordon split up in 1968 with Gordon's career tapering off and Peter going on to manage/produce James Taylor, Linda Ronstadt, Cher and Diana Ross. In 2015, Peter Asher was awarded a CBE for his contributions to the British music scene.

Recommended Listening

- A World Without Love (McCartney)
- True Love Ways (Buddy Holly)
- Woman (Bernard Webb)

Cilla Black

Influential British entertainment figure, Cilla Black

© Express Newspapers/Stringer/Getty Images

Cilla Black

Priscilla Maria Veronica White, OBE (May 27, 1943–August 1, 2015), was a young trendsetter regularly seen at the Cavern Club where she worked in the cloakroom. The friends she made at the Cavern Club became some of the world's biggest rock stars, and as a singer, she was along for the ride. She acquired her stage name when the local music paper *Mersey Beat* mistakenly referred to her as Cilla Black (instead of "White"). In mid 1963, her friend John Lennon persuaded Brian Epstein to sign her. George Martin then took her in and secured songs and recording time for her; Cilla signed and remained with EMI from 1963 to 1978. John Lennon and Paul McCartney gave her first charting single to her in 1964, called "Love of the Loved." In early 1964, she had her first #1 hit with "Anyone Who Had a Heart," by Burt Bacharach (the biggest selling single for a British female recording artist), and then a version of "Il Mio Mondo," which translates to "You're My World," also hit #1.

In August 1967, only days before his death, Brian Epstein secured Cilla a television deal where she became a celebrity and worked steadily until 2004. In England, Cilla had twenty consecutive Top Forty hits on the singles and EP charts and released fifteen studio albums and thirty-seven singles. In 1993, she was awarded an OBE, and for many years she was the highest-paid female entertainer on British television. In 2001, she demonstrated her clout with an ultimatum: "Move the Premiership football program or I quit." Management conceded, and, in a unique moment in television history, they had to move the popular sports programming to accommodate a regular family show (*Blind Date!*).

Recommended Listening

- Anyone Who Had a Heart
- You're My World

Herman's Hermits

Members

- Peter Noone (born November 5, 1947)—lead vocals
- Keith Hopwood (born October 26, 1946)—guitar, vocals
- Karl Green (born July 31, 1947)—bass, vocals
- Derek Leckenby (May 14, 1943–June 4, 1994)—lead guitar
- Barry "Bean" Whitwam (born July 21, 1946)—drums

Herman's Hermits formed in Manchester in 1963 and achieved success through their work with producer Mickie Most. Lead singer Peter Noone was a former child star (from the TV show *Coronation Street*) and teenage heart throb. Herman's Hermits became known for their clean-cut image and sound, which made them easy to listen to and more accessible than many other British invasion bands. Part of the reason for their clean sound was the use of studio musicians, including future members of Led Zeppelin Jimmy Page and John Paul Jones, to strengthen the quality of their albums. Their first #1 hit (in the UK) was in 1964 with "I'm Into Something Good," followed up by "Mrs. Brown, You've Got a Lovely Daughter" and "I'm Henry VIII, I Am" that both went to #1 in the USA in 1965. All in all, Herman's Hermits had eleven top ten hits from 1964 through 1967. "Mrs. Brown, You've Got a Lovely Daughter" was nominated for a Grammy award and sold over forty million copies.

Herman's Hermits

Herman's Hermits led by child star Peter Noone

© Mirrorpix/Contributor/Getty Images

Recommended Listening

- I'm Into Something Good
- I'm Henry VIII, I Am
- Mrs. Brown, You've Got a Lovely Daughter

Manfred Mann

Members
- Manfred Lubowitz (born October 21, 1940)—keys, guitar, vocals
- Mike Hugg (born August 11, 1942)—drums
- Mike Vickers (born April 18, 1941)—lead guitar
- Dave Richmond (born 1940)—bass
- Paul Jones (born February 24, 1942)—lead vocalist (1962–1966)
- Mike d'Abo (born March 1, 1944)—lead vocalist: (1966–1969)

Manfred Lubowitz (Manfred Mann) and drummer Mike Hugg formed the Manfred Mann band in 1962. They originally called themselves Mann-Hugg Blues Brothers before settling on Manfred Mann. Later, when the group split, they became the Manfreds and Manfred Mann's Earth Band. They had their first charting single with "5-4-3-2-1" in 1963 with a swinging London jazz feel that gave them a unique old school, but hip, character. Paul Jones sang briefly in the band Blues Incorporated with the future Rolling Stone Mick Jagger, and bass player Jack Bruce worked briefly with Manfred Mann in 1966 and played on the #1 hit "Pretty Flamingo" before leaving to form Cream. From 1963 to 1969, Manfred Mann became known largely as a singles band (most of their albums failed to chart), which partially contributed to their demise by 1970. Mann went into writing TV and radio jingles and experimental jazz-rock after the band's break-up.

Manfred Mann

Blues, jazz
influenced
rockers,
Manfred Mann

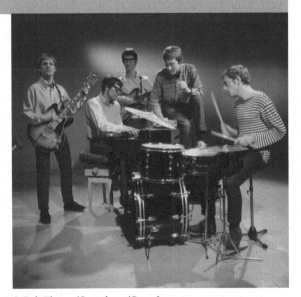

© Bob Thomas/Contributor/Getty Images

Recommended Listening

- Do Wah Diddy Diddy
- Pretty Flamingo
- Mighty Quinn

The Troggs

Members
- Reg Presley (June 12, 1941–February 4, 2013)—vocals
- Chris Britton (born January 21, 1944)—lead guitar
- Pete Staples (born May 3, 1944)—bass
- Ronnie Bond (May 4, 1940–November 13, 1992)—drums

The Troggs hit the U.S. scene a little later than most of the British invasion bands, but they enjoyed a stint of popularity after the success of their #1 charting hit "Wild Thing" in 1966. Although they had a number of hits in the UK and the USA, most of their popularity stemmed from Europe. The Troggs' sound is generally heavy, and some relate their style to early punk music. The Ramones credit the Troggs as an influence when they were developing their own sound.

Recommended Listening

- Wild Thing
- Love Is All Around

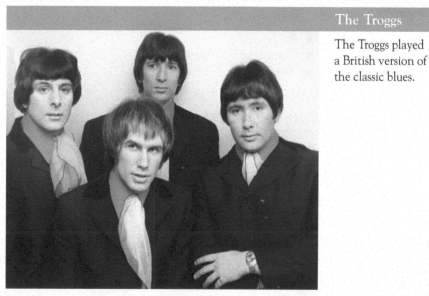

The Troggs

The Troggs played a British version of the classic blues.

© *Mirrorpix/Contributor/Getty Images*

Marianne Faithful

Marianne Faithfull was a British heart throb, pop singer and girlfriend of Mick Jagger

© Hulton-Deutsch Collection/Contributor/Getty Images

Marianne Faithfull

Marianne Faithfull (born December 29, 1946) started her career as a folk singer before being signed by Andrew Loog Oldham in 1964. Barely seventeen, she quickly became a teenage heart throb with her first hit song, "As Tears Go By," which was the first song that Mick Jagger and Keith Richards wrote together. Several other hits followed with "This Little Bird," Summer Nights" and "Come and Stay With Me." Faithfull began a relationship with Mick Jagger, which lasted until 1970, co-writing the song "Sister Morphine" with him; she actually recorded the song prior to its release on the Stones *Sticky Fingers* album. The song "Carrie Anne" by The Hollies was written about her, and, even though they were too embarrassed to use her real name, they came awfully close! By 1968, Faithfull had become completely addicted to cocaine and heroin, bringing her singing career to a halt until the mid 1970s. The Rolling Stones were influenced by and made reference to Faithfull in songs such as "Sympathy for the Devil" and "Wild Horses." Faithfull appeared in several films and made a comeback to singing in the mid-1970s. She has performed with artists Beck, David Bowie, The Chieftains, Emmylou Harris, Sly and Robbie, Tom Waits, Roger Waters and Steve Winwood. In 1998 she hit the charts again with "The Memory Remains" (with Metallica), and to this day continues to perform and act.

Recommended Listening

- As Tears Go By
- Come and Stay With Me
- The Memory Remains

Gerry and The Pacemakers

Members
- Gerry Marsden (September 24, 1942–January 3, 2021)—vocals and guitar
- Freddie Marsden (October 23, 1940–December 9, 2006)—drums
- Les Chadwick (May 11 1943–December 26 2019)—bass
- Les Maguire (born December 27, 1941)—keyboards

Gerry and The Pacemakers formed in 1959 (originally called the Mars Bars) in Liverpool and became popular in England around the same time as the Beatles. They were the second

band signed and managed by Brian Epstein. They hit the UK charts in 1963 with three #1 hit songs in a row: "How Do You Do It?" "I Like It" and "You'll Never Walk Alone." The Pacemakers spent time in Hamburg with the Beatles and followed their success in the USA with two hit singles: "Don't Let the Sun Catch You Crying" and "Ferry Cross the Mersey." After the release of their film *Ferry Cross the Mersey* in 1965, the popularity of the Pacemakers began to decline. Their innocent sound and adherence to the "beat music" style kept them from evolving with newer writing trends, and they disbanded in late 1966.

Gerry and The Pacemakers

Gerry and The Pacemakers stuck close to the beat music style

© Bettmann/Contributor/Getty Images

Recommended Listening

- You'll Never Walk Alone
- Don't Let the Sun Catch You Crying
- Ferry Cross the Mersey

The Hollies

Members
- Allan Clarke (born April 5, 1942)—lead singer
- Graham Nash, OBE (born February 2, 1942)—guitar
- Tony Hicks (born December 16, 1945)—guitar
- Eric Haydock (February 3 1943—January 5 2019)—bass
- Bobby Elliott (born December 8, 1941)—drums

Allan Clarke and Graham Nash, two Manchester school friends who had the same interests in rock and roll, formed the Hollies in 1962. They performed together before 1962 as a vocal duo calling themselves the Guytones and the Two Teens in an effort to recreate the sound of their idols, the Everly Brothers. When they teamed up with their new band mates in 1962, they called the band The Hollies as a tribute to another one of their influences, Buddy Holly. Their first big hit came in 1963 in the UK with "Just One Look" reaching #2, followed by "I'm Alive," which went to #1. The Hollies consistently made their way into both the UK and U.S. charts from 1964 to 1974, and, despite never reaching the #1 spot in the USA (their highest charting song was "The Air That I Breathe" at #2 in 1974), their records sold extremely well. In the late 1960s they experimented

The Hollies

The Hollies were one of the longest lasting British Invasion bands

© K & K Ulf Kruger OHG/Contributor/Getty Images

with folk-rock and psychedelic music, but they maintained their "classic" British pop sound. In 1968, Graham Nash left the band to form a new group with Stephen Stills and David Crosby called Crosby, Stills and Nash. In 2007, the Hollies were entered into the Vocal Group Hall of Fame, and in 2010, the Rock 'n' Roll Hall of Fame.

Recommended Listening

- Just One Look
- I'm Alive
- Carrie Anne
- The Air That I Breathe

The Kinks

Members
- Ray Davies, CBE (born June 21, 1944)—vocals/guitar/piano
- Dave Davies (born February 3, 1947)—guitar/vocals
- Pete Quaife (December 31, 1943–June 23, 2012)—bass/vocals
- Mick Avory (born February 15, 1944)—drums

The Kinks formed in 1962 and worked as The Ramrods and The Ravens before getting signed in early 1964. The band experienced several changes in lineup and featured Rod Stewart as their lead singer during 1962. In 1964 they hit the Top Ten in the USA and #1 in the UK with their single "You Really Got Me." People generally consider this song one of the first hard rock songs and a steppingstone to heavy metal. This is one of the earliest recordings using power chords (chords built in parallel fifths and octaves) on the electric guitars. The Kinks had limited success in the United States due to a four-year ban on touring following a series of brawls and destructive behavior in Europe. In one instance, drummer Mick Avory hit Dave Davies in the head with his hi-hat stand during a concert! Despite the touring ban, The Kinks charted fairly successfully in the U.S., and their rock and roll career remained strong until 1986. In 1990 they were inducted into the Rock and Roll Hall of Fame and in 2005 into the UK Music Hall of Fame.

The Kinks

The Kinks were one of the heaviest sounding British Invasion bands

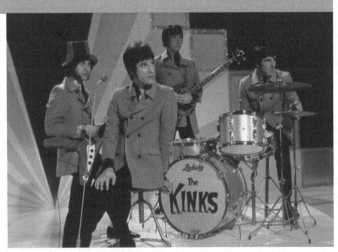

© Hulton Archive/Staff/Getty Images

Recommended Listening

- You Really Got Me
- All Day and All of the Night
- Tired of Waiting for You
- Sunny Afternoon

The Searchers

Members
- John McNally (born August 30, 1941)—rhythm guitar
- Mike Pender (born March 3, 1941)—lead guitar
- Tony Jackson (July 16, 1938–August 18, 2003)—bass
- Chris Curtis (August 26, 1941–February 28, 2005)—drums

The Searchers are another Liverpool "Mersey beat" style band that formed as a skiffle group in 1959, made the transition to beat music in Hamburg and then achieved popular success in the United States. Their name comes from the influence of American country music and the 1956 John Wayne movie *The Searchers*. The Searchers' first U.S. hit came in March 1964 with "Needles and Pins," followed by "Don't Throw Your Love Away" and "Love Potion No. 9." Following the initial heyday of the British invasion, the group experienced several changes in lineup. Chris Curtis left the group to become a founding member of Deep Purple, although he left that group before they were signed. The Searchers continued their successful recording and touring career for several more years.

The Searchers

The Searchers are an excellent example of the transition from skiffle to rock

© Keystone/Stringer/Getty Images

Recommended Listening

- Sweets for My Sweet (UK #1, 1963)
- Needles and Pins
- Don't Throw Your Love Away
- Love Potion No. 9

Spencer Davis Group

Members

- Spencer Davis (July 17, 1939–October 19, 2020)—multi-instrumentalist
- Steve Winwood (born May 12, 1948)—vocals, multi-instrumentalist
- Muff Winwood (born June 15, 1943)—bass guitar
- Pete York (born August 15, 1942)—drums

The Spencer Davis Group

Spencer Davis has maintained the classic British blues sound

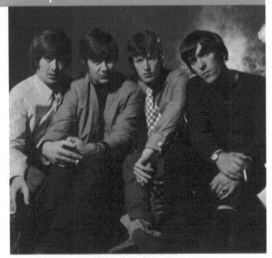

© Michael Ochs/Stringer/Getty Images

Spencer Davis formed his band with the Winwood brothers in London in 1963 playing covers of popular blues songs. At the end of 1965, the group hit #1 on the UK charts with "Keep On Running," and again with two hits in 1966, "Somebody Help Me" and "When I Come Home." At the beginning of 1967, the band had success in the USA with "Gimme Some Lovin'" and "I'm a Man" before Steve Winwood and his brother Muff left to form the band Traffic. The Spencer Davis Group toured with the Rolling Stones and The Who and spent a great deal of time with the Beatles. Pete York spent time playing in Eric Clapton's band Powerhouse with Steve Winwood in late 1967, and Muff Winwood went on to produce Dire Straights' first album in 1978. Spencer Davis has continued to perform with various sidemen and has maintained an active music career. Davis' blues heavy 2008 album, *So Far*, documents the story of his life from the early 1960s to 2008.

Recommended Listening

- Gimme Some Lovin'
- I'm a Man

The Zombies

Members

- Colin Blunstone (born June 24, 1945)—vocals
- Rod Argent (born June 14, 1945)—keyboards, vocals
- Paul Atkinson (March 19, 1946–April 1, 2004)—guitar, vocals
- Chris White (born March 7, 1943)—bass
- Hugh Grundy (born March 6, 1945)—drums

The Zombies formed in 1961 and began playing local venues in their hometown of St. Albans (just north of London). They won a *London Times* band competition and were

consequently signed by the Decca label. The band started with three big hits in the United States with "She's Not There," "Tell Her No" and "Time of the Season," but then drifted into obscurity and broke up by 1968. Music critics hailed The Zombies for their musicality, complex writing and performing style, vocal harmony and obvious jazz influences. *Rolling Stone Magazine* listed their 1967 album *Odessey and Oracle*, among the "500 Greatest Albums of All Time." Upon leaving the band, Paul Atkinson became an A&R executive and discovered ABBA, Bruce Hornsby, Mr. Mister and Judas Priest.

The Zombies

The Zombies were acclaimed for their musicality and complex writing style

© *Stanley Bielecki/ASP/Contributor/Getty Images*

Recommended Listening

- She's Not There
- Time of the Season

Jethro Tull

Members
- Ian Anderson MBE (born August 10, 1947)—lead vocals, flute
- Mick Abrahams (born April 7, 1943)—guitar, vocals
- Glenn Cornick (April 24, 1947–August 28, 2014)—bass
- Clive Bunker (born December 12, 1946)—drums, percussion
- Martin Barre (born November 17, 1946)—guitar from 1969

Ian Anderson and Glenn Cornick formed the blues-based Jethro Tull in 1967. Although they came late in the British invasion, their contribution to psychedelic music and their interpretation of American blues secured a quick rise to fame. Like many other bands, Jethro Tull worked under several other names before adopting their current name, which came from the name of an eighteenth-century farmer and inventor of the seed plow. The Rolling Stones' *Rock and Roll Circus* featured Jethro Tull in 1968, with Tony Iommi playing on the song "A Song For Jeffrey" (Iommi was only with the band for a few months before returning to Earth/Black Sabbath). Jethro Tull's real success came in the early 1970s with four top ten albums in the U.S. charts: *Aqualung*, *Thick as a Brick*, *A Passion Play* and *War Child*. The band's overall sound and style was very experimental, embracing folk music, psychedelic, rock, jazz and extended improvisation.

Jethro Tull

Ian Anderson of Jethro Tull named the band after the inventor of the seed plow.

© *Stan Frgacic/Contributor/Getty Images*

Recommended Listening

- Serenade to a Squirrel
- Locomotive Breath
- Thick as a Brick

Billy J. Kramer and the Dakotas

Billy J. Kramer and the Dakotas enjoyed great success with Lennon/McCartney songs that the Beatles rejected

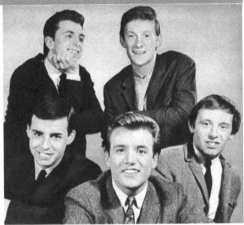

© GAB Archives/Getty Images

Billy J. Kramer and the Dakotas

Billy J. Kramer (born William Howard Ashton, August 19, 1943 in Liverpool) took his stage name randomly from a phonebook before teaming up with backing band The Dakotas in 1963. After being discovered by Brian Epstein and signed to work with George Martin, Kramer had a hit with the Beatles' "Do You Want to Know a Secret?" that went to #2 on the UK charts. He followed this hit with a series of Lennon/McCartney penned songs that the Beatles rejected, including "I'll Be On My Way," "I'll Keep You Satisfied," "From a Window," "I Call Your Name" and "Bad to Me." The success of these songs in both the UK and USA inspired him to work with American songwriter Mort Schuman who wrote Kramer's biggest international hit, "Little Children." Billy J. Kramer and the Dakotas disbanded in the mid 1960s when the Mersey beat sound lost popularity. They re-united in 1980 and have performed sporadically over the past three decades.

Recommended Listening

- Bad to Me
- Little Children

Small Faces

Members
- Steve Marriott (January 30, 1947–April 20, 1991)—guitar
- Ronnie Lane (April 1, 1946–June 4, 1997)—vocals, bass
- Kenney Jones (born September 16, 1948)—drums
- Ian McLagan (May 12, 1945–December 3, 2014)—keyboards

The Small Faces formed in 1965 as a "mod" group and are famous for their hit songs "Itchycoo Park," "Lazy Sunday" and "All or Nothing." Although their career together was

short lived (they broke up in 1969), the Small Faces transitioned from #1 selling records in the mod style to notoriety in the psychedelic scene. They were managed by Andrew Loog Olham and worked closely with one of the industry's top engineers, Glyn Johns. Many see them as one of the most successful of all the British invasion bands. In 1979, Kenney Jones became the drummer for The Who (after Keith Moon's death in 1978) and in 1996, they were awarded the Ivor Novello Outstanding Contribution to British Music Lifetime Achievement award.

Recommended Listening

- All or Nothing
- Itchycoo Park
- Lazy Sunday

The Faces

Members
- Rod Stewart (born January 10, 1945)—vocals
- Ronnie Wood (born June 1, 1947)—guitar
- Ronnie Lane (April 1, 1946 – June 4, 1997)—vocals, bass
- Kenney Jones (born September 16, 1948)—drums
- Ian McLagan (May 12, 1945–December 3, 2014)—keyboards

The Faces were a blues-based band with many influences from soul, jazz and Celtic music. One can hear their influence in bands ranging from the Sex Pistols to Pearl Jam, Aerosmith, the Charlatans, the Replacements, Oasis and the Black Crowes. The Faces formed in 1969 as a re-augmentation of the Small Faces after Steve Marriott left to form Humble Pie with Peter Frampton. Ronnie Wood and Rod Stewart, who had both played in the Jeff Beck Group, joined Ronnie Lane, Ian McLagan and Kenney Jones to create a "good time" rock and roll band to play the jumping club and concert scene in the UK. They enjoyed moderate chart success with their albums *First Step* (1970), *Long Player* (1971), *A Nod Is as Good as a Wink . . . to a Blind Horse* (1971) and *Ooh La La* (1973), which went to #1 on the UK charts. The Faces were one of the most successful touring bands of the early 1970s, particularly in the USA, before going their separate ways in 1975. Each member of The Faces has continued his career in exceptionally successful musical projects and groups.

In 1974, Ronnie Wood released his first solo album, *I've Got My Own Album To Do,* with the help of Keith Richards, Mick Jagger, Willie Weeks, Ian McLagan, Andy Newmark and other well known rock musicians. He then went on to join the Rolling Stones for their 1974 tour while still a member of the Faces, and he

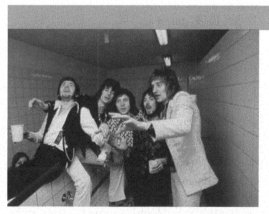

The Faces

The Faces were an all-star line-up of future British rock legends

© *Michael Putland/Contributor/Getty Images*

has remained a permanent member of the Stones ever since. As a member of the Rolling Stones, Ronnie Wood has released several critically acclaimed albums including *Now Look, Gimme Some Neck, Slide On This* and *Not For Beginners*. Ronnie Wood also fronted the legendary "outlaw" band the New Barbarian with Keith Richards, Ian McLagan, Bobby Keys, Stanley Clarke and Zigaboo Modelist for a 1979 tour. Ronnie Wood's playing and influence also were of great importance to Rod Stewart's early solo records, adding an organic and earthy musical quality Stewart never achieved after The Faces split in 1975. Rod Stewart has enjoyed a remarkably successful career as a solo artist. Stewart began recording his solo albums while still fronting The Faces. He had chart-topping albums with *Every Picture Tells a Story* (1971), *Never a Dull Moment* (1972), *Sing It Again Rod* (1973) and *Smiler* (1974) with #1 singles "Maggie May" and "You Wear It Well," while simultaneously reaching #2 with the Faces' "Cindy Incidentally." Ronnie Lane formed the band Slim Chance and also worked on a solo album with Pete Townshend. Kenney Jones joined The Who after Keith Moon died, and The Who asked Ian McLagan to join them in 1981, but he was busy working with the Rolling Stones on their *Tattoo You* album and tour.

Recommended Listening: Five most popular songs

- Flying
- Stay with Me
- Ooh La La
- Cindy Incidentally
- Pool Hall Richard

The Jeff Beck Group—Beck, Bogert and Appice

Members
- Jeff Beck (born June 24, 1944)—guitar
- Rod Stewart (born January 10, 1945)—vocals
- Ronnie Wood (born June 1, 1947)—bass
- Aynsley Dunbar (born January 10, 1946)—drums
- Nicky Hopkins (February 24, 1944–September 6, 1994)—keyboards

And, as a power trio:
- Jeff Beck, guitar
- Tim Bogert, bass (August 27, 1944–January 13, 2021)
- Carmine Appice, drums (born December 15, 1946)

The Jeff Beck Group was an influential rock band formed in 1967 that had a big influence on other progressive blues-based groups including Led Zeppelin and the Jimi Hendrix Experience. At this time, their level of musicianship was unsurpassed in the rock world. The original members of the band consisted of Rod Stewart on vocals, Jeff Beck on guitar, Ronnie Wood on bass and Aynsley Dunbar on drums. (Micky Waller eventually replaced Dunbar). In 1968, manager Peter Grant arranged a U.S. tour for the group, which received critical acclaim. The group acquired a record deal with Epic records and recorded the album *Truth*, considered one the most influential and progressive blues/rock albums. In late 1968, keyboardist Nick Hopkins joined the group prior to the recording of *Beck-Ola*, which was

released in 1969. On the eve of Woodstock in 1969, Stewart and Wood left the Jeff Beck group and joined the Small Faces, who ultimately reformed as The Faces. In 1972, Jeff Beck then transformed his group into the "power trio" Beck, Bogert and Appice with Tim Bogart and Carmine Appice from Vanilla Fudge. In 1975, Beck released *Blow By Blow*, an instrumental jazz/rock album that reached #4 on the album charts and was a big influence on the jazz/rock movement. Jeff Beck has continued to release successful albums and push the envelope as one of the world's most innovative and experimental guitarists. Although many consider Jeff Beck one of the finest virtuosic guitarists of the twentieth century, his

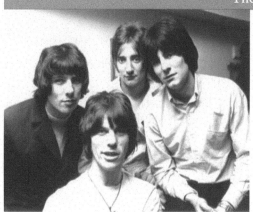

The Jeff Beck Group

Jeff Beck is one of the most innovative guitarists in rock and roll

© WireImage/Getty Images

inconsistent songwriting and inability to keep a band together (quitting the Yardbirds at their peak and letting Rod Stewart slip through his fingers in 1969) may have prevented him from achieving a level of popularity resembling that of Eric Clapton and Jimi Hendrix. Jeff Beck continues to be one of the most innovative and sought after guitarists in contemporary rock music.

Guitar Spotlight

Many people consider Jeff Beck rock's greatest living guitarist. Beck's style is unlike anyone else's. Cliff Gallup (guitarist for Gene Vincent) was an early influence on Beck, as were other rockabilly and blues players. Beck is also influenced by jazz guitarists Django Reinhardt and Les Paul. While playing with the Yardbirds, Beck began experimenting with feedback, which influenced Jimi Hendrix to experiment in similar ways. At times, Beck also emulated the phrasing of a sitar (ala Ravi Shankar) on guitar. The most unique things about Jeff Beck's playing are his note choices and his extremely musical and rhythmic quirky phrasing.

During Beck's solo career he played with keyboardist Jan Hammer. Hammer's use of the pitch wheel on the synthesizer seems to have influenced Beck in the mid 1970s. This is when Beck began bending notes microtonally. Beck began playing exclusively with a finger style (without a pick) in the early 1980s. Playing without a pick opened Beck's playing up to a higher level. While he plays, Beck keeps his little finger on the volume knob, simultaneously keeping the tremolo bar in his palm, and finger picking. With this technique Beck's control over his guitar sound is incredible. Even when plugged directly into an amplifier, without any effects Beck is able to produce sounds almost impossible to recreate. Jeff Beck is one of rock's few guitarists that continue to grow as a musician, and today he plays better than at any time previously in his career. Besides influencing many rock players, including Jimi Hendrix, Jeff Beck also influenced jazz/rock greats Scott Henderson and Michael Landau.

Trivia

- Many critics feel Rod Stewart's best work was with the Jeff Beck group.

- The great jazz bassist Stanley Clarke credits Ronnie Wood as one of his main influences on electric bass.

- Jeff Beck was the first guitarist to use feedback as part of his vocabulary, which influenced Jimi Hendrix to do the same.

- Beck is unique in his use of micro-tonal bends influenced by Indian music.

- The rumor is that the character Nigel Tufnel from the film *This Is Spinal Tap* is based on Jeff Beck.

Recommended Listening

- Shapes O Things
- Beck's Bolero
- I Ain't Superstitious
- You Shook Me
- Spanish Boots

The Yardbirds

Eric Clapton, Jeff Beck and Jimmy Page all cut their teeth in the Yardbirds

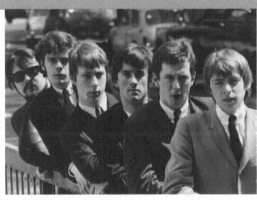

© *Evening Standard/Stringer/Getty Images*

Additional lead guitarists:
- Eric Clapton: 1963–65
- Jeff Beck: 1965–66
- Jimmy Page: 1966–68

The Yardbirds

Members
- Anthony "Top" Topham (born July 3, 1947)—lead guitar
- Keith Relf (March 22, 1943–May 14, 1976)—lead vocals, harmonica
- Chris Dreja (born November 11, 1945)—rhythm guitar
- Paul Samwell-Smith (born May 8, 1943)—bass
- Jim McCarty (born July 25, 1943)—drums

From 1962 to 1968, the Yardbirds served as a crucial link between British R&B and the psychedelic music scene. The band produced three of England's greatest rock guitarists in Eric Clapton, Jeff Beck and Jimmy Page. They formed as the Metropolitan Blues Quartet in 1962, exploiting a blues-based sound that evolved into experimental pop rock. Much of their early repertoire consisted of blues covers by artists like Howlin' Wolf, Chuck Berry and Bo Diddley.

Their contributions to rock set the framework for rock 'n' roll guitar playing in general, not only in the UK, but in the United States and the rest of the world. They created an early form of hard rock out of the standard twelve-bar blues by doubling the tempos and playing at high volumes. This helped shape heavy metal when they became the New Yardbirds in 1968 (in 1969, they changed their name to Led Zeppelin). The Yardbirds brought distinct attention to the talent of lead guitarists and their important role as soloists within rock and roll. After leaving The Yardbirds, each lead guitarist went on to a very successful solo career with Clapton, Beck and Page becoming pioneers in the power trio (guitar, bass and drums) style. The Yardbirds were inducted into the Rock and Roll Hall of Fame in 1992.

Recommended Listening

- For Your Love
- Over, Under, Sideways, Down
- Heart Full of Soul
- Happenings Ten Years Time Ago
- Shapes of Things

Trivia

- Keith Relf, the Yardbird's original lead singer, was electrocuted and died playing bass in 1976 while recording at home.

- The band graduated three greats of rock guitar: Eric Clapton, Jeff Beck and Jimmy Page.

- More than any other group, they brought guitar pyrotechnics to rock and roll in the 1960s.

- Paul Samwell-Smith became a music industry producer (after some production experience with The Yardbirds), and Chris Dreja became a popular photographer.

Dusty Springfield

Mary Isobel Catherine Bernadette O'Brien, OBE (April 16, 1939 – March 2, 1999), used the stage name Dusty Springfield and sang in the folk trio the Lana Sisters and then the Springfields before she took her career solo in 1963. Her first solo hit came with "I Only Want To Be With You," which became popular in both the UK and the U.S. and featured a blend of soul and pop music. From 1963 to 1969, Springfield had seventeen songs hit the Top Ten in the UK, many of which also charted in the USA. Her biggest hit songs were "You Don't Have To Say You Love Me" in 1966 and "Son of a Preacher Man" in 1968. As one of the top artists on the Atlantic Records label in 1968, Springfield recommended that the company sign the newest

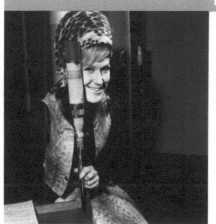

Dusty Springfield

One of the greatest women of British rock, Dusty Springfield

© Hulton-Deutsch Collection/Contributor/Getty Images

formation of the Yardbirds who had recently changed their name to Led Zeppelin. Movie soundtracks and TV shows have used many of Springfield's songs, including the 1967 *Casino Royale*, *Growing Pains*, *The Six Million Dollar Man*, *Ally McBeal*, *Hollyoaks* and *Pulp Fiction*. Dusty Springfield received her Order of the British Empire insignia just days before she died of cancer. She was posthumously inducted into the Rock and Roll Hall of Fame in 1999 and into the UK Music Hall of Fame in 2006.

Recommended Listening

- I Only Want To Be With You
- You Don't Have To Say You Love Me
- Son of a Preacher Man

Them

Them

Irish rockers, Them, featured the talents of Van Morrison

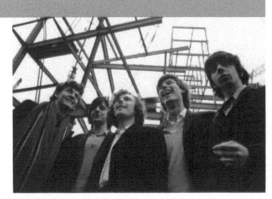

© *Tony Frank/Contributor/Getty Images*

The Northern Ireland band Them became part of the British invasion when the Decca label signed them and they moved to London in 1964. They are noted for their early garage rock style and blues influence mixed with music typical of the coming psychedelic era. Most importantly, Them gave birth to one of the greatest solo voices to come from across the Atlantic, George Ivan "Van" Morrison, OBE (born August 31, 1945). As a band, Them had a moderate hit with the song "Gloria" in 1965, which has since grown in popularity and become one of the most played classic rock songs. Them followed up with "Here Comes the Night," also in 1965, which brought Van Morrison's vocal potential to the attention of record executives; he left the group in mid 1966 and the band continued with reasonable success until 1971 when they disbanded.

Recommended Listening

- Gloria
- Here Comes the Night

The Beatles

John Winston (Ono) Lennon, MBE: October 9, 1940–December 8, 1980
 aka: the walrus
 Primary instrument: Rhythm guitar
 Other instruments: Harmonica, piano

Sir James Paul McCartney, MBE: born June 18, 1942
 aka: the walrus
 Primary instrument: Bass guitar
 Other instruments: Acoustic guitar, electric guitar, mandolin, piano, keyboards, drums

George Harrison, MBE: February 25, 1943–November 29, 2001
 aka: the quiet Beatle
 Primary instrument: Lead guitar
 Other instruments: Rhythm guitar, ukulele, sitar

Sir Ringo Starr (Richard Starkey), MBE: born July 7, 1940
 aka: Billy Shears
 Primary instrument: Drums
 Other instruments: Percussion

The Beatles, nicknamed the "Fab Four" in their early career, had more impact on rock music socially, historically and musically than any other group or performer. They achieved an unprecedented number of hit songs, expanded the boundaries of rock music compositionally, musically and sonically, and their ever-changing image has influenced international fashion trends. By 1985, The Beatles had sold more albums than any other artist or band in history with sales exceeding one billion units. And the excitement the Beatles generated throughout the world inspired youth pop culture for several generations. Their music later identified with the American counterculture (drugs, protest and social change) and had a profound effect on the society, which was going through a period of great social change in the mid-1960s. Following the breakup of the Beatles in 1970, all four members maintained very successful solo careers.

The Beatles in 1964

The Fab Four
performing on
stage in 1964

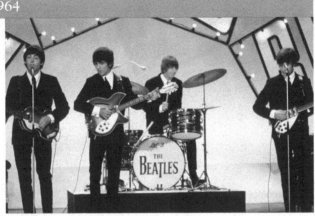

© Mirrorpix/Contributor/Getty Images

1957–1959

The band that would become known as the Beatles began as an amateur skiffle group in Liverpool, originally known as the Quarrymen. They were formed by John Lennon in 1957 featuring several different members and named after his high school, Quarry Bank High. John, Paul, George and Ringo all grew up in relatively poor working class families where the expectation (and success story) was to finish high school, get a job and get married. These boys had ambitions to venture well beyond working class Liverpool, although they never rejected their roots.

Paul McCartney joined the Quarrymen in July 1957, followed by George Harrison in March of 1958 and Stuart Sutcliffe (bass guitar) and Pete Best (drums) in 1960. Before settling on their new name, The Beatles, the band experimented with a variety of names, including Johnny and the Moondogs, Long John and the Beatles, the Silver Beetles, Long John Silver and the Beatles, Silver Beats, The Silver Beetles, the Silver Beatles and the Beat Brothers.

1960

In May 1960, the Beatles played a seven-day tour of Scotland, opening for Johnny Gentle. Several short tours followed during the next six months. In August, after recruiting Pete Best as drummer, they traveled to Hamburg, Germany, and played various venues in the red-light Reeperbahn district. George Harrison was deported in December for being underage, and McCartney and Best were (for apparently setting fire to their hotel room) arrested and also deported.

1961

In March, the Beatles played at the famous Cavern Club for the first time and then headed back to Hamburg for three more months. While in Hamburg, they recorded several songs with Tony Sheridan (credited using the name the Beat Brothers), from which they released the song "My Bonnie." After a great many requests from customers for the "My Bonnie" single, Brian Epstein went to see the Beatles perform at the Cavern and offered to become their manager. At that time, Brian Epstein ran a small record store in the back of his parent's furniture store. In December, Epstein began to negotiate for a record contract for the Beatles. Sutcliffe left the band before the end of the year and Paul McCartney, who was playing guitar and piano, switched to bass. Several record companies showed interest in the Beatles at this time, but none were prepared to risk the predicted "passing fad" of the Mersey Beat.

Brian Epstein (September 19, 1934–August 27, 1967)

Brian Epstein was the man who masterfully managed the Beatles and guided them to mega-stardom, making them the most successful musical artists of all time. Brian improved the Beatles' stage appearance, maintained the continuity of the group and ingeniously laid out their path to international stardom. His quality control with the media kept the group in public favor even in times of trouble.

Recommended Listening

- My Bonnie—Tony Sheridan (May 21, 1940–February 16, 2013) and the Beat Brothers

1962

In January, the Beatles recorded a variety of songs for the Decca label, but the company was unimpressed. Sadly, on April 10, Stu Sutcliffe died of a brain hemorrhage a few months before his twenty-second birthday. The 1994 film *Backbeat* portrayed Sutcliffe's role with the Beatles. The Beatles returned to Hamburg in April, and upon their return to England in June, Brian Epstein had secured a recording contract with Parlophone, a subsidiary of EMI (Electric and Musical Industries Ltd). Their first agreement with EMI paid the Beatles one penny for each disc sold (they had to split that penny four ways!). Producer George Martin signed the band purely on the enthusiasm of Brian Epstein, but he suggested replacing Pete Best on the drums. In August, they convinced Ringo Starr to leave Rory Storm and the Hurricanes and join the Beatles (Ringo had occasionally played with the Beatles in Hamburg). In early September the Beatles had their first serious recording sessions at EMI Studios in London with George Martin as producer. In October, the single "Love Me Do" backed with "P.S. I Love You," was released in the UK; it reached #17 on the charts by the end of the year. The Beatles were the opening act for Little Richard for a number of concerts and also made their fourth trip to Hamburg, now as a headlining band.

Sir George Henry Martin, CBE (January 3, 1926–March 8, 2016) is one of the most successful and most influential record producers of all time. His musical expertise helped mold the Beatles' raw talent and the sound they wanted to achieve. Martin wrote most of the Beatles' orchestral arrangements, and performed many of the keyboard parts on the early records. He has produced many of the world's greatest performers as well as preparing the music for Cirque du Soleil's Beatles show, *Love*.

Recommended Listening

- Love Me Do

The Beatles—Early 1960s

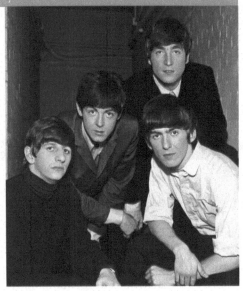

The Beatles posing for a press photo in the early 1960s

© Bettmann/Contributor/Getty Images

1963

The single "Please, Please Me" was released in January, 1963 and rose to #2 on the British charts. In March, the LP *Please, Please Me* was released and went straight to #1. The album ultimately spent thirty weeks in the #1 position on the charts (followed by twenty weeks at #2). In April, "From Me to You" became the Beatles' first #1 charting single followed by the EP "Twist and Shout." Their second LP, *With the Beatles*, was released in November (pre-sales exceeded three hundred thousand copies) and took over the #1 spot on the charts from "Please, Please Me." The single "She Loves You" sold over a million copies and sparked pre-sales of 950,000 for "I Want to Hold Your Hand." Britain officially declared "Beatlemania" as the Beatles escalated to superstardom. Their UK tour, recording schedule and short run-out tours to Europe filled nearly every day of 1963, along with numerous photo shoots, press interviews and merchandising. On the UK charts in December, the Beatles had singles in the #1 and #2 spots, EPs at #1, #2 and #3, and LPs at #1 and #2. The Beatles received an award for Top Vocal Group of the Year at the Variety Club Awards, and the *London Times* named Lennon and McCartney composers of the year. One of their defining traits was to begin many of their compositions with the chorus, which is usually the selling point of a song.

While playing the Royal variety concert, John Lennon made one of his often quoted comments to the audience, "Those of you in the cheaper seats can clap your hands. The rest of you, if you'll just rattle your jewelry."

Studio Albums

Please, Please Me (#1 for 30 weeks, UK release only)
With the Beatles (#1 for 21 weeks, UK release only)

Recommended Listening

- Please, Please Me
- From Me to You
- She Loves You
- I Want to Hold Your Hand

1964

Meet the Beatles was released in the USA, barely making the charts before the Beatles flew to New York on February 7 for their first of four U.S. tours. On February 9, the Beatles

appeared on the *Ed Sullivan Show* to an estimated national audience of seventy-three million people. At the conclusion of their nine-day tour, the Beatles were in the #1 spot on the U.S. charts. Their U.S. charting success continued from there, and at one point, they held all top five places with "Can't Buy Me Love" (#1), "Twist And Shout" (#2), "She Loves You" (#3), "I Want To Hold Your Hand" (#4) and "Please, Please Me" #5. *A Hard Day's Night* became a smash at the box office, raking in $5.8 million in the first six weeks. Later in the year, the Beatles toured Europe, Australia, New Zealand and the USA for the second time. Between the USA and the UK, the Beatles released five albums and eighteen singles in 1964. They had fourteen singles on the Billboard charts at the same time and received four Ivor Novello Awards (the UK equivalent of a Grammy). The Beatles also received two Grammy Awards in 1964 for Best New Artist and Best Performance by a Vocal Group.

Studio Albums

A Hard Day's Night (#1 for 21 weeks UK, #1 for 14 weeks USA)
Beatles for Sale (#1 for 11 weeks, UK release only)
Introducing . . . The Beatles (reached #2, U.S. release only)
Meet the Beatles! (#1 for 11 weeks, U.S. release only)

Recommended Listening

- Can't Buy Me Love
- A Hard Day's Night
- I Feel Fine

1965

This year was another busy year for the Beatles, who toured and recorded extensively. They shot and released their second film *Help!* (supported by both the single and the album of the same title), and their first single of the year, "Ticket to Ride," hit the UK charts at #1. While they were in the USA, the Beatles visited Elvis Presley and spent time with Bob Dylan, who became a big influence on their composing style. In June, Queen Elizabeth II announced that the Beatles would receive MBE awards (Member of the British Empire). This enraged several conservative recipients as bestowal of the title had primarily been given for military honors and civil leadership. Some even rescinded their title and returned the medals! John Lennon responded by saying, "Lots of people who complained about us receiving the MBE received theirs for heroism in the war—for killing people!" The Beatles had done just the opposite. The album *Help!* was released, and the Beatles made their third tour of the USA in August. On August 15, the Beatles played to the biggest concert audience (as of that date) in music history when they performed before 56,000 people at Shea Stadium in New York. *Rubber Soul* was released in December featuring George Harrison playing sitar on the song "Norwegian Wood." This album is where the Beatles began to shift stylistically away from their energetic beat music. Experimentation with marijuana and LSD also influenced their songwriting and studio concepts for their upcoming albums.

Studio Albums

Help! (#1 for 9 weeks UK, #1 for 9 weeks USA)
Rubber Soul (#1 for 8 weeks UK, #1 for 6 weeks USA)

Recommended Listening

- Ticket to Ride
- Help!
- We Can Work It Out
- Yesterday
- Eight Days a Week
- Norwegian Wood

1966

The Beatles began to find their new path forward in 1966 with the emergence of the American counterculture. They followed this style to create their next albums, *Revolver* and *Yesterday . . . and Today*. In March, John Lennon made his famous comment ". . . that Christianity was dying and that The Beatles were more popular than Jesus now." This incited mayhem across the "Bible Belt" states in the United States with people burning Beatle records, posters and merchandise. Paul McCartney joked about the situation saying, "They've got to buy them before they can burn them!" Lennon was later forced to apologize. The demands of touring brought the Beatles to the decision to retire from live performances and to concentrate solely on working in the studio. At the end of their fourth tour of the United States, the Beatles performed their last official concert in San Francisco on August 29. George Martin's expertise with production and arranging now became increasingly important and innovative as the Beatles broke new ground in studio recording capabilities. Work began on *Sgt. Pepper's Lonely Hearts Club Band* before the end of the year.

Studio Albums

Revolver (#1 for 7 weeks UK, #1 for 6 weeks USA)
Yesterday . . . and Today (#1 for 5 weeks, US release only)

Recommended Listening

- Paperback Writer
- Yellow Submarine
- Eleanor Rigby

1967

The Beatles spent four months working on the *Sgt. Pepper's Lonely Hearts Club Band* album. This was their masterpiece, bringing together all of their abilities, creativity and outside influences to send the art of recording into a new realm. Inspiration for the album came from the ingenious recording techniques used by Brian Wilson on the Beach Boys' *Pet Sounds* album. *Sgt. Pepper's* is a completely self-contained album from which no singles were released. It was also the first major release to include the lyrics within the album cover artwork. The cover itself is a piece of art that carries stories of the Beatles' past, present and

imagination (more details below in the "Paul is dead mystery"). In late August, the Beatles were in Wales on retreat with the Maharishi when they received the tragic news that Brian Epstein had died from a drug overdose (sleeping pills). Epstein had acted as the glue that held the Beatles together, keeping internal quarrels at bay and their focus on music. After his death, the direction of the group suffered from individual goals and demands surpassing those of the band as a whole. *The Magical Mystery Tour* album was released as a full album only in the United States, and the TV film *Magical Mystery Tour*

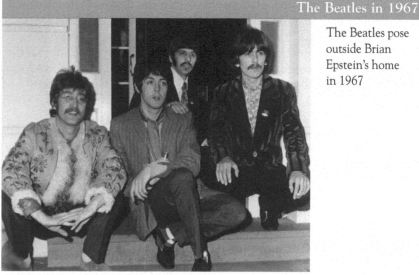

The Beatles in 1967

The Beatles pose outside Brian Epstein's home in 1967

© *Jan Olofsson/Contributor/Getty Images*

aired in the UK on December 26 (Boxing Day) to poor reviews. The film displayed too much of the social counterculture and required a color TV to appreciate the surreal artwork. Due to the mixed reception in the UK, ABC held back the U.S. broadcast, and it wasn't publicly available until 1976. The film is now considered a cult classic.

Studio Albums

Sgt. Pepper's Lonely Hearts Club Band (#1 for 27 weeks UK, #1 for 15 weeks USA)
Magical Mystery Tour (#1 for 8 weeks, US release only)
Magical Mystery Tour double EP (reached #2, UK release only), soundtrack to the film

Recommended Listening

- Sgt. Pepper's Lonely Hearts Club Band
- A Day in the Life
- Penny Lane
- Strawberry Fields Forever
- All You Need Is Love
- Hello, Goodbye
- Magical Mystery Tour
- I Am the Walrus

1968

The Beatles spent time in India with the Maharishi in the beginning of the year, and on their return they created Apple Corp in an effort to control their own business interests and management. Unfortunately, Apple Corp was a financial disaster that accelerated the

fraying relationships within the Beatles. The animated film *Yellow Submarine* came out in June and received far better reviews than *Magical Mystery Tour*. The Beatles' actual involvement with the film was minimal and voice actors played each of the Fab Four in the cartoon. Recording for *The Beatles*, more commonly known as the *White Album* due to its plain white cover with the only text being "the Beatles," was completed with a guest appearance on George Harrison's "While My Guitar Gently Weeps" by Eric Clapton.

Harrison had emerged in the late 1960s as a strong songwriter with hits including "Something," "Here Comes the Sun," "Savoy Truffle" and "I, Me, Mine" featured on the upcoming Beatles' albums. Upon release, the *White Album* sold two million copies in the first week and eventually went nineteen-times platinum in U.S. sales alone.

Studio Albums

The Beatles' The White Album (#1 for 8 weeks UK, #1 for 9 weeks USA)
Yellow Submarine (reached #3 UK, #2 USA)

Recommended Listening

- Lady Madonna
- Hey Jude
- Revolution

1969

More friction developed with the decision to hire a new manager. Paul McCartney wanted Lee Eastman, the father of his current girlfriend Linda Eastman, and the rest of the band wanted New York manager Allen Klein. They ultimately hired Klein who proved a bad choice when they discovered in 1971 that he had stolen over five million pounds from the Beatles. On January 30, 1969, the Beatles gave an impromptu performance on top of the Apple building for the making of the film *Let It Be*. They managed to perform five songs before the police shut them down for complaints about the noise. After completing the album and film for *Let It Be*, the Beatles stored them for later release. Originally, *Let It Be* was under the working title *Get Back* (a track from the album). As a refreshing aside to their recent massively produced albums, the Beatles had decided to record an album that would "get back" to the raw recordings they had made in the early 1960s. This seemed to work well until they reached an impasse over the final direction for the album. Internal quarreling and the constant presence of Yoko Ono didn't help and signified that the breakup of the Beatles was imminent. The Beatles, however, came together one last time to exit on a high note, uniting in the summer of 1969 to record their final album, *Abbey Road*.

Studio Albums

Abbey Road (#1 for 17 weeks UK, #1 for 11 weeks USA)

Recommended Listening

- Get Back
- Something
- Come Together
- The Ballad of John and Yoko

1970

John had told the band he was leaving in September of 1969, but kept it quiet from the press until after the release of both the album and the film *Let It Be*. Paul McCartney announced publicly that the Beatles had officially disbanded in April of 1970. Paul McCartney reached the final straw when Phil Spector was brought in to "tidy up the album" before its release. Spector made dramatic changes to some songs, but especially to Paul's song "The Long and Winding Road." In Paul's eyes, he had finished the song a year prior with a deliberately sparse and delicate accompaniment. When Spector took control of the song, he added a full orchestra, a choir, tape echo and various over dubbings to the track. According to Pete Brown (the balancing engineer), Spector was delusional, popping pills every thirty minutes and throwing tantrums to the point that part of the orchestra walked out and so did Brown. The song was released on the album (and also as a single) with Spector's changes, and more importantly, without McCartney's consent! In 2003, Paul McCartney helped with the release of "Let It Be . . . Naked," which stripped the album of Spector's production! The last song ever recorded by the Beatles as a group was George Harrison's "I, Me, Mine" for the *Let It Be* album, which was in January, 1970. "I, Me, Mine" is also significant because John Lennon did not perform on the song; he went on holiday instead. In the song's introduction, George makes reference to John having already quit the Beatles. Although the Beatles had broken up, their Apple Corp business partnership didn't officially dissolve until 1975.

Studio Albums

Let It Be (#1 for 3 weeks UK, #1 for 4 weeks USA)

Recommended Listening

- Let It Be
- The Long and Winding Road
- The Long and Winding Road—from Let It Be . . . Naked

Post Beatles

All four Beatles released solo albums in 1970 beginning with Ringo Starr's *Sentimental Journey* in March, followed by Paul McCartney's *McCartney* in April, George Harrison's *All Things Must Pass* in November and John Lennon's *Plastic Ono Band* in December.

In 1981, George Harrison released "All Those Years Ago," a song he had written about his time with The Beatles. He recorded it just before Lennon's death, with Ringo on drums. Then he overdubbed it with new lyrics that were a tribute to Lennon. Paul McCartney later added backing vocals to the track.

In 1994, the three surviving Beatles reunited again to overdub music for a few of John Lennon's home recordings. As a result, "Free as a Bird" was released as a single in late 1995, reaching #2 on the UK charts and #6 in the United States. The following year, "Free as a Bird" was nominated and won a Grammy Award for best pop song by a vocal duo or group.

Recommended Listening

- All Those Years Ago
- Free as a Bird

Awards

- 1965–Awarded MBEs by Queen Elizabeth II

- Nominated for two Academy Awards (both for A *Hard Day's Night*)

- 1970—Academy Award for film *Let It Be* as Best Original Score

- 1975—Inducted into the Grammy Hall of Fame

- 1987—Lennon and McCartney inducted into the Songwriters Hall of Fame

- 1988—Inducted into the Rock and Roll Hall of Fame

- 1999—Sir George Martin inducted into the Rock and Roll Hall of Fame

- The Beatles have earned twelve Grammy Awards.

- The Beatles have a record six diamond-selling albums (sales of ten million copies).

- The Beatles released more than forty different singles, albums and EPs that reached number one.

- The Beatles have the fastest selling CD of all time with *1*. It sold over thirteen million copies in four weeks.

- In 2004, *Rolling Stone Magazine* ranked The Beatles #1 on its list of 100 Greatest Artists of All Time and *Sgt. Pepper's* as the #1 Album of All Time (500 albums listed).

Trivia

- The Beatles played on *TV Star Search* in Liverpool in late 1959, but they lost to a woman who played the spoons.

- George Martin felt dissatisfied with Ringo Starr's drumming on "Love Me Do," and had session drummer Andy White play drums while Starr played tambourine.

- The Beatles played more than 270 times at the Cavern club during their career.

- Apparently, the *Sgt. Pepper's* album, which had eclipsed the studio parameters of *Pet Sounds*, was a big reason that Brian Wilson stopped working and went to bed for months.

- Ringo Starr walked out of Abbey Road studios having had enough of the infighting. In his absence, Paul McCartney recorded the drum tracks for the songs "Martha My Dear," "Wild Honey Pie," "Dear Prudence" and "Back in the USSR."

- Paul McCartney wrote "Hey Jude" for Julian Lennon, who was disturbed by his parents' divorce. The song was an attempt to cheer him up.

- "Dear Prudence" is about Mia Farrow's sister, Prudence, when she wouldn't come out and play with Mia and the Beatles at a religious retreat in India.

- Vee Jay records originally had the distribution rights to the Beatles in the USA, but they lost the contract for non-payment of royalties in late 1963.

- "We don't like their sound, and guitar music is on the way out." Decca Recording executive rejecting the Beatles, 1962.

Paul is Dead!

Paul McCartney Killed in a Car Accident—5:00 A.M. November 9th, 1966

In 1969, just after the release of the *Abbey Road* album, a rumor began to circulate that a car accident had killed Paul McCartney in late 1966 and that an impersonator had taken his place in the Beatles. The famous walk across Abbey Road and other hints on the album cover had Beatle fans digging deep for clues to solve the mystery. An American DJ, Russ Gibb, posed the question to his listeners: "Is Paul dead?"

The Story

After a late night session at the Abbey Road studios when tempers had worn thin, Paul McCartney stormed out and took off in his Aston Martin. At 5 A.M. he picked up a hitchhiker. When she realized whose car she was in, she threw her arms around Paul, causing him to lose control of the car and crash. The result was a horrific accident that not only killed Paul but decapitated him as well. With record sales booming, the Beatles management decided that hiding the accident from the public and finding a replacement was the answer. Paul's "double" was a man named William Campbell, introduced as Billy Shears, who won a Paul McCartney look-a-like contest (and obviously a singing and songwriting-a-like contest!). Could this also be the real reason why the Beatles had stopped touring?

The remaining Beatles filled their songs, album covers and promotional photos with clues for their fans about the death of McCartney. *Abbey Road* was the current album when fans discovered the mystery, and it carried the most obvious clues, which then led to the exploration of previous albums and more detailed, but subtle information surrounding the mystery. The three main albums that documented the "Paul is dead" mystery were *Sgt. Pepper's Lonely Hearts Club Band*, *Magical Mystery Tour* and *Abbey Road*. Clues in albums beyond and before these tended to become a little too far-fetched and obsessive!

Remember, at this point in time, the Beatles couldn't go anywhere without getting mobbed. They holed up in the studio recording day in and day out, experimenting with LSD and other drugs and trying to write inspiring new material. So what better way to get creative than to invent a mystery that would spark excitement in their work and span the remaining albums of their career? Here are some of the clues to explore:

The Clues: Sgt. Pepper's Lonely Hearts Club Band

- The cover of Sgt. Pepper is a depiction of Paul's burial and funeral gathering.
- A hand is over Paul's head, as though a priest is blessing him.
- The wax images of the younger Beatles look mournfully on the gravesite because the Beatles were no longer the same band.
- The Beatles are all holding gold band instruments, except for Paul; his is black.
- On the gravesite is a bass guitar (Paul's instrument). The strings of the instrument are made of sticks, but one of the four strings is missing.
- The yellow hyacinths spell "PAUL" (you need to be a little imaginative here!)
- If you hold a mirror across the middle of the words "LONELY HEARTS" written across the bass drum, you will see "I ONE IX HE ◇ DIE." This image suggests the date (11-9, or November 9, 1966), the day that Paul allegedly died.
- The diamond between the words "HE" and "DIE" points directly at Paul.
- Credit for the bass drum design goes to a Joe Ephgrave (an amalgam of epitaph and grave).
- A model of an Aston-Martin, the type of car that Paul was supposedly driving at the time of his fatal accident, sits on the Shirley Temple doll's leg.
- The Shirley Temple doll wears a sweater that reads "welcome the Rolling Stones," who would be the biggest rock band in the world if there were no Beatles.
- The grandmother figure, where the doll sits, is wearing a blood-stained driving glove.
- On the inside photo, Paul is wearing a patch with the letters "OPD," which can be interpreted as "Officially Pronounced Dead."
- On the back cover, Paul has his back turned to the camera. The three black buttons on the back of his coat represent the remaining three Beatles.
- Next to Paul's head are the words "without you" from the song "Within You Without You."
- George points to the words "Wednesday morning at five o'clock," supposedly the time of Paul's fatal accident.
- The title song introduces Billy Shears (said to be Paul's replacement William Campbell, but actually Ringo).
- Billy Shears tells the audience in "With a Little Help from My Friends . . .": "Lend me your ears and I'll sing you a song, and I'll try not to sing out of key." Perhaps he was still working on perfecting his singing voice?
- In "A Day in the Life," John sings, "He blew his mind out in a car, He hadn't noticed that the lights had changed, A crowd of people stood and stared, They'd seen his face before . . ."
- The line, "Nobody was really sure if he was from the House of Lords" sounds more like "house of PAUL."

The Clues: Magical Mystery Tour

- The Beatles all wear animal costumes, but who is in the black (symbol of death) walrus costume?
- On the *White Album*, John Lennon announces in "Glass Onion," ". . . and here's another clue for you all, the walrus was Paul."
- In the song "God" on the *Imagine* album John now sings, "I was the walrus, but now I'm John."
- Paul is sitting behind a desk with a sign that reads "I Was."
- The British flags behind Paul are crossed, as they would be in a military funeral.
- Ringo's bass drum head shows the numeral "3." The full inscription reads "Love the 3 Beatles."
- On the staircase, the Beatles are all wearing red carnations, but Paul's is black.
- The line "goo goo g'joob" is supposedly from *Finnegans Wake* by James Joyce; they were the last words of Humpty Dumpty before his fall. The exact phrase doesn't actually appear in the book at all.
- Shakespearean actors are heard reading lines from *King Lear* as "I am the Walrus" fades out, saying "O, untimely death" and "What! Is he dead?"
- In the second fade-out of "Strawberry Fields Forever," John says "cranberry sauce," which many fans heard as "I buried Paul."

The Clues: Abbey Road

- The cover photo of *Abbey Road* represents a funeral procession with John as the minister, Ringo the undertaker, Paul the corpse, and George the gravedigger.
- Paul is out of step with the other Beatles (leading with his right foot).
- Paul is holding a cigarette in his right hand (he is left handed!).
- The VW beetle in the background has the license plate "28 IF" (Paul's current age if he were still alive).
- On his 1982 album *Paul is Live*, he recreates the Abbey Road 'walk' and includes a picture of another VW beetle with the license plate "51 IS."
- The song "Come Together" could represent the wake, coming together, over Paul.
- Also in "Come Together," John sings the line "one and one and one is three" representing the three Beatles.
- A crack runs through the "s" of "Beatles" . . . deliberately?

Life after the Beatles

Solo Careers—Quick Facts and Trivia

John Lennon

- At age sixteen, John witnessed his mother Julia killed by a drunk driver. He later wrote the song "Julia" in memory of her.
- When *Rolling Stone Magazine* was launched in 1967, John Lennon was the first person on the cover.
- His animosity toward Paul McCartney after the break-up of the Beatles extended to interviews, and people generally perceive the song "How Do You Sleep?" from *Imagine* as a personal attack on Paul.
- In 1968, John Lennon and Yoko Ono released an album called *Two Virgins*. This was an avant-garde experimental album that used tape loops, sound effects and studio sound-altering devices. The album was banned in many places due to the cover artwork that featured John and Yoko in full frontal nudity. They apparently took the picture in Ringo's basement.

John Lennon and Chuck Berry

John Lennon seated with his idol, Chuck Berry, following the break-up of the Beatles

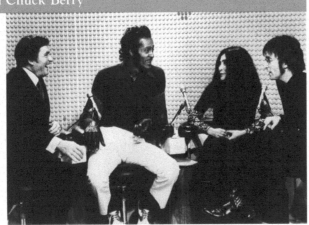

© Michael Ochs Archives/Stringer/Getty Images

- John became well known for his political activism, not only in his music, but through his actions such as the "bed-ins," which was his way of protesting for peace.
- He was fascinated with numerology and the symbolism of the number nine.
- In 1973, Yoko encouraged John to move in with their personal assistant May Pang, with whom he had a relationship for eighteen months before coming back to Yoko.
- John's two sons, Sean (with Yoko Ono) and Julian (with Cynthia Lennon) have both gone on to successful recording careers.
- John and his son Sean were born on the same day, October 9.
- John retired from performing in 1975 to take care of Sean and be an at-home dad.
- John Lennon co-wrote David Bowie's first #1 hit in 1975.
- Mark David Chapman, a deranged fan, believed God instructed him to assassinate John Lennon. Chapman had seen Lennon two times earlier in the day and had received an autograph before shooting him four times later that night. Following the murder, Chapman sat calmly waiting for the police. He read *The Catcher in the Rye* and stated that he knew he was largely Holden Caulfield (the main character in *The Catcher in the Rye*) and partially the devil.
- Lennon died shortly after 11 P.M. on December 8, 1980. In his home country, England, where it was five hours later, it was already December 9 (John was infatuated with the number 9 and numerology).
- *Rolling Stone Magazine* photographed John for their cover on the day of his assassination.
- Widow Yoko Ono's photograph of John Lennon's spectacles, bloodstained from the fatal shooting, was sold at an auction in London in April 2002.
- At a second Christie's auction, two tape recordings of Lennon improvising songs and telling stories to his stepdaughter sold for $195,000 USD.
- In 2001, the Liverpool Airport was renamed the John Lennon Airport.

"My role in society, or any artist or poet's role, is to try and express what we all feel. Not to tell people how to feel. Not as a preacher, not as a leader, but as a reflection of us all."

—**John Lennon**

Recommended Listening

- How Do You Sleep
- Imagine
- Julia
- God
- Give Peace a Chance
- Working Class Hero
- John Lennon *Rolling Stone* interview—iTunes podcast

George Harrison

- In 1968, George Harrison was often at odds with Lennon and McCartney and spent a great deal of time at Eric Clapton's house.
- While skipping a Beatles meeting, George was at Eric's home writing "Here Comes the Sun." He and Clapton also co-wrote the song "Badge" for Cream's *Goodbye* album in 1969.
- George and Eric both loved the same woman, Pattie Boyd, who married Harrison but spent most of her time with Clapton. In 1974, after divorcing George, Boyd and Clapton were married (with George as the best man). The three remained best friends!
- Harrison's first post-Beatles album, *All Things Must Pass*, hit #1 in both the UK and the USA. Phil Spector recorded the album and featured both Eric Clapton and Ringo Starr.
- The single "My Sweet Lord" reached #1 in the UK and the United States before running into trouble.
- Unfortunately, "My Sweet Lord" turned out to be extremely similar to the Chiffons 1962 hit "He's So Fine." The Chiffons' publishing company sued for the alleged plagiarism and won the majority of royalties from the single and a percentage of the *All Things Must Pass* album. Through appeals, the case dragged on into the 1990s.
- The many major charity concerts held today such as "Live Aid," "Band Aid" and "Live 8" hail back to 1971's "The Concert for Bangladesh," organized by George Harrison.
- George founded Hand Made Films in 1978 and produced movie classics such as Monty Python's *Life of Brian* and *Time Bandits*.
- He wrote an autobiography titled *I Me Mine* in the late 1970s, originally issued as an exclusive leather-bound edition selling for $350 per copy.
- He contributed songs to the 1985 movie *Porky's Revenge* soundtrack (perhaps not a highlight!).
- Harrison returned to touring in 1991, accompanied by his old friend Eric Clapton.
- In 1992, Harrison became the first recipient of Billboard's Century Award.
- In 1999, a man broke into Harrison's mansion outside of London and attacked him. Harrison was stabbed several times, but he made a full recovery. The intruder was found not guilty by reason of insanity.
- In 2000, George Harrison discovered that his real birthday was on February 24. His birth record noted

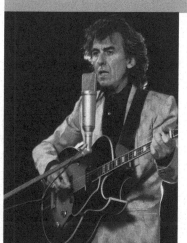

George Harrison

George Harrison's post Beatles career was at times prolific, rarely self-centered, and documents his search for religious contentment

© Terry O'Neill/Contributor/Getty Images

his birth as shortly before midnight around 11:50 P.M. He had believed his birthday was February 25 for his entire life.

- George Harrison died of cancer on November 29, 2001 at the age of 58.
- At the time of his death, his album *Brainwashed* was almost complete. His band mates and friends finished the album and released it in 2002.
- George held strong religious beliefs throughout his life, which are evident in many of his songs and particularly on his final album, *Brainwashed*.
- Harrison was inducted into the Rock and Roll Hall of Fame in 2004 and received a star on the Hollywood Walk of Fame in 2008.

"I'd rather be a musician than a rock star."

—George Harrison

"Everything else can wait but the search for God cannot wait."

—George Harrison

Recommended Listening

- While My Guitar Gently Weeps
- Here Comes the Sun
- My Sweet Lord (compare to The Chiffons' "He's So Fine")
- Looking for My Life

Ringo Starr

- Ringo's first solo single "It Don't Come Easy" reached #4 in the UK and the USA.
- After the Beatles split up, Ringo was the only one who stayed on good terms with the other three. He performed on all of their first solo releases and other subsequent albums.
- Ringo had two #1 hit singles in the USA in 1973: "Photograph" (written with George Harrison) and "You're Sixteen (You're Beautiful and You're Mine)."
- Ringo married Mary "Maureen" Cox in February 1965 and divorced in 1975.
- John Lennon wrote the song "Nobody Told Me" for Ringo's *Stop and Smell the Roses* album shortly before his murder. Ringo felt uncomfortable recording the song so Yoko released it in 1984 on *Milk and Honey*, a collection of John's music recorded in the weeks leading up to his death.
- Ringo sang seven songs for the 1977 children's album *Scouse the Mouse*.
- He narrated the first two seasons of the popular British television series *Thomas the Tank Engine and Friends*.
- Ringo married Barbara Bach in April 1981 and they are still happily married more than 30 years later.
- Ringo Starr was the character "The Mock Turtle" in *Alice in Wonderland* in 1985.

Ringo Starr

Ringo remained good friends with the other former Beatles and still has a light-hearted attitude to music and life today

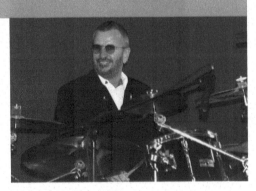

© Featureflash/Shutterstock.com

- In 1989, Ringo formed his first "All Starr Band" with friends Joe Walsh (the Eagles), Clarence Clemmons and Nils Lofgren (the E-Street Band), Rick Danko and Levon Helm (the Band), Dr. John, Billy Preston and Jim Keltner. More recently, the All Starr Band has featured his son Zak (Zak Starkey has performed with The Who and Oasis), John Entwistle, Peter Frampton, Dave Edmunds, Sheila E and Greg Lake.
- In 1991, Ringo appeared on an episode of *The Simpsons*.
- Ringo played drums on three tracks for Paul McCartney's 1997 album *Flaming Pie*, which produced the first McCartney/Starkey song credit ("Really Love You").
- Ringo was inducted into the Percussive Arts Society Hall of Fame in 2002.
- His book, *Postcards From The Boys*, was published in 2004. It is a collection of post-cards and letters from his former band mates John, Paul and George.
- Ringo Starr's album, *Liverpool 8*, was released in January 2008 as a celebration of his home city of Liverpool, which was marked as the European Capital of Culture in 2008.
- In 2017, Ringo release the album "Give More Love" in celebration of his 77th birthday.
- Ringo Starr was knighted by Queen Elizabeth II in 2018.

> *"First and foremost I am a drummer. After that, I'm other things."*
>
> **—Ringo Starr**

> *"As friends, as musicians, we had a lot of time together. Actually, we didn't have a lot of years in a band—eight. But we had a lifetime in those eight years."*
>
> **—Ringo Starr**

Recommended Listening

- It Don't Come Easy
- Back Off Boogaloo
- Photograph
- You're Sixteen
- Liverpool 8
- Keith and Ringo (from "Two Sides of the Moon")

Paul McCartney

- Paul McCartney is officially the world's most successful musician according to the *Guinness Book of Records*. He has over sixty gold records, Grammy and Academy awards and over one hundred million single sales. His accrued wealth is over $1.1 Billion USD.
- McCartney's first solo album, *McCartney*, reached #2 in the UK and #1 on the U.S. charts.
- His second solo album, *Ram*, in 1971 went to #1 in the UK and #2 in the U.S.
- Paul played all the instruments on two of his solo albums, *McCartney* (1970) and *McCartney II* (1980).
- Paul wrote several songs about his former band mate John Lennon, including "Dear Boy," "Too Many People," "Dear Friend," "Let Me Roll It" and "Here Today."

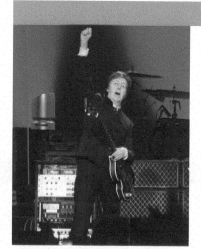

Paul McCartney

Paul McCartney is hailed as the most successful rock musician in the industry

© Alexander Mazurkevich/Shutterstock.com

- The original title of his favorite composition, "Yesterday," was "Scrambled Eggs."
- "Yesterday" is consequently the most covered song in history.
- Paul's band Wings, formed in 1971 with his wife Linda, enjoyed success through the 1970s and the early 1980s.
- Paul owns the double bass that once belonged to Elvis Presley's bassist Bill Black.
- He also owns the rights to the Buddy Holly song catalog.
- In 1973 McCartney was fined £200 for growing marijuana on his Scotland farm.
- In 1980, he was arrested in Tokyo, Japan, for marijuana possession.
- The 1982 album *Tug of War* was a #1 hit in the UK and the U.S. along with the album's single, "Ebony and Ivory," with Stevie Wonder.
- In 1983, McCartney had two hits with Michael Jackson: "Say, Say, Say" and "The Girl is Mine."
- Paul often used the pseudonym Paul Ramon (or Ramone) to travel and check into hotels. This name later inspired the naming of the punk group The Ramones.
- In 1990, Paul played to an audience of 184,000 people in Rio, the largest concert attendance in history.
- He composed several classical works, including *The Liverpool Oratorio*.
- He composed and recorded for several movie soundtracks, including *Live and Let Die* (1973) and *Vanilla Sky* (2001),
- In 1997, Queen Elizabeth II knighted McCartney.
- In April 1998, Linda McCartney, Paul's wife of thirty-one years, died of breast cancer.
- In 2002, he married former model Heather Mills, then separated from her in 2006. The couple experienced a bitter divorce and settlement proceedings.
- New York Police made Paul an Honorary Detective for the benefit concert he gave for 9/11 victims in April 2002.
- After George Harrison's death in 2001, Paul recorded some of George's songs in tribute to his friend. These include "For You Blue," "Something," "All Things Must Pass" and "While My Guitar Gently Weeps."
- In October, 2011, after a four year courtship, Paul married Nancy Shevell. As of May 2014, the couple are happy and seemingly inseparable.
- McCartney has again gained popularity on the charts with his recent albums *Chaos and Creation in the Backyard* (2005), *Memory Almost Full* (2007), *Kisses on the Bottom* (2012), and *New* (2013).
- In 2014, Paul and Ringo performed together at the Grammy's, and Paul was awarded a Grammy for his concert movie *Live Kisses*, and, Best Rock Song *Cut Me Some Slack*, with former members of Nirvana.

"If slaughterhouses had glass walls, everyone would be a vegetarian."

—**Paul McCartney**

"There are only four people who knew what the Beatles were about anyway."

—**Paul McCartney**

Recommended Listening

- Here Today
- Live and Let Die
- Interview from Paul's 2007 album *Memory Almost Full*

- Yesterday
- Ebony and Ivory

The Rolling Stones and The Who

The Rolling Stones

Members

- Mick Jagger (born July 26, 1943)—Vocals, harmonica
- Keith Richards (born December 18, 1943)—Guitar
- Bill Wyman (born October 24, 1936)—Bass 1962–1992
- Charlie Watts (June 2, 1941–August 24, 2021)—Drums
- Ron Wood (born June 1, 1947)—Guitar 1974–

Former Members

- Brian Jones (February 28, 1942–July 3, 1969)—Guitar 1962–1969
- Mick Taylor (born January 17, 1949)—Guitar 1969–1974
- Ian Stewart (July 18, 1938–December 12, 1985) "the Sixth Stone"—Keyboards, road manager

The Rolling Stones are one of the greatest rock and roll bands in history. Able to move with the times, they have maintained popularity with each generation, produced more than sixty albums and influenced trends in music for over fifty years. Unlike many other British invasion bands of the same period, the Rolling Stones had a background steeped in the blues rather than English "beat music."

Prior to forming the Rolling Stones, Michael "Mick" Jagger, Keith Richards and Dick Taylor performed together in a band called Little Boy Blue and the Blues Boys. Mick and Keith had been friends since primary school, and Brian Jones and Charlie Watts had played together in the band Blues Incorporated before they all collaborated in one band. The Rolling Stones were officially formed in 1962 by Mick Jagger, Keith Richards, Brian

Early 1960s Rolling Stones

The Rolling
Stones when
they still had
a relatively
clean-cut image

© Mark and Colleen Hayward/Contributor/Getty Images

Jones, Ian Stewart, bassist Dick Taylor and drummer Tony Chapman when they were offered an opportunity to perform at London's famous Marquee Club. The driving force behind the sound and material for the band was Brian Jones and his passion for American blues music. Along with covers of many great early blues artists, the Stones played songs by such artists as Chuck Berry, Bo Diddley, Willie Dixon and Muddy Waters. In fact, the band got the name Rolling Stones from a Muddy Waters song called "Rollin' Stone." By 1963, Bill Wyman had replaced Dick Taylor, and Charlie Watts replaced Tony Chapman to complete the classic Rolling Stones lineup. Fearing his look wouldn't be marketable, Ian Stewart was moved to the background, serving as road manager and playing piano from offstage, a role that he played until his death in 1985.

During 1963, the band rose to success in Britain with a long-running gig at the Crawdaddy Club in London, a Decca Records contract through their new manager Andrew Loog Oldham (a former publicist for the Beatles) and a fast-growing fan base. With their startling, unkempt, raunchy image, Oldham marketed the Stones as everything contrasting the Beatles. Their sound was rough with a raw bluesy feel; they dressed offensively (for the day) and advertised with such slogans as "Would you let your Sister go with a Rolling Stone?"

In June 1963, the Stones released their first UK charting single (reached #21) with a Chuck Berry song called "Come On," backed by a Willie Dixon song "I Want to Be Loved." In November they hit higher in the charts with the Lennon/McCartney song "I Wanna Be Your Man" (reached #12) and "Stoned" by Nanker Phelge (a name created by the Stones to represent the whole group). Their first top ten hit was with the Buddy Holly song "Not Fade Away" (reached #3) backed by "Little by Little" co-written with Phil Spector. In June, the Stones crossed the Atlantic to appear on the *Ed Sullivan Show* and perform their first U.S.

Ian Stewart and Charlie Watts

"The Sixth Stone,"
Ian Stewart (left)
played keyboards
with the Rolling
Stones from
1962–1985

© Hulton Archive/Getty Images

tour. During this tour, they recorded at the Chess studios in Chicago, which became their home base for many future recordings. The Stones' first UK album, *The Rolling Stones*, was released in April 1964 and went to #1. Their first #1 single followed in November with "Little Red Rooster" by Willie Dixon. The success continued with their first U.S. album *12 × 5* (that reached #3) and *The Rolling Stones 2*, released in January 1965 in the UK, which went to #1.

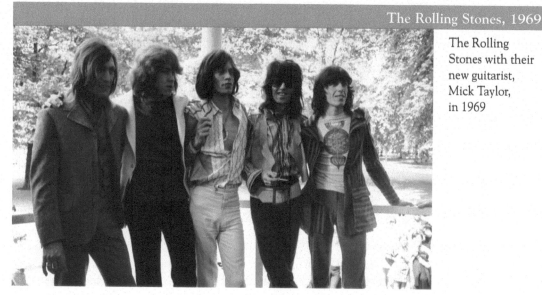

The Rolling Stones, 1969

The Rolling Stones with their new guitarist, Mick Taylor, in 1969

© Mirrorpix/Contributor/Getty Images

One of the Rolling Stones' most recognizable songs, "(I Can't Get No) Satisfaction," was released in September 1965 on the album *Out of Our Heads* featuring Keith Richards' signature guitar riff driving the song. "Satisfaction" is the pivotal song that catapulted the Rolling Stones into superstardom. In 2004, it ranked #2 on the *Rolling Stone Magazine's* "500 Greatest Songs of All Time" and was the first of four Jagger/Richards compositions to reach #1 in the USA and the UK simultaneously in the 1960s (the others were "Get Off of My Cloud," "Paint It Black," and "Honky Tonk Women").

In April 1966, the Rolling Stones released *Aftermath*, the first album comprised entirely of Jagger/Richards compositions. It reached #1 in the UK and #2 in the USA. The next albums, *Between the Buttons* and *Their Satanic Majesties Request*, demonstrated the Stones' search for diversity and their contributions to psychedelic music. Brian Jones introduced unique instruments to the group, such as the marimba and the sitar, and the experimentation and influence of drugs became evident in the band. In 1967, Jagger, Richards and Jones were arraigned on drug charges and went through a series of court cases. The ordeal strengthened Jagger and Richards, and they poured their energy into the band. Jones, however, delved further into his drug problem and began to lose control of his ability to create music effectively in the studio. The 1968 album, *Beggars Banquet*, introduced Keith Richards' rediscovery of open chord tunings (influenced by Robert Johnson), which added greater depth to his characteristic guitar sound. In December, 1968, the Rolling Stones filmed the *Rock and Roll Circus* with guests Eric Clapton, John Lennon, Mitch Mitchell, Jethro Tull, Marianne Faithfull, Taj Mahal and the Who.

Andrew Oldham decided to resign as manager in 1968, and Allen Klein (who later managed the Beatles) replaced him. By June 1969, Jones was no longer able to function in the studio. The band asked him to leave and replaced him with Mick Taylor (they told the press that he left due to "musical differences"). On July 3, 1969, Brian Jones was found dead in his swimming pool after a party at his country home. No one has ever truly solved Jones' death, and theories ranging from accidental drowning to murder have given a very mysterious rock and roll ending to the life of one of London's great blues guitarists. *Let It Bleed* was released in December 1969 with both Jones and Taylor appearing on two tracks each—a fitting changing of the guard.

The 1970s heightened the Rolling Stones' popularity with seven #1 albums in a row: *Get Yer Ya-Ya's Out!* (1970), *Sticky Fingers* (1971), *Exile on Main St.* (1972), *Goats Head Soup*

The Rolling Stones with Ronnie Wood

Ronnie Wood joined the Stones in 1974 as the permanent replacement for Mick Taylor

© *Mirrorpix/Contributor/Getty Images*

(1973), *It's Only Rock 'n' Roll* (1974), *Black and Blue* (1976) and *Some Girls* (1978). The Stones left Decca Records to form their own label, Rolling Stones Records. But in the mid-1970s the Stones became increasingly unstable, due in part to Richards' drug problems and Jagger's fast-paced lifestyle. In 1974, Mick Taylor left the band and was replaced by Ronnie Wood. Wood frequently acted as a middleman between Jagger and Richards, convincing them to set aside their differences and work together.

Emotional Rescue (1980) and *Tattoo You* (1981) soared to #1 as tensions increased in the band. In the mid-1980s, Wood again received credit for keeping the Stones from breaking up. Mick Jagger released two solo albums, *She's the Boss* (1985) and *Primitive Cool* (1986), followed by Keith Richard's *Talk is Cheap*, which was an obvious dig at Jagger's solo success. In 1989, with Jagger and Richards back on good terms, the Stones released *Steel Wheels*, a popular and creative album. After that release (actually in 1992), bassist Bill Wyman retired, electing to go out on top. The 1990s saw continued development of the solo careers of both Richards and Jagger while they worked on Stones projects. In 1994, the Rolling Stones won their first Best Rock Album Grammy for *Voodoo Lounge*.

In 2002, the *Forty Licks* album and tour celebrating forty years of the Rolling Stones brought them back into the top ten worldwide. The 2005 Bigger Bang tour began and ultimately brought in a massive $550 million (the highest grossing tour of all time). In 2006, the Stones were the featured entertainment at the Super Bowl, and Keith Richards had emergency brain surgery in May after suffering a head injury from a fall from a coconut tree while on vacation in Figi. He was back on stage performing 6 weeks later! In 2007, the Stones continued touring and performed at the Isle of Wight Festival in June, released the double album *Rolled Gold*, and a feature documentary film *Shine a Light* (filmed at the Beacon theatre, NYC in 2006) directed by Martin Scorcese. The famous *Exile on Main St.* double album was released in May 2010 entering the UK charts at #1 and the US charts at #2. Keith Richard's biography *Life* was also published in 2010 revealing much about the complexity and history of the band, and of the personal lives of its members. In 2012, the Rolling Stones celebrated 50 years in rock 'n' roll and released the album *GRRR!*, which went platinum in 3 countries and gold in 7 (including the US), a new documentary called *Crossfire Hurricane* and a hardcover book *The Rolling Stones 50* to commemorate their achievement. The 2012 and 2013 fifty year anniversary concerts featured guest former members Mick Taylor and Bill Wyman. The Rolling Stones toured extensively again in 2014 selling out stadium shows internationally. Although, the Australian leg of the tour had to be rescheduled after Mick Jagger's long time girlfriend, fashion designer and model, L'Wren Scott committed suicide in March 2014. Jagger was devastated and cancelled all shows for more than two months while he grieved. On March 25, 2016 in Havana, Cuba the Rolling Stones played a free concert for over 500,000 fans. The Rolling Stones' music, among other western music acts, had been banned in Cuba for decades during the Castro regime. At the end of 2016 the Stones released *Blue & Lonesome*, a studio album of blues covers that has been hailed as the first time in several years that the members had connected significantly in the studio as a band to make music that simply feels good. In 2017 the Stones embarked on the No Filter tour, which was paused in 2020 due to the global Covid-19 pandemic. The tour recommenced in 2021, after the passing of Charlie Watts with Steve

Jordan on drums, and grossed an extraordinary 545 million dollars. In June and July, 2022 the "Stones Sixty" tour marked their 60 years together as a band. The Rolling Stones are true pioneers of rock 'n' roll. They continue to forge ahead bringing innovations to the stage and surprise us with each new page in their legacy. Who said rock was a young persons game?

Guitar Spotlight

The Rolling Stones contained rock's greatest guitar duos: Keith Richards/Brian Jones, Keith Richards/Mick Taylor and Keith Richards/Ronnie Wood.

Keith Richards' rhythm playing is unsurpassed. Richards drives the band with his riffs and rhythms. After discovering open G tunings used by Delta bluesmen, Richards developed a powerful and unique style that is fluid and not based on set patterns.

Brian Jones was a great contrast to Richards' playing, adding color and texture. Mick Taylor was a great soloist. Ronnie Wood interacted (weaved) with Richards in a very musical (contrapuntal) way that was improvised and hard to recreate. Besides being a great soloist and slide, rhythm and pedal steel player, Wood reacts to Richards (and vice versa) in a spontaneous way that is closer to the way jazz musicians react to each other than is normally common in rock and roll. The song "Beast of Burden" is an excellent example of the "weaving" by Richards and Wood. The many layered guitars "weave" around each other like a musical organism that is alive and spontaneous. Each layer compliments and plays off the other. It is hard to tell where one guitar ends and the other begins. The "weaving" is like a musical tapestry, and it would probably be hard for Keith Richards and Ronnie Wood to tell who played what. Ronnie Wood's incredible feel and musicianship has contributed to the best interactive musical relationship of the Stones' history.

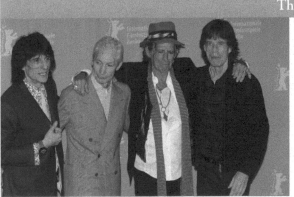

The Current Stones

The Rolling Stones 21st century line-up: Ronnie Wood, Charlie Watts, Keith Richards and Mick Jagger

© Denis Makarenko / Shutterstock.com

"Two guitars should sound like one guy with four hands."

—**Keith Richards**

Recommended Listening

Formative Years
- Come On (1963)
- Not Fade Away (1963)
- Little Red Rooster (1964)
- Time Is On My Side (1964)
- It's All Over Now (1964)

Coming of Age

- (I Can't Get No) Satisfaction (1965)
- Paint It Black (1966)
- Let's Spend the Night Together (1967)
- Ruby Tuesday (1967)
- Jumpin' Jack Flash (1968)
- Sympathy for the Devil (1968)
- Honky Tonk Women (1969)
- You Can't Always Get What You Want (1969)

Greatest Rock Band in the World

- Brown Sugar (1971)
- Sister Morphine (1971)
- Angie (1973)
- Hot Stuff (1976)
- Miss You (1978)
- Start Me Up (1981)
- Slave (1981)
- Harlem Shuffle (1986)

Awards

- Inducted into the Rock and Roll Hall of Fame in 1989
- MTV Lifetime Achievement Award, 1994
- Grammy Award, Best Rock Album for *Voodoo Lounge*, 1995
- Grammy Award, Best Music Video for *Love Is Strong*, 1995
- Mick Jagger was knighted in 2003.
- The Rolling Stone "100 Greatest Artists of All Time" poll ranked the Rolling Stones at #4.

Trivia

- Keith Richards describes . . . "Jones came up with the name The Rollin' Stones (later adding the 'g') while on the phone with a venue owner. "The owner asked, 'What are you called?' Panic . . . 'The Best of Muddy Waters' album was lying on the floor and track one was 'Rollin' Stone Blues'."

- At a 1969 concert at the Altamont Speedway, where the Hell's Angels biker gang provided security, a riot broke out that resulted in a fan being stabbed to death.

- Keith Richards legally changed his surname to "Richard" on the recommendation of manager Andrew Oldham to give him a connection to the famous British pop star Cliff Richard. He later added the 's' back to his name.

- "C***sucker Blues" is the title of a 1972 song Mick Jagger wrote as the Stones' final single for Decca Records, per their contract. He chose its context and language specifically to anger Decca executives.

- In album producing credits, "The Glimmer Twins" were Mick Jagger and Keith Richards.

- John Pasche, who was a student at the Royal College, designed the famous Rolling Stones "tongue" logo that first appeared on the inner sleeve and label of the album *Sticky Fingers*. He earned £50 for his work at the time, but he received a "generous" £200 a couple of years later for the success of the image. In 2006, Pasche sold the original artwork of the logo for £400,000.

The Who

Members

- Pete Townshend (born May 19, 1945)—Guitar
- Roger Daltrey (born March 1, 1944)—Vocals
- John Entwistle (October 9, 1944–June 27, 2002)—Bass
- Keith Moon (August 23, 1947–September 7, 1978)—Drums

The Who formed in London in 1964 as part of the hip "Mod" scene and donned strategically ripped jeans, pop icon t-shirts and a persona of intellectual rebellion. The band members embodied whatever was "in" on London's famous Carnaby Street and spoke out, through their music, about the troubles and declining social status of England's youth. At the time The Who hit the live and recorded music scene, bands like the Rolling Stones had already broken down many barriers, such as themes for lyrics, excessive volumes and stage antics, controversial album covers and the open use of drugs. This allowed The Who more experimental latitude than any other band before them and led to their becoming a pivotal group linking rock and roll and punk. It also provided them the vehicle they needed to create and compose an artistic "rock opera" and begin smashing instruments on stage.

Pete Townshend and John Entwistle played together in a Dixieland jazz band in the late 1950s before meeting guitarist Roger Daltrey in 1963.

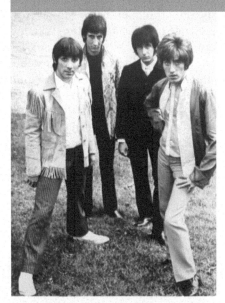

The Who, 1969

The Who were the first rock group to smash their instruments on stage

© Michael Ochs Archives/Stringer/Getty Images

Daltrey's band, The Detours, was originally a skiffle group looking to branch into rock and roll. After losing their vocalist and drummer, they began playing R & B music with Townshend and Entwistle. In 1964, Daltrey moved from lead guitar to vocals, and the group began trying out drummers. After an interesting audition they settled on Keith Moon, and the band signed on Peter Meaden as their manager. Meaden convinced them to appeal to the Mod crowd, change their name to the High Numbers and record songs written by him. After Meaden's songs failed to sell, they fired him and changed their name to The Who. Their first hit song came shortly afterward with "I Can't Explain," written by Pete Townshend, and made the UK top 10 in January 1965. The Who is one of the few bands of this era to make a successful start performing their own material.

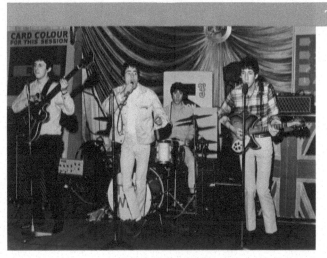

The Who, 1964

The finalized line-up of The Who performing in 1964

© Michael Ochs Archives/Stringer/Getty Images

Smashing instruments became synonymous with The Who during a show in late 1964 when Pete Townshend (known for his temper) accidentally broke his guitar on the club's low ceiling, got angry and destroyed it, and then rammed the pieces into his amplifier. Keith Moon, not wanting to be outdone, destroyed his drums on purpose to the cheers of the crowd, and the trademark for the band was born. When the Who appeared on the popular British TV show *Ready, Steady, Go*, they again destroyed their instruments and became an overnight sensation. Pete Townshend explained that the reason for continuing the ritual was to increase the stage energy. In the *History of Rock* DVD series, he states that the band couldn't play any louder, any more notes or any faster, so with the energy still building the only thing left to do was destroy the instruments. Townshend also adds to the stage presence by using a signature "windmill" strumming motion while playing power chords on the guitar.

Although the Who rarely reached the #1 spot on the charts, many of their albums and singles sold at the platinum and multi-platinum level. Their music, largely composed by Pete Townshend, had found its niche by 1967 with themes of teenage angst and sexual tension. On the 1965 debut album, songs like "My Generation" and "The Kids Are Alright" reflected the plight of teenagers around the world. As Townshend experimented, he wasn't afraid to explore unique angles to break through to the youth culture. This showed in songs like "Happy Jack" about a mentally disturbed teen, and "Pictures of Lily," an ode to masturbation. Flexing his compositional skills, Townshend began working on the concept of a "rock opera" that would follow a theme and characters through an entire album. He first introduced his ideas in mini rock operas on the Who's second album, *A Quick One*, with a medley of story songs that comprised "A Quick One While He's Away" and in "Rael" on their third album *The Who Sell Out*.

The Who, 1975

The Who produced the first rock opera with *Tommy* in 1969

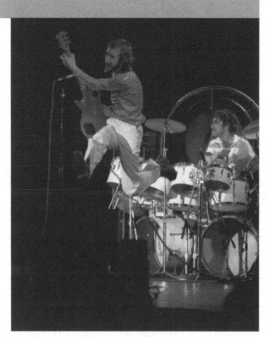

© Tom Hill/Contributor/Getty Images

In 1969, *Tommy* became the first successful full rock opera, with a libretto (also written by Townshend) revolving around the character Tommy Walker. Tommy becomes deaf, dumb and blind through the shock of witnessing, in a mirror, the murder of his mother's lover by his father (Captain Walker) when he returns home by surprise from WWI. The controversial themes that follow the story involve Tommy's life experiences where he gets beaten, sexually abused, exorcised by a religious cult, medicated with LSD and lifted to fame as a pinball wizard. In psychotherapy he retrieves his lost senses by smashing the offending mirror that caused him to shut down. Tommy then becomes a spiritual leader for many followers, but when he instructs them to become deaf, dumb and blind to experience a spiritual revelation, they revolt against him. The rock opera received critical acclaim from the press and fans,

brought appreciation to rock as serious art music and has since become a movie and Broadway show. Of the twenty-four songs featured in *Tommy*, Townshend composed all but one. Sonny Boy Williamson II composed the song titled "Eyesight to the Blind."

The Who's most famous album, *Who's Next* (1971), delivered three songs that have sustained radio play and popularity into the twenty-first century: "Baba O'Riley," "Behind Blue Eyes" and "Won't Get Fooled Again." In 1973, Townshend brought forward another rock opera with the album *Quadrophenia*, best described as an autobiography of the band to that point. The Who continued as a powerhouse band for the remainder of the 1970s with *The Who by Numbers* (1975) and *Who Are You* (1978) before the tragic death of Keith Moon from a drug overdose. After some time off, the band recruited one of Moon's friends, Kenney Jones, to replace him and recorded two more albums, *Face Dances* (1981) and *It's Hard* (1982) before deciding to break up in 1982.

Townshend, Daltrey, Entwistle and even Keith Moon all enjoyed successful solo albums and careers during and after The Who's breakup. The Who have reunited several times since the mid 1980s to tour and perform special concerts, but they did not release any new material until *Endless Wire* in 2006. In 1993, they adapted *Tommy* for the Broadway stage and won five Tony awards. In 2002, at the onset of their first world tour in many years, John Entwistle died of heart failure in his room at the Hard Rock hotel and casino in Las Vegas. The Who were the featured half time show performance for Super Bowl 44 (XLIV), and received the Kennedy Center Honors award in 2008. The Who continue to make appearances with front men Roger Daltrey and Pete Townshend, supported by session musicians.

Recommended Listening

- I Can't Explain (1964)
- My Generation (1965)
- The Kids Are Alright (1965)
- Happy Jack (1966)
- A Quick One While He's Away (1966)
- Pictures of Lily (1967)
- *Tommy*—the whole album (1969)

- Baba O'Riley (1971)
- Won't Get Fooled Again (1971)
- *Quadrophenia* (1973)
- Squeeze Box (1975)
- Who Are You (1978)
- You Better You Bet (1981)

Awards
- Inducted into the Rock and Roll Hall of Fame in 1990
- Inducted into the UK Music Hall of Fame in 2005
- Lifetime Achievement Award from the British Phonographic Industry in 1988
- Lifetime Achievement Award from the Grammy Foundation in 2001
- *Tommy* was inducted into the Grammy Hall of Fame in 1998, *My Generation* in 1999 and *Who's Next* in 2007.

Trivia

- Jimmy Page plays guitar on "Bald Headed Woman," the B-side to "I Can't Explain."

- The song "My Generation" was banned in the UK briefly as the broadcasting commission feared it would offend people who had a stutter.

- The CBS TV show *CSI* exclusively uses The Who songs for its theme and opening credits: "Who Are You" (CSI Las Vegas), "Baba O'Riley" (CSI New York) and "Won't Get Fooled Again" (CSI Miami).

- In 1976, the *Guinness Book of World Records* featured the Who for performing the loudest rock concert.

- Pete Townshend credits his inspiration for the "windmill" guitar strum to Keith Richards, who he saw warming up for a gig by swinging his arms around in a windmill fashion. Richards doesn't recall ever doing that!

- Townshend once remarked, "Drugs don't harm you . . . I know, I take them."

- While performing on *The Smothers Brothers Comedy Hour* one night in 1967, Keith Moon decided to surprise the audience by augmenting the band's standard pyrotechnic display with an enormous charge of gunpowder. At the end of "My Generation," Moon detonated his drums, was blown into the air and cut by flying shrapnel from his cymbals. The explosion melted a camera, the studio's monitors and burned much of guitarist Pete Townshend's hair, and left him with permanent hearing damage.—from *anecdotage.com*

- Zak Starkey (Ringo Starr's son) has been the primary drummer for The Who from the early 1990s to the present.

More on Keith Moon—One of Rock's Greatest (and Craziest) Drummers (Known as Moon the Loon!)

- Keith Moon was in reality one of the best and most innovative rock drummers of the 1960s and 1970s. His creative style had him using two bass drums, often no hi-hat and a very soloistic approach to his grooves. Moon felt restricted by the drums (often citing the freedom of the guitarist, bassist and singers to move around the stage) and became quite athletic behind the drums.

- Moon's antics became world famous, and he never got bored pulling practical jokes, doing crazy (and often dangerous) things and generally living every second of his life as if there were no tomorrow. He was extremely hyperactive as a child and could only focus his attention when playing music. Even there, his teachers complained that his attention span was short, he was constantly showing off and he was perhaps slightly retarded.

- While auditioning for The Who at a live gig in London, Keith Moon took a drum solo with so much energy that he felt the need to kick the drums off the stage. Remembering that they were not his drums, he went back to the bar where Roger Daltrey and Pete Townshend met him with the words, "You're hired!"

- Keith Moon played on The Who recordings from their debut, including 1964 singles through 1978's *Who Are You*, released two weeks before his death.

- When clear plastic drums hit the market, Keith bought himself a set and filled them with water and goldfish. Playing the drums at a concert looked spectacular; unfortunately, the fish didn't fare too well.

- Keith had water poured onto his drums while performing so the audience would see bursts of rhythm in the air illuminated by colored lights (thirty years before Blue Man Group).
- Moon often flushed powerful fireworks down the toilet and detonated them for amusement.
- He once drove his Rolls Royce into a swimming pool (the gate was locked, and he wanted to go for a swim).
- At one hotel, he nailed all of the furniture to the ceiling.
- At a Holiday Inn, Keith celebrated his birthday by throwing a cake at the manager, destroying his room, putting the fire extinguishers to use in the lobby and throwing a television out of the window. The Who were banned from Holiday Inns for life!
- On their 1973 *Quadrophenia* tour, at the Cow Palace in Daly City, California, Moon took fifteen horse tranquilizers before the show (four times the amount used on a horse). He passed out in "Won't Get Fooled Again" and again in "Magic Bus" and was replaced by an audience member.
- Keith Moon was the inspiration behind the famous Muppet drummer "Animal."
- In 1975 he released his only solo album, *Two Sides of the Moon*. The cover art features a picture of Moon "mooning" the camera through a window in his car. The album features Moon singing and playing drums with many of his musician friends, including Ringo Starr, David Bowie, Joe Walsh, Spencer Davis, David Foster, Jim Keltner and Klaus Voormann.
- Moon often gets credited with naming the band Led Zeppelin. When talking with Jimmy Page, he said that he wouldn't join the band as it would eventually ". . . go down like a lead zeppelin."
- Moon went to a Monkees concert in 1968 and jumped up and down shouting "we want The Who!"
- Originally cast in *Monty Python's Life of Brian*, Keith died before filming. They dedicated the published edition of the screenplay to him.
- In the mid 1970s, Moon accidentally killed his friend and driver Neil Boland while trying to escape an attack from a group of skinheads. Moon was devastated, and this event haunted him with depression for the rest of his life.
- When Keith died of a drug overdose in 1978, he had remained clean for almost six months. The night of his death he had attended a preview of the *Buddy Holly Story* and

Keith Moon

Keith Moon was one of rock and roll's most innovative and creative drummers

© *Michael Putland/Contributor/Getty Images*

a party with Paul McCartney. Keith fell off the wagon that night, and, in addition to taking at least twenty-six Heminevrin pills (a pill designed to wean alcoholics off alcohol), he was drinking and taking cocaine. His girlfriend reports that he felt he had to be in character and would disappoint guests if he was not his "usual" self. Keith Moon was only thirty-two when he died.

■ Roger Daltrey was reportedly producing a film about Moon called *See Me Feel Me: Keith Moon Naked for Your Viewing Pleasure*, though the project is apparently stalled. Mike Myers was rumored to have been cast as the lead.

"I am the best Keith Moon type drummer in the world."

—**Keith Moon**

Motown

"Motown" encompasses three record labels (Tamla, Motown, and Gordy), several small subsidiary labels, the Jobete music publishing company, a style of music, and a family of musicians, singers, songwriters and producers, all under the direction of Berry Gordy. The term "Motown" relates to the "Motown Record Corporation," and this chapter uses it throughout to describe all of the above. The name "Motown" derives from "motor town," the nickname for Detroit because of the many automotive factories around the city. The most productive era for Motown was the Detroit years of 1959 to 1972 that earned the original house and recording studio the nickname "Hitsville USA." Berry Gordy, the man responsible for creating Motown, brought a new level of respect to rock and roll with polished, sharp performers (predominantly black artists). He also prided himself on his ability to locate talent, shape his artists and send them out as superstars. Motown went on to become one of the most influential forces socially and musically in America, sustaining multiple songs on the charts at a single time, before the company relocated to Los Angeles in June 1972.

The Years Leading Up to Motown

Berry Gordy, Jr., was born in Detroit, Michigan, on November 28, 1929, and grew up with a keen interest in music, especially jazz. He dropped out of high school in his junior year with ambitions to become a professional boxer. In 1951, he entered the military and spent two years in the service before returning to Detroit to open a jazz-based record store. Throughout

Jackie Wilson

Jackie Wilson helped Berry Gordy get his career off the ground in 1957

Hitsville USA

Known as Hitsville USA, this house is where all of the famous Motown records of the 1960s were produced

© Raymond Boyd/Contributor/Getty Images

Gordy's successful career, his passion for jazz never waned, and he always maintained a jazz element to his business. By 1955, his jazz record store had failed, and he began to work for the Ford Motor Company on the assembly line. Gordy didn't give up his dream of working in the music industry and spent his spare time learning the process for songwriting, recording and producing.

In 1957, Jackie Wilson recorded one of Berry Gordy's songs, "Reet Petite," which became a moderate hit. He liked Gordy's work enough that he commissioned four more songs from him over the next couple of years. After seeing how small the royalty checks were with all of the middlemen taking their cut, Gordy decided that it was far more profitable to produce his songs and keep the rights to the published music and recordings himself. By the end of the year, Gordy released his first produced record, "Ooh Shucks" by the Five Stars, and distributed it through the Mark-X record label (he wasn't licensed with his own label yet). The profit margin was much better, so he began setting up his own completely self-contained business. Gordy then signed a popular local group, the Miracles (originally called the Five Chimes and then the Matadors), and convinced their lead singer, William "Smokey" Robinson, to become his songwriting and production partner. The first song Gordy and Robinson collaborated on was "Got a Job" as a response to the Silhouettes' hit "Get a Job." Although the song didn't make it to the pop charts, it did receive national airplay and confirmed for Gordy that he was heading in the right direction.

In 1958, Gordy set up a music publishing company called Jobete to retain the publishing rights of the Motown song catalog. He named the company after his three children

Smokey Robinson and Berry Gordy

The brains and motivation behind the Motown company, Smokey Robinson and Berry Gordy

© AP/Wide World Photos

(Jo)y, (Be)rry IV and (Te)rry. Throughout 1958, he assembled songwriters and producers (notably Brian and Eddie Holland) and the top local jazz players to work as session musicians in the recording studio. The Motown Company formed in 1958 and was incorporated in early 1959. Gordy and his production team met regularly and analyzed the recorded songs, comparing them to what was currently in the top five on the pop charts. If a song didn't meet the Motown model, fit the projected criteria for a hit song and challenge the current top five, it was not released. This rigorous test provided the "Motown formula" for success, but it also excluded some songs that were ahead of their time. Many of these "cut" songs reappeared years later, fitting the evolved formula and making the charts.

Recommended Listening

- Reet Petite—Jackie Wilson
- Ooh Shucks—the Five Stars
- Got a Job—the Miracles

1959

In January 1959, Berry Gordy borrowed $800 for a down payment on the home where his dream started to become a reality. In the basement of the house, Gordy launched his record label, Tamla, with Marv Johnson as his first charting artist. Johnson hit the top thirty on the R&B charts in 1959 with "Come To Me," followed shortly after by "You Got What it Takes," which was the first top ten hit for Gordy. Johnson had nine more hits during his Motown career. The Miracles made their first chart appearance with "Bad Girl" (reached #93) and went on to have twenty-six top ten hits during their illustrious career. Smokey Robinson was one of the most important songwriters for Motown. He became vice president in 1961, produced and mentored several Motown artists and was the only artist who had complete creative control of his musical output from day one.

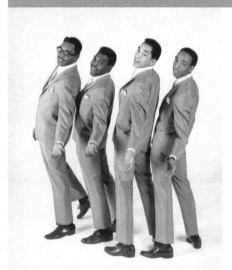

The Miracles

Smokey Robinson and The Miracles were the first Motown group to sell over one million records

© *Michael Ochs Archives/Stringer/Getty Images*

Recommended Listening

- You Got What It Takes—Marv Johnson

1960

Early in 1960, Barrett Strong joined Motown as a songwriter after his song "Money" became a popular hit, reaching #2 on the R&B charts and #23 on the pop charts. Strong's singing career was short-lived as he didn't have the soulful voice that Berry Gordy was looking for. Fortunately, his songwriting and producing skills were exceptional, and he signed on as a core part of the Motown production team. Strong remained with Motown until the Detroit offices closed in 1972. Gordy's first real success story was with 17-year-old Mary Wells, who turned out many hit songs including "Two Lovers," "My Guy," "Dear Lover" and a 1981 Disco hit with "Gigolo." Sadly, Mary Wells died at 49 in 1992 after battling cancer for several years. He also signed a male vocal group, the Distants, which, after changing their name to the Temptations, released their first record on his Miracle label. Late in 1960, a local

The Temptations

The Temptations had three #1 pop chart hits and fourteen #1 R&B hits for Motown

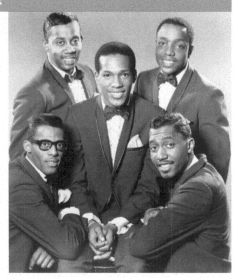

© Michael Ochs Archive/Stringer/Getty Images

high school girl group called the Primettes approached Gordy about a record deal. He recognized their talent immediately, but he instructed them to finish school before he would work with them. When he officially signed the Primettes in January 1961, he changed their name to the Supremes. Gordy signed the Contours (famous for "Do You Love Me") and acquired the contract for singer Marvin Gaye from another record company at the close of the year. Gaye played drums, sang backing vocals and only had moderate success as a lead singer with Motown until the 1970s when he assumed creative control of his recordings.

Recommended Listening

- Money—Barrett Strong

1961

Gordy discovered the Marvelettes (originally called the Marvels) at a local talent contest in 1961. Impressed with their sound, he signed them to Motown and they recorded the song "Please Mr. Postman" in August. The

The Marvelettes

The Marvelettes had the first #1 single on the pop charts for Motown

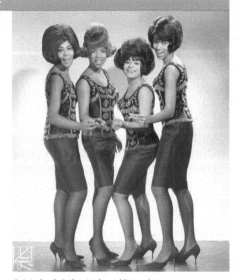

© Michael Ochs Archives/Getty Images

Marvelettes became the first group to hit #1 on the pop charts for Motown and repeated this success several times over the next few years with songs such as "Playboy" and "When You're Young and in Love." The Miracles also brought success to Motown in 1961 with their song "Shop Around" (actually released in December 1960), which not only went to #1 on the R&B charts, but was also the first Tamla record to sell over one million copies. The Miracles would go on to have over 50 songs on the hot 100 for Motown over a period of 19 years.

Berry Gordy demanded perfection from his artists and expected flawless performances in the studio and on the stage. He believed it was his duty not only to produce good music, but to raise the general perception and acceptance of black music in America. To achieve this, Gordy provided his artists with coaching for interview

strategies, deportment classes, hair styling and make-up techniques, choreography for dance moves, directions on how never to turn their backs to the audience while singing, and how to present themselves to the public as clean cut, impressive, polished entertainers. The man supervising the development of many of the Motown artists through the 1960s was the choreographer and former tap dancer, Charles "Cholly" Atkins.

Recommended Listening

- Please Mr. Postman—the Marvelettes
- Shop Around—the Miracles

1962

Prior to being signed as a singer to Motown, Martha Lavaille had worked as a secretary for Berry Gordy since 1959. When Mary Wells was unable to attend a recording session, Martha (now married with the last name Reeves) and her group the Del Phis stepped in as backing singers for Marvin Gaye's "Stubborn Kind of Fellow." Martha turned out to have a great voice, and they added Martha and the Vandellas to the Motown roster. Lamont Dozier also joined the Holland brothers' team as a songwriter and producer. The Holland-Dozier-Holland team was part of a small group of 1960s producers, along with Phil Spector and George Martin, who became almost as famous as the artists they produced.

Recommended Listening

- Stubborn Kind of Fellow—Marvin Gaye

1963

Berry Gordy signed a talented eleven-year-old blind singer (and multi-instrumentalist) by the name of Steveland Morris to Motown. The musicians in the studio affectionately called him "Little Stevie Wonder," a nickname that stuck throughout his career. Coming to national attention while on the "Motor Town Revue," Stevie's first hit, "Finger Tips, part 2," went to #1. The resulting album, *12 Year Old Genius*, became the first #1 charting album for Motown. Gordy also signed the Four Tops (formerly the Four Aims), who had worked as a jazz/doo-wop style group since 1956. Martha Reeves and the Vandellas released "Come and Get These Memories" in 1963, which had a slightly heavier and more soulful style. Many credit it as the

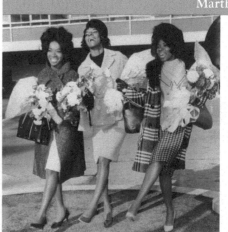

Martha and the Vandellas

Martha and the Vandellas are credited with the "coming of age" of the Motown sound in 1963

© *AP/Wide World Photos*

coming of age of the "Motown sound." They created this sound by utilizing what Gordy called a stable of Detroit jazz musicians that rotated through the recording sessions for every Motown artist. You can identify the musicians on each recording by their personal style, licks and grooves, and they became known as the Funk Brothers. (See a detailed description of the Funk Brothers at the end of this chapter.) The success of Martha and the Vandellas led to similar soulful hits like "Heat Wave," "Nowhere to Run" and "Jimmy Mack."

Recommended Listening

- Finger Tips, Part 2—Little Stevie Wonder
- You've Really Got a Hold on Me—the Miracles
- Come and Get These Memories—Martha and the Vandellas
- Heatwave—Martha and the Vandellas

The Four Tops

The Four Tops were one of the mainstays of the Motown label with hits like "Baby I Need Your Loving" and "Reach Out I'll Be There."

© Michael Ochs/Stringer/Getty Images

1964

The Four Tops released "Baby I Need Your Loving" in 1964, the first of their many charting hits fronted by their baritone lead singer Levi Stubbs. (Usually a tenor voice sang lead with male vocal groups.) The Supremes, who had recorded seven singles to this point without success, finally hit the charts with three of what would be a run of five #1 hits in a row: "Where Did Our Love Go," "Baby Love" and "Come See About Me." Other Motown hits this year included "My Guy" by Mary Wells and "Dancing in the Street" by Martha and the Vandellas. Mary Wells' "My Guy" is the song that knocked the Beatles off the top spot on the charts. Her other hits included "You Beat Me to the Punch" and "You Lost the Sweetest Boy" in 1963, with the Supremes and the Temptations singing backup, and "Once Upon a Time" and "What's the Matter With You Baby" in 1964. Unhappy with her low pay at Motown, Wells left the label, sued for back royalties and continued her career as a solo artist on Atlantic Records.

Recommended Listening

- Baby I Need Your Loving—Four Tops
- Where Did Our Love Go—the Supremes
- Baby Love—the Supremes
- Come See About Me—the Supremes
- Dancing in the Street—Martha and the Vandellas
- My Guy—Mary Wells

1965

In 1965, Motown was consistently push-ing out top ten hits and still discovering new talent for the label. In 1965, Gordy acquired Junior Walker and the All Stars, who jumped right into the top ten with "Shotgun" on Motown's new Soul label (they had signed with a label in 1961 that Motown assumed control of in 1965). Walker's group followed up with several covers of existing Motown hits and "(I'm a) Road Runner" and "Shake and Fingerpop." The Supremes released the fourth and fifth of their #1 hits in a row with "Stop! In the Name of Love" and "Back in My Arms Again" followed by "I Hear a Symphony." The Supremes' suc-cess and popularity was growing astronomically, and they went on to become the third largest selling artists in the world in the 1960s (behind the

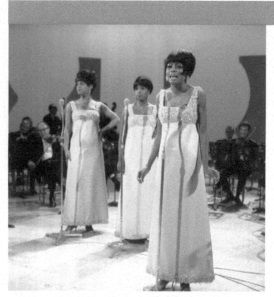

The Supremes

The Supremes had five #1 hits in a row in 1964 and 1965. In albums sales, they rank third for the most albums sold by an individual or group.

© Michael Ochs Archives/Stringer/Getty Images

Beatles and Elvis). They had twelve #1 singles in the USA alone and were the biggest sell-ing act on the Motown label in the 1960s. The Temptations, who hit #1 on the pop charts with "My Girl" in 1965, have had over twenty different members during their extended career, but the 1965 lineup became known as the "classic five" with Melvin Franklin, Eddie Kendricks, Otis Williams, Paul Williams and David Ruffin.

Recommended Listening

- Stop! In the Name of Love—the Supremes
- Back in My Arms again—the Supremes
- I Hear a Symphony—the Supremes
- Shotgun—Junior Walker and the All Stars
- My Girl—the Temptations
- I Can't Help Myself (Sugar Pie, Honey Bunch)—the Four Tops

1966

Gladys Knight and the Pips (the Pips were Gladys's brother and cousins) joined the Motown family in 1966 and recorded Marvin Gaye's "I Heard It Through the Grapevine," which went to #2. Gordy had refused to release Gaye's version of the song as it broke from the Motown formula. He finally agreed to issue the song on an album and as a single in 1968 and it went straight to #1. This was the assurance Gaye needed to continue the push to gain control of the production of his records. Gladys Knight had other charting achieve-ments with "The Nitty Gritty" (1968), "Friendship Train" (1969), "If I Were Your Woman" (1970) and "Neither One of Us," which won a Grammy Award in 1973. The Isley Brothers, famous for their 1962 hit "Twist and Shout," signed with Motown on the Tamla label and

Gladys Knight and the Pips

Gladys Knight and the Pips recorded the first version of "I Heard It Through the Grapevine"

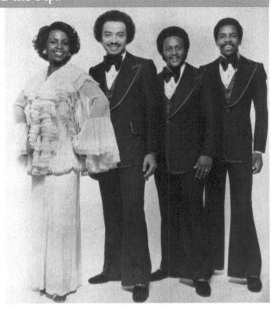

© Bettmann/Contributor/Getty Images

reached the top ten with "This Old Heart." They continued their success with a series of #1 R&B hits in the mid-late 1970s. The Supremes topped the charts again with "You Can't Hurry Love" and "You Keep Me Hanging On," while the Four Tops reached #1 with "Reach Out I'll Be There," as did the Temptations with "Ain't too Proud to Beg." The Temptations managed to have three #1 pop chart hits and fourteen #1 R&B hits while selling over 22 million records during their career.

Recommended Listening

- I Heard It Through the Grapevine—Gladys Knight and the Pips
- You Can't Hurry Love—the Supremes
- You Keep Me Hangin' On—the Supremes
- Reach Out I'll Be There—the Four Tops
- This Old Heart—the Isley Brothers
- Ain't Too Proud to Beg—the Temptations

1967

The success of the Supremes and the creative direction of the group started to cause tension between Diana Ross, credited more and more as the leader, and Mary Wilson and Florence Ballard. Gordy, who had begun a relationship with Ross, renamed the group Diana Ross and the Supremes and released two more #1 hits for the group with "Love is Here and Now You're Gone" and "The Happening." Tammi Terrell, who Motown signed in 1965 (previously with Checker and James Brown's label Try Me), came to critical acclaim in 1967 singing duets with Marvin Gaye. They sang such hits as "Ain't No Mountain High Enough," "Ain't Nothing Like the Real Thing" and "You're All I Need to Get By." Terrell collapsed on stage while performing with Marvin Gaye and died in 1970 at the young age of twenty-four from a brain tumor. In her short life she became romantically linked with both James Brown and David Ruffin of the Temptations. Crushed by Terrell's death, Gaye withdrew from live performances for two years.

Recommended Listening

- Love is Here and Now You're Gone—Diana Ross and the Supremes
- The Happening—Diana Ross and the Supremes
- Ain't No Mountain High Enough—Tammi Terrell and Marvin Gaye
- Ain't Nothing Like the Real Thing—Tammi Terrell and Marvin Gaye

1968

Berry Gordy moved to L.A to expand the Motown Company and to attract the talent of potential West Coast artists. Although recording continued in the original Hitsville studios, Motown also opened a new studio in downtown Detroit in 1968. With a change in dynamic in Detroit, the great production team of Holland-Dozier-Holland left Motown to form its own record label. In order to maintain control of his producers and writers, Gordy had most future Motown songs credited to "the Corporation," which was a small group consisting of his main producers, songwriters, executives and himself.

Recommended Listening

- I Heard It Through the Grapevine—Marvin Gaye
- Love Child—Diana Ross and the Supremes
- Ain't Nothing Like the Real Thing—Tammi Terrell and Marvin Gaye

1969

Berry Gordy formed another subsidiary label, Rare Earth, to produce psychedelic music and a handful of international artists. Michael Jackson and the Jackson Five (also working under the names Jackson 5, Jackson 5ive and J5), from Gary, Indiana, were discovered and signed to Motown marking the beginning of a great musical legacy and one of the greatest solo careers of all time. After many talent shows and attempts to get the family group signed to a major label, Joe Jackson secured an audition at Motown in late 1968 that would finally put the family on the entertainment map. The group soared to the top of the charts with four #1 hits in a row in 1970 with "I Want You Back," "ABC," "The Love You Save" and "I'll Be There."

The Jackson Five continued their success throughout the 1970s and well into the 1980s with hits such as Never Can Say Goodbye" and "Mama's Pearl" (1971), "Dancing Machine" (1973), "Enjoy Yourself" (1976), "Shake Your Body (Down to the Ground)" (1979),

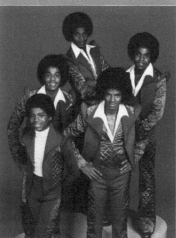

The Jackson Five

The success of the Jackson Five launched solo careers for several members, but especially Michael, who holds claim to the greatest selling rock album of all time with *Thriller*

© *John D. Kisch/Separate Cinema Archive/ Contributor/Getty Images*

"State of Shock" with Mick Jagger (1984) and at least 15 platinum selling albums between 1969 and 1989. The family group eventually broke up in 1989 following their final release *2300 Jackson Street*.

The members of the original Jackson Five are Jackie Jackson (born 1951), who now runs the record company, Jesco, Tito Jackson (born 1953), who is still active in music recording and performing and has managed and produced the group 3T (his three sons), Jermaine Jackson (born 1954), who stayed with Motown after the group left in 1983 (also assuming an executive role after marrying Berry Gordy's daughter Hazel who is active in many areas of the entertainment industry), Marlon Jackson (born 1957), who left the group just before the final album and got out of the music business to become a real estate agent, and Michael Joseph Jackson (August 29, 1958–June 25, 2009), who became the self proclaimed "King of Pop".

Although not in the original Jackson Five, Rebbie (born 1950), Latoya (born 1956), Randy (born 1961) and Janet (born 1966) Jackson have all sustained successful careers in the music business. Sadly, Brandon Jackson (twin brother of Marlon) died at birth.

Michael Jackson

The King of Pop, Michael Jackson.

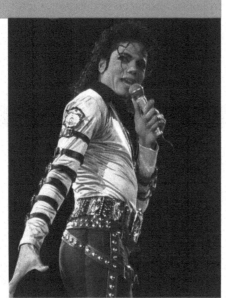

© *LUKE FRAZZA/Staff/Getty Images*

Michael Jackson was groomed from birth by his father, Joe Jackson, to be an entertainer. And, while fronting the Jackson Five from age ten, Michael was also being isolated as an up-and-coming solo artist. His first solo single, "Got to Be There," was released in 1971, followed in 1972 with "Ben," which became Michael Jackson's first #1 single (at 14 years old). The albums *Music & Me* (1973) and *Forever, Michael* (1975) were released with moderate success before *Off the Wall*, released in 1979, catapulted Michael to super stardom selling over 20 million records. In late 1982 Michael released a storybook album for *E.T.: The Extraterrestrial* and won a Grammy for best Children's Recording.

The #1 charting album *Thriller* (released in December 1982) topped the charts for 37 weeks and is the biggest selling album to date in recording history with more than 70 million RIAA certified units sold (millions more have been sold since his death). Additionally, the singles released from *Thriller* have sold more than 100 million copies. In December 1983, MTV debuted Michael Jackson's 14-minute *Thriller* film (*The Making of Michael Jackson's Thriller* is now the largest-selling music video ever). Michael's artistic approach to music videos with *Thriller*, *Beat It* and *Billie Jean* in the early 1980s defined the genre as a relevant and integral part of the Rock and Pop musician's complete package. During this time, Michael was still performing and recording with the Jackson Five, but finally quit the group in 1984 after the release of the *Victory* album and tour.

In August 1987, *Bad* was released, rising to #1 with 35 million records sold, followed by *Dangerous* in 1991, which sold 40 million records and was his third #1 solo album in a row. Michael Jackson's 1993 halftime performance at Superbowl XXVII became the largest viewed television show in American history with an estimated audience of 135 million. In 1994, Michael married Lisa Marie Presley, divorcing two years later in 1996. In 1995, *HIStory: Past, Present and Future, Book I* was released, selling 25 million records, followed by *Invincible* in 2005, which sold over 12 million records.

Michael Jackson died June 25, 2009, of a heart attack at the age of 50. Within one month of Michael's death, more than 10 greatest hits, best of, and classic hits albums were released, along with masses of merchandise capitalizing on the media frenzy surrounding his untimely departure. Michael Jackson has been inducted into the Rock and Roll Hall of Fame twice (as a solo artist and with the Jackson Five) and the Songwriters Hall of Fame, won 19 Grammy Awards (winning 8 in 1988 alone) and 22 American Music Awards, sold over 750 million records worldwide, had 13 #1 singles and has received multiple awards from many international organizations. In July 2009, the Sony Corporation reportedly paid over $50 million for the rehearsal video footage of Michael's upcoming London concert series. The footage was made into a full-length movie feature titled *This Is It*.

Recommended Listening

- Someday We'll Be Together—Diana Ross and the Supremes
- I Want you Back—the Jackson Five
- I Can't Get Next to You—The Temptations
- Ben—Michael Jackson
- Thriller—Michael Jackson

1970

Berry Gordy began issuing spoken word records from another Motown subsidiary, with speeches, prose and poetry from Martin Luther King, Jr., Stokely Carmichael and others.

Diana Ross and the Supremes performed their last live show together in 1970 at the Frontier Hotel in Las Vegas. The group parted on strained terms, with Diana Ross pursuing a solo career and the remaining Supremes continuing with Jean Terrell as their new lead singer. They ultimately broke from fulltime recording and performing in 1977 to pursue their own solo careers. The Supremes have had many lineup changes over the years, but they always maintained at least one original member of the group. The only Supreme to experience the group's entire history was Mary Wilson (March 6, 1944–February 8, 2021).

Supremes Lineup (original members in bold)
- **Diana Ross** (1959–1970)
- **Mary Wilson** (1959–1977)
- **Florence Ballard** (1959–1967)
- Cindy Birdsong (1967–1972, 1973–1976)
- **Betty McGlown** (1959–1960)
- Barbara Martin (1960–1962)
- Jean Terrell (1970–1973)
- Lynda Laurence (1972–1973)
- Scherrie Payne (1973–1977)
- Susaye Greene (1976–1977)

Recommended Listening

- The Tears of a Clown—Smokey Robinson and the Miracles
- ABC—the Jackson Five
- I'll Be There—the Jackson Five
- Ain't No Mountain High Enough—Diana Ross

Marvin Gaye

Marvin Gaye's career came to an abrupt end when he was shot by his father in 1984

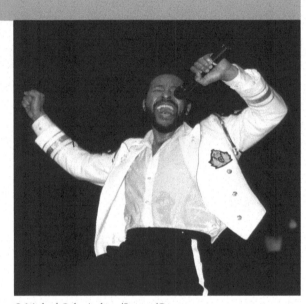

© Michael Ochs Archives/Stringer/Getty

1971

The Motown Company launched a series of successful television features with *Diana, Goin' Back to Indiana* (the Jackson Five) and a Jackson Five cartoon series. Marvin Gaye finally took creative control of his records and released his solo album *What's Goin' On*, which sold over one million copies upon release. Three songs from the album reached #1 on the R & B charts and also the top ten on the pop charts ("What's Goin' On," "Inner City Blues" and "Mercy, Mercy Me"). Gaye's career flourished under his own direction and motivation until April 1, 1984, when his father shot and killed him during an argument.

Recommended Listening

- Just My Imagination—the Temptations
- What's Goin' On—Marvin Gaye

1972

Diana Ross portrayed Billie Holiday and received an Academy Award in the movie about Holiday's life, *Lady Sings the Blues*. With the thriving L.A. music scene, Berry Gordy decided to close the Detroit studio and offices of Motown in June 1972. This decision effectively ended the heyday of the Motown label as Gordy focused his attention on a new direction in music production. The musicians and artists that resided in Detroit and who had worked for the label for many years received little notice. Many of the musicians heard on Motown's biggest hits went back to regular jobs and playing casual jazz gigs around the city.

Recommended Listening

- Papa Was a Rollin' Stone—the Temptations
- Ben—Michael Jackson

1973

Berry Gordy resigned as president of Motown in 1973, although he still played a very active role in running the company. Under new direction, the hits continued to pour out, with new talent discovered and signed. Stevie Wonder released the album *Innerversions*, which won him five Grammy Awards.

Recommended Listening

- Superstition—Stevie Wonder
- You Are the Sunshine of My Life—Stevie Wonder
- Let's Get It On—Marvin Gaye
- Keep On Truckin'—Eddie Kendricks
- Touch Me in the Morning—Diana Ross

1974–1988

At the dawn of a new Motown era, Stevie Wonder (the link from the Detroit era) had the only #1 record with *Fulfillingness' First Finale*. This again earned him five Grammy Awards. Ultimately, Stevie Wonder had nine U.S. number-one hits and more than thirty top ten hits; he has won twenty-five Grammy Awards and sold over fifty million records. In 1975, Motown diversified even further to include country artists, Latin music and several mainstream pop artists. Lionel Richie and the Commodores signed with the label in 1976 and became the best selling act in the remaining portion of the decade. Stevie Wonder received four more Grammys for the album *Songs in the Key of Life* and continued his success with several #1 selling singles. Thelma Houston joined Motown in 1971 after a moderately successful career on previous labels. Her songs struggled to chart until 1977 when she had a #1 hit with "Don't Leave Me This Way." Rick James joined Motown in 1977 and sold two million copies of his first album *Come and Get It* followed by *Street Songs* in 1981. In 1984, Lionel Richie released the biggest selling album in Motown history with *Can't Slow Down*, which sold over ten million copies.

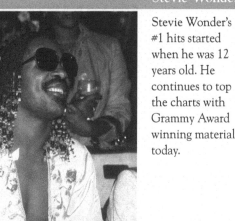

Stevie Wonder

Stevie Wonder's #1 hits started when he was 12 years old. He continues to top the charts with Grammy Award winning material today.

© *Chris Walter/Contributor/Getty*

In June 1988 Berry Gordy retired and sold his interest in the Motown conglomerate, but he retained ownership of the Jobete publishing catalog. Smokey Robinson stepped down as vice president at the same time. Many have dubbed Gordy the most successful black businessman of the twentieth century, a man who turned an eight hundred dollar loan into over 367 million dollars in personal wealth in just sixteen years. Under Gordy's direction Motown had 110 Top Ten hits from 1961 to 1971 and became known as "the sound of young America." Motown produced more #1 hits during the 1960s than any other label in recording history and earned a timeless reputation through radio plays, TV shows and commercials, as well as in many movies. Since Gordy's retirement from Motown, the label has produced such popular artists as Boyz II Men, Brian McKnight, Erykah Badu, Michael McDonald, Trick Trick and Lindsay Lohan.

Recommended Listening

- You Haven't Done Nothin'—Stevie Wonder (1974)
- Boogie on Reggae Woman—Stevie Wonder (1975)
- Love Machine—the Miracles (1976)
- Sir Duke—Stevie Wonder (1977)
- Got to Give It Up—Marvin Gaye (1977)
- Three Times a Lady—the Commodores (1977)
- Still—the Commodores (1979)
- Upside Down—Diana Ross (1980)
- Endless Love—Diana Ross and Lionel Richie (1981)
- Ebony and Ivory—Paul McCartney and Stevie Wonder (1983)

Rock and Roll Hall of Fame Inductions

Smokey Robinson—1987
Jackie Wilson—1987
Marvin Gaye—1987
Berry Gordy—1988
The Supremes—1988
The Temptations—1989
Stevie Wonder—1989
The Four Tops—1990
Holland, Dozier, Holland—1990
Isley Brothers—1992
Martha and the Vandellas—1995
Gladys Knight and the Pips—1996
The Jackson Five—1997

Motown in the Songwriters Hall of Fame

Lamont Dozier	Barrett Strong
Brian Holland	Nickolas Ashford and Valerie Simpson
Edward Holland	Norman Whitfield
Smokey Robinson	

Trivia

- Berry Gordy originally wanted to name his Tamla label "Tammy" after a Debbie Reynolds film.

- Jackie Wilson suffered a massive heart attack while performing on stage in 1975 in New Jersey. He survived the heart attack, but he remained in a comatose state for eight years, and consequently died, due to falling directly on his head when the heart attack struck.

- The Primettes (better known as the Supremes) named themselves after the male vocal group the Primes. The Primes changed their name to the Distants and finally the Temptations.

- Smokey Robinson served for a long time as the vice president of Motown and later named his daughter "Tamla" and his son "Berry" out of gratitude to Gordy.

- When Mary Wells got diagnosed with throat cancer and depleted her savings, sold her house and borrowed money to cover the cost of treatment, her friends Diana Ross, Mary Wilson and Martha Reeves supported her financially and emotionally until her death in 1992.

- It was on the Motown twenty-fifth anniversary TV special in 1983 that Michael Jackson introduced his famous "moonwalk."

- The twenty-fifth anniversary special also saw the closest we would come to a Supremes reunion with Diana Ross, Mary Wilson and Cindy Birdsong singing together.

The Funk Brothers 1959–1972

"The Funk Brothers" is the name given to the group of session musicians that provided the backing music for all of the Detroit Motown recordings. They are an integral part of the Motown sound and give each artist or group a familiarity for fans to latch onto that enhanced the unique quality of the vocalists and songs. The Funk Brothers were all hand-selected jazz musicians with exceptional talent for quickly learning songs and the traits of the artists they were supporting. They became well known for their ability to record tracks with near perfection on the first take and usually in a "live" studio setting (as opposed to laying down one instrument at a time). Many musicians worked the hitsville studio as a Funk Brother, but a handful of musicians stood out as the "first call" band for Motown (listed under "The Key Funk Brothers"). The rhythm section, keyboards, guitar, bass, drums and percussion were the heart and soul of the Motown signature sound, which a world-class horn section (trumpet, trombone, saxophones and flutes) then reinforced.

The basement of Gordy's house (Hitsville USA) was home to "studio 1," a crude working room with a dirt floor where the musicians spent many hours a day recording some of the world's biggest hit songs. The Funk Brothers called that basement studio "the snake pit." During the thirteen years that they sweated out hundreds of hard grooving tracks, these musicians spent long days recording and then went out to play in the local Detroit jazz clubs at night. Earl Van Dyke (keyboard), Benny Benjamin (drums) and James Jamerson (bass) are probably the most important members of the Funk Brothers. They created the soulful grooves and melodic bass lines that characterized the band's sound and set the bar for quality on the Motown records. Benjamin would introduce each song he played with a signature

trademark lick, a technique duplicated by drummers Uriel Jones and Pistol Allen. When listening to a Motown record, you can identify which drummer played on the session by those trademark licks.

The Funk Brothers rarely received credit on the Motown records, and until the movie documentary *Standing in the Shadows of Motown* was released in 2002, many fans had no idea who was playing in the band of their favorite artists. Berry Gordy left the musicians' names out of the record liner notes for two reasons. First, he believed the term "funk" brought a negative connotation to the Motown image, and second, he did not want anything to detract from the artist he was promoting.

To understand the Motown sound and the roots of the amazing music produced during the Detroit years, review the movie *Standing in the Shadows of Motown*. This movie documents the lives of the musicians and the history of the music recorded between 1959 and 1972, and it provides great insight into the success of the Motown artists.

The Key Funk Brothers

Keyboards

Joe Hunter (Nov. 19, 1927–Feb. 2, 2007), band leader **1959–1964**
Earl Van Dyke (July 8, 1930–Sept. 18, 1992), band leader **1964–1972**
Johnny Griffith (July 10, 1936–Nov. 10, 2002), **1963–1972**

Guitarists

Robert White (Nov. 19, 1936–Oct. 27, 1994), **1959–1972**
Eddie "Chank" Willis (June 3, 1936–August 20, 2018), **1959–1972**
Joe Messina (Dec 13, 1928–April 4, 2022), **1959–1972**

Bassists

James Jamerson (Jan. 29, 1936–Aug. 2, 1983), **1959–1972**—inducted into the Rock and Roll Hall of Fame in 2000
Bob Babbitt (Nov. 26, 1937–July 16, 2012), **1967–1972**

Drums

William "Benny" Benjamin (July 25, 1925–April 20, 1969), **1959–1969**—inducted into the Rock and Roll Hall of Fame in 2003
Richard "Pistol" Allen (Aug. 13, 1932–June 30, 2002), **1959–1972**
Uriel Jones (June 13, 1934–March 24, 2009), **1963–1972**

Vibes/Percussion

Jack Ashford (born May 18, 1934), **1959–1972**
Eddie "Bongo" Brown (Sept. 13, 1932–Dec. 28, 1984), **1959–1972**
John "Jack" Brokensha (Jan. 5, 1926–Oct. 28 2010), **1963–1972**—Jack Brokensha was an Australian vibraphone player and percussionist.

Trivia

- The Funk Brothers played on more number-one records than The Beatles, Elvis, The Rolling Stones, and The Beach Boys combined.
- The Funk Brothers received a Grammy Lifetime Achievement Award in 2004.
- When Marvin Gaye first joined Motown, he played drums (1959–1962) and sang backing vocals.
- Stevie Wonder would hang around the studio when he was young, learning how to play a variety of instruments from the Funk Brothers. He also sat in on many sessions, often being recorded in the backing band.
- Marvin Gaye's album *What's Going On* was the first record to credit the Funk Brothers by their individual names.
- When the Funk Brothers started recording for Motown, their pay was just $10 per song. This scale did improve over time. To avoid wasting time in the studio, the incentive was to record more songs well and earn better money in each session.
- When James Jamerson tried to get into the theatre for the twenty-fifth anniversary of Motown in 1983, he had to pay for a ticket and stand in the audience. He died shortly thereafter with hundreds of recording credits, twenty-five of them #1 hits.

Soul and Funk

"Soul" refers to a style of music that evolved as an expression of the need for social change in America (particularly in the South), which came to a critical point in the late 1950s and early 1960s. This era brought hundreds of years of civil inequality, Jim Crow laws and racial prejudice to the breaking point through a variety of events, written actions to the government, and rallies, protests, and riots for human rights. Many Americans made a stand for the desegregation of schools, restaurants, public transport, drinking fountains and other amenities. Soul music supported and expressed people's needs by voicing these concerns, uniting the population and often maintaining peace when things reached the boiling point. Some of the crucial events in the timeline that eventually forced social and constitutional change in America include:

- In 1909, W. E. B. Du Bois founded the National Association for the Advancement of Colored People (NAACP) and spoke out about civil rights.

- A 1955 controversial court case followed Rosa Parks' arrest in Montgomery, Alabama, for disobeying a city law that required blacks to give up their seats to white people and to sit in the back seats of buses.

- In 1957, riots and civil outcry exploded when Autherine Lucy, who was the first black student admitted to the University of Alabama, was expelled after white students rioted. President Dwight D. Eisenhower eventually used federal troops to enforce the court order allowing blacks to enter the campus and attend classes.

- In August 1963, two hundred thousand people gathered for The March on Washington, where Martin Luther King, Jr., gave his famous "I Have a Dream" speech demanding a change in national policies and laws in order to remove discrimination against blacks and segregation in public places.

- On February 21, 1965, Malcolm X was assassinated during National Brotherhood Week, just one year after he formed the Muslim Mosque, Inc, based on the Nation of Islam's religious beliefs.

- 1965–1968: Riots erupted in the Watts section of Los Angeles in 1965, in Detroit and Newark in 1967 and in Cleveland in 1968. The Detroit riot was the most violent, with

millions of dollars in damage, 43 deaths, 467 injuries, over 7,200 arrests and 2,000 buildings and houses burned down. It took five days, 8,000 National Guardsmen, 4,700 paratroopers, tanks, helicopters, and 360 police officers to bring the city under control.

- April 4, 1968: Martin Luther King's assassination took the life of the strongest proponent and most public figure of the civil rights movement.

Although elements of soul music were present in such musical genres as jazz, blues, folk and the other performing and visual arts, the soul artists and music in this chapter represent those who made their voices heard through rock and roll. Soul music puts rhythm, feel and groove to the themes of the civil rights protests and the need for political and social change. The roots of soul music come directly from gospel and doo-wop, with innovators like the Ink Spots, Mahalia Jackson, Clyde McPhatter, Jackie Wilson and Ray Charles. These artists and many others led the development of soul in the early 1940s to mid-1950s, paving the way for Sam Cooke, Otis Redding, Wilson Picket and James Brown to flourish in the late 1950s and 1960s. Just as W. E. B. Du Bois, Rosa Parks, Malcolm X and Dr. Martin Luther King led the way to desegregation in America, soul music effectively supported the public events of the civil rights movement and the protests for equality, and it promoted the coming of age of black pride.

As soul took hold as a popular style of music and impacted the R&B and pop charts, another genre emerged with even deeper roots: funk music. Funk was born out of the soul style and carries many similar elements and themes, though it has one major difference. Funk brought rhythm and harmony back into popularity through the influence of African rhythm and groove, which originally inspired the founding of the blues a century earlier. In addition to the soul influence, funk makes use of many elements of traditional Cajun and New Orleans style music. Early examples of the funk style are evident in Professor Longhair's *Tipitina* (1953) and the Hawkettes' *Mardi Gras Mambo* (1954). Utilizing clean, syncopated sixteenth note guitar riffs, heavy bass lines, a strong downbeat from the drums and polyrhythmic horn lines, funk music continued the civil rights cause through social commentary from artists like James Brown and Marvin Gaye. But it also laid the foundation for dance, disco, rap, fusion and many other forms of music.

Through soul and funk music, the anger, hurt, need for peace and desperation to unite people was captured on record, played over the airwaves and brought to the people in live concerts. Ultimately, it had a positive influence toward civil unity, desegregation and improving the rights and living conditions of all Americans.

Recommended Listening

- We Shall Overcome, Mahalia Jackson
- Tipitina, Professor Longhair
- Mardi Gras Mambo, the Hawkettes

Sam Cooke

Sam Cooke (January 22, 1931–December 11, 1964) was the son of a Baptist minister in Clarksdale, Mississippi, but he grew up in the Chicago area. In 1946, he began performing with a teenage gospel group called the Highway QC's, followed in 1950 with another gospel quartet called the Soul Stirrers. The Soul Stirrers brought Cooke into the limelight as an

important gospel artist in his early twenties. In the mid-1950s, he left the Soul Stirrers and began to record more secular music. In 1956, he had a minor hit with "Lovable," but it was his second release, "You Send Me," that went to #1 in 1957 and solidified his popularity as a rising soul artist. Cooke became a mainstay on the pop charts, with twenty-nine hits making the top 40 before his untimely death in 1964. These included "Chain Gang," "Twistin' the Night Away" and "Shake." Sadly, the manager of an L.A. hotel shot Cooke in a confusing and suspicious situation. His posthumous release "A Change is Gonna Come" became a civil rights anthem and was inspired by Bob Dylan's "Blowin' in the Wind." He is generally considered the father of modern soul music and one of the first singers to develop the gospel singing style into a modern soul style.

Sam Cooke was inducted into the Rock and Roll Hall of Fame in 1986, and we cannot overstate his influence on defining 1960s soul artists.

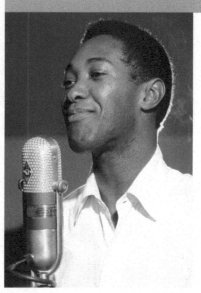

Sam Cooke

Sam Cooke, the father of modern soul music

© Michael Ochs/Stringer/Getty

Recommended Listening

- You Send Me (1957)
- A Change Is Gonna Come (1964)

Trivia

- It was very controversial for a gospel singer to move to secular music as Cooke did in the mid-1950s

Otis Redding

Otis Redding (September 9, 1941–December 10, 1967) was born in Dawson, Georgia (near Macon, Georgia), where he sang in the Vineville Baptist Church choir. Redding began his singing career backing Little Richard after dropping out of high school in the tenth grade. In 1960, he started touring the "Chitlin' Circuit" with Johnny Jenkins and The Pinetoppers, and, in 1962, he recorded his first hit song "These Arms of Mine" for Stax Records in Memphis. Volt Records (a Stax subsidiary) quickly signed Otis Redding, and, by 1965, he was enjoying success on the R&B charts with hits like "Mr. Pitiful" and "I've Been Loving You Too Long." In 1965, Redding wrote and recorded "Respect" (covered by Aretha Franklin in 1967) and recorded a funky soul version of the Rolling Stones' "Satisfaction" in 1966. Redding's 1967 appearance at the Monterey Pop Festival, performing opposite Janis Joplin, The Who and Jimi Hendrix, won over a young white following, but this success seemed to come too late. Redding and four members of his live band, the Bar-Kays, died in a plane

Otis Redding

Otis Redding, one of the great crossover soul artists

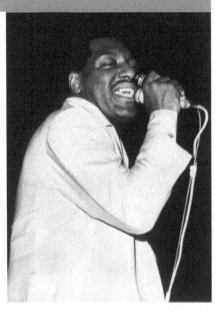

© Michael Ochs Arcive/Stringer/Getty Images

crash near Madison, Wisconsin, on December 10, 1967, only days after recording what would become his largest hit, "Dock of the Bay," which reached #1 on the pop charts in 1968. Otis Redding influenced black and white singers aspiring to sing soul, and his crossover success helped white American and European audiences to accept soul music. Redding was inducted into the Rock and Roll Hall of Fame in 1989.

Recommended Listening

- These Arms of Mine (1962)
- I Can't Turn You Loose (1965)
- Respect (1965)
- Satisfaction (1966)
- Dock of the Bay (1970)

Trivia

- In 1993, the U.S Post Office issued an Otis Redding 29-cent commemorative stamp.

Wilson Picket

Wilson Pickett (March 18, 1941–January 19, 2006) was born in Alabama and grew up singing in church gospel groups. After his family moved to Detroit in 1955, he continued singing in gospel groups until he joined the Falcons in 1959. Pickett spent the years from 1959 to 1964 honing his sound singing both with the Falcons and as a solo artist. In 1964, he signed a deal with Atlantic Records. During the next couple of years, Pickett recorded almost all of the major hits of his career at the Fame Studios in Muscle Shoals, Alabama,

and at Stax studios in Memphis, Tennessee. His hit, "In the Midnight Hour," signaled a new stripped-down R&B sound that reinforced the emerging funky soul sound. In 1970, Pickett worked in Philadelphia with Gamble and Huff, who were an integral part of the developing Philadelphia pop sound. Pickett has remained mostly out of the limelight since the mid-1970s, but he continued to perform occasionally until 2006. He released a new album in 1999 titled *It's Harder Now*. Wilson Pickett recorded more than fifty songs that made the top 40 on the pop charts, and he was inducted into the Rock and Roll Hall of Fame in 1991.

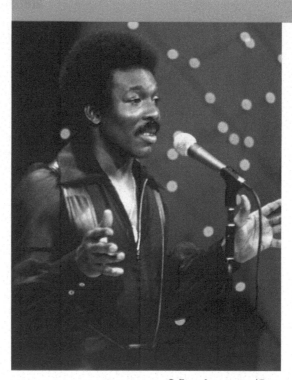

© Fotos International/Getty

Wilson Pickett

Wilson Pickett added to the pop element of soul music with his hit "In the Midnight Hour"

Recommended Listening

- In the Midnight Hour (1965)
- Land of 1000 Dances (1966)
- Mustang Sally (1966)
- Funky Broadway (1967)
- Engine Number 9 (1970)

Trivia

- While on a lunch break from recording at Fame studios, one of the sound engineers suggested that Pickett do a cover of the Beatles' "Hey Jude." Pickett learned the song after lunch and recorded a gritty R&B version of the song that afternoon. Featured on that recording was a young guitarist working at the Fame Studios named Duane Allman, who went on to found the Allman Brothers.

Aretha Franklin

Lady Soul, Aretha Franklin

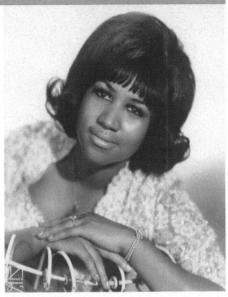

© *Michael Ochs Archive/Stringer/Getty Images*

Aretha Franklin

Aretha Franklin, aka Lady Soul (March 25, 1942–August 16, 2018), is the daughter of Reverend C. L. Franklin, a nationally famous preacher. Aretha toured the country with her father during her childhood, developing her vocal style while working with many major gospel and secular artists. Aretha's time on the road as a youth gave her worldly experience that most young singers lacked. By age eighteen, when she started her singing career, she had experienced everything from discrimination to childbirth. When she initially signed with Columbia Records, she was forced to sing pop ballads, which were not commercially or artistically successful. Columbia eventually sold her contract to Atlantic in 1966, and her career immediately picked up when Jerry Wexler took her to Fame Studios in Muscle Shoals, Alabama, to record. Her initial hits in the 1960s are still her most popular work, but her more recent material has captured the attention of a whole new generation of fans. Aretha's signature traits are the combination of a powerful voice with a personal and intimate sound that inspired and promoted the role of the female vocalist. Aretha was inducted into the Rock and Roll Hall of Fame in 1987 and recognized with a Grammy Lifetime Achievement Award in 1994.

In 2003 she founded her own record label Aretha Records, and, in 2005 received the Presidential Medal of Freedom. She has been the focus of documentary films, sung for the inauguration of Presidents (Clinton and Obama), and won a staggering 18 Grammy Awards. In 2017 Franklin said that she was retiring from entertainment, but still maintained a close eye on her creative work, which, in 2019, posthumously won her a Pulitzer Prize for five decades of contribution to the Arts. Before her passing she specifically chose Jennifer Hudson to portray her life in the much anticipated biopic *Respect* (released in October 2020). Aretha Franklin died from complications surrounding pancreatic cancer on August 16, 2018, but will forever be known as the Queen of Soul.

Recommended Listening

- I Never Loved a Man (the Way I Love You) (1967)
- Respect (1967)
- Think (1968)
- The House that Jack Built (1968)
- Spirit in the Dark (1970)

Trivia

- Aretha went to Muscle Shoals, Alabama, in 1967 to record her first hit, "I Never Loved a Man (the Way I Love You)." The band literally put the song together on the spot and captured it in only a couple of takes. Unfortunately, a fight broke out in the studio, and Aretha left before recording any more songs.

James Brown

James Brown (May 3, 1933–December 25, 2006) is a songwriter, bandleader and record producer who singlehandedly created funk music. He is often referred to as "the Godfather of soul" or "the hardest working man in show business" and influenced Motown artists, jazz innovator Miles Davis, Sly and the Family Stone, New Orleans funk, Tower of Power, disco, hip hop, dance music, house music, rock and rap music. In 1955, Brown joined the Gospel Starlighters, which evolved into the more secular Famous Flames. The Famous Flames signed with Federal Records and released the single "Please, Please, Please" in 1956, which reached #5 on the R&B charts. By 1958, the group was re-named James Brown and the Famous Flames. In 1963, Brown released *Live at the Apollo* (on King Records), a self-financed album that stayed on the pop charts for fourteen months.

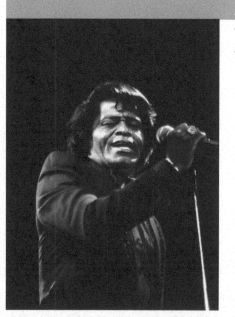

James Brown

The Godfather of soul, James Brown

© David Redfern/Staff/Getty Images

In June 1965, James Brown released "Papa's Got a Brand New Bag," which introduced a new sound, emphasizing the bass and drums, that paved the way to funk. "I Got You (I Feel Good)," released in October 1965, reinforced the funk sound and took the traditional drive of rock away from the two and four backbeat, making the downbeat of each measure the strongest part of the groove. Other significant James Brown releases that shaped the funk style include "Cold Sweat" (1967), "Funky Drummer" (1968), which contains the most sampled drum groove in hip hop and rap music, "Sex Machine" (1970), "Papa Don't Take No Mess" (1974), "Get Up off a That Thing" (1976) and "Living in America" (1985). Brown also had many influential musicians in his band, including saxophonist Maceo Parker, guitarist Jimmy Nolen, drummer John "Jabo" Starks and bass great Bootsy Collins.

James Brown was a key figure during the 1960s civil rights movement, inspiring a new sense of black pride. After Martin Luther King's assassination on April 4, 1968, he played a televised free concert in Boston to help calm the city. Brown's music has stayed relevant well into the twenty-first century, and he continued performing live shows until his death on December 25, 2006. James Brown's awards include a Grammy Award in 1966 for Best R&B recording with "Papa's Got a Brand New Bag," induction in the Rock and Roll Hall of Fame in 1986, a Lifetime Achievement Award in 1992 and induction in the UK Hall of Fame in 2006. He also received a star on Hollywood's Walk of Fame in 1997.

Recommended Listening

- Please, Please, Please (1956)
- Papa's Got a Brand New Bag (1965)
- I Feel Good (1965)
- Cold Sweat (1967)
- Sex Machine (1970)
- Papa Don't Take No Mess (1974)

Trivia

- James Brown's band members (the JB's) reported that Brown would fine them for mistakes—$50 per mistake. This contributed to his having one of the best bands of his time.

- James Brown's entire band walked out on him in 1969, citing his being "too difficult to work with." He replaced them with the Pacemakers, a band from Cincinnati that stayed with him through the 1970s.

- James Brown comes in second behind Elvis Presley for most hit singles in his career.

- After an argument with his wife Adrienne one day, James Brown threw all of her fur coats on the lawn and blasted them with a shotgun.

- "Everybody's got soul! Everybody doesn't have the same culture to draw from, but everybody's got soul."—James Brown

Isaac Hayes

Isaac Hayes was the first African American to win an Academy Award in a non-acting category

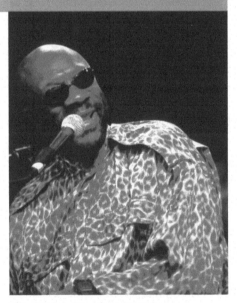

© Ian Dickson/Contributor/Getty Images

Isaac Hayes

Isaac Hayes (August 20, 1942–August 10, 2008) was an actor, singer and songwriter who recorded for several labels, including Stax, Atlantic, Enterprise, ABC and Columbia. Hayes was one of the main roots of the Memphis Sound and had an enormous influence on disco and soul music.

Isaac Hayes first recorded at Stax Records in late 1963, and then continued as a session player on piano and saxophone and sometimes writer/arranger. Hayes and Stax producer David Porter (together credited as the "Soul Children") started writing and arranging in 1966 with successful hits such as "Hold On! I'm Comin'" and "Soul Man" (written for Sam & Dave), which were among over 200 Hayes-Porter songs that became soul and disco standards.

In the summer of 1969, Hayes released his acclaimed album *Hot Buttered Soul*, which stayed on the charts for 81 weeks (10 weeks at #1). He followed this with seven #1 R&B albums in five years and 20 charting albums by 1980. His famous 1971 *Shaft* movie theme song and accompany-ing album became the first

album in history by a solo black artist to reach #1 on both the Pop and R&B charts, winning him three Grammy awards, a Golden Globe award, the NAACP Image Award, and Europe's Edison award. *Shaft* made Hayes the first African-American composer to win an Oscar for Best Musical Score, and also became a hit television series in 1973.

As an actor Hayes appeared in TV shows such as *The Rockford Files*, *The A-Team*, *Hunter*, *Miami Vice*, *Tales From the Crypt*, *The Fresh Prince Of Bel-Air*, *Sliders*, *The Hughleys*, *The Education of Max Bickford*, *Fastlane* and *Stargate: SG-1*. His movie credits include *Escape from New York*, *Jailbait*, *Counterforce*, *Dead Aim*, *Final Judgment*, *Robin Hood: Men In Tights*, *It Could Happen To You*, *Flipper*, *Reindeer Games*, *Dr. Dolittle 2* and a revised version of *Shaft* with Samuel L. Jackson in 2000.

Isaac Hayes is often credited with being the first person to turn chains (once a symbol of slavery and degradation) into ornaments and stage wear. Hayes worked with many great artists over the years including Sam & Dave, Otis Redding, Booker T & the MGs, the Mar-Keys, the Bar-Kays, Rufus & Carla Thomas, Dionne Warwick , Donald Byrd, Barry White, B.B. King, Eric Clapton, Bo Diddley, Dr. John, Billy Preston and Lou Rawls. Hayes also had genre-defining albums with *The Isaac Hayes Movement*, *. . . To Be Continued*, *Black Moses* for Stax, *Chocolate Chip* for HBS and *U-Turn* and *Love Attack* for Columbia.

Hayes is an accomplished author, creator of a cookbook, radio personality, and voice actor for the famous cartoon series *South Park* as the character "Chef" until he suddenly left the show following an episode that satirized his religion, Scientology. His music has been sampled over 200 times and used on recordings by Dr. Dre, Snoop Dogg, Destiny's Child, Portishead, TuPac Shakur and Notorious B.I.G. He was inducted into the Rock & Roll Hall of Fame in 2002 and the Songwriters Hall of Fame in 2005. Isaac Hayes died on August 10, 2008 after suffering a stroke (he had experienced a mild stroke in 2006).

> *"There is a place in this world for satire, but there is a time when satire ends and intoler-ance and bigotry towards religious beliefs of others begins. Religious beliefs are sacred to people, and at all times should be respected and honored. As a civil rights activist of the past 40 years, I cannot support a show that disrespects those beliefs and practices."*

—**Isaac Hayes on why he quit** *South Park* **(1997) in 2006**

Recommended Listening

- Theme from Shaft
- Do Your Thing
- Walk On By

Trivia

- Hayes was the voice of Chef on the animated sitcom South Park, a role originally created for Barry White.
- Hayes dropped out of high school, but later he earned his diploma at age twenty-one.

Sly & The Family Stone

Members
- **Sly Stone** (born March 15, 1943), vocals
- **Freddie Stone** (born June 5, 1947), guitar
- **Cynthia Robinson** (January 12, 1946–November 23, 2015), trumpet
- **Gregg Errico** (born September 1, 1948), drums
- **Jerry Martini** (born October 1, 1943), saxophone
- **Larry Graham** (born August 14, 1946), bass
- **Rose Stone** (born March 21, 1945), keys

Sly Stone and his brother Freddie fronted a group of family and friends that combined soul, funk and psychedelic music into an energized new style of funk music. They adopted the name Sly & The Family Stone in 1966 and attracted the interest of industry great Clive Davis, who signed them to CBS records. After a slow start on the charts, the "Stone" sound took off with such hits as "Dance to the Music," "Everyday People," "Sing a Simple Song," "I Want to Take You Higher," "Thank You (Falettinme Be Mice Elf Agin)," "Family Affair" and "If You Want Me to Stay." Bassist Larry Graham is credited with inventing the "slap" bass technique that became popular in funk music. Due to internal difficulties with members of the band, the Family Stone broke up in 1975 only to perform together again in a brief tribute in their honor at the 2006 Grammy Awards. (Sly only appeared onstage for a portion of "I Want to Take You Higher.") Sly went on to a fairly successful career with Warner Bros. Records, and other members of the group had fleeting success with other bands. Sly & The Family Stone were inducted into the Rock and Roll Hall of Fame in 1993 and received the R&B Foundation Pioneer Award in 2001.

Sly & The Family Stone

Sly & The Family Stone are one of the first successful American bands to feature an integrated line-up

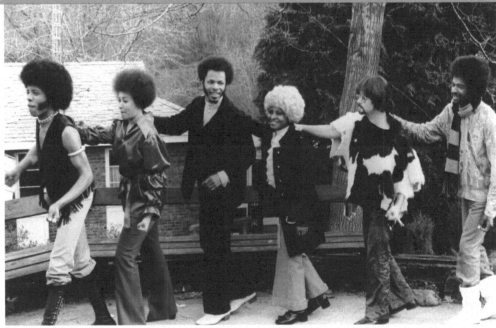

© *Michael Ochs Archives/Stringer/Getty Images*

Recommended Listening

- Dance to the Music, 1966
- Everyday People, 1968
- Stand!, 1969
- Sing a Simple Song, 1969
- Thank You (Falettinme Be Mice Elf Agin), 1969
- I Want to Take You Higher, 1970
- Family Affair, 1971
- If You Want Me to Stay, 1973

Trivia

- Sly & The Family Stone are one of the first major American rock bands to have an integrated lineup in both race and gender.

The Meters/ The Neville Brothers

The Meters Lineup
- Art Neville (December 17, 1937–July 22, 2019), keyboards/vocals
- Aaron Neville (born January 24, 1941), keyboards/vocals
- George Porter, Jr. (born December 26, 1947), bass/vocals
- Leo Nocentelli (born June 5, 1946), guitar
- Joseph "Ziggy" Modeliste (born December 28, 1948), drums
- Cyril Neville (born October 10, 1948), percussion/vocals

The Neville Brothers Lineup
- Art Neville (December 17, 1937–July 22, 2019), keyboards/vocals
- Charles Neville (December 28, 1938–April 26, 2018), saxophone
- Aaron Neville (born January 24, 1941), keyboards/vocals
- Cyril Neville (born October 10, 1948), percussion/vocals
- Ivan Neville (born August 19, 1959), multi-instrumentalist

The Meters are one of the first New Orleans style funk bands that successfully blended the traditional New Orleans "second line" sound with doo-wop, New Orleans R&B, blues, soul, Caribbean rhythms, funk, jazz and rock elements. Their unique style has influenced artists ranging from the Rolling Stones and the Allman Brothers to the Grateful Dead, Santana, the Red Hot Chili Peppers, Phish and a new genre of jazz-funk adopted by John Scofield, Mike Stern, Martin, Medeski and Wood and others. The Meters are also one of the inspiring forces of the "Jam Band" scene.

"Papa Funk" Neville first hit the funk scene in 1966 when he created Art Neville and The Neville Sounds with his brothers Aaron and Cyril and Leo Nocentelli, George Porter, Gary Brown and Joseph "Zigaboo" Modeliste (one of funk's most influential drummers). A new formation of the band, called The Meters, emerged by 1969 with the departure of

The Meters

The Meters became known as a great backing band through their work for artists such as Dr. John, Paul McCartney and Robert Palmer.

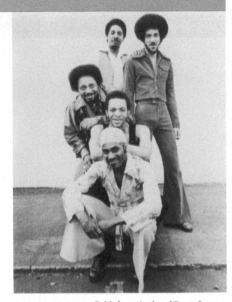

© *Hulton Archive/Getty Images*

Aaron and Cyril from the band and began recording for producer Allen Toussaint. In 1969, The Meters released "Cissy Strut," an instrumental funk tune that instantly became popular. The Meters also released their first album, *The Meters*, in 1969, followed by a series of classic New Orleans funk albums. These included *Look-Ka Py Py* (1970), *Cabbage Alley* (1972), *Rejuvenation* (1974) and *Fire on the Bayou* (1975). The Meters have also performed as the studio backing band for several leading artists, including Dr. John, Patti Labelle, the Wild Tchoupitoulas, Paul McCartney and Robert Palmer.

By 1978, The Meters disbanded, and Art Neville moved forward with another family-based band he had formed in 1977: The Neville Brothers, with Aaron, Charles and Cyril Neville. Upon the release of their first official album, *The Neville Brothers*, the group became known as "New Orleans' first family of funk." In 1981, The Neville Brothers released *Fiyo On the Bayou* on A&M records, which Keith Richards called "the best album of the year." The Nevilles' critically acclaimed 1989 release, *Yellow Moon*, featured the Dirty Dozen Brass Band and is their best-selling album. In 1994, Art formed the Funky Meters to revisit some of the original Meters songs and musical concepts, and then he reformed the Original Meters in 2004 for the Vegoose Festival and a series of special concerts. Art Neville is considered the father of New Orleans Funk and is one of the world's great organists, singers and songwriters. Though the Nevilles were producing great music in the late 1970s and early 1980s, the public was

The Neville Brothers

New Orleans' first family of funk, The Neville Brothers

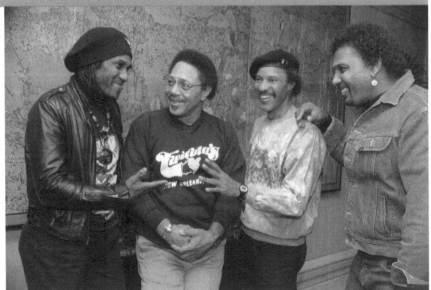

© *AP/Wide World Photos*

slow to learn of the group due to poor marketing and publicity. In the early 1980s, the Nevilles were considered the best kept secret in the music industry. They are still active today with live performances, recording and a strong international following.

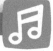

Recommended Listening

- Cissy Strut—The Meters
- Fiyo On the Bayou—The Meters
- Hey Pocky Away—The Meters
- Brother John/ Iko Iko—The Neville Brothers
- Yellow Moon—The Neville Brothers
- Tell it Like is—The Neville Brothers

Trivia

- Before Amelia, the Neville Brothers' mother, passed, she asked Art to "keep the brothers together." That is when Art decided to bring the brothers together as a performing group.
- Aaron Neville has been awarded three Grammy Awards in 1984, 1989 and 1990.

Earth, Wind and Fire

Maurice White (December 19, 1941–February 4, 2016) formed Earth, Wind and Fire (aka EWF) in 1969 in Los Angeles, and it has become one of the most successful music groups in the pop/funk genre. Through the various versions of the band, EWF has featured Fred and Verdine White, Maurice's brothers. Maurice White was a drummer for the Chess record company and later for jazz pianist Ramsey Lewis before forming EWF. His goal was to form a band that blurred the lines between musical genres, but would still achieve financial and charting success. Initially, the band went through several lineup changes and earned only moderate chart success before breaking through to the mainstream in 1974 with the song "Shining Star." They originally recorded "Shining Star" as a supporting song for the movie *That's The Way Of The World* (that featured EWF as "the group"), but it turned out to be more successful than the movie itself. In the late 1970s, EWF made use of lasers, pyrotechnics, light shows and levitating guitarists to enhance their stage show experience.

Earth, Wind and Fire

Earth, Wind and Fire broke through to mainstream success in 1974 with "Shining Star"

© AP/Wide World Photos

EWF has been nominated for over twenty Grammy Awards (winning eight), they have a star on the Hollywood Walk of Fame (1995), and they were inducted into the Rock and Hall of Fame in 2000 and the Vocal Hall of Fame in 2003.

Recommended Listening

- Shining Star
- September
- In the Stone
- Let's Groove

Trivia

- The band's name came from White's astrological sign (Sagittarius), which has the elements of fire, earth, and air.
- Throughout EWF's history, the band has had over fifty different members.

Barry White

Barrence Eugene Carter, aka "Barry White" (September 21, 1944–July 4, 2003), became a popular soul artist in the early 1970s with his smooth approach to soul music. His music is often cited as the "music for love" and his deep baritone voice is considered "classic soul," transcending the music itself. Many consider the song "Love's Theme" (1974) the first disco song, and "Love Serenade (Part 1)" is representative of White's spoken word introductions/breakdowns that he often includes in his songs to serenade the listener. He is also famous for his dream-size backing orchestra, the Love Unlimited Orchestra, that featured up to five electric guitars, several keyboards, a full string orchestra, woodwinds and brass, and a percussion section. Many of the more recent "boy band" vocal groups have imitated Barry White's style. He was nicknamed the "Walrus of Love," has won several Grammy Awards for his music and was inducted into the Dance Music Hall of Fame in 2004.

Barry White

Barry White took soul music into the realm of disco and passionate funky ballads.

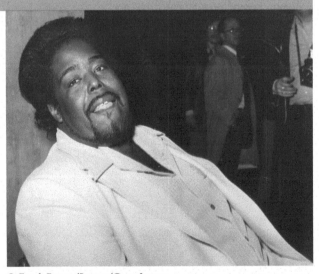

© Frank Barratt/Stringer/Getty Images

Recommended Listening

- Love's Theme
- Love Serenade (Part 1)
- Can't Get Enough of Your Love Babe
- You're the First, the Last, My Everything

Parliament, Funkadelic and George Clinton

George Clinton's (born July 22, 1941) Funkadelic and Parliament are, in effect, the same band and collectively known as P-Funk or the P-Funk All-Stars (the "P" stands for "Pure"). Clinton (using the stage name Dr. Funkenstein) had the goal of making funk as popular as rock and roll. He formed the first incarnation of Parliament in 1968 using members of James Brown's backing band, the JB's. The band's concerts became massive party scenes incorporating up to twenty-five performers on stage, massive props and sets, and use of a script and characters throughout the show. Avant-garde jazz great Sun Ra's Intergalactic Arkestra inspired the band and "mothership" concept, with the script's theme being the creation of the earth when funk caused the big bang.

The story revolves around the "mothership" and various versions of the "good versus evil" story, with each musician on stage playing specific characters. In the beginning the main character, "Starchild," brings funk to earth and hides its secrets in the Egyptian pyramids until humans are ready to be funkified. But Sir Nose D'Voidoffunk, funk's enemy, tries to destroy the funk and take it away from earth by using the "Pinocchio Theory," from Bootsy's Rubber Band. One can trace the story through the entire concert and corresponding albums with extended improvisations, rappers, psychedelic rock and soul music. Representative albums of Parliament-Funkadelic include *Up for the Down Stroke* (1974), *Mothership Connection* (1975), *The Clones of Dr. Funkenstein* (1976) and *One Nation Under a Groove* (1978). The single "One Nation Under a Groove" was the only Funkadelic song to hit the top 40, peaking at #31, but topped the soul charts for six weeks. In 1996, Clinton reunited the band to record one more album, *T.A.P.O.A.F.O.M.* (The Awesome Power of a Fully Operational Mothership). Parliament-Funkadelic were inducted into the Rock and Roll Hall of Fame in 1997.

George Clinton aka Dr. Funkenstein

Parliament, Funkadelic and the mothership connection

© AP/Wide World Photos

Recommended Listening

- P-Funk (Wants to Get Funked Up)
- Give Up the Funk (Tear the Roof Off the Sucker)
- One Nation Under a Groove

Trivia

- "I don't remember much," George Clinton once remarked of the 1970s. "I was under the influence of funk."

- Rapper Snoop Dog is the nephew of legendary funk bassist Bootsy Collins.

- Bootsy Collins' solo work after Parliament-Funkadelic has him featured with his own band named Bootsy's Rubber Band.

Other Important Soul/Funk Artists

- Stevie Wonder
- Al Green
- The Brothers Johnson
- Maceo Parker
- Bootsy Collins
- Tower of Power
- Ohio Players
- The Commodores
- War
- Kool & the Gang
- Confunkshun

Acid Rock

The "Summer of Love" refers to the summer of 1967 and the social rebellion against white collar America when over one hundred thousand young people living in San Francisco renounced what they considered the establishment's ideals for society. As a result, a counter culture, otherwise known as the "hippie movement," emerged, bringing a focus to the social elements of life with music, psychedelic drugs (especially LSD), philosophical exploration, sexual freedom, communal living and creative expression. Musically, we tend to trace the roots of the Summer of Love back to 1965 and the formation of the many bands that would define that famous summer two years later. The coming of age for psychedelic music (acid rock) was the "Human Be-in" held in San Francisco's Golden Gate Park in January 1967. This event really marks the birth of the hippie movement, acid rock and the multiple-day rock festival.

The Haight-Ashbury district of San Francisco quickly became the home of the hippie movement, where people shared all that they had, explored exotic literature, non-Western religions, organic living, the influence of the arts and the Beats and adopted a carefree attitude with a "take it as it comes" lifestyle. The hippies sought to shed the stereotypical American image by breaking down preconceived ideas and the psychological walls of society so they could rediscover the core human needs, openly express and create.

The music that came out of the mid-1960s reflected this experimental era and took rock and roll in a completely new direction. The psychedelic sounds and concept concerts that began in San Francisco challenged the current parameters and influenced popular music across the world. Songs written as three-minute singles exploded into twenty- to thirty-minute open jams reinforced with light shows, surreal posters and projected images, as well as smoke machines and other pyrotechnics, films, sound effects, dancing, costuming and massive stage sets. This idea for rock music was essentially a twentieth-century reincarnation of Richard Wagner's nineteenth century efforts in the opera style called Gesamtkunstwerk (the term translates to "total work of art"). The psychedelically enhanced Gesamtkunstwerk came to life with bands such as the Grateful Dead, Jimi Hendrix, Quicksilver Messenger Service, Jefferson Airplane, Janis Joplin and the Doors.

Chart success for many of the psychedelic bands based in the American West remained fairly limited in the early years as their main motivation was live performing and the "total experience" of their music. Gold and platinum record sales have usually resulted from steady sales over twenty to forty years as each generation "turns on" to its music in contrast to the immediate hit single of a well-publicized advertising campaign. A good example of this is the Grateful Dead's *American Beauty* album released in 1970, which went gold in 1974, platinum in 1986 and double platinum in 2001. Overall, these bands have maintained their popularity and over the years have received more and more radio play as they entered the classic rock genre.

By the end of 1967, commercialism overtook the psychedelic music scene with entrepreneurs and record companies influencing the musical output according to what would sell to the public. Bands succumbed to the lucrative offers, artists accepted invitations to exhibit and sell their works, and the lifestyle became compromised by promotional tourist vacations that promoted spending a weekend as a hippie; all packaged with clothes, meal plan and accommodation in a commune. The 1967 summer of love enjoyed a brief innocent life of just a few months before everything it represented became intertwined in mainstream society. Several bands and artists continued to follow the dream established in 1967 without being swayed by monetary incentives, but ultimately the hey day was over.

The Beats

The Beats (later known as beatniks) were a small group of writers who came to prominence in the 1950s when they announced themselves above man-made laws and the boundaries set by publishers and censorship. Their controversial literary works and drug-induced poetry inspired a generation of anti-establishmentarians that became an influential part of the 1960s psychedelic movement and also the early punk scene. The most influential of the Beats were Jack Kerouac, William S. Burroughs and Allen Ginsberg. Many mid-1960s musicians cite them as direct influences, including the Beatles, Bob Dylan and Jim Morrison.

Jack Kerouac (March 12, 1922–October 21, 1969)

Kerouac is famous for *On The Road*, a largely autobiographical book published in 1957 that he wrote in approximately three weeks (during 1951) after spending several years traveling. The book brought to prominence his traveling companion Neal Cassady (the character Dean Moriarty) who later became one of Ken Kesey's merry pranksters. Often considered the Father of the Beat movement, Kerouac died of cirrhosis of the liver at age forty-seven from years of heavy drinking.

Allen Ginsberg (June 3, 1926–April 5, 1997)

Ginsberg came to notoriety when his poem Howl, published in 1956, became the subject of an obscenity trial. The poem documents the destructive lives of his friends and disapproval of conformity (sheep-like attitudes) in America. He was active in the hippie movement in San Francisco, an avid believer in and supporter of Tibetan Buddhism and openly gay throughout his lifetime (his life partner was writer Peter Orlovsky). Ginsberg is visible standing in the background of the Bob Dylan film for the song "Subterranean Homesick Blues".

William S. Burroughs (February 5, 1914–August 2, 1997)

Burroughs had the most public and scandalous life of the founding Beats. He wrote his book *Naked Lunch* (1959), also brought to trial for obscenity, during 1954 when he was a fugitive

and under the influence of morphine. In 1944, he began a romantic relationship with Joan Vollmer, whose husband was serving in the military during WWII. After being arrested for failing to report a murder he witnessed, for drug charges and for forging narcotics prescriptions, Burroughs fled to Mexico. In 1951, during a drunken game of "William Tell," Burroughs shot his common-law wife (Vollmer) and was arraigned on murder charges. Released on bail, he fled Mexico and returned to the USA, where he wrote *Naked Lunch* in reaction to the events he had experienced. He continued a transient lifestyle involving several other serious brushes with the law in the USA and Europe (he was eventually convicted for the killing, but never was extradited to serve time). Burroughs struggled with heroin addiction and legal problems throughout his life, but he made a lasting impression on society through his writings. Noted as some of the best literature of the twentieth century, Burroughs' work inspired several bands (especially punk). The band Steely Dan settled on their name after reading about a dildo affectionately called Steely Dan in *Naked Lunch!*

LSD

Chemist Dr. Albert Hofmann (January 11, 1906–April 29, 2008) developed lysergic acid diethylamide (LSD) in Switzerland in 1938. He discovered its hallucinogenic qualities when he accidentally spilled the drug on his skin and later self-tested the drug for potency. Hofmann described the kaleidoscopic sensation and aurally fantastic experience as a ". . . not unpleasant intoxicated like condition." His studies brought attention to LSD as a potential cure for schizophrenia, migraines, relief from emotional episodes and military research as a possible truth serum. By 1966, government research showed no signs of useful mind control and abandoned tests with LSD, at which time the drug became officially banned and declared an illegal narcotic. In 1967, it became the drug of choice for San Francisco hippies and Ken Kesey's "acid tests." Its most common association is with the Summer of Love psychedelic bands (especially the Grateful Dead). The drug is non-addictive, due to users rapidly developing a tolerance, but it potentially can do psychological damage in the long term. Users can experience "flashbacks," memory loss and symptoms of dementia in extreme cases.

The High Priest of Acid—Timothy Leary, Ph.d (October 22, 1920–May 31, 1996)

Timothy Leary, a former Harvard professor, was a strong advocate of psychedelic drug research for therapeutic and spiritual benefits. After losing his job at Harvard for providing students with LSD and administering tests after the school asked him to stop, he set up a private lab to continue his research with LSD. He and his colleague, Richard Alpert, tested four hundred people in 1961 in a controlled environment with the following results: 90% wanted to do it again, 83% believed they had learned something and 62% felt their lives improved after taking LSD. To promote his findings, Leary used the catch phrase "turn on, tune in, drop out." Leary considered his experiments and research academic, of merit to society and furthering the medication possibilities in the field of mental health. While studying the effects of LSD, he discovered four levels of consciousness in the human mind.

1. The lowest level of consciousness, sleep or stupor, occurs through the use of alcohol, barbiturates and so forth.
2. Level two is the "conventional" wakeful state.
3. Level three, brought on by marijuana, opens up the billions of sensory impulses that surround us.
4. The final level is cellular, achieved by taking LSD, which takes you beyond the sensory level and into a psychedelic panoramic world.

Trivia

■ In June 1969, Leary ran against Ronald Reagan as a candidate for governor of California. He joined John Lennon and Yoko Ono at their Montreal Bed-In, and Lennon gave Leary a campaign song called "Come Together."

Kenneth Kesey (September 17, 1935–November 10, 2001)

Author Ken Kesey (and his merry pranksters) became a familiar name in the mid-1960s when he conducted his "acid tests" on unsuspecting Americans while traveling across the country to meet Timothy Leary. He and his pranksters "spiked" convenience store items in rural America with the intention of creating art out of everyday life. When the pranksters arrived at Leary's house, Leary refused to meet with Kesey as he considered him a recreational drug user whose acid tests were no more than pranks rather than controlled scientific tests such as his own. Kesey's novel, *One Flew Over the Cuckoo's Nest*, is a disturbing LSD-inspired book (1962) written while institutionalized. He had voluntarily committed himself to a mental asylum to understand his characters. Kesey is a linking author and celebrity figure between the beat generation and the hippie culture. At one time, he volunteered for a CIA study of LSD, and, in 1966, he tried to avoid a drug conviction with a failed fake suicide while he fled to Mexico.

The Bands

The Grateful Dead

Original Members
■ Jerry Garcia (August 1, 1942–August 9, 1995)—guitar, vocals
■ Bob Weir (born October 16, 1947)—guitar, vocals
■ Bill Kreutzmann (born April 7, 1946)—drums
■ Phil Lesh (born March 15, 1940)—bass, vocals
■ Ron "Pigpen" McKernan (September 8, 1945–March 8, 1973)—keyboards, harmonica, vocals

Other Members
■ Tom Constanten (born March 19, 1944)—keyboards
■ Donna Godchaux (born August 22, 1945)—vocals
■ Keith Godchaux (July 19, 1948–July 23, 1980)—keyboards
■ Mickey Hart (born September 11, 1943)—drums, percussion
■ Robert Hunter (June 23, 1941–September 23, 2019)—lyricist
■ Brent Mydland (October 21, 1952–July 26, 1990)—keyboards, vocals
■ Vince Welnick (February 22, 1951–June 2, 2006)—keyboards

In 1965, the Grateful Dead (previously known as the Warlocks) began as a bluegrass band that adopted traits of the blues, reggae, country and jazz improvisation into their style. As the band began to experiment in the rock and psychedelic realm, Ken Kesey invited them to play at his "acid test" parties, and they became known as the pied pipers of psychedelic rock. The drug culture strongly influenced them, and they allowed imagination to dominate their creation of music while actively promoting the psychedelic revolution of the 1960s. They developed a strong and loyal fan base (often called "Deadheads") over the years and became

one of the most popular live bands in the United States. When Warner Brothers signed them in 1966 and allowed them complete artistic freedom, the Dead popularized the idea of full albums instead of singles as the primary source of output for rock bands.

Live concerts were the most popular way of experiencing the Grateful Dead. Their fans followed the band for months and even years holding huge parking lot parties and reliving the Summer of Love experience. The Dead allowed a unique group of fans, known as tapers, to record their live shows, which involved extended improvisation, often integrating non-Western music and the avant-garde. Although record sales were respectable for the band, their main source of income was from their psychedelic and surreal merchandise, and they were often at the top of annual box office ticket sales reports. The Grateful Dead helped keep the spirit of the 1960s alive, touring for almost thirty years until Jerry Garcia's death in 1995. The band members then decided to call it quits and pursue

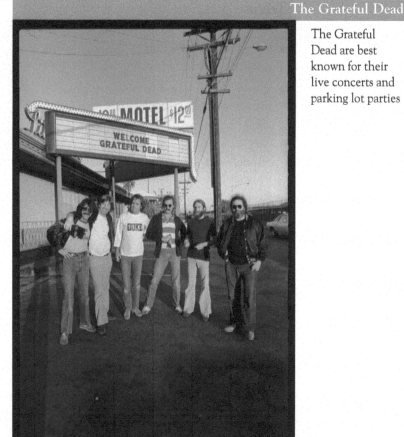

© Corbis/Contributor/Getty Images

The Grateful Dead

The Grateful Dead are best known for their live concerts and parking lot parties

solo careers. They have performed together since 1995 with various lineups as "The Furthur." Credit also goes to the Grateful Dead for inspiring what became the jam band scene of the 1990s that included Phish, the Dave Mathews Band and Bela Fleck and the Flecktones. There are many Grateful Dead albums (especially live) and over three thousand bootleg concert recordings (made by the tapers), but representative studio albums include *The Grateful Dead* (1967), *Aoxomoxoa* (1969), *American Beauty* (1970), *Blues for Allah* (1975) and *In The Dark* (1987). The Grateful Dead were inducted into the Rock and Roll Hall of Fame in 1994.

Recommended Listening

- Truckin'
- Casey Jones
- Sugar Magnolia
- Uncle John's Band
- Touch of Grey
- Dark Star
- Sugar Magnolia

Trivia

- "The Grateful Dead is not for cranking out rock and roll, it's not for going out and doing concerts or any of that stuff, I think it's to get high."—Jerry Garcia

- In retrospect, Jerry Garcia commented ". . . We were right about a lot of things, but we might have been wrong about acid."

- "Dark Star," known as the holy grail of Grateful Dead songs, was made into a musical collage called "Grayfolded" by John Oswald in 1994 when he combined over a hundred versions of the song in an almost two hour rendition. It is the only Dead song that involves every band member from 1965–1994.

- In the spring of 1966, Jerry Garcia and the rest of the Grateful Dead moved into their "Rancho Olompali" off California Highway 101. The Dead posted a sign out front reading "No Trespassing—Violators Will Be Experimented Upon."

Janis Joplin (January 19, 1943–October 4, 1970)

In 1966, after several trips to the West Coast and only moderate success as a blues singer, Janis Joplin moved from Texas to San Francisco. There, manager Chet Helms asked her to join the band Big Brother and the Holding Company. She later performed and recorded with two other west coast bands, Kozmic Blues Band and Full-Tilt Boogie. Joplin had a husky and powerful singing voice, which made her an overnight sensation in the 1960s rock and roll world. Her career was also enhanced when she shared the bill with Jimi Hendrix, The Who and Otis Redding at the 1967 Monterey Pop Festival. Her vocal style was heavily influenced by Bessie Smith and Big Mama Thornton and partially characterized by her excessive drinking. She was renowned for her completely uninhibited live performances, with many regarding her as a feminist icon. Her solo project *Pearl*, released posthumously in 1971, was her best-selling album, and she had scheduled the re-recording of the track "Buried Alive in the Blues" for the day she died. "Me and Bobby McGee," from *Pearl*, became her biggest selling single. She died at the young age of twenty-seven from an overdose of heroin and alcohol just days after recording a birthday message and the song "Happy Trails" for John Lennon. Often credited as the greatest white urban blues and soul singer of her generation, she helped pave the way for future female artists by her powerful singing style and emotional stage performances. Janis Joplin was inducted into the Rock and Roll Hall of Fame in 1995 and awarded a Grammy Lifetime Achievement Award in 2005.

Janis Joplin

Janis Joplin is credited as the greatest white urban blues and soul singer

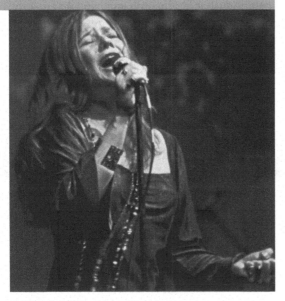

© Elliott Landy/Contributor/Getty Images

Big Brother and the Holding Company

Members

- Sam Andrew (December 18, 1941–February 12, 2015), lead guitar
- James Gurley (December 22, 1939–December 20, 2009), rhythm guitar
- Peter Albin (born June 6, 1944), bass
- Dave Getz (born January 24, 1940) joined in 1966

Big Brother and the Holding Company formed in 1965 and became one of San Francisco's prominent psychedelic rock bands. They are most famous for their work with Janis Joplin, but they have enjoyed their own successful career since signing with Bob Dylan's manager, Albert Grossman, in 1967. Their first album, *Big Brother and the Holding Company*, received moderate chart success and was followed by *Cheap Thrills* in 1968, which reached #1. It catapulted Janis Joplin to fame with the single "Piece of My Heart." Joplin left the band at the end of 1968, and Peter Albin and Dave Getz also left to become members of Country Joe and the Fish. Big Brother reformed in late 1969 and added Nick Gravenites as their lead singer. They took a fifteen-year hiatus beginning in 1972 and, since 1987, have made sporadic returns to the touring and concert circuit.

Recommended Listening

- Down on Me—with Big Brother and the Holding Company
- Piece of My Heart—with Big Brother and the Holding Company
- Ball and Chain—with Big Brother and the Holding Company
- Try (Just a Little Bit Harder)—with the Kozmic Blues Band
- Me and Bobby McGee—with the Full Tilt Boogie Band
- Get It While You Can—with the Full Tilt Boogie Band

Trivia

- "On stage, I make love to 25,000 different people," Joplin once declared. "Then I go home alone."

- "Don't compromise yourself. You are all you've got."—Janis Joplin

Jefferson Airplane

Members

- Marty Balin (January 30, 1942–September 27, 2018)—vocals
- Grace Slick (born October 30, 1939)—vocals
- Paul Kantner (March 17, 1941–January 28, 2016)—guitar
- Jorma Kaukonen (born December 23, 1940)—guitar
- Jack Casady (born April 13, 1944)—bass

- Skip Spence (April 18, 1946–April 16, 1999), drums, replaced by Spencer Dryden (April 7, 1938–January 11, 2005) after the first album
- Several other members include Signe Toly Anderson, John Barbata, Joey Covington, Papa John Creach, Bob Harvey, David Freiberg and Jerry Peloquin.

Formed by Marty Balin in 1965, Jefferson Airplane evolved from the San Francisco folk scene to become one of the finest examples of psychedelic rock in the 1960s. The group grew in popularity with the addition of Grace Slick's voice and stage presence in 1966 under Bill Graham's management. They became a flagship of the acid rock era, helping to shape the hippie counterculture and an attitude towards the politics of that time. At the 1967 "Human Be-In" in Golden Gate Park, Jefferson Airplane was one of the featured bands alongside the Grateful Dead and Quicksilver Messenger Service. They recorded *Jefferson Airplane Takes Off* in 1966, and their top ten album *Surrealistic Pillow*, produced by Jerry Garcia (credited as a spiritual advisor) in 1967. The latter featured the hit singles "White Rabbit" and "Somebody to Love." After several successful albums, including *After Bathing at Baxter's*, *Crown of Creation*, *Volunteers* and *Long John Silver*, Jefferson Airplane became Jefferson Starship during the 1970s, Starship in the 1980s and then Jefferson Starship, The Next Generation in the 1990s. Band members Jack Casady and Jorma Kaukonen formed a popular side project called Hot Tuna, and Paul Kantner went on to a solo career launched with the album *Blows Against The Empire* featuring David Crosby, Graham Nash and members of the Grateful Dead. Jefferson Airplane and its various incarnations have a longstanding reputation as a successful touring band and was inducted into the Rock and Roll Hall of Fame in 1996.

Jefferson Airplane

Jefferson Airplane was one of the flagship bands of the psychedelic era

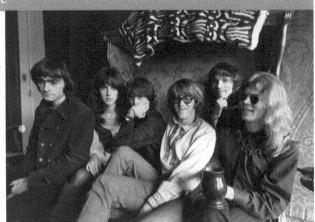

© AP/Wide World Photos

Recommended Listening

- Somebody to Love
- White Rabbit
- Pretty as You Feel
- Ballad of You and Me and Pooneil
- Watch Her Ride

Trivia

- While performing at the Whiskey a Go Go one evening, Marty Balin took too much acid, became completely mesmerized by an enormous pair of breasts in the audience and fell off the stage.

- Grace Slick had two medicine cabinets in her house, one for recreational use and the other for medicinal use!

- Grace Slick kicked off Jefferson Starship's 1978 European tour by drinking the entire contents of her hotel room minibar . . . she was so drunk she began by telling the German audience "Who won the war?" After swearing at the audience and performing a swan dive, Slick left the band and returned to America.

Joni Mitchell (born November 7, 1943)

Canadian singer-songwriter, guitarist, poet and visual artist Joni Mitchell began her career performing folk music in the coffee houses of Saskatoon in the early 1960s. She joined the psychedelic festival circuit of the mid- to late-1960s where, due to her political themes, she was often referred to as the "female Bob Dylan." Throughout the 1960s, Joni Mitchell released successful folk-based albums and wrote much of her own music. This included the song "Woodstock," which became an anthem for that generation and which Crosby, Stills, Nash and Young later recorded. From the mid 1970s, Mitchell became influenced by jazz, as one can hear on the albums *Hejira*, *Don Juan's Reckless Daughter* and *Mingus*, featuring jazz greats Larry Carlton, Herbie Hancock, Jaco Pastorius and Wayne Shorter. In 1985, techno musician Thomas Dolby produced Mitchell's *Dog Eat Dog*, which was another new and diverse area for the singer-songwriter. Mitchell's music is generally very creative, and her

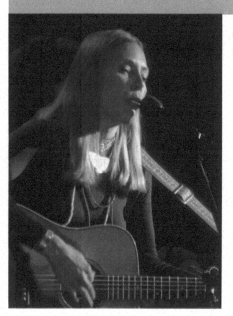

Joni Mitchell

Joni Mitchell carried the folk tradition into psychedelic music

© *Michael Ochs Archive/Stringer/Getty Images*

lyrics often present current issues and express visual imagery. Joni Mitchell has received eight Grammy Awards, ranging from her 1969 album *Clouds* and 1974 *Down to You* (both for Best Folk Performance), to her 2008 Best Pop Instrumental Performance for *One Week Last Summer*. In 1997, Mitchell was inducted into the Rock and Roll Hall of Fame and, in 2001, she was awarded a Grammy Lifetime Achievement Award.

Recommended Listening

- Big Yellow Taxi
- Help Me
- Woodstock

- Free Man in Paris (about a trip Joni took with David Geffen)
- One Week Last Summer

Trivia

■ Joni Mitchell taught herself to play guitar with the *Pete Seeger Guitar Book*.

■ Joni Mitchell took up folk singing for fun and to earn pocket change for cigarettes, movies and dances while she attended art school.

Quicksilver Messenger Service (QMS)

Original Members
■ Dino Valenti (October 7, 1943–November 16, 1994)—singer-songwriter
■ John Cipollina (August 24, 1943–May 29, 1989)—guitar
■ Gary Duncan (September 4, 1946–June 29, 2019)—guitar, vocals
■ David Freiberg (born August 24, 1938)—bass guitar, vocals and viola
■ Greg Elmore (born September 4, 1946)—drums
■ Jim Murray (vocals, guitar and harmonica)—left before the band was signed

Other Members
■ Nicky Hopkins (February 24, 1944–September 6, 1994)—piano/keys

Quicksilver Messenger Service (QMS) formed in 1964 as a jam band-style rock group demonstrating an improvisatory style of rock. The band's lineup changed almost immediately when Valenti was sent to prison on a drug offense (he rejoined the group in 1969), leaving the remaining members to establish the band's sound and style. QMS signed with Capitol Records in late 1967 and recorded two well-received albums, *Quicksilver Messenger Service* in 1968 and *Happy Trails* in 1969. The band became known for their talented guitarists, John Cipollina and Gary Duncan, who are featured together on the Bo Diddley song "Who Do You Love" and the QMS variations "How . . . , When . . . , Where . . . and Which Do You Love" on the *Happy Trails* album. In 1969, Duncan left the group and was replaced by keyboardist Nicky Hopkins, who had worked with the Rolling Stones, the Beatles, the Kinks and The Who. This lineup produced the last of their real jam band-style albums with *Shady Grove* in late 1969. Upon the return of Valenti, QMS recorded two Hawaiian albums and a couple of attempted revival records as their popularity waned. QMS officially disbanded in the mid-1970s and have since reformed with various past members for special events.

Recommended Listening

■ Pride of Man
■ Happy Trails
■ Shady Grove
■ Who Do You Love
■ Fresh Air

The Doors

Members

- Jim Morrison (December 8, 1943–July 3, 1971)—lead vocals
- Robby Krieger (born January 8, 1946)—guitar, vocals
- Ray Manzarek (February 12, 1939–March 20, 2013)—keyboards, keyboard bass, vocals
- John Densmore (born December 1, 1944)—drums, percussion

Jim Morrison (nicknamed the Lizard King and Mr. Mojo Risin') and Ray Manzarek were UCLA film graduates who met by chance in Venice Beach, California, in 1965. They became friends and formed the band the Doors that same year. The two recruited Robby Krieger and John Densmore to complete the band and began working on music to primarily support Morrison's poetry. Morrison considered himself a "post-Beat" poet, closely modeling his style and themes on the great Beat poets of the previous generation. The name for the band, the Doors, derives from Aldous Huxley's 1954 mescaline-inspired book titled *The Doors of Perception*. Incidentally, the title for Huxley's book came from a line in the William Blake poem *The Marriage of Heaven and Hell*, and both the poem and the book influenced Morrison. Electra Records president Jac Holtzman and producer Paul Rothchild heard the Doors when the band was playing a steady gig at L.A.'s Whiskey a Go Go and promptly signed them. The Doors' ensuing career is divided into three popular periods: periods I and II, the Morrison years from 1965–1971, which involved the early defining years of 1965 to 1968 and what are known as the post-Miami-incident years of 1969–1971, and period III, the Doors as a trio without Morrison from 1971–1972.

In 1967 the Doors released their self-titled album (which has subsequently gone 5X platinum), a musical drama called *The End*, and a revolutionary promotional film *Break on Through (to the Other Side)*, which inspired later developments in music videos. They also released their #1 selling single "Light My Fire," which brought them into the limelight of counterculture psychedelic bands. When the *Ed Sullivan Show* invited them to perform "Light My Fire," Sullivan didn't want the word "higher" sung on the show and instructed the band to find another word to sing in its place. Morrison sang the original lyric anyway, Sullivan refused to shake hands with the band, and the Doors never performed on the show again!

On March 5, 1969, five days after a Doors concert in Miami, Morrison was indicted for obscenity, indecent exposure, lewd behavior and inciting a riot. This was the beginning of the demise for the Doors as a touring live act. Morrison became more temperamental on the road and was impossible to deal with in publicity situations. The Doors' last public performance with Morrison was at the Warehouse in New Orleans, Louisiana, on December 12, 1970. In 1971, the band decided to tour without Jim Morrison in an effort to keep the original intent of the music alive, but they too called it quits by August 1972. After finishing the recordings for *L.A Woman*, Morrison moved to Paris for some time off. It was here that his drug

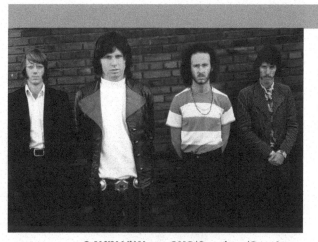

The Doors

The Doors' music, much like Bob Dylan's, was intended to support the poetry and lyrics.

© K&K Ulf Kruger OHG/Contributor/Getty Images

and alcohol problem became uncontrollable and caused his untimely death at the age of twenty-seven. The actual facts surrounding his death are still disputed by his friends and fans with mysterious rumors of where and how he died very much a part of popular culture. The general consensus is that Jim Morrison died in the bathtub at his Paris apartment of a heart attack induced by a night of heavy drinking and an overdose of heroin. His girlfriend Pamela Courson was in the apartment asleep at the time. His body is buried in Père Lachaise Cemetery, the same cemetery as Oscar Wilde, Edith Piaf and Frederic Chopin, and fans from around the world visit it frequently. Because of "fans" stealing the bust of Morrison that once adorned his gravesite, his is the only fenced-in grave in Pere Lachaise.

During 1967–1971 the Doors had six platinum albums with *The Doors, Strange Days, Waiting for the Sun, The Soft Parade, Morrison Hotel, L.A. Woman* and in 1978 another platinum album *An American Prayer*. Their only other #1 charting single was "Hello, I Love You" in 1968. The Doors contributed a dark, moody style to the psychedelic scene of the 1960s with themes for their music depicting sex, drugs and social commentary. They embraced an improvisatory style and inspired future punk rock artists through Morrison's aggressive stage persona. The Doors have maintained their popularity for more than forty years, with album sales consistently sustained by the teenage and college generations. The Doors were inducted into the Rock and Roll Hall of Fame in 1993 and earned a lifetime achievement award at the 2007 Grammy Awards. In February 2007, they received a star on the Hollywood Walk of Fame.

Recommended Listening

- Break on Through (to the Other Side)
- Light My Fire
- Hello, I Love You
- Riders on the Storm

- Love Me Two Times
- Touch Me
- The End

Trivia

- In 1968, Jim Morrison showed up drunk at a club where Jimi Hendrix was playing. In the middle of one of Hendrix's solos, Morrison crept onstage, wrapped himself around Hendrix's legs and screamed "I want to suck your c***." Janis Joplin appeared onstage and clubbed Morrison with a bottle of liquor, and all three artists ended up brawling on the floor.—from *anecdotage.com*

- In 1970, after the deaths of Janis Joplin and Jimi Hendrix, Jim Morrison told friends at a bar "You're drinking with number three . . ." The following year, on July 3, 1971, Morrison died of a heart attack.

- The Doors were uniquely one of few groups not to use a bass player. The bass was provided by Manzarek's keyboard.

- Jim Morrison's grave is the fourth most visited monument in Paris!

- The Doors were originally called the Psychedelic Rangers.

- By 1970, Jim Morrison was facing no fewer than twenty paternity suits.

- "Mr. Mojo Risin" is an anagram of "Jim Morrison."

Other Psychedelic Bands of Note

- The Avant-Garde
- The Charlatans
- The Lovin' Spoonful
- Buffalo Springfield
- Country Joe and the Fish
- Arlo Guthrie
- Santana
- The Mamas & the Papas

The Power Trios section (Chapter 18) features such artists as Jimi Hendrix, Cream and other mid-late 1960s bands that merged into other styles in the 1970s and were also major contributors to the psychedelic scene.

Power Trios and Heavy Metal

Power Trios

The Power Trio concept began in the mid-1960s to highlight the musical ability of the guitarist. The original lineup consisted of electric guitar, bass and drums, with the guitarist pulling double duty playing both the rhythm and lead roles. The members of the group often shared the vocals, if there were any, but in some cases they were also the guitarist's responsibility. The rise of the power trio took place in England with two of rock and roll's greatest bands leading the way: Cream, featuring Eric Clapton and, most famously, the Jimi Hendrix Experience.

The inspiration for the power trio, as with many genres of rock and roll, came from the Chicago blues bands and especially from the Muddy Waters trio. The bands developed well beyond the blues as their style of musical output, but in the midst of the blues revival and the dawn of heavy metal, the blues was the perfect launching pad to showcase the artistry of three strong musicians. As the power trio concept became popular, bands employed extended improvisation, hyper-amplification and the use of effects. These effects included delay, echo, reverb, octavers, chorus effects, overdrive distortion, phase shifters, talk boxes, tremolo, compressors, flangers, fuzz bass, wah wah pedals and so on. Along with this evolution, some of the bands augmented the "traditional" power trio instrumentation by replacing the guitarist with a keyboard player, as did Emerson, Lake & Palmer and Jimmy Smith's trio, or by adding a vocalist who did not play an instrument, as in bands like The Who, Led Zeppelin, Black Sabbath and Queen. The three instrumentalists plus vocalist is, however, a point of contention with many musicians and critics as to whether that really constitutes a power trio. Because of the blues foundation and generally heavy approach to the music, power trios are often considered the precursors to heavy metal, although today we would classify them as either classic rock or hard rock.

Later successful bands that fit the various power trio mold include Rush, Beck, Bogert, and Appice, ZZ Top, the Police, Nirvana, Motorhead, Green Day, the Violent Femmes, Primus, Los Lonely Boys, Wolfmother and the John Mayer Trio. Some artists even took the idea of a big sound with a small lineup further by forming power duos. These groups include The Black Keys, Lightning Bolt, Jucifer and, the most famous example, the White Stripes.

Cream

Members

- Eric Clapton, CBE, guitar (born March 30, 1945)
- Jack Bruce, bass (May 14, 1943 – October 25, 2014)
- Ginger Baker, drums (19 August 1939–6 October 2019)

Cream is considered the first real power trio, combining blues, psychedelic rock, pop and jazz, with the albums *Fresh Cream* (1966), *Disraeli Gears* (1967) and *Wheels of Fire* (1968) pushing rock into a new direction. Guitarist Eric Clapton, bassist Jack Bruce and drummer Ginger Baker formed the band in 1966 and were considered the "cream of the crop" of British instrumental artists. Each member of this super-group had previously earned fame and admiration for his musicianship in prominent bands, with Eric Clapton playing in The Yardbirds (1963–65) and John Mayall's Bluesbreakers (1965–66), and both Ginger Baker and Jack Bruce playing in the Graham Bond Organization, a popular R&B and jazz group. In the concert setting, Cream utilized extended improvised solos at a level of musicality never heard before in rock and roll. Cream's innovative performances directly influenced other emerging improvising bands like the Jimi Hendrix Experience, the Jeff Beck Group and Led Zeppelin. For the first time, the instrumentalist, and not the singer, was the focus of the music. Cream's music challenged the musical trends of the 1960s and encouraged fans to have an open mind when listening and an appreciation for many styles of music.

After Cream disbanded in 1968, Eric Clapton formed Blind Faith with Steve Winwood and Ginger Baker, and in 1970 he formed Derek and The Dominos with Bobby Whitlock, Carl Radle and Jim Gordon. Derek and The Dominos are best known for their album *Layla and Other Assorted Love Songs*, which featured Duane Allman. Clapton has continued his success with a solo career. Upon leaving Derek and The Dominos in 1970, Ginger Baker formed Ginger Baker's Air Force and later The Baker Gurvitz Army (1974–76). In 1972, Jack Bruce revitalized his musical career by forming West, Bruce and Laing with Leslie West and Corky Laing.

Cream was inducted into the Rock and Roll Hall of Fame in 1993. In 2005, Cream re-formed for a series of concerts at London's Royal Albert Hall and New York's Madison Square Garden.

Cream

Cream: R-L Eric Clapton; Ginger Baker; Jack Bruce

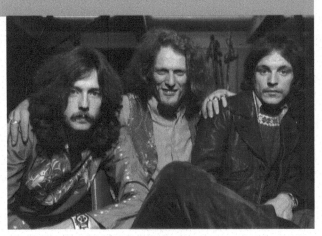

© *Michael Ochs Archives/Stringer/Getty Images*

Recommended Listening

- Tales of Brave Ulysses
- Sunshine of Your Love
- White Room

- Spoonful
- Crossroads

Jimi Hendrix

Rolling Stone Magazine lists James Marshall "Jimi" Hendrix (November 27, 1942–September 18, 1970) as the greatest guitarist of the twentieth century, and the Rock and Roll Hall of Fame credits him with expanding the range of the electric guitar further than any other musician. In his short lifetime, Hendrix was innovative and he mastered and influenced several genres of rock music, including psychedelic, blues, power trios and heavy metal. His sound and style display characteristics of the blues, soul music and jazz; his playing is largely improvised; and his ability to re-create expressive renditions of other rock and roll hits are often considered the best, even by the original artists. Although Hendrix was a self-taught guitarist, artists such as B. B. King, Muddy Waters, Albert King and T-bone Walker influenced him. Guitarists Curtis Mayfield, Steve Cropper, Eric Clapton and Cornell Dupree, as well as jazz guitarists Wes Montgomery and

Jimi Hendrix

The Jimi Hendrix Experience in 1967

© *David Redfern/Staff/Getty Images*

Kenny Burrell, also had an impact on Hendrix. His use of distortion and feedback came from Jeff Beck's work with the Yardbirds, Johnny "Guitar" Watson, and The Who; rock pioneer Little Richard may have inspired the flamboyant stage persona.

Hendrix grew up in Seattle, Washington, and received his first guitar in the summer of 1958. He spent one year in the army, where he formed his first band, the King Kasuals, with his friend Billy Cox before cutting his teeth as a freelance, backing guitarist (sideman). He played the "Chitlin' Circuit" as a sideman for such artists as Jackie Wilson, King Curtis, Ike and Tina Turner, Little Richard, the Isley Brothers and James Brown.

Hendrix moved to Harlem in 1964 (still performing as a sideman), and in 1966 he formed the band Jimmy James and the Blue Flames. Promoter Chas Chandler (former bassist for the Animals) heard them at a Greenwich Village nightclub and became Hendrix's manager, convincing him to move to London where he secured him a record deal with Track Records. Hendrix quickly became the talk of London after sitting in with Cream and playing club gigs frequented by the Beatles, the Rolling Stones and Jeff Beck. Hendrix then formed a power trio named the Jimi Hendrix Experience with Noel Redding on bass and Mitch Mitchell on drums. When the Jimi Hendrix Experience debut album *Are You Experienced* was released in May 1967, it produced three top ten singles in the UK. The U.S. debut for the Jimi Hendrix Experience was at the Monterey Pop Festival in 1967, where Hendrix stole the show by setting his guitar on fire. Follow up albums *Axis: Bold As Love*, also in 1967, and *Electric Ladyland* in 1968 were both received with critical acclaim.

After the Jimi Hendrix Experience disbanded in mid-1969, Hendrix formed Gypsy Sun and the Rainbows, who performed with him at the Woodstock Music Festival where he gave his famous Star Spangled Banner performance.

In late 1969, Hendrix formed another new band, the Band of Gypsys, with his army buddy Billy Cox on bass and Buddy Miles on drums. The Band of Gypsys recorded a self-titled live album at New York's Fillmore East on December 31, 1969, which contains some of Hendrix's best playing. Hendrix toured Europe during 1970, performed at the Isle of Wight Festival with Billy Cox and Mitch Mitchell to an audience of 600,000 and performed his last official concert on September 6 in Puttgarden, Germany (he did play again at a jam session at Ronnie Scott's in London on September 16). On September 18, 1970 Jimi Hendrix died from an overdose of sleeping pills and red wine, although there are several contradicting versions of what really happened. At the time of Hendrix's death, he had completed a demo of sixteen songs for a concept album to be titled *Black Gold*. Mitch Mitchell had the only tapes of these demos (Mitchell died on November 12, 2008), which have never been copied or released and only a handful of people have heard. A bootleg record by the same name circles among fans, but it is not this famous set of songs. Hendrix was inducted into the Rock and Roll Hall of Fame in 1992 and the UK Music Hall of Fame in 2005. His star on the Hollywood Walk of Fame (at 6627 Hollywood Blvd.) was dedicated in 1994, and, in 2006, his debut album *Are You Experienced* was inducted into the United States National Recording Preservation Board's National Recording Registry.

The Chitlin' Circuit

The Chitlin' Circuit is a string of theaters, nightclubs and honky-tonks considered "acceptable" for African American musicians, comedians and other entertainers from the 1800s to the 1960s. They are mostly spread throughout the eastern and southern United States and include such venues as the Apollo Theater and the Cotton Club.

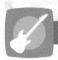

Guitar Spotlight

Many consider Jimi Hendrix the biggest influence on electric guitar throughout the late sixties and beyond. Hendrix based his playing on the blues, but he took blues-based music to another level. Jimi Hendrix played in a trio, which gave him a lot of open space (musically) to work with. When Hendrix played rhythm, many times he had moving lines within the chords that added interest for listeners and musicians. Curtis Mayfield, who Hendrix listened to, and Ike Turner, who Hendrix worked with for a short time, probably influenced this type of rhythm playing with fills. Hendrix's lead playing was completely his own but with influences. Hendrix listened to B. B. King, Hubert Sumlin and Jeff Beck (with the Yardbirds), where he may have picked up the art of feedback, as well as Eric Clapton and others. Hendrix took these influences and crafted his own style. His use of the tremolo bar (whammy bar) feedback, wah-wah pedal and fuzz face effects, combined with his musically powerful phrasing, were unlike anything heard before him. Hendrix also had a musically sensitive solo style with phrasing that sounded like notes falling off a waterfall in slow motion. Hendrix's guitar sound had a vocal quality that ranged from a soothing voice to screams and cries. On top of all this, Hendrix wrote great songs.

Recommended Listening

- Hey Joe
- Foxy Lady
- Fire
- Purple Haze
- Voodoo Child
- The Wind Cries Mary
- The Star Spangled Banner

Trivia

- Hendrix described his approach to improvisation as "Earth and Space." Earth is all of the chord changes and rhythm that supply the foundation for his solo, and space is everything that he hears on top of the foundation (the solo itself).

- An avid drug enthusiast, Jimi Hendrix reportedly placed hits of LSD in his bandanna during his performance at Woodstock in 1969.

- Jimi Hendrix was born Johnny Allen Hendrix, the son of Al Hendrix and Lucille Jeter Hendrix. His name was changed to James Marshall Hendrix later in memory of his deceased brother.

- Hendrix was known for his wild stage antics and for setting his guitar on fire.

- "One of the wrongs I did in my life," Ike Turner once declared, "was that I fired this guy because he was too slow with them pedals, and come to find out ten or twelve years later it was Jimi Hendrix. You can't win 'em all."

- Hendrix played guitar right-handed whenever his father was present . . . because the man believed that left-handedness was a sign of the devil.

- Hendrix influenced the great jazz musician Miles Davis to incorporate elements of rock with jazz.

- He was one of the first to experiment with stereophonic and phasing effects during recording.

- He is #1 on *Rolling Stone Magazine's* list of "100 Greatest Guitarists of All Time."

- "I've been imitated so well I've heard people copy my mistakes."—Jimi Hendrix

Heavy Metal

Heavy metal is an electric guitar-driven style of music—generally supported by powerful drum and bass rhythms—that developed in Britain in the mid-1960s. The guitarist's use of power chords and heavy, dark tonalities helped to define this style, along with influences from classical music, the blues, and, in many cases, an aggressive vocal style. Heavy metal lyrics and themes often portray darkness, evil, the apocalypse, negative imagery, war and political and religious themes; however, in many cases these themes are made to be the focus due to negative media attention toward the style. One can describe heavy metal music as high energy, generally loud and requiring a high level of technical proficiency from all of the musicians.

There are three contrasting periods of development for heavy metal that have contributed to its rise in popularity. The birth of metal and creation of the basic style elements (1965–1969), the evolution of mainstream heavy metal (1975–1977) and the emergence of thrash metal (1981–1983). Each of these periods marks a monumental change in the sound, the style of the bands and the approach to the music. The most popular era for heavy metal is the mid-1980s when radio play was at its highest.

Several artists and songs have contributed to the formation of the development of the early heavy metal style. These include the Kinks' 1964 hit "You Really Got Me," often called the first heavy metal song, Dave Edmunds' distorted guitar version of Khachaturian's Sabre Dance (representing early classical influence on heavy metal) and bands like The Who and Vanilla Fudge, whose sheer volume inspired new bands to enter the heavy metal genre. In 1968, with technology and the development of guitar effects, more bands began to embrace the heavier style of playing. Steppenwolf's "Born to be Wild," the Yardbirds' "Think About It," the Beatles' "Helter Skelter" and Iron Butterfly's "In-A-Gadda-Da-Vida" (which marks the transition of psychedelic rock to heavy metal) all carried the characteristics of what was evolving into the heavy metal sound. Likewise, the power trios, especially Jimi Hendrix and Cream, were also becoming classified as heavy metal due to the full sound texture and loud amplification that they used. The first three bands that we really consider as heavy metal innovators and who bring us into the first generation of heavy metal are Led Zeppelin, Black Sabbath and Judas Priest.

Recommended Listening

Early Influences
- You Really Got Me, the Kinks
- Think About It, the Yardbirds
- Helter Skelter, the Beatles

Classical Influence
- Sabre Dance, Dave Edmunds

Rock Dots Trivia

- Many heavy metal bands are known for their use of "rock dots." These are umlauts over letters in the name of the band that have Germanic and Scandinavian roots. The rock dots give strength and masculinity to the visual appearance of a band's name. Blue Öyster Cult was the first band to use the rock dots in their name.

The First Generation of Heavy Metal Bands: 1965–1969

1965

■ **The Scorpions:** Formed in 1965 as a German "Beat" group who were heavily influenced by the Yardbirds. Their debut album, *Lonesome Crow*, did not appear until 1972. The Scorpions have sold over 100 million records worldwide and are known for hits such as "Rock You Like a Hurricane," "No One Like You," and "Wind of Change."

1966

■ **Iron Butterfly:** Signed with the ATCO label in 1967 and released their debut album, *Heavy*, that same year. Their most famous song, "In-A-Gadda-Da-Vida," hit the charts in 1968 and has since become a cult classic with the album selling over 25 million copies. The intended original title was supposed to be "In the Garden of Eden"!

1967

■ **Steppenwolf:** Named after Hermann Hesse's mystical novel of the same name, came to prominence in 1968 with "Born to be Wild," which capitalized on the heavy guitar sound and introduced the first reference to heavy metal in the lyrics "heavy metal thunder," making reference to motorcycles and bikers.

■ **Budgie:** A Welsh hard rock band that led the way into fast (or speed) metal playing. They are considered ahead of Judas Priest and Iron Maiden in this style. Budgie are known for their singles "Breadfan," "Crash Course in Brain Surgery," and "Napoleon Bona 1 & 2."

■ **Blue Öyster Cult:** Originally called Soft White Underbelly, were the first heavy metal band to begin using the umlaut. Blue Öyster Cult's biggest single, "Don't Fear the Reaper," appeared on their first platinum album, *Agents of Fortune*, followed by *Burnin' for You*, and *Veteran of the Psychic Wars*. Their band name came from a poem written by their manager Sandy Perlman.

■ **Blue Cheer:** A San Francisco based power trio that hit the U.S. charts in 1968 with Eddie Cochran's "Summertime Blues." There is a rumor the group's name comes from a brand of LSD.

1968

■ **Deep Purple:** Considered innovators in the heavy metal genre with their album *Shades of Deep Purple* that debuted while they were opening for Cream on their "Goodbye tour." Their follow-up album *Machine Head* features the famous song "Smoke on the Water." This song was written after the Waterfront Hotel in Montreaux, where they were scheduled to record, burned to the ground.

1969

■ **UFO:** A transitional band that bridged heavy metal and the New Wave of British Heavy Metal. They were a big influence on later thrash metal bands such as Metallica and Megadeth.

■ **Thin Lizzy:** An Irish band that broke into the heavy metal scene with popular hits like "The Boys Are Back in Town" and "Whiskey in the Jar." In the mid-1970s, the band featured the great guitarist Gary Moore.

Recommended Listening

- In-A-Gadda-Da-Vida, Iron Butterfly
- Born to Be Wild, Steppenwolf

Led Zeppelin

Members
- Robert Plant, vocals (born August 20, 1948)
- Jimmy Page, guitar (born January, 1944)
- John Paul Jones, bass (born January 3, 1946)
- John Bonham, drums (May 31, 1948–September 25, 1980)

Led Zeppelin formed from the remains of the Yardbirds, with whom Jimmy Page had played bass and guitar from 1966 to 1968. Prior to being a member of the Yardbirds, Page was one of London's top studio guitarists, playing on albums for The Who, Van Morrison, Marianne Faithfull, the Kinks, John Mayall, Joe Cocker and the Rolling Stones, among others. He was also a staff songwriter-producer at Immediate Records. When the Yardbirds officially disbanded in 1968, Page formed the New Yardbirds to satisfy remaining touring contracts. He recruited recommended singer Robert Plant, drummer John Bonham and fellow session musician John Paul Jones to play bass and embarked on a Scandinavian tour. After the tour at the end of 1968, he changed the New Yardbirds name to Led Zeppelin. The Chicago blues heavily influenced the band's first two albums, *Led Zeppelin* and *Led Zeppelin II*, which included such songs as "I Can't Quit You Baby" and "You Shook Me" by Willie Dixon and "Whole Lotta Love," co-written with Dixon.

Led Zeppelin

Led Zeppelin onstage during the zoso tour, 1971

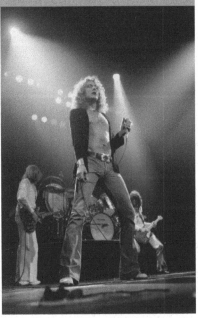

© *Michael Putland/Contributor/Getty Images*

Led Zeppelin became a big influence on the heavy metal scene, and some consider them the first metal band. But they also explored many other styles in their developing sound, including Indian, Arabic, Celtic, folk, funk and classical music. After critics gave a lukewarm reception to their third album (largely due to the number of acoustic style songs), Led Zeppelin's fourth album, *Led Zeppelin IV*, was an instant hit and one of the best-selling records of all time. The album actually has no official title other than the four symbols on the cover artwork because Page and Plant wanted to prove that the music was strong enough to carry the album without media promotion. This album includes "Stairway to Heaven," which is one of the most played songs on FM radio (and also banned in many guitar shops in the USA!). 1973's *Houses of the Holy* explored odd-time meters and advanced harmony and was a dedication to all of their fans who attended their concerts (they dubbed the ven-ues as houses of the holy). Led Zeppelin's tours of the seventies broke venue attendance records; they sold over 85 million records; and, during the years

1971–1975, they were known as "the greatest rock band in the world." In 1980, it all came to an end when John Bonham was found dead from alcohol poisoning/asphyxiation at Jimmy Page's house the morning after rehearsals had begun for their next album. Many considered John Bonham rock's greatest drummer, utilizing poly-rhythms with rock drumming. The band decided that they could not continue with a replacement drummer and disbanded on December 4, 1980. Led Zeppelin played a reunion concert in London with Jason Bonham (John Bonham's son) on December 10, 2007 and embarked on a world tour in 2008. They were inducted into the Rock and Roll Hall of Fame in 1995.

Guitar Spotlight

Jimmy Page, Led Zeppelin's great guitarist, got his start as a studio player in London, eventually producing sessions for Andrew Loog Oldham. Page found this experience invaluable when he formed Zeppelin (after his stint with The Yardbirds). Though known as a great guitarist, Page is often overlooked as a great producer. Page was a master at close and ambient miking to get a big sound in the studio, miking drums and guitar amps at different distances simultaneously and mixing them together to get a huge and musical sound. Page was also great at orchestrating guitars. Zeppelin records may record three, four or five guitars in ways that blend, compliment and separate from each other at the same time. Jimmy Page was also one of rock's first "World" musicians, combining elements of Middle Eastern music, classical, jazz, folk, blues and rock. As a live performer, Page seemed to write for a trio, writing powerful riffs that worked with bass, guitar and drums that still sound fresh today. Page is also a great improviser. Each night, songs at a Led Zeppelin concert might evolve into something new. Songs originally five minutes on a record may turn into twenty-minute improvisations live. The interaction among Zepp's musicians was unbelievable with Jimmy Page leading the way. One can hear Page on live recordings sneaking in advanced jazz harmonies (chords) at times uncommon to rock. Jimmy Page is definitely one of rock's maestros.

As one of the best selling bands, now classified in the hard rock genre, Led Zeppelin's U.S. sales alone are staggering:

- Led Zeppelin, 1969—8× Platinum
- Led Zeppelin II, 1969—12× Platinum
- Led Zeppelin III, 1970—6× Platinum
- Led Zeppelin IV, 1971—23× Platinum
- Houses of the Holy, 1973—11× Platinum
- Physical Graffiti, 1975—16× Platinum
- Presence, 1976—6× Platinum
- In Through the Out Door, 1979—3× Platinum
- Coda, 1982—Platinum

Recommended Listening

- Whole Lotta Love
- Heartbreaker
- Stairway to Heaven

- Black Dog
- Rock and Roll
- Kashmir

Trivia

- *In Through the Out Door* was recorded at Abba's studio in Stockholm.

- The piano on "Rock & Roll" was played by Ian Stewart, the Rolling Stones sixth member.

- "Stairway to Heaven" is the biggest selling piece of sheet music in rock history. It sells about 15,000 copies every year. In total, over one million copies have sold and the song has been broadcast on the radio over three million times.

- Led Zeppelin is the only band to have had all of their albums reach the U.S. Billboard Top 10; of these, six went to #1.

Black Sabbath

Members

- Ozzy Osbourne, vocals
 (born December 3, 1948)
- Tony Iommi, guitar
 (born February 19, 1948)

- Terry 'Geezer' Butler, bass
 (born July 17, 1949)
- Bill Ward, drums
 (born May 5, 1948)

Black Sabbath is one of the first true heavy metal bands. They deliberately embraced all of the characteristics that defined the early years of heavy metal and became an underground band of cult proportions. They are famous for their slow, riff-based songs that carry elements

Black Sabbath

Black Sabbath's Tony Iommi, Ozzy Osbourne, Bill Ward and Geezer Butler

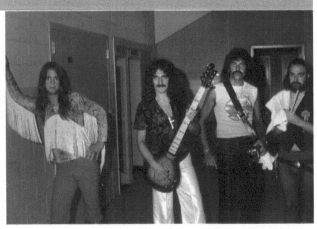

© *Michael Ochs Archives/Contributor/Getty Images*

of heavy doom-laden and occult themes. Black Sabbath formed in Birmingham in the Midlands region of England where they originally called themselves the Polka Tulk Blues Band, later simply Polka Tulk and then Earth. The band settled on the name Black Sabbath in 1969, when they saw the name in a cult horror film.

Black Sabbath's first album, *Black Sabbath*, was released in 1970, and their second album, *Paranoid*, became a surprise hit in the UK in 1971. The single "Paranoid" hit #1 on the UK charts in 1970 (the single was released before the album) and also on the U.S. charts in early 1971. In 1973, Rick Wakeman, the keyboard player from Yes, joined the band to record the album *Sabbath Bloody Sabbath*. From this time on, the band members had increasing personnel problems, though they have never disbanded. In 1979, Ozzy Osbourne left Black Sabbath to pursue a successful solo career. A number of lead singers came and went in the following years: Dave Walker, Ronnie James Dio, Ian Gillan and Dio once again. By 1986, Tony Iommi was the only remaining original member of the band, and the quality of their music had dropped along with their popularity. By this time the band's roster changed as frequently as albums released, which damaged the group's credibility. They made some efforts to rejoin the original members, and, in December 1997, the four came together again for two live shows in Birmingham. They released a double album of live recordings with two new studio tracks in 1998, which broke into the Billboard Top 20, and they continue to tour. Black Sabbath was inducted into the UK Music Hall of Fame in November 2005 and the Rock and Roll Hall of Fame in March 2006.

Recommended Listening

- Black Sabbath
- Iron Man
- Paranoid
- War Pigs

Dio

Although the band didn't officially form until 1982, Dio relates directly to the heavy metal bands of the first generation. Ronnie James Dio was the singer who took over lead vocals in Black Sabbath for Ozzy Osbourne when he left to pursue a solo career. When Ronnie formed Dio, it was with Vinny Appice (who was in Black Sabbath with him) to take the developing sound of Black Sabbath to the next level. Dio never intended to break into a solo career, but that is where the music took him.

Recommended Listening

- Holy Diver
- Mystery

Judas Priest

Judas Priest:
Glenn Tipton,
K. K. Downing,
Rob Halford,
Dave Holland
and Ian Hill

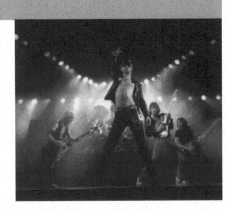

© *Fin Costello/Getty Images*

Judas Priest

Members

- Alan Atkins, vocals 1969–1973 (born October 11, 1947)
- Rob Halford, vocals 1973–1996 (born August 25, 1951)
- K. K. Downing, guitar (born October 27, 1951)
- Glenn Tipton, guitar (born October 25, 1947)
- Ian Hill, bass (born January 20, 1951)
- Alan "Skip" Moore (born January 1, 1950), drums 1971–72 and 1975–77
- John Hinch (June 19, 1947–April 29, 2021), drums 1973-75
- Les Binks (born April 5, 1951), drums 1977–79
- Dave Holland (April 5, 1948-January 16, 2018), drums 1979-89
- Scott Travis (born September 6, 1961), drums 1989–present

Judas Priest is one of the first heavy metal bands to use dual lead guitars and extremely fast tempo songs. They are seen as pioneers of the heavy metal genre and paved the way for Speed Metal. Alan Atkins, K. K. Downing and long-time friend Ian Hill formed Judas Priest in Birmingham, England, in 1969, adding John Ellis in 1971 for their first gig in Essington. The name of the band, suggested by Atkins (who had used the name for a previous band), came from the Bob Dylan song "The Ballad of Frankie Lee and Judas Priest." When the band started performing frequently, they made several lineup changes, which included replacing Atkins with Judas Priest's signature voice, Rob Halford. As the band gained notoriety, they added a second lead guitarist, Glenn Tipton, to the ranks.

In 1974, Judas Priest toured the Netherlands and Germany on their first album, *Rocka Rolla*, which turned out to be disappointing and marked the departure of drummer John Hinch. The drum chair in Judas Priest seemed to be a constant revolving door with Chris Campbell (1971–1973), John Hinch (1973–1975), Alan Moore (1971, 1975–1976), Les Binks (1977–1979), Dave Holland (1979–1989) and other session drummers, including Simon Phillips covering some album work. Their second album, *Sad Wings of Destiny*, proved a marginal improvement on the first record, but it wasn't until signing with CBS records that the band began to become internationally popular. The albums *Sin After Sin* and *Stained Class* showed improving quality, and the band reached the peak of their popularity with *British Steel* in 1980. Judas Priest followed with several more highly successful albums, including *Point of Entry* and *Screaming for Vengeance*. During this time (the early 1980s), they toured successfully, selling out concerts in the UK and the U.S., and received regular play on MTV. The band waned in popularity on the charts after *Turbo* (1986) but remained successful on tour. After officially leaving in 1996, Rob Halford rejoined Judas Priest in 2004 (he briefly left from 1991–1994 also) to coincide with the Metalogy CD box set release and the 2004 Ozzfest tour. MTV has named Judas Priest the second most influential metal band after Black Sabbath.

Recommended Listening

- Take On the World
- Breaking the Law
- Living After Midnight
- You've Got Another Thing Coming
- Hot Rockin'

The Second Generation of Heavy Metal Bands: 1975–1977

After the success of Led Zeppelin, Black Sabbath and Judas Priest, several American bands emerged during the 1970s with a new form of heavy metal music that was more accessible to the top 40. Alice Cooper and Kiss used catchy hooks and choruses with outrageous stage shows; Aerosmith pushed the envelope of blues with sleazy boogie-style grooves; and Van Halen and AC/DC contributed a party-like atmosphere to heavy metal.

1975

- **Aerosmith:** Formed in 1970, had moderate success in 1973 as Boston's most popular band and saw mainstream popularity in 1975 when their *Toys in the Attic* album went gold. Their next album *Rocks* became a multi-platinum selling record, and songs such as "Walk This Way" became influential on the third generation of heavy metal bands.

- **Kiss:** Formed in1971 (came to popularity in 1975) by Paul Stanley, Gene Simmons, Peter Criss and Ace Frehley. They brought make-up, fire breathing, blood spitting, smoking guitars, pyrotechnics and excessive theatrical elements to rock and roll. Although hugely popular with hits such as "I Was Made for Loving You," "Detroit Rock City" and "Rock and Roll All Nite," Kiss have only had one #1 charting single, which was "Psycho Circus" in 1998!

- **Quiet Riot:** Formed in 1973 (came to popularity in 1975) are well known for their influence in developing the 1980s Glam Metal genre through such hit singles as "Cum on Feel the Noize."

- **Iron Maiden:** Formed in 1975, became one of the most popular heavy metal bands of the 1980s through an underground network of fans. With little media attention or radio play, Iron Maiden sold over one hundred million records using elaborate stage shows, harmonized guitar lines and lyrics derived from poets such as Poe, Coleridge, Tennyson and Shakespeare.

- **Rainbow:** Formed in 1975 when Ritchie Blackmore left Deep Purple to team up with Ronnie James Dio and other members of Elf (1974's opening act for Deep Purple) to create a more classically based heavy metal with medieval themes. The band named themselves after the Rainbow Bar and Grill in Hollywood.

- **Van Halen:** Originally called Mammoth, formed in 1972 with Eddie Van Halen (January 26, 1955–October 6, 2020) lead vocalist/guitarist, and brother Alex Van Halen, drums (born May 8, 1953). After several lineup changes, a name change (to Van Halen) and the addition of David Lee Roth and Michael Anthony, the band grew in popularity and landed a series of steady gigs on the Sunset Strip by 1975. Gene Simmons (from Kiss) financed the band's first recordings in 1977, which produced the hit "Runnin' With the Devil." From 1978 to 1985 they produced several multi-platinum records, including *Van Halen*, *Van Halen II*, *1984* and, following the exit of David Lee Roth, more hit records featuring Sammy Hagar with *5150*, *OU812* and *For Unlawful Carnal Knowledge* sustaining the band's popularity. Van Halen are a pioneering band in the area of "technical riders" and what were considered wish list requirements, which now are standard practice requests for touring rock bands. Van Halen were inducted into the Rock and Roll Hall of Fame in 2007.

Recommended Listening

- Walk This Way, Aerosmith
- Rock and Roll All Nite, Kiss
- Cum on Feel the Noize, Quiet Riot
- Run to the Hills, Iron Maiden
- Man on the Silver Mountain, Rainbow
- Runnin' With the Devil, Van Halen
- Jump, Van Halen

1976

- **Ratt:** Formed in 1976 as Mickey Ratt (later becoming just Ratt) to capitalize on the glam metal scene in L.A. They enjoyed a reasonable amount of success in the late 1970s and early 1980s, but drifted into obscurity following the release of their sixth album *Detonator* in 1990. Their most memorable hit is "Round and Round," which reached #12 on the charts in 1984.

1977

- **Def Leppard:** An English heavy metal band formed in 1977 are known primarily for their power ballads. They became one of the best selling rock acts in the 1980s with over 65 million sales, and are credited as one of the leading bands of the "NWOBHM"— New Wave of British Heavy Metal. Their 1983 album *Pyromania* sold over six million copies that year alone and set Def Leppard apart from their peers. Despite losing his left arm in a car wreck in 1984, drummer Rick Allen continued to play for Def Leppard, and their very next album *Hysteria* went twelve times platinum.

- **Whitesnake:** Emerged in 1977 as the backing band for David Coverdale (formerly with Deep Purple). The band is often compared to Deep Purple for similarities in their style, but they are influential for their melodic approach to heavy metal. Whitesnake has featured many famous musicians in its lineup, including Ian Paice, Rudy Sarzo, Tommy Aldridge and Steve Vai.

Recommended Listening

- Round and Round, Ratt
- Love Bites, Def Leppard
- Is This Love, Whitesnake

AC/DC

Members

- Bon Scott (July 9, 1946–February 19, 1980), vocals: 1974–1980
- Brian Johnson (born October 5, 1947), vocals: 1980–present
- Angus Young (born on March 31, 1955), guitar
- Malcolm Young (January 6, 1953–November 18, 2017), rhythm guitar
- Cliff Williams (born December 14, 1949), bass
- Phil Rudd (born May 19, 1954), drums

The Australian hard rock band AC/DC formed in 1973 at the initiative of Malcolm Young and his younger brother Angus. Their brother George Young, of the Easybeats, helped locate other band members and ultimately managed the group. Bon Scott, the band's chauffeur at the time, replaced original singer Dave Evans in 1974, giving AC/DC the final element to their signature sound. AC/DC's first two albums, *High Voltage* and *T.N.T.*, established them as a successful Australian heavy metal band and included new members Mark Evans on bass

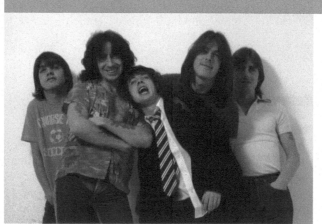

© Fin Costello/Staff/Getty Images

AC/DC

The Australian band AC/DC are one of the world's greatest rock bands

and Phil Rudd on drums. Cliff Williams later replaced Rudd for the albums *If You Want Blood, You've Got It* and *Highway to Hell*. *Highway to Hell* led AC/DC to international stardom, but sadly it would also be Bon Scott's last album with his sudden death from alcohol poisoning in 1980. Brian Johnson replaced Scott as lead singer, and his first album with the band was *Back In Black*, which proved their biggest hit album (and eponymous single) with over 44 million sales. Subsequent albums *For Those About to Rock*, *Who Made Who*, *The Razors Edge* and *Ballbreaker* were also highly successful with multiple platinum sales. AC/DC were inducted into the Rock and Roll Hall of Fame in March 2003 and have continued to tour and release albums every couple of years.

Recommended Listening

- T.N.T.
- Jailbreak
- Back in Black
- Hells Bells
- You Shook Me All Night Long
- For Those About to Rock

Trivia

- Angus and Malcolm Young developed the idea for the band's name after seeing the acronym "AC/DC" on the back of a sewing machine owned by their sister, Margaret. "AC/DC" is an abbreviation for "alternating current/direct current," which indicates that an electrical device can use either type of power. The brothers felt that this name symbolized the band's raw energy and power-driven performances, and the name stuck.

- Despite charting over 40 singles, 20 platinum selling albums (*Back In Black* has gone 44 times platinum alone) and over 150 million record sales worldwide, AC/DC have only had three #1 charting songs: "Big Gun" (1993), "Hard as a Rock" (1996) and "Stiff Upper Lip" (2000).

Motörhead

Members
- Ian "Lemmy" Kilmister, vocals/bass (December 24, 1945–December 28, 2015)
- "Fast" Eddie Clarke, guitar (October 5, 1950–January 10, 2018)
- Phil "Philthy Animal" Taylor, drums (September 21, 1954–November 11, 2015)

The power trio Motörhead was formed in 1975 by Ian Kilmister (aka Lemmy) after he was sacked from the band Hawkwind. The first line-up included Larry Wallis (ex Pink Fairies) on guitar and Lucas Fox on drums, but by 1976 "Philthy" Phil Taylor replaced Fox, and "Fast" Eddie Clarke joined the band as a second guitarist until Wallis quit. The combination of Lemmy, Taylor and Clarke lasted for six years during which they produced the classic Motörhead records and gained a following of Hell's Angels bikers. The peak of their popularity came in 1980 with the album *Ace of Spades*, whose title track is considered one of the definitive heavy metal performances. The live album *No Sleep 'Til Hammersmith*, released in 1982, was also highly successful. Motörhead's success with a dirty heavy metal sound also influenced punk rock, speed metal and thrash.

 Recommended Listening

- Ace of Spades
- Louie Louie
- Motorhead

The Third Generation of Heavy Metal Bands: 1981–1983

In the late 1970s, a handful of British bands dubbed the New Wave of British Heavy Metal (NWOBHM) started playing heavy metal faster, harder and more aggressively than ever before. Such bands as Judas Priest, Iron Maiden and Motörhead ushered in a new metal style known as thrash that American bands and fans embraced in the 1980s.

Four groups emerged as leaders in the American scene that became known as the "big four of thrash": Anthrax, Metallica, Slayer and Megadeth. Due to their massive followings, the big four pushed heavy metal into mainstream rock and roll and introduced a whole new audience to heavy metal music. Death metal, speed metal and black metal evolved out of thrash, birthing a series of underground sub-genres.

■ **Anthrax:** Formed in 1981 blending a combination of hardcore, rap and heavy metal music with a "surfer" image. Their debut album, *Fistful of Metal*, drew a good fan base, but *Spreading the Disease*, their second album, put them on the map with other metal acts. "Madhouse," the single from *Spreading the Disease*, is one of Anthrax's most popular hits and is featured on the video games *Grand Theft Auto: Vice City*, *V-Rock* and *Guitar Hero II*. Anthrax have ten studio albums; they have appeared on many TV shows and in feature films, and they maintain a humorous approach to their music.

Anthrax

One of the big four of thrash, Anthrax formed in 1981

© *Lynn Goldsmith/Contributor/Getty Images*

Recommended Listening

■ Madhouse

■ **Metallica:** Formed in L.A by drummer Lars Ulrich in 1981 with rhythm guitarist/vocalist James Hetfield, lead guitarist Dave Mustaine and bassist Ron McGovney. Before the first record was made Mustaine and McGovney were asked to leave the band, and were replaced by Kirk Hammett (guitar) and Cliff Burton (bass). Metallica are solely responsible for bringing thrash metal to the general public, and their album *Master of Puppets* (1986) is hailed as one of the greatest thrash records of all time. Their intricately structured compositions and

Metallica

Metallica are solely responsible for bringing thrash metal to the general public

© *Shinko Music/Contributor/Getty Images*

clean recordings gave Metallica a fresh approach to heavy metal that revitalized the industry and interest in the genre. Metallica's popularity in mainstream music is verified by the following four albums, *Metallica* (1991), *Load* (1996), *ReLoad* (1997) and *St. Anger* (2003), all reaching #1 on the Billboard charts and over one hundred million record sales. They have been awarded MTV, Billboard and American Music Awards and seven

Grammy Awards. Metallica's 2008 album *Death Magnetic* exceeds the quality of all previous material, with five singles coming from the album. *Death Magnetic* debuted on the charts at #1 and received excellent reviews.

Recommended Listening

- Fade to Black
- Master of Puppets
- One

- **Slayer:** Formed in Southern California in 1981 by Tom Araya, Jeff Hanneman, Kerry King and Dave Lombardo. The band has come under constant criticism from the press and various public groups for the dark and apparently evil lyrics in their music, which include themes of genocide, necrophilia, Satanism and serial killers. Slayer's first album, *Show No Mercy*, released in 1983, was followed by *Hell Awaits* in 1985 and their 1986 album *Reign in Blood*, which has been called the heaviest album of all time. Slayer is the most extreme of the "big four" thrash bands, particularly noted for their speed, chaotic guitar solos, violent lyrics and grisly artwork. They have won two Grammy awards (2006 and 2007) and continue to record and tour.

Recommended Listening

- Raining Blood

Slayer

Slayer is the most extreme of the "big four" thrash bands

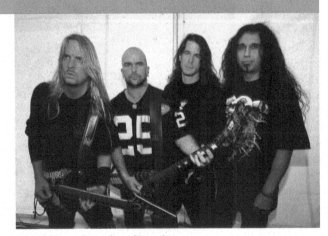

© *Mick Hutson/Contributor/Getty Images*

- **Megadeth:** Formed in 1983 by Dave Mustaine after Metallica asked him to leave. While the animosity between Mustaine and Metallica has caused controversy over the years, both bands have enjoyed excellent record sales and extended careers. Megadeth has had six consecutive platinum albums, and they are known for their intricate arrangements, use of acoustic instruments combined with electric instruments, sampled effects and controversial lyrics. The

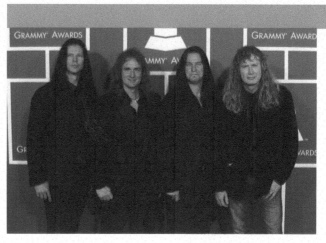

© DFree/Shutterstock.com

Megadeth

Megadeth's *Peace Sells . . . But Who's Buying?* is possibly the greatest thrash album beginning to end

album *Peace Sells . . . But Who's Buying?* is recognized as one of the most important records in the thrash style and possibly the greatest "beginning to end" heavy metal album ever. Megadeth has seen many band member changes over the years, but the classic lineup is Dave Mustaine (guitar, vocals), Marty Friedman (guitar, vocals), David Ellefson (bass guitar, vocals) and Nick Menza (drums, vocals). They have been nominated for seven Grammy Awards, have appeared in many movies and on TV shows and are second only to Metallica in commercial success.

Recommended Listening

- Peace Sells
- Symphony of Destruction
- Trust

Other Influential Heavy Metal Bands

- Alice Cooper
- Cathedral
- Deep Purple
- Engage
- Enslaved
- Entombed
- Faith No More
- Helloween
- Killswitch
- KoRn
- Mayhem

- Ministry
- Montrose
- Motley Crue
- Nightwish
- Pantera
- Queen
- Rammstein
- Rush
- Stryper
- Venom

Punk Rock

Punk is a term that the press originally used in the late 1960s to slander less than average rock bands who they felt were trying to make a statement. As time went on, the name applied to bands that had a certain type of attitude, or whose themes went against the mainstream. The idea of embracing the name didn't come about until the mid-1970s as audiences latched onto something with which they could identify. Punk can mean reckless, inspiring or revolutionary. It can mean an attitude of rebellion against tradition, a form of rock music with deliberately offensive lyrics expressing anger and social alienation and even a fashion concept.

The interpretation of the word "punk," meaning worthless or disrespectful, or having a negative attitude towards authority, sums up the impression of the general public toward punk music. While this may be true in some cases, punk music as a genre challenges us to reconsider what music really is and whether the early punk bands, some of which had little to no musical ability before putting a band together, could seriously contribute to the music scene. When twentieth century composers such as Igor Stravinsky, Arnold Schoenberg and John Cage began pushing the boundaries of classical music, audiences often considered them innovative and ahead of their time. The composers sometimes completely improvised their music, performed on homemade instruments or instruments of opportunity (simply found at the performance venue, sometimes during the performance itself), and, in the case of Cage's 4'33", have nothing on the page at all! The early evolution of punk music used many of the same concepts to challenge the listener to focus on the facts of what was being presented rather than on a guitar solo, an impressive arrangement, a record production or special effects used in a song.

The British punk scene that exploded in the mid-1970s with the Sex Pistols often characterizes punk music, but there are many other styles and traits that really made punk music what it has become. The earliest punk bands stripped away anything that was unnecessary to what they were trying to say and gave their audiences raw rock and roll with a message. Most simply, punk music is a statement, an attitude or a form of expression that deals with real-life issues, and, in many cases, political and social problems affecting a particular group of people. Punk's songs are simple in structure and short (about two to three minutes long), and, in

most cases, they have a driving, aggressive rhythm. Punk fashion, or anti-fashion as it was called, was usually identified with the Bromley contingent and Malcolm McLaren of the British scene, but it actually was first seen with American punk rocker Richard Hell. The typical punk image includes denim or leather jackets with metal studs, self-designed t-shirts, jeans and jackets decorated with markers and patches, bondage-type clothing, kicker boots or Doc Martens, spiked hair and mohawks, piercings and later tattoos.

"Punk ain't the boots or the hair dye. I've been asked to define it many times so I've actually thought about it for a couple of seconds. It must be the attitude that you have, and approach everything in life with that attitude."

—Joe Strummer, the Clash

The Velvet Underground

In 1964, John Cale OBE (born March 9, 1942) and Lou Reed (March 2, 1942–October 27, 2013) met in New York City to experiment with the possibilities of avant-garde music. Both were classically trained musicians, but they wanted to expand their musical identity into something that listeners could not immediately classify as any particular style. The music they created became the ingredients for punk music where musicality took a back seat to artistry or a social statement. The Velvet Underground (usually abbreviated to the Velvets or VU) formed in 1965 in New York with pop artist Andy Warhol as their manager. The group took its name from the title of a book about sadomasochism by Michael Leigh that Reed found when he moved into his New York City apartment. Using an unusual combination of viola with electric guitar and drums, the VU hit the New York music scene with their intentional crudity and sense of beauty in ugliness. The lyrics (often in the form of beat poetry) reflected social alienation, sexual deviancy, drug addiction, violence and hopelessness, and they evoked the destructiveness of modern life.

In 1966, Warhol made the VU the aural component of his mixed media touring show, the Exploding Plastic Inevitable. He added German model/actress Nico on vocals, which helped bring national attention to the band. The classic Velvets lineup was John Cale (viola and piano), Sterling Morrison (bass and guitar), Maureen "Mo" Tucker (drums) and Nico (vocals). The VU's first album *The Velvet Underground and Nico* (1967) is their most well known with the famous Warhol design of a bright yellow banana labeled "Peel Slowly and See." The band never sold many records but influenced many future punk artists, including Iggy Pop, David Bowie, the New York Dolls, Television, Patti Smith and the Sex Pistols. The band continued its moderate success until 1973 and a short reunion of original members in 1992/1993 and 1996. The VU's contribution to rock and roll earned them induction into the Rock and Roll Hall of Fame in 1996.

The Velvet Underground

The Velvet Underground with Nico and Andy Warhol

© Steve Schapiro/Contributor/Getty Images

Recommended Listening

- Black Angel's Death Song
- Pale Blue Eyes
- Heroin

Trivia

- Only two of the VU's albums made Billboard's Top 200—*The Velvet Underground and Nico* (#171) and *White Light/White Heat* (#199).

- Lou Reed underwent electro-shock treatment in his youth to remove homosexual tendencies from his mind.

- Lou Reed worked as a staff writer in the Brill Building before forming the VU.

- Florence Greenberg's label Scepter (founded to showcase the Shirelles) recorded and released *The Velvet Underground and Nico* in 1967.

- "I'm an artist and that means I can be as egotistical as I want to be."—Lou Reed

- "The only reason we wore sunglasses onstage was because we couldn't stand the sight of the audience."—John Cale

The Motor City Five (MC5)

The Motor City Five (MC5) formed in Detroit in 1965 as part of the Bohemian arts community. Their sound was quickly defined as a loud, fast style of R&B mixed with free jazz (inspired by Albert Ayler, Sun Ra and John Coltrane), electronic distortion and a rebellious attitude. The MC5 are one of the most important pre-punk bands that, despite fading into obscurity in the early 1970s, laid the foundation for punk music. They especially influenced the New York Dolls. By 1968, the MC5 had developed a national following and signed with Elektra records; they released their first album, a live concert recording titled *Kick out the Jams* in 1969. As the MC5's lyrics celebrated free love, drugs and revolution in youth culture, many record retailers refused to stock the album, stating that the lyrics were obscene. Seeing the potential problems ahead, Elektra dropped the MC5 and Atlantic Records picked them up to record two albums, *Back in the U.S.A.* in (1970) and *High Time* in 1971. In 1972, having made their impression on the future punk rockers, the MC5 disbanded with financial problems stemming primarily from drug addiction. The MC5 had several attempts at re-uniting without great success, but audiences regard their first three albums today as classics.

Recommended Listening

- Kick out the Jams

The Stooges

The Stooges, featuring front man Iggy Pop (born James Newell Osterberg, Jr.), began their career in 1967 as the Psychedelic Stooges, a hard-hitting rock band that capitalized on shock value to excite their audiences. After dropping the "psychedelic" from their name in 1968, Elektra Records signed the Stooges (at the same concert as the MC5). Iggy Pop quickly became known for his outrageous stage demeanor with wild antics. These included self-mutilation, verbal abuse of the audience, smearing his chest with hamburger meat and peanut butter, leaping off the stage (he was one of the innovators of "stage-diving") and sometimes exposing himself to the audience. As with many of the pre-punk bands, their records did not sell in huge quantities, but they left an impact that would define the coming punk era. Their debut album *The Stooges* was released in 1969, followed by two other important records *Fun House* (1970) and *Raw Power* (1973), which Kurt Cobain cites as his favorite album of all time. Some have said that the Stooges made some of the most raucous and harsh music of the late 1960s, music that is deliberately amateurish with depressing and perverse lyrics. The Stooges officially broke up in 1974 with a reunion in 2005 that resulted in a new album, *The Weirdness*, in 2007. Drug addiction was also a contributing factor to the original break-up of the group with Iggy Pop hopelessly addicted to heroin and alcohol problems with bassist Dave Alexander. The other original members of the group were brothers Scott Asheton (drums) and Ron Asheton (guitar). Although neither the Stooges nor Iggy Pop have had a Top Ten album or best-selling single, Pop has enjoyed a successful solo career with many projects in collaboration with David Bowie.

Recommended Listening

- I Wanna Be Your Dog
- No Fun
- Search and Destroy

Trivia

- The Sex Pistols covered the Stooges' song "No Fun" in 1976.
- Iggy Pop got the first part of his stage name from his high school band the Iguanas (he was the drummer). He added the "Pop" to make him appealing to the current music and art trends of the late 1960s.
- John Cale produced *The Stooges* and David Bowie produced the Stooges' final album *Raw Power*.
- Iggy Pop once performed a whole concert zipped inside a military duffle bag.

New York Dolls

The New York Dolls were formed in New York City in 1971 by guitarists Johnny Thunders and Sylvain Sylvain, bassist Arthur "Killer" Kane, drummer Billy Murcia and singer David Johansen. The group received early interest from promoters, and, in 1972, Rod Stewart helped bring the band to the UK for a European tour. During this tour, Billy Murcia died of accidental suffocation when, after overdosing on drugs and alcohol, some groupies put him in a cold bath and poured coffee down his throat to try and wake him. Jerry Nolan (who later co-formed the Heartbreakers) replaced him. In 1973 Malcolm McLaren became their new manager and decided to use fashion as the motivating force behind the group. Their first album, *The New York Dolls* (1973), was

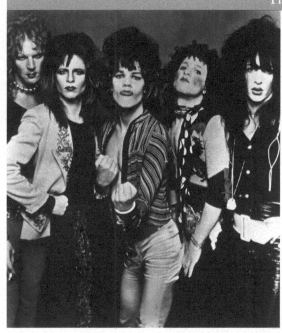

The New York Dolls

The New York Dolls brought fashion into the punk world

© RB/Staff/Getty Images

received relatively well and contained the early punk classic "Personality Crisis." They released their second and only other studio album, *Too Much Too Soon,* in 1974.

The New York Dolls loosely based their style on the Rolling Stones, the MC5, the Stooges and the Velvet Underground, but they had a more deliberately amateurish sound. This ultimately lost them their recording contract because their sound and image were considered too weird. As with many early punk bands, their lyrics addressed controversial issues like the Vietnam War, mental health and other social issues of the time. Thunders and Nolan left the Dolls in 1975 due to conflicts with McLaren, but the group continued until 1977. The Dolls influenced the cross-dressing and glam-rock scene of the 1990s and helped set the stage for the punk movement. Thunders died in New Orleans in 1991 of an alleged heroin and methadone overdose, although there are signs that someone may have murdered him and the police didn't properly investigate. Nolan died a few months later in 1992 as a result of a stroke. In 2004 the band reformed with three of their original members to issue a new album, *The Return of the New York Dolls.* Unfortunately, Arthur Kane died suddenly from complications with leukemia, ending any hope of a complete reunion tour.

Recommended Listening

- Personality Crisis
- Trash
- Jet Boy
- Don't Start Me Talkin' (Sonny Boy Williamson II)

Television

Television was formed in New York City in 1973 by Tom (Miller) Verlaine, Richard Lloyd, Richard Hell and Billy Ficca. Prior to forming Television, Verlaine and Hell worked together in the Neon Boys (1972 to early 1973). The band is best known for their brilliant guitar work, extended solos, clever song writing and lyrics that related directly to the punk movement. The single "Marquee Moon" (1977) is an excellent example of the band's interlocking lead and rhythmic guitar lines. A certain amount of psychedelic influence is noticeable in the extended soloing that was inspired by the San Francisco Summer of Love bands. Along with the Patti Smith group, Television was one of the first bands to play at the famous CBGB nightclub. Television had a devout following in New York City and a major impact on the British post-punk scene. Despite rave reviews, the mass market largely ignored their albums *Marquee Moon* (debut 1977) and *Adventure* (1978). Hell decided to leave the group to form The Heartbreakers in 1975 with former members of the New York Dolls because Verlaine frequently refused to play his songs (such as "Blank Generation") in concert. Television reunited in 1991; they released a new album, *Television*, and performed a series of special concerts in 2001.

Recommended Listening

■ Marquee Moon
■ Little Johnny Jewel
■ See No Evil

Richard Hell

Richard Meyers, aka Richard Hell (born October 2, 1949), became the unintentional poster boy and originator of punk fashion in the mid-1970s. He was the first influential figure to wear spiked hair and the now classic, self-decorated ripped jeans and t-shirts held together with safety pins. Hell was most prominent in his role as bass player and front-man of the punk band Richard Hell & the Voidoids. He formed the Voidoids in 1976 after being a member of the Neon Boys and Television with Tom Verlaine, and the Heartbreakers with Jerry Nolan and Johnny Thunders of the New York Dolls. Many view the Voidoids' 1977 album, *Blank Generation*, as a landmark punk recording and credit the title song, "Blank Generation," as being among the top ten defining punk songs. Dissonant jagged guitar lines characterize the Voidoids' sound as one of most harshly uncompromising bands of punk scene. In 1982, Hell formed a band called Destiny Street; he has since published two novels and several short works, formed indie rock group the Dim Stars in the early 1990s, and worked as a film critic for *Black Book* magazine from 2004–2006. He was a heroin addict for twenty years and had a brief acting career appearing in Susan Seidelman's *Smithereens* (1982) and Rachel Amodeo's *What About Me?* (1993). He has a daughter (named Ruby) with Patty Smyth, who was the lead singer of the punk band Scandal, and is now married to John McEnroe. Richard Hell was the direct inspiration for Malcolm McLaren when he was creating an image for the Sex Pistols.

Recommended Listening

- Blank Generation
- Love Comes in Spurts

Trivia

- Hell had a non-speaking cameo role as Madonna's murdered boyfriend in Susan Seidelman's 1985 *Desperately Seeking Susan*.

- "Rock & roll is trying to convince girls to pay money to be near you"—Richard Hell

Patti Smith

Patricia "Patti" Lee Smith (born December 30, 1946) began her performing career on the streets of Paris with her sister as a busker (pan handler) in 1969. After returning to the U.S., Smith wrote poetry, collaborated in songwriting endeavors with other future punk rockers, set her poems to the electric guitar accompaniment of Lenny Kaye and contributed reviews of rock bands to *Creem* magazine. By 1974, she had formed the Patti Smith Group, financed by her friend Robert Mapplethorpe, and released her first single "Hey Joe" backed with a spoken word B-side titled "Piss Factory." In 1975, producer Clive Davis signed Smith to Arista Records and produced (with John Cale) her first album, *Horses*. This album opens with a cover of Them's (Van Morrison) "Gloria" and fuses spoken word and rock music in

Patti Smith

Patti Smith
performing at
CBGB

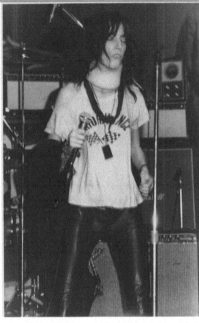

© Lynn Goldsmith/Contributor/Getty Image

the punk style. Mick Jagger and Jim Morrison largely inspired Smith's vocal style and erratic stage antics. She has only had one Top Twenty single in her career, which was "Because the Night" written with Bruce Springsteen in 1978 for her *Easter* album. Upon the release of her 1979 album *Waves*, Smith retired from music to focus on her poetry and only returned to live performing in 1988 with a new album *Dream of Life*. She has since collaborated on songs with R.E.M, toured briefly with Bob Dylan and recorded the theme song "Walking Blind" for the film *Dead Man Walking* in 1995. Smith released *Trampin'*, an album about motherhood, in 2004 and was inducted into the Rock and Roll Hall of Fame in 2007. She is also the feature of a documentary film, *Patti Smith: Dream of Life* (2008). Her peers have dubbed her the poet laureate of punk rock, and the French Ministry of Culture officially named her a Commander of the Ordre des Arts et des Lettres in 2005.

Recommended Listening

- Gloria
- Because the Night
- People Have the Power
- Walking Blind

Trivia

- Billy Roberts wrote Patti Smith's first single, "Hey Joe" (the same song made famous by Jimi Hendrix).
- Smith fell fifteen feet off a stage into a concrete orchestra pit in Tampa Florida in 1977 and broke several neck vertebrae.
- While in the hospital she wrote her fourth book of poetry.

The Ramones

Often regarded as the first real punk rock group, the Ramones formed in 1974 in New York. They were the first New York punk group to embrace completely what would become the punk sound, image and lifestyle, and they were also the first punk group to get a major-label recording contract. Their Web site credits 2,263 concerts to the band's history and a track record of touring virtually nonstop for twenty-two years. From their first shows at CBGB in the mid-1970s, the Ramones shaped the sound of punk rock

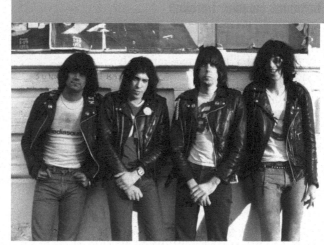

© Denis O'Regan/Contributor/Getty Images

The Ramones

The original Ramones: Left to right: Johnny Ramone, Tommy Ramone, Joey Ramone and Dee Dee Ramone

in New York and became the model for both American and British punk rockers. Even bands like the Sex Pistols and the Clash credit the Ramones with motivating their first live performances. They also note that the Ramones defined the shock value of punk and that musicality was always second to the statement they could make. When Joe Strummer told the Ramones that the Clash had not played a live show because they were not ready yet, Johnny Ramone told him "Are you kidding? We're lousy; we can't play. If you wait until you can play, you'll be too old to get up there. Really, we stink!"

The Ramones came up with their name when they heard that Paul McCartney used the pseudonym Paul Ramone to check into hotels when he was with the Beatles. Most of their songs were fast and short, coming in under two and a half minutes and featuring deadpan lyrics, no guitar solos and hard aggressive playing. Sometimes the Ramones' live shows were so short they had to play the set twice. Even with their international following and reputation as the "best night out" by concertgoers, their only album to reach gold status in the U.S. was their compilation album *Ramones Mania*. The Ramones produced fourteen studio albums, released seven live albums and seventeen unauthorized bootleg albums between 1976 and 1996. Fans generally prefer their definitive early albums *Ramones* (1976), *Rocket to Russia* (1977), *Road to Ruin* (1978), *End of the Century* (1980) and *Pleasant Dreams* (1981). The Ramones also appeared in a number of feature films, including *Blank Generation* (1976), *Roger Corman's Rock 'n' Roll High School* (1979), *Lifestyles of the Ramones* (1990) and an excellent double DVD tribute to their whole career titled *It's Alive 1974–1996* released by Rhino Records (2007).

The original line-up for the Ramones was Jeffry Hyman on drums, John Cummings on guitar and Douglas Colvin on bass and lead vocals. Colvin was the first member to adopt the name Ramone, calling himself Dee Dee Ramone. Hyman soon became Joey Ramone and moved into the lead singer role (Dee Dee moved to backing vocals), and Cummings became Johnny Ramone. Needing a fourth member to fill the drum chair, manager Thomas Erdelyi joined the band as Tommy Ramone in late 1974. As manager, Tommy had auditioned many drummers. Unhappy with all of them, he got tired of showing what beats to play, so he decided just to be the drummer himself. In 1978, Tommy was sick of touring and found replacement Marc Bell, who became Marky Ramone. The original three members of the Ramones held the group together for over twenty years until Dee Dee Ramone left in 1989 (replaced by Christopher Joseph Ward, aka C. J. Ramone).

Ramones Member Timeline

1974–1989	Joey Ramone, lead vocals Johnny Ramone, guitar Dee Dee Ramone, bass
1974–1978	Tommy Ramone, drums
1978–1983	Marky Ramone (Marc Bell), drums
1983–1987	Richie Ramone (Richard Reinhardt), drums and sometimes lead vocals
1987	Elvis Ramone (Clement Bozewski), drums
1987–1996	Marky Ramone
1989–1996	C. J. Ramone (Christopher Joseph Ward), bass and sometimes lead vocals

After performing at the Lollapalooza music festival and a short club tour, the Ramones decided to hang it up and disbanded. Their final show was in Los Angeles on August 6, 1996. Within eight years of the breakup, all three of the band's founding members died.

Joey Ramone died of lymphoma on April 15, 2001, in New York; Dee Dee Ramone was found dead at his Hollywood home on June 5, 2002, of a heroin overdose (only two months after The Ramones were inducted into the Rock and Roll Hall of Fame); and Johnny Ramone died of prostate cancer on September 15, 2004, in Los Angeles, California.

Recommended Listening

- Blitzkrieg Bop
- I Wanna Be Sedated
- Needles and Pins
- The KKK Took My Baby Away
- Howling at the Moon

Trivia

- The Ramones played so loud while recording their first album that they destroyed several pieces of studio equipment.

- While working with the Ramones one day in 1980, Phil Spector insisted on re-recording the opening chord on "Rock 'n' Roll High School" in a thirteen-hour session during which he held the band at gunpoint to keep them singing.

- Joey Ramone apparently wrote the song "The KKK Took My Baby Away" after Johnny stole his girlfriend Linda from him and married her in 1981. The two never recovered from their falling out. Joey referenced the KKK because there was a rumor that Johnny carried a KKK membership card in his wallet.

- The first Ramones gig at CBGB was terrible. "I never wanted them back again," said CBGB owner Hilly Kristal. "They were worse than Television. And Television was terrible!"

- The Ramones summed up: "Eliminate the unnecessary and focus on the substance."
—Tommy Ramone

The Misfits

Singer Glenn Danzig and bassist Jerry Only formed the Misfits in January 1978 and later added guitarist Doyle Wolfgang Von Frankenstein (Jerry's youngest brother). They are credited with the birth of horror punk, a primitive form of punk rock that uses 1950s-sounding chord progressions with a harsh to-the-point instrumental and vocal sound and horror-style make-up. The band took the name from the title of Marilyn Monroe's last movie *The Misfits* to immortalize her image. Their famous iconic skull logo comes from a scene in the 1946 movie *The Crimson Ghost*. The Misfits recorded four studio albums, but they released only their third and fourth albums while together, *Walk Among Us* (1982) and *Earth A.D.* (1983). They released their first two albums, *Static Age* (1997, recorded in 1978) and *12 Hits From Hell* (2001, recorded in 1980) after breaking up. The last show of the original Misfits was at Greystone Hall, Detroit, Michigan, on Saturday, October 29, 1983. In the mid-1990s, the group reformed as the Resurrected Misfits led by Jerry Only. They released an album, *American Psycho*, in 1997 that brought a new audience to the music of the Misfits. The band still has a massive cult following, especially with their image. In fact, the Misfits sell more merchandise than they do records due to the popularity of their logo. Despite a relatively short career, the Misfits inspired hard rock and psychobilly bands both musically and through their neo-punk image, bands including Green Day, Rancid, Blink 182, Good Charlotte, slipknot, Rob Zombie, Marilyn Manson, Tiger Army, The Reverend Horton Heat and Horror Pops.

Recommended Listening

- The Last Caress
- Who Killed Marilyn?

Trivia

- Marky Ramone played drums for the Misfits twenty-fifth anniversary tour that lasted three years.

- The police arrested the Misfits in New Orleans in 1982 and held them on charges of grave robbing when they tried to obtain a skull from one of the above-ground crypts.

- Audiences credit Jerry Only with inventing the hairstyle known as the "Devil lock," where the bangs come to a point in front of the nose or chin.

The Dead Kennedys

The Dead Kennedys, formed in 1978, usually receive credit as the first significant "hard-core" punk band in the United States. A much heavier sound and faster style than earlier 1970s punk rock defines hardcore punk. Early leaders in the hardcore style included the bands Black Flag, Bad Brains and Minor Threat and the English band the Damned, but it wasn't until the Dead Kennedys released their single "California Über Alles" in 1979 (an

attack on then governor of California Jerry Brown) that the style became nationally and internationally recognized. The Dead Kennedys were the United States' answer to the Sex Pistols with deliberately shocking lyrics and baiting themes featured on their first three albums *Fresh Fruit for Rotting Vegetables* (1980), *In God We Trust, Inc.* (1981) and *Plastic Surgery Disasters* (1982). They made themselves prominent in the general public, wreaked havoc in the music industry (almost sending their record label into bankruptcy) and gave American punk an anti-social aggressive image that damaged the scene for other bands. The band officially broke up in 1986, but that did not stop the obscenity trials, lawsuits over royalties and attacks on the music industry, especially MTV, that dominated their performing career.

Recommended Listening

- California Über Alles
- Holiday in Cambodia

Trivia

- The 1985 *Frankenchrist* album included a poster with art that depicted penises (Penis Landscape by H. R. Giger), which brought criminal charges for distribution of harmful matter to minors.

The Sex Pistols

Members
- Johnny Rotten, vocals (born January 31, 1956)
- Steve Jones, guitar (born September 3, 1955)
- Paul Cook, drums (born July 20, 1956)
- Glen Matlock, bass 1975–1977 (born August 27, 1956)
- Sid Vicious, bass 1977–1979 (May 10, 1957–February 2, 1979)

The Sex Pistols were the definitive English punk rock band of the mid-1970s and the most well known in punk history. They hit the London scene in late 1975 with a hardcore punk attitude and a raucous sound. They brought with them the birth of mainstream punk fashion and Malcolm McLaren's managing experience and funding. Their short turbulent career and rise to the top of the British charts became captured in a media frenzy that saw their music banned from the airwaves and removed from record stores and most of their concerts cancelled. In a matter of months, three record companies signed and dropped the band, Londoners who disapproved of their anti-establishment attitude beat them up, and they were arrested for disturbing the peace during a performance on the Thames. The Sex Pistols ultimately put British punk on the map, inspired a myriad of new bands and then single-handedly destroyed the punk scene as we knew it.

Early versions of the Sex Pistols existed from 1973 as the Strand and the Swankers, but the real formation of the group occurred in 1975 with the addition of Glen Matlock on bass and finally vocalist John Lyndon aka Johnny Rotten. Later, Matlock quit the band, replaced

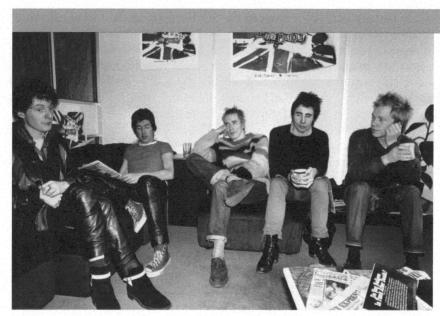

The Sex Pistols

The Sex Pistols, l-r: manager Malcolm McLaren; Steve Jones; Johnny Rotten (John Lydon); Glen Matlock; and Paul Cook.

© Hulton-Deutsch Collection/Contributor/Getty Images

by John Simon Ritchie aka Sid Vicious. The Sex Pistols' career was a well-choreographed business venture of Malcolm McLaren, who owned a London boutique shop (called SEX) and was the former manager of the New York Dolls. McLaren conceived the idea of a rock act that would challenge the established music scene with crude, intensely emotional stage shows calculated to exhilarate or offend, all designed to have maximum shock value with the press. McLaren and his business partner, Vivienne Westwood, capitalized on the punk craze by promoting anything punk related through their fetish wear store; they advertised their designer clothes as "anti-fashion."

The Sex Pistols began playing local school and college venues in late 1975 with most of their shows cut short due to the offensive nature of the group. In early 1976, prominent London venues such as the 100 Club and the Nashville booked them.

As they grew in popularity, a fan base called the Bromley contingent followed the band. Just as much hype surrounded this contingent who were as influential in punk style in fact as much so as the band itself. This fashionable punk crowd included Siouxsie Sioux and Steve Severin, who formed the Banshees, and Billy Idol, who formed Generation X.

The first Sex Pistols single, "Anarchy in the U.K.," was released on November 26, 1976, on the EMI label. It rose to #38 on the UK charts with defiant lyrics that compared the English government to terrorist groups such as the IRA (Irish Republican Army) and the UDA (Ulster Defence Association). In December 1976, the Bill Grundy show in London featured the band, where, after both the band and host consumed a lot of alcohol, Grundy made suggestive comments to Souxsie Sioux (Bromley contingent members were present for the interview), resulting in Steve Jones making some crude comments about Grundy being a dirty old man. Grundy urged Jones and Johnny Rotten to further their insults, and the producers immediately shut down the show. As the headlines hit the morning papers, everyone in England now knew of the Sex Pistols, their crude behavior and awful punk music. What better way to promote the band!

The Sex Pistols second single, "God Save the Queen," released in May 1977, was regarded as a direct attack on the British monarchy and sparked vicious attacks on the band members from devout royalists. The Sex Pistols' shows and tours from this time on repeatedly faced difficulties from authorities, and public appearances often ended in disaster and riots.

In January 1977, EMI dropped the Sex Pistols from their label, allowing them to keep their forty thousand pound advance. By February, Sid Vicious, the former drummer of Siouxsie & the Banshees and the Flowers of Romance, replaced Glen Matlock. In March, the band signed a new record deal with A&M Records. After destroying several of the A&M offices during a party, A&M dropped them, only six days after signing them (leaving the band twenty-five thousand pounds richer this time!). Virgin Records finally took the Pistols' contract in May and stayed with them through the end of their career.

Around the time that Sid joined the Pistols, he met Nancy Spungen, a drug addict and occasional prostitute, and took her as his girlfriend. This relationship led to Sid's ultimate demise (they were both hopelessly addicted to heroin) and ended in tragedy with Nancy's murder (stabbed to death), Sid being charged with the homicide and his death from a drug overdose shortly after his release on bail.

The Sex Pistols only recorded and released one album during their career, *Never Mind the Bollocks, Here's the Sex Pistols*, in December 1977, but it ranks as one of the most important rock and roll records ever. It reached #1 on the UK charts, despite being banned almost everywhere, and #106 on the U.S. charts. In January 1978, the band embarked on a U.S. tour, which put the nail in the coffin of their wild and out-of-control career. After seven U.S. performances the band members were sick of each other, their own songs and the whole idea of being in a rock band. On January 14, 1978, the Sex Pistols ended their final performance in San Francisco only a few songs into the set with Johnny Rotten asking the audience, "Do you ever get the feeling you've been cheated?" They would not reunite again until 1996 when the original four members performed a world tour that produced a live album titled *Filthy Lucre Live*.

The Sex Pistols changed the rock and roll world forever (for better or for worse) and directly inspired the formation of the Clash, Buzzcocks, X-Ray Spex, Joy Division, Siouxsie and the Banshees and countless other British rebel groups in the late 1970s. They embodied the complete punk package and changed the world in doing so. At the end of their fleeting brush with super-stardom they had so little money that Johnny Rotten had to plead with Virgin owner Richard Branson to buy him a ticket back to England. The Sex Pistols were officially inducted into the Rock and Roll Hall of Fame in 2006, even though, in true Sex Pistols form, they refused to attend, calling the museum a "piss stain." They have since reunited in 2003, 2007 and 2008 for world tours.

Recommended Listening

- Anarchy in the UK
- God Save the Queen
- Holidays in the Sun
- Pretty Vacant
- My Way

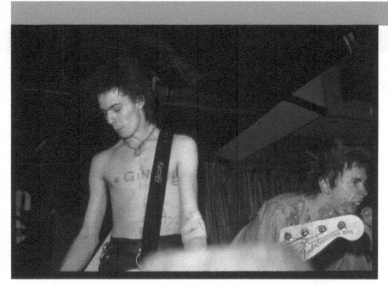

© *Lynn Goldsmith/Contributor/Getty Images*

Trivia

■ Johnny Rotten received his nickname because of green hair, decaying teeth and a lack of personal hygiene.

■ "Actually, we're not into music, we're into chaos." Steve Jones.

■ Steve Jones played all of Sid Vicious's bass parts for *Never Mind the Bollocks, Here's the Sex Pistols* as Sid really couldn't play the bass.

■ *Never Mind the Bollocks* didn't earn platinum certification until 1992.

■ During an interview one day, Sid Vicious produced a bicycle chain and blindsided his interviewer.

Siouxsie and the Banshees

Siouxsie and the Banshees were formed in 1976 in London by Siouxsie Sioux and Steven Severin, members of the Bromley contingent and friends of Malcolm McLaren and the Sex Pistols. They started out with a classic UK abrasive punk rock sound, but they moved quickly to a more mainstream style. This style made use of symphonic elements and techno/dance grooves in the 1980s and a pop sound demonstrated on their 1991 Top Forty hit "Kiss Them for Me" (from the album *Peepshow*). They released their first UK Top Ten single in 1978 with "Hong Kong Garden," followed quickly by their first album *The Scream*. On their debut performance, the Banshees featured drummer Sid Vicious, who went on to become the bass player for the Sex Pistols. Along with the Clash, Siouxsie and the Banshees became a fixture of the British post-punk movement, sustaining their fan base and popularity through live shows and eleven studio albums; they officially disbanded in 1996.

Recommended Listening

- Hong Kong Garden
- Peek-a-Boo
- Kiss Them for Me

The Clash

The Clash (started as the London SS) formed in 1976 in London, England, and enjoyed a successful career until 1986 when they broke up to pursue solo careers. After several lineup changes, the band settled on Mick Jones (guitar, vocals), Paul Simonon (bass), Terry Chimes (drums) and John Graham Mellor (vocals, guitar), using the stage name "Joe Strummer," to play their first official show on July 4, 1976 (opening for the Sex Pistols). They signed a record contract late in 1976 and released their first album, *The Clash*, in April 1977. At this time, Chimes left the group (but returned in 1982 for a year), and Nick "Topper" Headon replaced him. During 1977, the band developed an outlaw image through a series of arrests with band members that directly transferred into their raw punk sound. This image grabbed the attention of the London youth culture, and the Clash started to draw a big underground fan base through strong political messages of anti-Thatcherism, racism and police brutality in their music.

In 1979, their second album, *Give 'Em Enough Rope*, debuted at #2 on the UK charts, but still failed to make an impact in the USA. After the Clash made two U.S. tours in 1979, they finally hit the U.S. billboard charts at #23 with the release of the double album *London Calling*. Many saw this album as a revolution in the punk world with the Clash experimenting with funk, reggae and rap without leaving the three-minute punk song formula. Their most successful album, *Combat Rock*, was released in 1982, reaching #7 in the USA and #2 in the UK, and became certified double platinum. Just as the Clash were beginning to break through to American audiences, they fired Topper Headon. They were unable to work around his heroin addiction, and the tensions between Joe Strummer and Mick Jones had also reached the breaking point. Jones left the band in 1983 to form Big Audio Dynamite; meanwhile, Strummer struggled to keep the Clash from sinking in the charts and in general popularity. By 1986, Joe Strummer and Paul Simonon agreed to dissolve the band completely and began solo careers. Ironically, the Clash had their first #1 hit song in 1991 with "Should I Stay or Should I Go" (originally released in 1982), six years after they broke up. Sadly, Joe Strummer died in December of 2002, only four months before the Clash were inducted into the Rock and Roll Hall of Fame in 2003.

The Clash

The Clash on their first U.S. visit

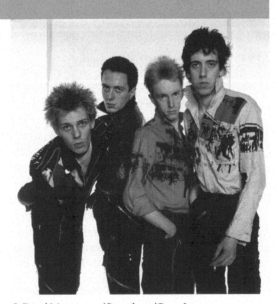

© David Montgomery/Contributor/Getty Images

Recommended Listening

- White Riot
- Should I Stay or Should I Go
- Rock the Casbah
- London Calling
- Train in Vain"

Trivia

- Joe Strummer scored music for the movie *Grosse Pointe Blank*.

- The first song played on Armed Forces Radio during operation Desert Shield was the Clash's "Rock the Casbah."

- The cover of the album *London Calling* features a photograph of Paul Simonon smashing his bass guitar against the stage at The Palladium in New York City. *Q Magazine* voted it the best rock and roll photograph of all time.

- "When you blame yourself, you learn from it. If you blame someone else, you don't learn nothing, cause hey, it's not your fault, it's his fault, over there!"—Joe Strummer

The Damned—UK Goth Punk

The Damned formed in London in 1976 from the remains of the band Masters of the Backside (that featured Chrissie Hynde, later of the Pretenders). They kicked off their career opening for the Sex Pistols at the 100 club in London. The original Damned members were Dave Vanian (David Lett) on vocals and theremin, Captain Sensible (Raymond Burns) on bass, Rat Scabies (Chris Millar) on drums and Brian James on guitar. The MC5, Iggy and the Stooges and the New York Dolls were big influences on their developing sound. The Damned became the first British punk band to release a single, "New Rose," and an album, *Damned Damned Damned*, and to tour the United States (all in 1977). Their aggressive early style was a direct inspiration to the first wave of American West Coast hardcore punk bands. They released a second album in 1977, *Music For Pleasure*, and four singles in the UK, but problems with the band internally ended with Brian James, the main songwriter, leaving the group in 1978, replaced by Algy Ward. Captain Sensible moved over to guitar so Ward could play bass. Performing for a short time under the name the Doomed, the band began to embrace the Gothic sound and image; then they reverted back to their original name the Damned. They released an eclectic album, *Machine Gun Etiquette*, that produced a Top Twenty hit called "Love Song" in 1979, marking the success that was to continue. Paul Gray stepped in on bass when Ward quit in 1980 and contributed to two albums before Bryn Merrick replaced him in 1983. The Damned have continued to keep a presence in the punk world, and many consider them one of the first bands to adopt the Gothic image and sound.

Recommended Listening

- New Rose
- Love Song
- Eloise

Trivia

- Brian James named The Damned after a 1969 movie about pre-Nazi Germany.

- The introduction of "Is She Really Going Out With Him?" comes from The Shangri-La's 1964 "Leader of the Pack."

- Lemmy of Hawkwind and Motörhead played bass with the Damned for a short time in 1978.

- The Damned performed "Nasty" live on the cult BBC television show *The Young Ones* in 1984.

Other Pre-Punk Bands

Known as proto punk (U.S. and UK):

- Billy Bragg
- David Bowie
- The Deviants
- Mott the Hoople
- The Pink Fairies
- Roxy Music
- Suicide
- London SS

Other First Wave Punk Bands (US and UK)

- Adam & the Ants
- Bad Religion
- Black Flag
- Blondie
- Boomtown Rats
- The Buzzcocks
- Circle Jerks
- The Delinquents
- Generation X
- Joy Division/New Order
- The Lords of the New Church
- The Only Ones
- The Slits
- Social Distortion
- The Stranglers
- Talking Heads
- The Urinals
- The Vibrators
- The Weirdos

20

Where Do We Go from Here?

Other Artists of Significant Influence in Rock 'n' Roll History

In the preface of this book, I describe our intent to provide an "appetizer" for rock 'n' roll. It is impossible to cover every significant artist and detail every success (or failure!) of the artists that we cover in a text designed for a one-semester course. We have provided what we believe to be a "well-rounded overview" of the evolution of rock 'n' roll that educates both the novice on the origins and innovations of this music, and, fills some gaps for the more experienced enthusiast. With over 15,000 students completing UNLV's History of Rock course with this text since 2008, there hasn't been a single student walk away without discovering, not one, but many pieces of information they found enlightening. That certainly makes us happy as authors and course developers; however, we receive requests constantly to add other significant artists that have impacted rock music history. The conundrum is that we want to stay away from relatively new artists, despite major success in some cases, due to the fact they are not yet in the "history" of rock 'n' roll. But, we do

want to recognize major contributions. Over the past few years, we've kept track of these requests while simultaneously researching pivotal points, changes, and trends. We have now added this chapter to feature artists and bands who we believe have made contributions to rock 'n' roll that have changed, defined and reshaped the art -form. This chapter will most likely be in a constant state of evolution, but we are pleased to introduce some major innovators in rock 'n' roll. TJ

David Bowie

David Bowie
At RCA

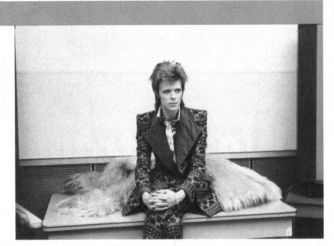

© *The Estate of David Gahr/Getty Images*

David Bowie

David Robert Jones was born in Brixton, England on January 8, 1947.

After hearing Little Richard's "Tutti Frutti" at age nine, David developed an interest in Rock 'n' Roll. He began saxophone lessons at age thirteen and broadened his musical interests to Jazz; especially through the influence of musicians Eric Dolphy and John Coltrane. Jazz would particularly impact David's music in his later career.

As a teenager, David played saxophone and sang with several musical bands: The Kon-Rads, The King Bee's, The Mannish Boys, and The Lower Third. In 1966, a TV show, *The Monkees* was launched and the lead singer was Davey Jones. Because of the success of the TV show, David Jones changed his name to David Bowie to avoid any confusion with Davy Jones.

Bowie's first album, *David Bowie*, was released in July 1967 with marginal success, coming in at number 125 on the UK charts. His second album, *Space Oddity* (UK title. Also released under the title *Man of Words/Man of Music* in the United States), was released in November 1969 launched by the defining single "Space Oddity" (*Ground Control to Major Tom*). This single was Bowie's first real success peaking at number 5 on the UK charts. The song was inspired by the lunar landing on July 20, 1969 and Stanley Kubrick's movie *2001: A Space Odyssey*. The album *Space Oddity* was released by Mercury Records and brought the attention of RCA Records, who Bowie would be contracted to for the next ten 10 years.

In 1970, Bowie released *The Man Who Sold the World*, produced by American record producer, Tony Visconti. Guitarist Mick Ronson, who would help define the "Bowie sound," joined Bowie on this album. Tony Visconti produced Bowie off and on from 1969 through to his farewell album, *Black Star*, in 2016.

Hunky Dory was released in December 1971, followed by *The Rise and Fall of Ziggy Stardust* in June 1972. Both of these albums were produced by British record producer/engineer Ken Scott and David Bowie. While *Hunky Dory* established Bowie as a serious writer, *Ziggy Stardust* is credited as beginning the Glam/Glitter Rock movement, which became its own sub-genre of rock music. It is here that Bowie developed his alter ego, Ziggy Stardust, an androgynous image that was both shocking and influential. The Ziggy Stardust concept continues to influence current performers (i.e. Madonna and Lady Gaga).

In 1972, David Bowie wrote the song "All the Young Dudes" for Mott The Hoople, which became the title track to the album of the same name. Bowie then released *Aladdin*

Sane in April 1973, followed by an extensive U.S. and UK tour. On the final performance of the concert tour at the Hammersmith Theatre in London (June 3, 1973), Bowie famously announced "This is the last show we'll ever do" and retired the "Ziggy" character.

Bowie began to transition his style with the release of the album *Diamond Dogs* in May 1974, followed by a summer U.S. tour. The show featured a Broadway set design, including skyscrapers, a catwalk, and a cherry picker arm, which extended Bowie over the audience when he sang "Space Oddity."

In March 1975, Bowie released the album *Young Americans*, which was a soul based album. For *Young Americans* Bowie collaborated with soul singer Luther Vandross and guitarist Carlos Alomar (who co-wrote the single "Fame" with Bowie and John Lennon). "Fame" was David Bowie's first single to reach the #1 spot on U.S. Billboard charts. The LP "Young Americans," which featured famous jazz-pop alto saxophonist David Sanborn, illustrated Bowie's stylistic diversity.

In 1977, Bowie moved to Berlin, Germany and collaborated with Brian Eno to write material for three more albums: *Low*, released in January 1977; *Heroes*, October 1977; and *Lodger*, in May 1979; all produced by David Bowie and Tony Visconti.

The albums were considered Bowie's "Berlin Trilogy" and made use of electronic ambient sounds with angular (syncopated, detached) guitar playing. The title track of *Heroes* is a powerful statement about lovers behind the Berlin wall. While in Berlin, Bowie also produced albums for Iggy Pop (*The Idiot*, September 1977 and *Lust for Life*, November 1977).

By 1983, David Bowie was living between Switzerland and Australia. He moved from RCA to EMI Records and released the album *Let's Dance* April 1983. *Let's Dance* was produced by Nile Rodgers and featured, a then unknown blues guitarist, Stevie Ray Vaughan. *Let's Dance* sold over 7 million copies and was followed by a 1983 world tour dubbed "The Serious Moonlight Tour."

In April 1987, Bowie released the album *Never Let Me Down*. He followed this album release with "The Glass Spider" world tour, which was performed in large outdoor stadiums. Bowie felt that both the album and tour were overly commercial. The commercialization troubled Bowie enough, that in 1990, he vowed to never again perform his older hits live in concert.

In 1989, Bowie put a band together called Tin Machine with Tony Sales, Hunt Sales and Reeves Gabrels. Tin Machine released *Tin Machine* in May 1989, and *Tin Machine 2* in September 1991. Tin Machine had what could be characterized as an abrasive sound and was never commercially accepted (possibly a relief to Bowie from the 1987 experience?).

In 1993, David Bowie re-embarked on his solo career with the album *Black Tie White Noise* in April 1993, which featured jazz trumpeter Lester Bowie (no relation). *Black Tie White Noise* is recognized as one of the first albums to combine jazz and hip hop rhythms. The album *Outside* was released in September 1995, followed by the *Earthling* in February 1997.

In September 2003, Bowie released *Reality* produced again by Bowie and Visconti. During the "Reality Tour" in Schessel, Germany, Bowie suffered a heart attack. As a result, he decided to stay out of the public eye for nine 9 years, surprising the music world with the release of a new album in March 2013, *The Next Day*. This album was a huge commercial and critical success reaching the number 1 one spot on charts all over the world.

On David Bowie's birthday January 8, 2016, he released the album *Blackstar* co-produced again with Tony Visconti. Two days after the release, David Bowie succumbed to a battle with cancer, that he had kept out of the public eye, and died on January 10, 2016. David Bowie created *Blackstar* knowing that it would be his final project since he

had been diagnosed with an accelerated terminal cancer. Always the consummate musician and artist, *Blackstar* has proved to be one of Bowie's most innovative albums, receiving rave reviews and reaching #1 on album charts around the world.

David Bowie should be considered to be one of the most innovative artists of the 1970s, with a legacy that remains influential today; he was able to remain relevant throughout his career. Bowie is also recognized as a talented actor starring in films such as *The Man Who Fell to Earth* in 1976, *The Hunger* in 1983, *Merry Christmas Mr. Lawrence* in 1983, the cult film *Labyrinth* 1986, *The Last Temptation of Christ* in 1988, and *The Prestige* in 2006.

Recommended Listening

- Space Oddity 1969
- Changes 1971
- Moonage Daydream 1972
- Rebel Rebel 1974
- Young Americans 1975
- Heroes 1977
- Ashes to Ashes 1980
- Modern Love 1983
- I'm Afraid of Americans 1997
- Sue (or, In a Season of Crime) 2016

Awards

- Inducted into the Rock and Roll Hall of Fame in 1996
- BRIT Award Best British Male 1984, and 2014
- BRITs Icon award 2016 Outstanding Contribution to British Music Award 1996
- NME Awards for Best male singer 1977, 1978, 1981, and 1983
- WB Radio Music Awards Legend Award 1999
- Berklee College of Music Honorary Doctorate 1999
- Grammy Lifetime Achievement Award 2006
- Webby Lifetime Achievement Award 2007

Alice Cooper

Vincent Damon Furnier (aka Alice Copper) was born on February 4, 1948 in Detroit, Michigan. He is the son of a fundamentalist minister of the Church of Jesus Christ. When Vincent was young, the Furnier family moved to Phoenix, Arizona where he attended high school and developed an interest in music.

At age 17, Vincent formed a band called the Earwigs, who became The Spiders and later The Nazz. The Nazz were influenced by the Beatles, the Rolling Stones, the Kinks, the Yardbirds, and the Doors. After moving to Los Angles in 1967, the band learned that L.A. guitarist and songwriter Todd Rundgren already had a band called Nazz. With almost identical band names, The Nazz decided to once more change their name. To mirror their sound, the band wanted a name that sounded like a female axe murderer; so they decided on the name Alice Cooper. The original band members included Furnier (vocals), Glen Buxton, (guitar), Michael Bruce (guitar), Dennis Dunaway (bass), and Neal Smith (drums).

After playing a show at the Cheetah club in Venice, California, the band was approached by Shep Gordon, a Hollywood talent manager and producer, who set up an audition for them with Frank Zappa. Zappa, who at that time, was looking for creative bands for his new label Straight Records, signed Alice Cooper to a three-album deal in 1969. A female band named The GTOs who were signed to Zappa's label, helped Alice Cooper develop a glam look by dressing them in glittery clothes. Alice Cooper's first album was *Pretties for You* (1969). This album had a psychedelic feel and reached #193 on the U.S. charts.

On September 13, 1969 Shep Gordon secured a slot for Alice Cooper to perform at the Toronto Rock and Roll Revival before a huge outdoor audience. The bill also included John Lennon's Plastic Ono Band and the Doors. After Alice Cooper took the stage, Gordon threw a live chicken onstage from the audience. Furnier tossed the chicken back over the crowd, thinking it would fly away. After landing in the first few rows, the fans tore the chicken into pieces and threw the chicken parts back on the stage. The next day a local Toronto newspaper printed a story about Furnier biting the head off the chicken and drinking its blood. Frank Zappa told Furnier that people loved the story about the chicken and said "Well, whatever you do, don't tell anyone you didn't do it."

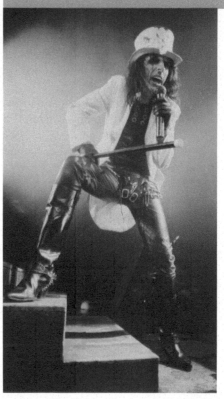

Alice Cooper

American rock singer Alice Cooper performing on stage, circa 1988.

© *Tony Mottram/Contributor/Hulton Archive/ Getty Images*

When Alice Cooper's second album *Easy Action* failed to reach the Billboard Top 200, the band moved to the Detroit area, as audiences were more accustomed to raw sounding bands like The Stooges and The MC5. They were more accepting of Alice Coopers' stage act than the west coast audiences.

Bob Ezrin was hired to produce Alice Cooper's third and final album on Zappa's label *Love It to Death*. The single from the album, "I'm Eighteen," was released in November 1970, and reached #21 on the U.S. charts. In early 1971, Warner Brothers bought Alice Cooper's contract from Zappa and re-issued *Love It to Death* in March 1971. On this second release, the album peaked at #35 on the U.S. album charts. Bob Ezrin's production and mentorship helped the band develop a harder rock sound, which ultimately would influence heavy metal.

Alice Cooper's stage act began to develop into a style similar to a theatrical horror movie. Their stage props included a fake electric chair, a live boa constrictor, an axe to behead dolls, a Hangman's noose, and eventually a guillotine.

The album *Killer* was released November 1971 and reached #21 on the U.S. charts. The follow up album was *Schools Out*, which was released June 1972 and reached #2 on the U.S. charts. The single "Schools Out" peaked at #7 and became a rock anthem for kids ready for summer school vacation. The first Alice Cooper album to reach #1 on the U.S. (and UK) charts was *Billion Dollar Babies* released in February 1973.

Although "Alice Cooper" was originally the band's name, not Furnier's name, fans assumed Furnier (being the lead singer) was Alice Cooper. When the original Alice Cooper

band broke up in 1975, and Furnier launched a solo career, he capitalized on this assumption and legally changed his name to Alice Cooper. Now with Atlantic Records, Alice Cooper released his first album as a solo artist; *Welcome to My Nightmare* in March 1975. To fill the backing band, Bob Ezrin hired two veteran guitarists Steve Hunter and Dick Wagner who had previously toured with Lou Reed and played studio sessions for Aerosmith. *Welcome to My Nightmare* included the single "Only Women Bleed," which reached #12 on the U.S. charts.

In the 1980s, Alice Cooper released several successful albums: *Flush The Fashion* (1980), *Special Forces* (1981), and *DaDa* (1983). In 1990, Cooper released *Hey Stoopid*, and, in 1994 *The Last Temptation*.

In addition to music, Alice Cooper has also appeared in some films with a cameo role in the *Nightmare on Elm Street, Freddy's Dead: The Final Nightmare* (1991), and played himself in the Mike Meyers comedy *Wayne's World* in 1992.

After many years working with other producers, Alice Cooper reunited with Bob Ezrin and released *Welcome 2 My Nightmare* in September 2011 on the UMe label. For this album, Alice Cooper brought back members of his original band, country artist Vince Gill, and heavy metal artist Rob Zombie. *Welcome 2 My Nightmare* was Cooper's 26th studio album. It reached #22 on U.S. album charts.

Alice Cooper is a rock icon whose stage performances have influenced many artists including Kiss, David Bowie, and Marilyn Manson. Alice Cooper is considered one of heavy metal's early innovators both in sound and stage presence.

Recommended Listening

1. I'm Eighteen
2. Under My Wheels
3. Schools Out
4. Billion Dollar Babies
5. Welcome To My Nightmare
6. No More Mister Nice Guy

Awards

1. Hollywood Walk of Fame——2003
2. Grand Canyon University Honorary Doctorate——2004
3. Scream Awards, Rock Immortal Award—2007
4. Inducted into the Rock and Roll Hall of Fame——2015

Elton John

Sir Elton Hercules John, CBE was born Reginald Kenneth Dwight in Middlesex, England on March 25, 1947. He was considered a prodigy starting to play piano at the age of 3. And by 11, he was awarded a scholarship to study at the Royal Academy of Music in

London. At age 15, he formed his first band, Bluesology who specialized in R&B and performed as a backup band for many American artists touring the UK.

RIO DE JANEIRO, BRAZIL— September 12, 2011: Singer Elton John performing at the Rock in Rio held at Parque Olimpico Cidade do Rock in Barra da Tijuca.

In 1967, Dwight met his writing partner; lyricist Bernie Taupin (born May 22, 1950), after they both answered an ad for songwriters in the *New Music Express* (*NME* magazine) placed by A&R manager Ray Williams. Williams gave Dwight lyrics that Taupin had written and tasked him with writing the music. After writing music to these lyrics, Dwight contacted Taupin to start a writing partnership that still continues today. After initially meeting in 1967, Dwight and Taupin recorded their first original song "Scarecrow." A few months later, Reginald Dwight decided to change his name, taking the stage name Elton John. In 1968, the duo of Elton John and Bernie Taupin were employed as staff writers for Dick James's DJM Records and got to work on what would become Elton's first album.

© A. RICARDO/Shutterstock.com

Elton John's first album was *Empty Sky* released June 6, 1969. *Empty Sky* was slow to gain public interest, but eventually rose to #6 on the Billboard charts in 1975 as fans looked for earlier examples of Elton John's work. Elton's second album *Elton John* was produced by Gus Dudgeon and released in April 1970. The album's single "Your Song" reached #7 in the UK and #8 in the U.S., with the complete album reaching #5 in the UK and #4 in the United States.

Elton John's U.S. debut was at the Troubadour Club in Los Angeles in August 1970. Promoted largely as a solo act, Elton has always been backed by talented musicians such as Nigel Olsson (drums), Dee Murray (bass), and guitarist and music director Davey Johnstone. Both Nigel Olsson and Davey Johnstone have worked with Elton off and on since 1971.

On November 5, 1971, Elton John released the album *Madman Across the Water* DJM (UK), which reached #8 in the United States. The album *Honky Chateau* was released May 19, 1972 and became Elton John's first #1 album holding the top spot for 5 weeks. *Honky Chateau* included the hits "Rocket Man" and "Honky Cat." In 1973, the album *Don't Shoot Me I'm Only the Piano Player* also reached #1 on the U.S. and UK charts. The next album, *Goodbye Yellow Brick Road* was released in October 1973 and spent two 2 months at the #1 position on the U.S. album charts; it also reached #1 on the UK and Australian charts. *Goodbye Yellow Brick Road* contained the hit singles "Candle in the Wind," "Saturday's Alright for Fighting" and, of course, "Goodbye Yellow Brick Road."

In 1973, Elton John founded The Rocket Record Company with Bernie Taupin, Gus Dudgeon and Steve Brown. Rocket Records distributed singles and albums through Island Records (UK) and MCA Records (United States). Rocket Records signed several major artists including Neil Sedaka, Kike Dee, Cliff Richard and the Hudson Brothers. Elton John wanted to sign Iggy Pop and the Stooges to Rocket Records, but they declined. In 1999, Universal Music's Island Records absorbed Rocket Records as a subsidiary label.

In 1974, Elton John worked collaboratively with John Lennon, releasing a cover of the Beatles "Lucy in the Sky with Diamonds." Elton also sang and played piano on Lennon's

single "Whatever Gets You Thru the Night" that was released October 4, 1974. Elton bet Lennon that if the song hit #1, Lennon would have to join him on stage. After "Whatever Gets You Thru the Night" hit #1 on the U.S. charts, Lennon honored the bet and joined Elton on stage at Madison Square Garden for his November, 1974 concert.

In 1977, Elton John announced his retirement from live performing to focus on studio work. He worked with lyricist Gary Osborne and created the 1978 album "A Single Man," which, unfortunately, failed to produce any top 20 hit singles in the USA. In 1983, he reunited with Bernie Taupin and produced the album *Too Low for Zero* on Geffen records. The singles "I'm Still Standing" and "I Guess That's Why They Call it the Blues" reached #12 and #4 on the U.S. charts respectively.

Heading into the 1990s, Elton John established the Elton John AIDS Foundation (1992) to battle AIDs and HIV worldwide. In 1993, Elton collaborated with Tim Rice to write the music for Disney's *The Lion King*, which won him a Grammy for Best Male Pop Vocal Performance. In 1997, Elton John revised the lyrics and re-released the single "Candle in the Wind" in tribute to Lady Diana, Princess of Wales. The single sold over 33 million copies and is the biggest selling single in history. Proceeds went to the Diana, Princess of Wales Memorial Fund. On February 24, 1998, Elton John received a knighthood from Queen Elizabeth II for "services to music and charitable services" and became Sir Elton Hercules John, CBE.

In 2004, Elton John began a residency show at Caesars Palace Coliseum, Las Vegas called "The Red Piano." The show ran through April, 2009 and he completed 241 performances during its residency. Elton John has sold over 250 million albums and 100 million singles worldwide. He has earned 37 gold and 27 multi-platinum albums as well as having the biggest selling single in history.

Recommended Listening

1. "Your Song"
2. "Levon"
3. "Rocket Man"
4. "Goodbye Yellow Brick Road"
5. "Candle In The Wind"

Awards

1. Grammy, Best Pop Performance by a duo or group with vocal "That's What Friends Are For," 1986
2. Grammy, Best Instrumental Composition "Basque," 1991
3. Grammy, Best Male Pop Vocal Performance "Can You Feel The Love Tonight," 1994
4. Grammy Best Musical Show album Elton John & Tim Rice's *Aida*, 1997
5. Grammy, Best Male Pop Vocal Performance "Candle In The Wind," 1997
6. BRIT Award Best Male Artist, 1991
7. Inducted into the Rock and Roll Hall of Fame, 1994
8. Honorary Doctorate, Royal Academy of Music, 2002
9. Kennedy Center Honor, 2004
10. BRITs Icon Award, 2013

Pink Floyd

Pink Floyd was formed in 1965 by Syd Barrett (guitar), Roger Waters (bass), Nick Mason (drums), and Richard Wright (keyboards) in London, England. Roger Waters and Nick Mason met as students at the London Polytechnic School. Syd Barrett met the other band members when he moved to London to study at the Camberwall College of Arts. The name of the band came from merging the first names of two Delta bluesmen Pink Anderson and Floyd Council who were influences on the evolving band.

In 1966, Pink Floyd played at London's Marquee club and attracted the interest of their future managers, Andrew King and Peter Jenner. The band also played at the All Saints' Hall and the UFO club where they performed extended improvised versions of R&B tunes. During this time period, Syd Barrett began writing and using his original songs with the band to replace the R&B jams.

© Michael Ochs Archives/Getty Images

Pink Floyd

LOS ANGE-LES—AUGUST 1968: Psychedelic rock group Pink Floyd pose for a portrait shrouded in pink in August of 1968 in Los Angeles. (L-R) Nick Mason, Dave Gilmour, Rick Wright (center front), Roger Waters.

Pink Floyd was signed to E.M.I in 1967 with Barrett responsible for the majority of the writing and lead singing. Pink Floyd's first single, "Arnold Layne," was released in March 1967, and reached #20 on the UK charts, followed soon after by "See Emily Play" in June 1967 and reached #6 on the UK charts.

While promoting the Pink Floyd singles on the English TV show *Top of the Pops* and U.S. TV show *The Pat Boone Show*, Barrett began to act unpredictably due to his LSD use that began in 1967; this ultimately led to a mental breakdown. While recording their first album *The Piper at the Gates of Dawn* in 1967, Barrett's erratic behavior had become a serious problem and threatened the future of the band. David Gilmour was asked to join Pink Floyd in December 1967, initially as a fifth member, but replaced Syd Barrett early in 1968 as the lead guitarist. Barrett had become too unstable to perform on stage or contribute in the studio.

A Saucerful of Secrets, Pink Floyd's second album was released in June 1968 and peaked at #9 on the UK charts. Although Roger Waters and Richard Wright did the majority of the writing, one composition by Syd Barrett, "Jugband Blues," was included.

The album *The Dark Side of the Moon* was released March 1973, reaching #1 on the U.S. charts and #2 on the UK charts, and remained on the Billboard charts for more than 14 years selling over 40 million copies worldwide. It has earned the title of most charting weeks on the Billboard 200 with 917 weeks!

The next album, *Wish You Were Here*, was released in September 1975 and was inspired by Syd Barrett's departure from the band. In November 1979, Pink Floyd released one of rock 'n' roll's most imaginative albums, *The Wall*, which reached #1 on the U.S. charts and #3 on the UK charts with 23 million copies sold in the U.S. alone. Roger Waters became the lead songwriter for *The Wall*; however, the album also included some significant writing contributions from David Gilmour. Richard Wright agreed to leave the band after the making of *The Wall* because he had stopped contributing to the song writing. *The Wall* was a concept album (an album with a theme), which evolved into the movie *The Wall* starring Bob Geldof; it was released in July 1982. Roger Ebert is quoted as saying "The Who produced *Tommy* in 1969 and *Quadrophenia* in 1973. David Bowie and Genesis followed, and Pink Floyd: *The Wall* essentially brought a close to that chapter. … the film is without question the best of all serious fiction films devoted to rock." (RogerEbert.com, February. 24, 2010).

Due to personal differences with David Gilmour, Roger Waters left Pink Floyd at the end of 1983 and pursued a solo career, releasing his first solo album *The Pros and Cons of Hitch Hiking* in April 1984. David Gilmour answered with his own solo album *About Face*, also in 1984. Waters started a futile legal battle to prohibit the remaining band members from using the name "Pink Floyd," which he ultimately lost.

A *Momentary Lapse of Reason*, released September 1987, was Pink Floyd's first release after the departure of Roger Waters. In a very unusual arrangement, keyboardist Richard Wright was hired back into Pink Floyd as a salaried member of the band. The album *The Division Bell*, the final studio album for Pink Floyd, was released March 1994 and earned triple platinum status.

In July 2, 2005, after a long hiatus, Roger Waters, David Gilmour, Nick Mason, and Richard Wright were reunited on stage for the first time in 24 years when Bob Geldof organized the Live 8 Concert in Hyde Park, London. Although they were offered many millions for a reunion tour, the band members declined the offer.

Pink Floyd's original creative force, Syd Barrett was in and out of mental institutions for most of his adult life and died on July 7, 2006 at the age of 60. Keyboardist, Richard Wright died on September 2008 at the age 65 after an unsuccessful battle with cancer.

David Gilmour and Nick Mason released an album *The Endless River* in November 2014 with much of the material based on recordings from *The Division Bell* sessions. The album was a tribute to Richard Wright and inspired by Wrights work on *The Division Bell* sessions; it included contributions by other musicians in tribute of Wright. In 2015, David Gilmour stated that Pink Floyd was "done" and would never reunite because of the loss of Richard Wright.

Pink Floyd's style was generically categorized as psychedelic music, but was influenced by many other musical styles including rock 'n' roll, space rock, experimental music, folk, country, and electronic music. Pink Floyd are considered by their fans to be Art Rock or Progressive Rock. David Gilmour's guitar work, although blues based, carries beautiful tones and feel. Gilmour was rated #14 on *Rolling Stone's* 100 Greatest Guitarist of All Time, and is known for his tasteful, melodic solos.

Recommended Listening

1. See Emily Play
2. Money
3. Us and Them
4. Another Brick In The Wall Part 2
5. Learning To Fly
6. Shine On You Crazy Diamond (Parts 1-5)
7. Wish You Were Here

Awards

1. International Album of the Year Juno award for *The Wall* 1981
2. MTV Video Music Award: Best Concept Video for "Learning To Fly" 1988
3. Grammy Award for Best Rock Instrumental Performance for "Marooned" 1990
4. Q award for Best Live act 1994
5. Inducted to the Rock and Roll Hall of Fame 1996
6. Pink Floyd was inducted into the "UK Music Hall of Fame" November 2005.

Prince

Prince Rogers Nelson (aka Prince) was born June 7, 1958 in Minneapolis Minnesota to a musical family; his father was a pianist and his mother a jazz singer who both performed in a band called Prince Nelson. As a child, Prince taught himself to play piano, guitar, and drums. As somewhat of a musical prodigy, Prince wrote his first song, "Funk Machine," at age seven.

While attending Minneapolis Central High School, Prince formed his first band, Grand Central Station, with his cousin Charles Smith and his friend Andre Anderson (aka André Cymone). Charles Smith was later replaced by Morris Day on drums. The band later changed their name to Champagne and began playing original music that was influenced by George Clinton, James Brown, Earth, Wind & Fire, Sly and the Family Stone, Jimi Hendrix, and others.

In 1976 at age 17, Prince signed a management deal with Owen Husney, who sent his press kit to several record companies. As a result, Prince signed a three-album deal with Warner Brothers that included terms that gave him creative control and ownership of his publishing rights. Prince's debut album *For You* was released in April 1978 on Warner Brothers Records. Prince wrote all the music and played every instrument on the album (guitars, keys, drums, bass, and percussion). The song "Soft and Wet," which was co-written with Chris Moon, reached # 12 on the Hot Soul Singles chart.

Prince

NEW YORK, NY–DECEMBER 29: (Exclusive Coverage) Prince performs during the "Welcome 2 America" tour at Madison Square Garden on December 29, 2010 in New York City. (Photo by Kevin Mazur/NPG Records 2010)

© *Kevin Mazur / Getty Images*

Prince formed a new band in 1979 with André Cymone (bass), Dez Dickerson (guitar), Gayle Chapman (keys), Doctor Fink (keys), and Bobby Z (drums). In October 1979, Prince released his second album *Prince*, which reached #4 on Billboard's R&B chart and #22 on Billboard's album chart. The album's single "I Wanna Be Your Lover" reached #11 on the Billboard Hot 100 singles chart. Prince composed and played every instrument on the "Prince" album.

The album *Dirty Mind* was released October 8, 1980 and was recorded with Prince's band. *Dirty Mind* combined the styles of funk, R&B, pop and new wave, and the album's single "Uptown" reached #5 on Billboard's dance chart. In 1981, Prince opened for the Rolling Stones on their "Tattoo You" U.S. tour; however, he was booed off the stage for dressing in lingerie and overly sexualizing his act.

In October 1982, Prince released the double album *1999* that reached # 9 on the Billboard album charts. *Rolling Stone* Magazine considered "1999" to be Prince's most influential album because of its creative utilization of drum machines and synthesizers; the album was also inducted into the Grammy Hall of Fame in 2008. The album singles "1999" and "Little Red Corvette" reached #12 and #6 respectively on Billboard's Hot 100 singles chart. The band Prince used on *1999* was called The Revolution and included Lisa Coleman (keys), Doctor Fink (keys), Brown Mark (bass), Dez Dickerson (guitar), Bobby Z. (drums), and Jill Jones (backing vocals).

In 1984, Prince produced his most monumental work and contribution to rock 'n' roll with the release of *Purple Rain* on July 25. *Purple Rain* is the soundtrack album that accompanies his autobiographic film of the same name (*Purple Rain*), which was released 2 days later on July 27, 1984. Prince played the character in the film based on his persona and featured his band The Revolution. Another band known as The Time, were also included in the film. The Time had been a creative side project for Prince with Morris Day as lead

singer. The album *Purple Rain* has sold over 22 million copies worldwide and is considered by *Rolling Stone* Magazine to be the second most important album of the 1980s. The singles from *Purple Rain*, "When Doves Cry" and "Let's Go Crazy," both reached #1 on the Billboard Hot 100 chart; while the title track "Purple Rain" reached #2.

In 1989, Prince was commissioned to write the music for the *Batman* movie, directed by Tim Burton, that featured Michael Keaton, Jack Nicholson, and Kim Basinger. The *Batman* album was released in June 1989 and reached #1 on Billboard's Hot 100 album chart and sold over 11 million copies worldwide.

In 1993, Prince changed his name to the symbol ♀ as a form of protest and rebellion toward Warner Brothers records. The reason for his "subordinance" was that Warner Brothers had limited the number of records Prince could release each year. As a prolific artist, and in a period of highly creative output, Prince wanted the freedom to release multiple albums a year, effectively providing his fans with the music as close to the time it was conceived. He certainly did not want to be limited to just one album per year so the record company could capitalize on the longevity of sales. Because the symbol ♀ was hard to use by the press, Prince became known as "the Artist Formerly Known as Prince" until 2000. In 1994, Prince released the single *The Most Beautiful Girl in the World* independently, which reached #3 on the Billboard singles chart (Warner Brothers wrote off the "contract violation" release as allowing the artist an experiment).

Prince's relationship with Warner Brothers deteriorated further as the label continued to successfully release albums of material "required from him under contract," or captured in earlier recordings. Four significant albums were released between 1995 and 1999 including *The Gold Experience* (1995) with charting hits "I Hate U" and "P Control,;" *Girl 6* (1996), *Chaos & Disorder*, and *The Vault: Old Friends 4 Sale* (1999). In November 1996, after his recording contract with Warner Brothers had expired, Prince released a 3-CD album set called *Emancipation* on his own label New Power Generation (NPG) Records. Then, in March 1998, Prince released another 3-CD album set *Crystal Ball*; again on NPG.

In 1999, Prince signed with Arista records and released *Rave Un2 the Joy Fantastic* in November 1999. His first album returning to using the name "Prince" was with *The Rainbow Children* in 2001. In 2004, Prince appeared at the Grammy Awards performing with Beyonce, and a couple of months later at the rock 'n' Roll Hall of Fame for his own induction. At the end of his solo on George Harrison's "While my Guitar Gently Weeps" Prince threw his guitar in the air and left the stage; the audience was left wondering how the guitar "vanished!" In 2007, Prince played the halftime show for the Super Bowl, bringing him, and his music, back into the spotlight all around the world. Between 2001 and 2015 Prince released a staggering sixteen 16 albums, experiencing major chart success for *Musicology*, Billboard #3 (2004), *3121* Billboard #1 (2006), *Planet Earth*, Billboard #3 (2007), and *LOtUSFLOW3R*, Billboard #2 (2009).

The last album Prince released before his premature death was *HITnRUN Phase Two*, released December 12 2015, on NPG records. Sadly, on April 21 2016, Prince was found dead in the elevator of his Paisley Park home. During his life, Prince released 39 studio albums, making him one of music's most prolific artists.

Recommended Listening

1. 1999
2. Purple Rain
3. Little Red Corvette

4. When Doves Cry
5. Kiss
6. The Most Beautiful Girl in the World
7. Cream

Awards

1. Grammy 1984 "Purple Rain" (song) best rock performance
2. Grammy 1984 "I Feel For You" best R&B song
3. Grammy 1984 "Purple Rain" best album original score for motion picture
4. Grammy 1986 "Kiss" best R&B performance
5. Grammy 2004 "Musicology" best traditional R&B vocal performance
6. Grammy 2004 "Call My Name" best male R&B vocal performance
7. Grammy 2007 "Future Baby Mama" best male R&B male vocal performance

Frank Zappa

Frank Vincent Zappa was born December 21, 1940 in Baltimore, Maryland, but moved to San Diego by the time Frank began high school. Soon after, the Zappa family moved again to Lancaster, California where Zappa graduated from high school.

Zappa was a self-taught musician who listened to many styles of music from R&B and Doo-wop to avant-garde composers such Edgard Varese, Igor Stravinsky, and Anton Webern. Unique among rock musicians, Zappa taught himself musical notation, which gave him the ability to write for orchestral instruments. While attending Antelope Valley High School in Lancaster, Zappa began to play guitar and played drums for a local band called The Blackouts. During his time at Antelope Valley High School Zappa, befriended fellow musician Don Vliet (aka Captain Beefheart) who became a well-known recording artist. Zappa also composed for the Antelope Valley High School orchestra. And, after high school, attended Chaffey College for one semester.

Zappa moved to the Los Angeles area in 1959, married Kathryn Sherman in 1960, and in 1962, composed music for the film *The World's Greatest Sinner* and, in 1961, began

Frank Zappa

SATURDAY NIGHT LIVE— Episode 10—Pictured: Musical guest Frank Zappa performs on December 11, 1976

© NBC / Getty Images

working at Pal Studio (Pal is famous for producing "Wipe Out" and other surf classics) in Cucamonga, California. In 1963, Zappa had his first TV appearance as a guest on the Steve Allen show playing an amplified bicycle. Allen makes fun of Zappa and plays the whole thing off as a joke, but Zappa provides some very insightful, philosophical commentary and reasoning for his "weird" performance (check it out on YouTube!). Zappa bought Pal studio from owner Paul Buff in 1964 and renamed it Studio Z. In 1965, he joined a band called the Soul Giants with Ray Collins (singer), Roy Estrada (bass), and Jimmy Carl Black (drums). The Soul Giants began playing Zappa's original compositions and changed their name to the "Mothers" on Mother's Day 1965 with Zappa as the bandleader. This was the first incarnation of Frank Zappa's Mothers of Invention.

Under the management of Herb Cohen, who also managed Tom Waits, George Duke, and Linda Ronstadt among others, the Mothers signed a five-album deal with Verve records (an MGM records subsidiary) in March, 1966. The Mothers expanded their name to the Mothers of Invention to reflect the experimental nature of the band, and released their debut album *Freak Out* in June 1966. *Freak Out* was a double album, which was a risky move for the release of debut album. *Freak Out* introduced a combination of satirical comedy with rock 'n' roll and avant-garde music. Zappa admitted to being a big Spike Jones fan, which more than likely influenced the blending of comedy and music.

The Mothers of Invention became a nine-piece band with the addition of Jim Fielder (guitar), Don Preston (keyboards), Billy Mundi (drums), Bunk Gardner (woodwinds) and Jim "Motorhead" Sherwood (saxophone). The Mothers sophomore album *Absolutely Free* was released in June 1967 and broke onto the Billboard album charts at number 50. In February 1967, while still working with the Mothers of Invention, Zappa produced his first solo album, *Lumpy Gravy*, featuring avant-garde music, electronics, and jazz and orchestral influences. Due to a contractual dispute with Capitol Records, the album's release was stalled until May 1968 and issued on Verve Records. *Lumpy Gravy* is often erroneously compared as a follow up album to *We're Only In It For The Money?* with the Mothers of Invention. *We're Only In It For The Money?* was released in March 1968, a month before *Lumpy Gravy*, but *Lumpy Gravy* was recorded a year earlier.

In 1968, Frank Zappa and Herb Cohen launched a new record label, Bizarre Records (distributed by Reprise Records). The label was used for the release of the Mothers of Invention albums and other acts Zappa selectively signed to the label. Zappa released another double album, his fifth studio album, *Uncle Meat* on Bizarre Records in April 1969. Zappa signed the band "Alice Cooper" to his label and released their debut album *Pretties For You* in May 1969.

On May 15, 1970, Zappa performed his work titled *200 Motels* with conductor Zubin Mehta and the Los Angeles Philharmonic Orchestra at UCLA. For *200 Motels*, Zappa expanded the Mothers by adding vocalists Mark Volman and Howard Kaylan, formerly with the Turtles. For a 1970 tour, Zappa also added Aynsley Dunbar (drums) and Jazz keyboardist George Duke to the Mothers. In early 1971, Zappa made a movie version of *200 Motels* in London with the Royal Philharmonic Orchestra. The movie starred Frank Zappa and his band members as well as Ringo Starr, Keith Moon, and Theodore Bikel. *200 Motels* premiered in movie theatres October 29, 1971.

The Mothers performed at the Fillmore East theatre in New York City in 1971 during its closing week on June 5 and 6 with John Lennon and Yoko Ono as guest performers on the June 6 show. A live album was released titled *Fillmore East June-1971* in August 1971. Part of John Lennon and Yoko Ono's performance with The Mothers was included on John and Yoko's *Sometime in New York City* album in 1972.

While Zappa and the Mothers were performing at the Casino de Montreux in Montreux, Switzerland December 4, 1971 a fan shot off a flare gun, which burned down the casino. The incident was depicted in Deep Purple's song "Smoke on the Water." A week later, during a performance at London's Rainbow Theatre, a fan pushed Zappa into

the orchestra pit resulting in a broken ankle and serious injuries to his back and neck. For over a year Zappa was confined to a wheelchair and not able to tour. The accident also ended the current lineup of the Mothers as some of the musicians needed to take other gigs during Zappa's recovery.

During the 1970s, Frank Zappa released a total of 21 albums including *Burnt Weeny Sandwich*, *Weasels Ripped My Flesh*, and *Chunga's Revenge* in 1970, *200 Motels* and *Fillmore East June-1971* in 1971, *Just Another Band From L.A.*, *Waka/Jawaka* and *The Grand Wazoo* in 1972, *Over-Nite Sensation* in 1973, *Apostrophe (')* and live album *Roxy & Elsewhere Zappa/Mothers* in 1974 with a new "Mothers" line-up that included Ruth Underwood (percussion), Napoleon Murphy Brock (tenor saxophone), Bruce Fowler (trombone), Walt Fowler (trumpet), Tom Fowler (bass), George Duke (keyboards), Chester Thompson (drums), and Ralph Humphrey (drums), *One Size Fits All* and *Bongo Fury* in 1975, *Zoot Allures* in 1976, *Zappa In New York* and *Studio Tan* in 1978. In 1977, Frank Zappa launched Zappa records, and in 1979 recorded the album *Sheik Yerbouti*, which was his first release on the Zappa new label. *Sheik Yerbouti* sold over two million records, and was Zappa's best-selling album.

Zappa released the albums *Shut Up 'N Play Yer Guitar*, *Shut Up 'N Play Yer Guitar Some More* and *The Return of the Son of Shut Up 'N Play Yer Guitar* all in 1981. The three albums were instrumental (no vocals) and focused on Zappa's guitar playing. In 1983, Zappa released *London Symphony Orchestra, Vol. 1*, followed up by *London Symphony, Vol. 2* in 1987. Both albums featured the London Symphony Orchestra and included Zappa compositions specifically arranged for orchestra.

In 1990, Frank Zappa was diagnosed with prostate cancer, but continued working on his music until his death on December 4, 1993. His new compositions included works for the German chamber ensemble, Ensemble Modern.

Zappa's unique ability to comfortably compose music for orchestras and rock bands alike, and cross musical genres from R&B, doo-wop, rock, jazz-rock, classical, electronic experimental and the avant-garde made him truly a genius in rock 'n' roll. Frank Zappa was highly respected in the classical music world as a serious composer. The rock world considered him an innovative guitarist and groundbreaking for producing some of the most challenging and innovative music in rock history, while simultaneously being provocative and controversial with his use of satirical comedy. For all of his perceived weirdness and "out there" music, Frank Zappa never drugs or drank alcohol. In fact, he took an aggressive approach to discouraging the drug culture of the 1960s and 1970s. *He believed that taking drugs would transform people and mutate their personalities and values. He was very adamant in promoting a no drug policy among his band members, ensuring that there was no drug use while on the road touring* (from strictlyzappawordpress.com). Zappa did, however, drink copious amounts of coffee and chain-smoked right up to his death at 52. During his lifetime, Frank Zappa released 62 albums, and the Zappa Family Trust released another 40 albums after his death. He is considered Rock's most prolific composer.

Recommended Listening

1. Wowie Zowie
2. Peaches En Regalia
3. Cosmik Debris
4. Billy The Mountain
5. Zoot Allures

Awards

1. 1994 *Down Beat* Magazine's Hall of Fame
2. 1995 Inducted into the Rock and Roll Hall of Fame
3. 1997 Grammy Lifetime Achievement Award 1997
4. 2011 *Rolling Stone* Magazine ranked Frank Zappa #22 of the 100 greatest guitarists of all time

Other significant artists

- Bruce Springsteen
- Fleetwood Mac
- Lynyrd Skynyrd
- Maddona
- Nirvana
- Radio Head
- Rush
- Queen
- U2
- The Bee Gees
- The Killers
- The Police

The Allman Brothers

Brothers Duane Allman (November 20, 1946-October 29, 1971) and Gregg Allman (December 8, 1947-May 27, 2017) were born in Nashville, Tennessee, and grew up in Daytona Beach, Florida. After taking up the guitar in their teens, the brothers formed The Allman Joys band in the mid-1960s. The Allman Joys were renamed The Hour Glass and

The Allman Brothers Band

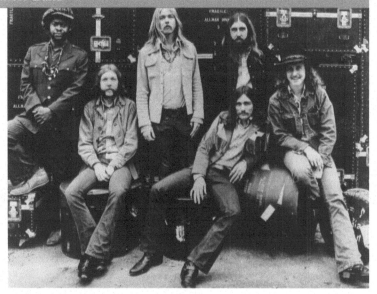

© *ullstein bild Dt./Contributor/Getty Images*

moved to Los Angeles in 1967. After recording two relatively unsuccessful albums for Liberty Records, Duane moved to Muscle Shoals, Alabama, to be a session guitarist at Fame Studio, working with artists such as Wilson Pickett and Aretha Franklin. While Gregg stayed in Los Angeles to record a solo album in an attempt to mend the relationship with the record company after the turbulent break.

The Allman Brothers Band officially formed in March 1969 with Duane Allman on guitar, Gregg Allman on vocals and organ, Dickey Betts (born December 12, 1943) on guitar, Berry Oakley (April 4, 1948-November 11, 1972) on bass, and both Butch Trucks (May 11, 1947-January 24, 2017) and Jai Johanny "Jaimoe" Johanson (born July 8, 1944) on drums. The Allman Brothers Band moved to Macon, Georgia, in May 1969 and signed with new label Capricorn Records. The band's first album "The Allman Brothers Band" was recorded in New York City and released in November 1969, selling just over 35,000 copies.

The Allman Brothers felt their music could draw stronger sales if they shifted their attention to live concert recording as they were considered to be one of the greatest live performing bands. In March 1971, the Allman Brothers recorded "At Fillmore East" (released in July 1971), which reached number 13 on the Billboard Album Charts, was certified gold (500,000 copies) within four months, and became the breakthrough album for the band. This album is considered to be one of the best live albums in rock 'n' roll history and was selected for preservation in the Library of Congress.

On October 29, 1971, Duane Allman was tragically killed in a freak motorcycle accident in Macon, Georgia. The remaining Allman Brothers Band members decided Duane would want them to continue, so they directed their focus to completing their third studio album "Eat a Peach" that Duane had already started to record. "Eat a Peach" was released in February 1972 with guitar credits to Duane Allman, Gregg Allman, and Dickey Betts. It reached number 4 on the Billboard album charts and was certified platinum (1,000,000 sales).

Eerily, bassist Berry Oakley was involved in a motorcycle accident only three blocks from where Duane's accident occurred. Oakley left the scene of the accident stating that he felt fine, but was rushed to hospital hours later and died from his injuries. His death came just one year after Duane's death, under similar circumstances, and at the same age (24). Lamar Williams replaced Berry Oakley on bass, and, in 1973, Keyboardist Chuck Leavell also joined the Allman Brothers.

The Allman Brothers' next album "Brothers and Sisters" was released in August 1973 and reached number 1 on the Billboard Album Charts. It included the single "Ramblin' Man," which reached number 2 on the singles charts prompting radio play across the United States.

In 1975, Gregg Allman moved to Los Angles, married Cher with whom he has one child, but the pair divorced only two years later. In order to record 1975s "Win, Lose or Draw" album, Gregg Allman overdubbed his vocals in Los Angeles after the band had recorded their parts in Macon, Georgia. Gregg's lack of involvement in the main recording process caused tension and uncertainty in the direction of the band.

With an unclear future, the Allman Brothers decided to break up in 1976, and remained on a hiatus until 1978. In 1978, Capricorn Records President Phil Walden approached Allman and Betts about Allman Brothers Band reunion. Guitarist Dan Toler and bassist David Goldflies joined the band for the making of the "Enlightened Rogues" album, which was released in February 1979. In 1979, Dickey Betts sued Capricorn Records for nonpayment of royalties, which caused the struggling label to file for bankruptcy later that same year. The Allman Brothers quickly signed with Arista Records and released "Reach for the Sky" in 1980, which didn't represent the true potential of the Allman Brothers Band. In fact, it was considered a musical low point by the band.

After releasing a second album for Arista, "Brothers on the Road," in 1981, the Allman Brothers broke up again in 1982 after a clash with Arista President Clive Davis over the band's musical direction.

In 1989, the Allman Brothers reunited to celebrate their twentieth anniversary. For the reunion, guitarist Warren Haynes, bassist Allen Woody, and pianist Johnny Neel joined the band. Warren Haynes studied Duane Allman's slide guitar style that brought back a missing element to the Allman Brothers sound.

In the early 1990s, the Allman Brothers toured regularly and released the live album "An Evening with the Allman Brothers Band: First Set" in June 1992. The album was recorded at the Beacon Theatre, New York City, where the Allman Brothers performed an annual two-week residency. In 1994, the Allman Brothers released the album "Where It All Began," which was again recorded live capitalizing on the Allman's classic style of blues, rock, country, and jazz.

In the late 1990s, tensions grew between Dickey Betts, Warren Haynes, and Allen Woody due to their involvement with their other band Gov't Mule. After leaving the Allman Brothers to concentrate on Gov't Mule, Allen Woody was replaced by bassist Oteil Burbridge. In 2000, Dickey Betts was fired from the Allman Brothers Band under dubious accusations of his guitar playing not being "up to par," and his drug and alcohol addiction (post rehab) being a threat to the band. Betts received a cash settlement following his termination and Derek Trucks, drummer Butch Trucks nephew, began playing with The Allman Brothers. Trucks had joined the band in 1999 just prior to Dickey Betts firing, but was now an official member. Trucks was only 20 years old when he joined the band, but was already considered a guitar virtuoso; especially as a slide guitarist. Trucks had studied all of Duane Allman's slide solos, and is now considered one of the best slide guitarists is the world.

On October 28, 2014, the Allman Brothers Band played their final show at the Beacon Theatre in New York City. The band had played a staggering 238 consecutive sold out shows at the Beacon Theatre. In May 2017, Gregg Allman died from liver cancer, which sadly brought to an end a great American musical legacy.

The Allman Brothers Band is one of the originators of southern rock, and, to this day they are considered one of the biggest influences on the evolution of the jam band scene.

Recommended Listening

1. Statesboro Blues
2. Whipping Post
3. Stormy Monday
4. Ramblin' Man
5. Melissa

Awards

Inducted into the Rock and Roll Hall of Fame, 1995
Grammy Award, "Jessica" Best Rock Instrumental Performance 1996
Grammy Award, "At The Fillmore East" Grammy Hall of Fame 1999
Four Allman Brothers guitarists are listed in the 2003 Rolling Stone 100 Greatest Guitarists of all Time list: No. 2 Duane Allman, No. 23 Warren Haynes, No. 58 Dickey Betts, No. 81 Derek Trucks
Grammy Award, Life Time Achievement Award 2012

Bruce Springsteen

Bruce Springsteen was born on September 23, 1949, in Freehold, New Jersey. His interest in pursuing music was inspired after seeing Elvis Presley on the Ed Sullivan show in 1956.

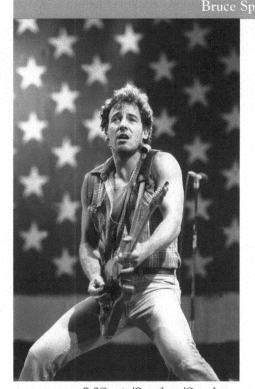

Bruce Springsteen 1975

Springsteen cut his teeth in a series of bands as a lead guitarist and singer in the mid1960s through early 1970s. His road to success included runs with the Castiles 1965-67, the bands Earth and Steel Mill from 1968, then in 1971 Springsteen formed both Dr. Zoom & the Sonic Boom, and the Sundance Blues Band. Later in 1971, he formed the Bruce Springsteen Band including pianist David Sancious and Southside Johnny Lyon on Harmonica, Garry Tallent bass, Steve Van Zandt guitar, and Clarence Clemons on tenor sax. In May 1972, his manager Mike Appel arranged for an audition with John Hammond of Columbia Records.

Springsteen was signed by Columbia Records in 1972 and recorded his debut album "Greetings from Asbury Park, N.J." Springsteen added Max Weinberg on drums and Roy Bitten on piano for this album and named the now completed band the E Street

© SGranitz/Contributor/Getty Images

Band. Although the album took a long time to gain traction with fans, it would eventually go double platinum in the United States. Springsteen's second album, 1975s "Born to Run," was an immediate success reaching number 3 on the Billboard charts, selling over six million copies in the United States alone.

When Springsteen hired new manager/producer Jon Landau, a legal battle with his former manager, Mike Appel, became bitter and forced Springsteen out of the studio until settled. After a settlement was reached, Springsteen was able to record again and released "Darkness on the Edge of Town" in 1978. This album remained on the charts for ninety-seven weeks and was certified triple platinum in the United States. Springsteen and the E Street Band were riding high on the popularity of the band and began using their notoriety to benefit causes they believed in. One early example was the "Musicians United for Safe Energy anti-nuclear power" concert at Madison Square Garden in September 1979.

In October 1980, Springsteen released a double album titled "The River." This was Springsteen's first album to reach number 1 on the Billboard Album Charts. Springsteen toured the United States and Europe in 1980 through 1981 to support the album. Immediately following the tour, Springsteen got to work on a solo acoustic album "Nebraska," which featured him playing all instruments. Most of the 1982 album "Nebraska" tracks were comprised of home recordings Springsteen made on a four-track tape recorder. Even with mixed reviews, "Nebraska" went platinum.

June 1984 became a landmark for Springsteen and the E Street Band with the release of "Born in the U.S.A.," their most successful album, which sold more than thirty million copies worldwide. "Born in the U.S.A." contained seven singles that reached the Billboard top ten, and the title track, "Born in the U.S.A.," was used in President Ronald Reagan's 1984 presidential campaign. The song's lyrics were about the mistreatment of Vietnam veterans, and the American military industrial complex; although the subject matter has often

been misunderstood (to be a pro-American anthem). In November 1986, Springsteen released a five-record concert box set "Live/1975-85" that also reached number 1 on the album charts. "Live/1975-85" sold thirteen million copies and included an "ultimate 40 song concert" running order. Springsteen's live concerts are known to last up to four hours!

On July 19, 1988, Springsteen performed a concert in East Germany for 300,000 fans. The concert was part of East Germany's attempt to placate their youth who wanted more freedom and access to western music. The successful show is thought to have contributed to the fall of the Berlin Wall in 1989. After headlining the Amnesty International "Human Rights Now" tour, Springsteen dissolved the E Street Band. There was no major issue in the band, but, Springsteen was getting creatively restless and needed to explore broader musical direction. His two 1992 solo albums "Human Touch" and "Lucky Town" are regarded as his worst and most unpopular among fans. Even Springsteen admitted that the experiment, while worth doing, didn't work out.

In 1995, Springsteen won a Grammy award for the song "Streets of Philadelphia," which was used in the soundtrack for the film "Philadelphia" starring Tom Hanks. He then released a four-disc box set titled "Tracks" in November 1998, which included unreleased tracks, demos, and single B-sides. In 1999, U2's Bono inducted Springsteen into the Rock and Roll Hall of Fame, and Springsteen announced that the E Street Band had reunited and had a year-long reunion tour. In 2002, Springsteen released "The Rising," which was the first studio album featuring the E Street Band since 1984. It hit number 1 on the Billboard charts, and was certified platinum in multiple countries. The album can be seen as both a reunion and comeback.

In 2006, Springsteen released "We Shall Overcome: The Seeger Sessions" as a tribute to folk singer, songwriter, musician, and social activist Pete Seeger. The album contained songs Seeger was known to perform, but did not write. Although "We Shall Overcome: The Seeger Sessions" was Springsteen's first album that did not contain any of his original material, it was critically acclaimed. Tragedy struck the E Street Band in the 2000s with organist Danny Federici passing in 2008, and saxophonist Clarence Clemons in 2011. Clemons was nicknamed by Springsteen and fans as "the big man" due to his stature and big beautiful sound on the tenor sax.

In December 2015, Springsteen released "The Ties That Bind: The River Collection" celebrating the thirty-fifth anniversary of "The River" album. The boxed set contained four CDs and included unreleased tracks from "The River" sessions, a remaster of "The River," and three DVDs.

Springsteen has been actively involved with politics most of his career, and his songs are scattered with his views. He officially supported President Obama's 2008 presidential campaign, and was subsequently awarded the Presidential Medal of Freedom by Barack Obama in 2016.

Springsteen is considered one of America's greatest singers/songwriters and one of the best live performers. Committed to pleasing his fans, Springsteen always gives his audience 100 percent.

Recommended Listening

1. Blinded By the Light
2. Rosalita
3. Born to Run

4. Tenth Avenue Freeze-Out
5. Born in the U.S.A.

Awards

- Grammy, Best Rock Vocal Performance "Dancing in the Dark" 1985
- Grammy, Best Rock Vocal Solo Performance "Tunnel of Love," 1986
- Academy Award, Best Original Song "Streets of Philadelphia," 1994
- Grammy, Best Contemporary Folk Album "The Ghost of Tom Joad," 1997
- Inducted into the Rock and Roll Hall of Fame, 1999
- Grammy, Best Traditional Folk album "We Shall Overcome: The Seeger Sessions," 2006
- Golden Globe, Best Original Song "The Wrestler," 2009

Rush

Rush was formed in Toronto, Canada, in 1968. The original lineup consisted of Alex Lifeson, guitar (born August 27, 1953), Jeff Jones, vocals, bass (born September 20, 1953), and John Rutsey, drums (July 23, 1952-May 11, 2008). Within a few weeks of forming, Jones left and was replaced by Geddy Lee (born July 29, 1953) on bass and vocals.

The band's first release was a cover of Buddy Holly's "Not Fade Away" in 1973 which proved to be unsuccessful. Due to lack of record company interest, Rush and their manager, Ray Daniels, formed the independent record label Moon Records and released Rush's debut album *Rush* on March 1, 1974. This first album showed heavy influences from Led Zeppelin and Cream. Shortly after the release of *Rush*, John Rutsey left the group citing health reasons related to diabetes. His replacement was none other than, now drumming legend, Neil Peart (September 12, 1952–January 7, 2020). Their next album *Fly by Night* was released

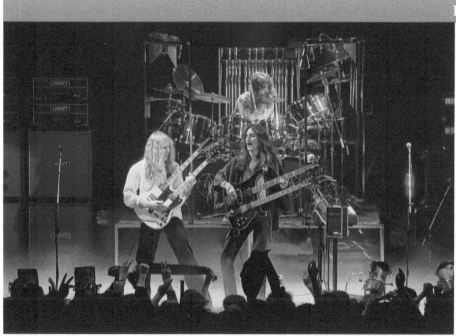

Fin Costello/Staff

Rush perform at the Odeon in Birmingham, England, in February 1978.

© Fin Costello/Staff/Getty Images

February 15, 1975, through Anthem Records featuring Neil Peart's drumming and creative writing as lyricist. *Fly by Night* reached number 113 on the Billboard album charts and began to attract interest from a growing fan base.

Neil Peart influenced the band to became more progressive by introducing influences such as Yes and King Crimson. The Mercury label tried to get Rush to be more commercial due to low record sales; however, the April 1, 1976, album *2112* opened with a 20-minute title track. Arguably their most progressive album to date, *2112* reached number 61 on the Billboard album charts.

In January 1980, Rush released the album *Permanent Waves* with the sounds of reggae rhythms and synthesizers. Permanent Waves climbed to number 4 on the Billboard album charts.

In the 1980s, Rush continued to adopt more complex instruments with electronic drums, sequencers, and layered synthesizers. And, with producer Peter Collins, released the albums *Power Windows* and *Hold Your Fire*, which both had a lasting impact on the charts.

In the 1990s, Rush began to focus on more guitar-based sounds and less on the use of layered synthesizers. Once again working with Peter Collins, Rush released *Counterparts* (1993) and *Test for Echo* (1996). Both albums were the most guitar-driven productions to date with *Test for Echo* reaching number 5 on the Billboard album charts.

Tragedy stuck Neal Peart in the late 1990s with his daughter, Selena, killed in a car accident in August 1997, and his wife Jacqueline died from cancer in October 1998. Peart wrote a memoir called "Ghost Rider: Travels on the Healing Road," chronicling his 55,000-mile motorcycle trip across North America in an attempt to overcome his grief. In 1998, Rush released a three-disk live album titled *Different Stages* in memory of Selena and Jacqueline.

In June 12, 2012, Rush released their twentieth and final album *Clockwork Angels*, produced by Rush and Rick Raskulinecz. *Clockwork Angles* reached number 2 on the Billboard album charts, and won Rock Album of the Year at the 2013 Juno Awards.

Rush is considered one of the most successful progressive rock bands of all time, and their fan base continues to grow. Rush were inducted into the Canadian Music Hall of Fame in 1994. Lee, Lifeson, and Peart were awarded OC medals (Officer of the Order of Canada) in May 1996, and inducted to the Rock and Roll Hall of Fame in 2013. Neil Peart has received dozens of drumming awards and is the author of several notable instruction methods for drummers. In January 2020 Neil Peart succumbed to his more than three year battle with brain cancer, and died in Santa Monica, CA.

The fact that Rush's music is so complex and simultaneously viable commercially is a testament to their vision. They have sold over forty million albums worldwide and have twenty-four gold, fourteen platinum, and three multiplatinum albums to their credit.

Recommended Listening

1. Tom Sawyer
2. Spirit of the Radio
3. Fly by Night
4. 2112 Overture / The Temples of Syrinx

Awards

- Juno award most promising group of the year 1975
- Juno award Artist of the Decade 1980s
- Juno award DVD of the year 2004 "Rush in Rio"
- Juno award Rock album of the year 2012 "Clockwork Angels"
- Inducted into the Rock and Roll Hall of Fame 2013

U2

U2 was formed in Dublin, Ireland, in 1976 when vocalist Paul Hewson (Bono), guitarist David Evans (the Edge), and bassist Adam Clayton responded to an ad looking for band members placed at Mount Temple Comprehensive School by drummer Larry Mullen Jr. The band was originally called the Larry Mullen Band and changed their name to Feedback, and then briefly the Hype. Several guitarists passed through the band before they determined the four-piece lineup would give them the most creative options. In March 1978, after throwing around a variety of ambiguous names, the band settled on U2.

U2 brought on Paul McGuinness as their manager in mid-1978 who set up a demo session to record a three-song EP, which was released by CBS in Ireland. In early 1980, U2 played at the National Stadium in Dublin where Island Records A&R representative Bill Steward signed them to Island Records.

U2's first album on Island Records "Boy" was produced by Steve Lillywhite, who would produce U2's first three albums, was released in October 1980. "Boy" reached number 52 on the UK charts, 63 on the US charts, and received very positive reviews. The first single from the "Boy" album was A Day Without Me that featured The Edge using an Electro-Harmonix Memory Man delay unit, which would influence his style as a guitarist, and create a signature sound for U2.

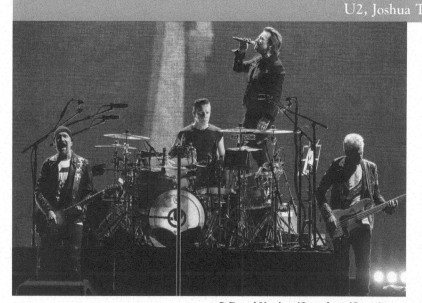

U2, Joshua Tree Tour 2017.

© Daniel Knighton/Contributor/Getty Images

While on tour in the United States, Bono lost a briefcase containing his lyric ideas for songs to be used on U2's next album project. So, for "October," U2's second album, songs were written quickly and Bono improvised some of the lyrics in the studio. "October" was released in October 1981, and reached number 11 in the United Kingdom. A video for the single Gloria received airplay on MTV which increased U2's following in Europe and the United States. U2's third album, "War," was recorded at Windmill Lane Studios in Dublin, Ireland, and released in February 1983. "War" was U2's first album to reach number 1 in the United Kingdom, and climbed to number 12 in the United States; it included the singles New Year's Day and Sunday Bloody Sunday. Capitalizing on the success of "War," U2 followed up with a live concert version of the album titled "Under a Blood Red Sky" (also 1983).

U2 negotiated a new contract deal with Island Records in 1984, giving the band rights to their previously released songs and a higher royalty rate. As the band embarked upon their fourth album, they decided to work with producer Brian Eno, which upset Island Records President Chris Blackwell due to Eno's use of avant-garde ambient sounds and unconventional studio technique. The result was the album "The Unforgettable Fire," released in October 1984 lead by the single Pride (In the Name of Love), U2's first top 40 hit in the United States.

In July 1985, U2 performed at the Live Aid concert at Wembley Stadium to support Ethiopian famine relief. The concert was broadcast to over two billion fans worldwide. U2's performance at Live Aid solidified them as a "super group" of the 1980s, and Rolling Stone magazine called them "the band of the 1980s."

After a meeting Bob Dylan and Keith Richards, Bono realized the band needed to dig deeper into their musical roots to add greater historic musical influence to their vocabulary. To achieve this goal, the band's next album project explored what they called "roots music" influences based heavily on folk and blues. The finished product was "The Joshua Tree," U2's fifth album, which was released March 1987. "The Joshua Tree" went to number 1 in twenty countries and Rolling Stone magazine proclaimed U2 "the greatest Rock and Roll band in the world." U2's US tour supporting "The Joshua Tree" grossed more than forty million dollars; an astronomical success at the time.

In late 1988, U2 continued their success with the release of "Rattle and Hum," an album with more roots music, and partially recorded at the famous Sun Recording Studio in Memphis. "Rattle and Hum" also included collaborations with B.B. King and Bob Dylan. The album reached number 1 in the United States, United Kingdom, and Europe and sold over fourteen million copies. In November 1991, the album "Achtung Baby" produced by Danie Lanois and Brian Eno was released, again to critical acclaim, and won U2 a Grammy award for Best Rock Performance. This album was inspired by Germany's reunification and had European industrial and electronic dance influences.

In 1993, U2 again renewed their contract with Island Records with the record company awarding the band sixty million dollars; the highest figure ever paid for a rock band. Well-produced albums followed steadily with "Zooropa" (1993), "Original Soundtracks No. 1: Passengers" (1995), "Pop" (1997), "All That You Can't Leave Behind" (2000), and "How to Dismantle an Atomic Bomb" (2004). After three decades in rock 'n' roll, U2 released the album "No Line on the Horizon" in 2009 to critical acclaim and 2009 and number 1 chart ranking in thirty countries. The supporting 360 Degree Tour, which covered the United States, Europe, South America, South Africa, Australia, and New Zealand, grossed $736 million making it the highest grossing tour in history.

U2's thirteenth studio album, "Songs of Innocence," was released at an Apple product launch in September 2014, and became available as a free download to 500 million Apple iTunes customers worldwide. U2 was paid a lump sum by Apple (estimated at $100 million) for the promotional release and future support of development of music technology. U2's following Innocence + Experience Tour in 2015 grossed $152 million. The free download

of "Songs of Innocence" was criticized as a move only a handful of highly successful artists could afford. Songs of Experience, U2's most recent studio album debuted in December 2017 at number 1 on the Billboard charts and quickly earned platinum status.

Since 1976, U2 has grown from a college garage band to one of the most successful acts in rock 'n' roll. They have earned seven number 1 albums, twelve number 1 singles, a plethora of Grammy, Brit, Billboard, Golden Globe, and other awards, inducted into the Rock and Roll Hall of Fame, have five of their albums listed in the Rolling Stone 500 Greatest Albums of all Time, sold over 170 million albums, and, have earned over $1.5 billion from touring ticket sales.

Recommended Listening

1. Gloria
2. Sunday Bloody Sunday
3. Desire
4. One
5. With or Without You
6. I Still Haven't Found What I'm Looking For
7. Vertigo
8. Beautiful Day

Awards

Grammy Award "The Joshua Tree" Album of the Year, 1988
Grammy Award "Desire" Best Rock performance by a Duo or Group, 1989
Billboard Music Award "Mysterious Ways" Top Rock Song, 1992
Grammy Award "Zooropa" Best Alternative music performance, 1994
Grammy Award "Beautiful Day" Album of the year, 2001
Grammy Award "Beautiful Day" Song of the year, 2001
Inducted into the Rock and Roll Hall of Fame, 2005
Grammy Award "The Joshua Tree" Grammy Hall of Fame, 2014

The Killers

The Killers formation began in 2001 with Brandon Flowers joining guitarist Dave Keuning, drummer Matt Norcross, and bassist Dell Neal to record demo songs at the Kill the Messenger recording studio in Las Vegas. These recordings included versions of future hits "Mr. Brightside" and "Under the Gun." The Killers promoted themselves playing shows in small venues in Las Vegas and giving away free copies of their demo recording. The unique sound they created was described as a combination of Indie Rock and 1980s pop mixed with British influences. In 2002, Brian Havens replaced Matt Norcross on drums and bassist Dell Neal quit the band. Within weeks, Ronnie Vannucci Jr. stepped in as Norcross' replacement on drums, and, near the end of 2002 Mark Stoermer joined on bass to complete the Killers lineup. In Vannucci's garage, the Killers focused on writing songs for their debut album. At night, they played local venues, and with Ronnie Vannucci studying at UNLV, the Killers gained access to practice late at night in the percussion complex after the build-

The Killers

The Killers, (L-R)
Ronnie Vannucci,
Ted Sablay, Dave
Keuning, Brandon
Flowers, Mark
Stoermer, and
Jake Blanton

© *Rob Loud/Contributor/Getty Images*

ing had closed. The Killers were 100 percent committed to success and became savvy in negotiations, courting several record companies before signing with Warner Brothers Records.

In July 2003, the Killers became part of the British label Lizard King Records and the songs "Somebody Told Me" and "Mr. Brightside" premiered on BBC Radio 1 to positive reviews, a quick rise in popularity, and a sudden surge in fan base in the United States. Ironically, many US fans were initially under the impression that the Killers were a British band, but Las Vegas quickly claimed them as their own! After the Killers played the ASCAP CMJ Music Marathon in Manhattan, their record contract was expanded to included Island Def Jam records.

The Killers debut album *Hot Fuss* was produced by the Killers and Jeff Saltzman, and released in June 2004 on Lizard King Records in the United Kingdom and Island Def Jam in the United States. *Hot Fuss* included the singles "Mr. Brightside," "Somebody Told Me," and "All These Things That I've Done," and was nominated for a Grammy Award. In 2005, *Hot Fuss* reached number 1 in the United Kingdom, number 7 in the United States, and ultimately sold over seven million copies worldwide. In 2005, the Killers won the MTV Music Award for Best New Artist and a World Music Award for best selling new band. *Gigwise* listed Hot Fuss as the "Best Debut Album of All Time" in 2013, and *Rolling Stone* ranked it at number 33 on "The 100 Greatest Debut Albums of All Time."

The Killers second album *Sam's Town* (named after a Las Vegas casino) released in October 2006 was recorded at the Studio at the Palms, Las Vegas, and Criterion Studios in London. *Sam's Town* reached number 2 on the Billboard charts and was a multiplatinum selling album in the United Kingdom. In November 2006, the Killers recorded *Live from Abbey Road* at Abbey Road Studios, where the Beatles had recorded in the 1960s. In November 2007, the Killers released *Sawdust*, a compilation album including B-sides and previously unreleased material. *Sawdust* included the single "Tranquilize" in collaboration with Lou Reed.

The Killers third studio album *Day & Age* was released in November 2008 was produced by Stuart Price, and recorded at the Killers' Battle Born Studio in Las Vegas. The album reached number 6 in the United States and number 1 in the United Kingdom and Ireland. The Killers supported *Day & Age* with their third world tour in 2009. The Killers' world tours generally span a 20- to 22-month time frame with a grueling schedule of press, recording, video shoots, song writing, and travel commitments jammed in between concert and festival performances.

Although, officially on a break to record solo albums and recuperate from the last tour, the Killers still headlined select shows in 2011 such as the Lollapalooza Festival in Santiago, Chile, the Hard Rock Calling in Hyde Park, London, and the Orlando Calling Festival in Orlando, Florida.

In 2012, the Killers were back in the studio working on their fourth studio album, *Battle Born*, which was produced by Daniel Lanois, Stuart Price, Brendan O'Brien, Damian Taylor, and Steve Lillywhite. *Battle Born* reached number 1 in the United Kingdom and Ireland, number 2 in Australia, and number 3 on the US Billboard charts. The *Battle Born* world tour was the Killers most extensive tour to date, which included concerts in China, Russia, Europe, Australia, North and South America, and a show at London's "Wembley" stadium with 90,000 fans in attendance.

The Killers have strategically released songs that didn't make a studio album, or, the band felt was better represented on an alternative style release. These albums, released between major studio albums, include *Sawdust* in 2007 that reached number 12 on the Billboard charts, *Live from the Royal Albert Hall*, an album and DVD release, in 2009 that reached number 1 on the DVD charts and was certified platinum, and, 2013's *Direct Hits* that reached number 20 on the Billboard charts. This album is a highlight of the most successful selections from *Hot Fuss*, *Sam's Town*, and *Battle Born* plus two new songs.

In September 2017, the Killers' released their fifth studio album *Wonderful Wonderful*, produced by Jacknife Lee. With a five-year gap between studio albums *Wonderful Wonderful* brought a great deal of anticipation from both fans and the music industry. In the lead up to the release, the song "The Man" was used to promote the Conor McGregor and Floyd Mayweather fight. The album debuted at number 1 in the United States, Scotland, and Australia, and was the band's fifth album in row to reach number 1 in the United Kingdom. The world tour for *Wonderful Wonderful* had the Killers being named one of the greatest touring acts of 2017 and 2018. The Killers 2020 album release *Imploding the Mirage* (sixth studio album) was delayed due to the world-wide COVID-19 pandemic. The first single, "Caution," released days before quarantine, on March 13, entered the US Billboard Alternative and Rock Airplay charts at #1! The Killers maintained an active recording schedule during the pandemic producing another noteworthy album *Pressure Machine* that was released in August 2021.

Since 2006, the Killers have released an annual Christmas song in support of the Product Red campaign, run by Bobby Shriver and U2's Bono, to help eliminate HIV/AIDS. All proceeds of the Killers' Christmas singles and videos support this cause. On April 6, 2016, the Killers headlined the opening night of the T-Mobile Arena in Las Vegas (a world-class arena modeled after the best arenas in the world including Madison Square Garden). Shortly following the T-Mobile opening, the Killers announced both Mark Stoermer and Dave Keuning would take a hiatus from touring with the band while pursue education and spending more time with family, respectively. Both are still official members of the Killers. Their replacements for the Wonderful Wonderful tour were Jake Blanton (bass) and Ted Sablay (guitar) who have served as supporting musicians for previous Killers tours.

The Killers have had great success combining alternative rock with pop and blending their roots of retro-1980s music with iconic Nevada, Wild West imagery. Official fans of the Killers, aptly called the "Victims," receive updates, special communications, and advance options for music downloads, concerts, and secret shows. The Killers have also taken a very entrepreneurial approach in the rise and success of their brand capitalizing on

their songs being used in video games such as Guitar Hero III: Legends of Rock, SingStar Amped, Rock Band, and Guitar Hero Live; movies and TV shows including *The Twilight Saga: New Moon*, *Training Day*, *Ballers*, *Jericho*, *The O.C.*, *How to Lose Friends & Alienate People*, *Dark Shadows*, *Smallville*, *The Hills*, *Spider-Man 3*, *The Holiday*, *ER*, and have had songs featured on NBC's The Voice, and, Nike used "All These Things That I've Done" as the theme music for their 2008 Olympics advertising.

The Killers continue to break new ground creatively capturing the past and rolling it into the everchanging future of rock 'n' roll. Their forward-thinking ideas for promotion and deep connection with fans keep them surging forward in an arena where many bands have fallen into obscurity.

Recommended Listening

1. Mr. Brightside
2. Somebody Told Me
3. Bones
4. When You Were Young
5. The Man

Awards

- NME Award Best International Band, 2005, 2008, 2009, 2013
- BRIT Award Best International Band, 2006
- MTV Europe Award Best Rock Group, 2006
- Q Award Best Video single "When You Were Young," 2006
- University of Nevada, Las Vegas College of Fine Arts Hall of Fame Inductee, 2008
- Brit Awards nominated for Best International Group, 2018
- MTV Europe Best Rock Act, 2012
- Music Video Production Awards, Best Animated Video, 2013
- NME UK, Best International Band, 2013
- Billboard Best Performances of 2014

Bibliography

"AC/DC," in *The Encylopedia of Popular Music*, 4th ed. Edited by Colin Larkin. Oxford: Oxford University Press, 2006.

"Acuff, Roy." In *The Encyclopedia of Popular Music*. 4th Ed. edited by Colin Larkin Oxford: Oxford University Press, 2006.

Altman, Billy. "A Blues-Shouting Bartender Who Never Changed His Style." *The New York Times* 144, Issue 49851 (1994), H33.

Allman, Gregg, and Light, Alan. (2012). *My Cross to Bear*. William Morrow, New York City

Associated Press. www.ap.org

Author Unknown. "Big Bill Broonzy." http://www.oafb.net/once141.html (accessed January 28, 2007).

B. B. King The Official Website. "Discography" http://www.bbking.com/discography (accessed January 28, 2007).

B. B. King The Official Website. "History." http://www.bbking.com/about/features.asp?AssetID=256122 (accessed January 28, 2007).

Bacon, Tony. "The electric guitar." In *Grove Music Online*. http://www.grovemusic.com (accessed July 7, 2007).

Barry White Biography from Who2. http://www.who2.com/barrywhite.html (accessed May 14, 2007).

Barry White Discography. Allmusic.com.http://www.allmusic.com/cg/amg.dll?p=amg&searchlink=BARRY|WHITE&uid=MIW060603192028&sql=11:4zfqoarabijv~T2 (accessed May 14, 2007).

"Barry White." In Wikipedia. http://en.wikipedia.org/wiki/Barry_White (accessed May 13, 2007).

"Beatles," in *The Encyclopedia of Popular Music*, 4th ed. Edited by Colin Larkin. Oxford: Oxford University Press, 2006.

Benke, James. "Gene Vincent, Performer." Rock and Roll Hall of Fame and Museum Website. Available from http://www.rockhall.com/hof/inductee.asp?id=205 (accessed February 4, 2007).

Benke, James. "Hank Williams: Early Influences" in Rock and Roll Hall of Fame http://www.rockhall.com/hof/inductee.asp?id=211 (accessed January 20, 2007).

Benke, James. "Howlin' Wolf: Early Influences" Rock and Roll Hall of Fame. http://www.rockhall.com/hof/inductee.asp?id=211 (accessed January 20, 2007)

Benke, James. "Little Richard, Performer." In Rock and Roll Hall of Fame http://www.rockhall.com/hof/inductee.asp?id=179 (accessed January 20, 2007).

Benke, James. "Pete Seeger, Performer." In Rock and Roll Hall of Fame at http://www.rockhall.com/hof/inductee.asp?id=185 (accessed February 25, 2007).

Benke, James. "The Drifters, Performers." In Rock and Roll Hall of Fame. http://www.rockhall.com/hof/inductee.asp?id=94 (accessed February 6, 2007).

"Black Sabbath," in *The Encyclopedia of Popular Music*, 4th ed. Edited by Colin Larkin. Oxford: Oxford University Press, 2006.

"Blues Lyrics—Charley Patton." http://www.harptab.com/lyrics/a24.shtml] (accessed January 2007).

Booklet accompanying the Complete Recordings box set (Robert Johnson). Stephen LaVere, Sony Music Entertainment, 1990, Clapton quote on p. 26.

Bowman, Rob. "Grateful Dead, The." In *Grove Music Online* edited by L. Macy. Available from http://www.grovemusic.com (accessed May 13, 2007).

Bowman, Rob. "Robinson, Smokey (William)." In *Grove Music Online* edited by L. Macy. http://www.grovemusic.com (accessed May 19. 2007).

Bowman, Rob. "Gaye (Gay), Marvin." In *Grove Music Online* edited by L. Macy. http://www.grovemusic.com (accessed May 20, 2007).

Bowman, Rob. "Gordy, Berry." In *Grove Music Online* edited by L. Macy. http://www.grove music.com (accessed May 18, 2007).

Bowman, Rod. "Supremes, The." In *Grove Music Online* edited by L. Macy. http://www.grovemusic.com (accessed May 18, 2007).

Bowman, Rod. "Temptations, The." In *Grove Music Online* edited by L. Macy. http://www.grovemusic.com (accessed May 18, 2007).

Boyd, Amanda. "Biography of Charley Patton." http://shs.starkville.k12.ms.us/mswm/MSWritersAndMusicians/musicians/CharleyPatton/CharleyPatton.html#biograpy (accessed January 2007).

Brackett, Dave. "Jackson Five (The Jacksons)." In *Grove Music Online* edited by L. Macy. http://www.grovemusic.com (accessed May 21, 2007).

Brackett, David. "Joplin, Janis." In *Grove Music Online* edited by L. Macy. Available from http://www.grovemusic.com (accessed May 13, 2007).

Brackett, David. "Presley, Elvis." In *Grove Music Online* edited by L. Macy. Available from http://www.grovemusic.com (accessed February 3, 2007).

"Buddy Holly and the Crickets." http://www.history-of-rock.com/buddy_holly.htm (accessed February 2007).

Campbell, Michael and James Brody. *Rock and Roll: An Introduction*. Belmont, CA: Schirmer, 1999.

"Charley Patton—Delta School." http://www.cr.nps.gov/delta/blues/people/ charley_patton.htm (accessed January 2007).

"Chubby Checker." Biography. http://www.chubbychecker.com/bio.asp (accessed February 10, 2007).

"Chubby Checker." In Wikipedia. http://en.wikipedia.org/wiki/Chubby_Checker (accessed February 10, 2007).

Classic Bands.com. "Quicksilver Messenger Service," Classic Bands Website. Available from http://www.classicbands.com/quicksilver.html (accessed May 15, 2007).

Corcoran, Michael. "The Soul of Blind Willie Johnson: Retracing the life of the Texas music icon," Austin American-Statesman: http://www.austin360.com/music/content/music/blindwilliejohnson_092803.html

Covach, John. "Doors, The." In *Grove Music Online* edited by L. Macy. Available from http://www.grovemusic.com (accessed May 14, 2007).

Covach, John. "Jefferson Airplane," In *Grove Music Online* edited by L. Macy. Available from http://www.grovemusic.com (accessed May 13, 2007).

Cowley, John. "Really the 'Walking Blues': Son House, Muddy Waters, Robert Johnson, and the Development of a Traditional Blues." *Popular Music* 1 (1981), 57–72.

Dicaire, David. *Blues Singers*. Jefferson, North Carolina: McFarland & Company, Inc., Publishers, 1999.

Duke, Jan. Article. Member of the local historical society. http://nashville.about.com/od/historyandsites (accessed July 13, 2007).

"Earth, Wind & Fire." In Wikipedia. http://en.wikipedia.org/wiki/Earth,_Wind_&_Fire (accessed May 14, 2007).

Elevation Group. The Official Neville Brothers Website. http://66.70.148.219/index.html (accessed 14 May 2007).

Elevation Group. The Original Meters Official Website. http://www.themetersonline.com/index.html (accessed May 14, 2007).

Elvis Presley Official Website. "Elvis Presley," Official Website for Elvis Presley. Available from http://www.elvis.com (accessed February 5, 2007).

Erlewine, Stephen Thomas. "Hank Williams." Yahoo Music Downloads http://music.yahoo.com/ar-268534—-Hank-Williams (accessed January 20, 2007).

Evans, David. "Handy, W(illiam) C(hristopher)." In *Grove Music Online* edited by L. Macy. http://www.grovemusic.com (accessed January 27, 2007).

Gabler, Milt." http://rockhall.com/hof/inductee.asp?id=108 (accessed February 4, 2006).

Garofalo, Reebee. *Rockin' Out*. 3rd ed. Upper Saddle River: Prentice Hall, 2005.

George-Warren, Holly and Patricia Robinson. *The Rolling Stone Encyclopedia of Rock & Roll*. 3rd ed. New York: Rolling Stone Press, 2001.

George-Warren, Holly, Patricia Romanowski, and Jon Pareles. *The Rolling Stone Encyclopedia of Rock & Roll*, Fireside ed. (Revised and Updated for the 21st Century) New York: Fireside, 2001.

Gilmore, Mikal. "Johnny Cash." In *Night Beat: A Shadowy History of Rock & Roll*. New York: Doubleday, 1998. http://www.johnnycash.com (accessed February 2007).

Griffiths, Dai. "Dylan, Bob." In *Grove Music Online* edited by L. Macy. Available from http://www.grovemusic.com (accessed February 24, 2007).

Griffiths, Dai. "Mitchell, Joni." In *Grove Music Online* edited by L. Macy. Available from http://www.grovemusic.com (accessed May 14, 2007).

"Haley, Bill, And His Comets." In *The Encyclopedia of Popular Music*, 4th ed. Edited by Colin Larkin. Oxford: Oxford University Press, 2006.

"Haley, Bill." http://rockhall.com/hof/inductee.asp?id=116 (accessed February 4, 2006).

"Hall of Fame: Inductee Detail." Rock and Roll Hall of Fame and Museum. http://www.rockhall.com/hof/inductee.asp?id=119 (accessed February 2007).

Hill, Marilynn. "Jefferson, Blind Lemon." *The Handbook of Texas Online*. http://www.tsha.utexas.edu/handbook/online/articles/JJ/fje1.html (accessed 27 January 27, 2007).

History of Rock n' Roll. "The Marvellettes." History of Rock n' Roll Website. Available from http://www.history-of-rock.com/marvelettes.htm (accessed May 23, 2007).

https://web.archive.org/web/20150315091239/http://www.thewallanalysis.com/main/, accessed May 15, 2016

http://albumlinernotes.com/Echoes_-_The_Best_Of.html, accessed May 15, 2016

http://www.alicecooper.com

http://www.allmusic.com

http://www.angelfire.com/ok2/wall/singles.html, accessed May 15, 2016

http://archives.cnn.com/2002/SHOWBIZ/TV/10/03/ed.sullivan.sidebar/

https://beyondthedash.com/obituary/art-neville-1076021094, accessed May 9, 2020

http://billyjkramer.com

https://bobdylanstore.com/, accessed May 9, 2020

http://canadianmusichalloffame.ca/inductee/rush/. Accessed June 2016

http://classic.motown.com/artist.aspx?ob=per&srs=prd&aid=53

http://consequenceofsound.net/2014/03/dusting-em-off-pink-floyd-division-bell/, accessed May 15, 2016

http://countrymusic.about.com/library/blopryquotes.htm (accessed July 13, 2007).

https://deadline.com/2020/02/jennifer-hudson-wraps-production-aretha-franklin-biopic-respect-1202860933/, accessed May 9, 2020

http://en.wikipedia.org - various trivia points

https://en.wikipedia.org/wiki/Bruce_Springsteen. Accessed May 2, 2017

https://en.wikipedia.org/wiki/Caution_(The_Killers_song), accessed May 9, 2020

http://en.wikipedia.org/wiki/Kingston_Trio (accessed February 25, 2007).

https://en.wikipedia.org/wiki/The_Allman_Brothers_Band. Accessed March 28, 2018

http://en.wikipedia.org/wiki/The_Beatles (accessed March 25, 2007).

https://en.wikipedia.org/wiki/U2. Accessed March 24, 2018

http://guterman.com/guterman_jerrylee/guterman_jerrylee.html

https://hollowverse.com/bruce-springsteen. Accessed May 19, 2018

http://home.rca.com/en-US/PressReleaseDetail.html?Cat=RCAHistory&MN=8

https://people.com/music/llittle-richard-dies-at-87/, accessed May 9, 2020

https://pitchfork.com/reviews/albums/22653-blue-lonesome/, accessed April 7, 2022 (Blue & Lonesome, The Rolling Stones, 2016, reviewed by Stuart Berman)

http://princevault.com/index, accessed May 11, 2016

http://rockhall.com/inductees/rush/bio/, accessed April 21, 2016

https://rollingstones.com/news/stones-sixty-2022-european-tour/, accessed April 7, 2022

https://shop.thekillersmusic.com/products/imploding-the-mirage-cd-digital-album, accessed May 9, 2020

http://staxrecords.free.fr/king.htm (accessed July 8, 2007).

https://strictlyzappa.wordpress.com/2009/10/19/zappa-coffee-cigarettes/, accessed May 11, 2016

http://The-Faces.com/

http://thebluestraveller.blogspot.com/

http://thesurfaris.com (accessed February 25, 2007).

http://ultimateclassicrock.com/frank-zappa-lumpy-gravy/, accessed May 11, 2016

http://www.45-rpm.org.uk/dirg/gerryp.htm

http://www.abc.net.au/triplej

http://www.alicecooper.com/bio/, accessed April 6, 2016

http://www.allmusic.com/

http://www.allmusic.com/artist/pink-floyd-mn0000346336/biography, accessed March 27, 2016

http://www.allmusic.com/artist/pink-floyd-mn0000346336/awards, accessed March 28, 2016

http://www.allmusic.com/artist/elton-john-mn0000796734/biography, accessed April 3, 2016

http://www.allmusic.com/artist/alice-cooper-mn0000005953/biography, accessed April 6, 2016

http://www.allmusic.com/artist/alice-cooper-mn0000005953/awards, accessed April 7, 2016

http://www.allmusic.com/artist/bruce-springsteen-mn0000530745/biography. Accessed April 18, 2017

http://www.allmusic.com/artist/frank-zappa-mn0000138699/biography, accessed April 14, 2016

http://www.allmusic.com/artist/frank-zappa-mn0000138699/awards, accessed April 14, 2016

http://www.allmusic.com/artist/prince-mn0000361393/biography, accessed April 28, 2016

http://www.allmusic.com/artist/rush-mn0000203008/biography, accessed April 22, 2016

https://www.allmusic.com/artist/rush-mn0000203008. Accessed June 2016

https://www.allmusic.com/artist/the-killers-mn0000670226/biography. Accessed February 18, 2018

https://www.allmusic.com/artist/u2-mn0000219203/biography. Accessed March 19, 2018

http://www.Anecdotage.com

http://www.anecdotage.com/index.php?aid=12043

http://www.arts.ac.uk/camberwell/, accessed May 15, 2016

https://www.bbc.co.uk/music/artists/b5128db0-2221-470c-a575-63c7d7ebc91a, accessed May 9, 2020

http://www.beatles.com (accessed March 25, 2007).

http://www.berryoakley.net/raymond_berry_oakley. Accessed May 18, 2018

https://www.biography.com/musician/aretha-franklin, accessed May 9, 2020

http://www.biography.com/people/prince-9447278, accessed May 11, 2016

http://www.biography.com/people/prince-9447278#career-highlights, accessed May 11, 2016

https://www.billboard.com/articles/news/obituary/8471293/eddie-willis-motown-funk-brothers-dead, accessed May 9, 2020

http://www.billboard.com/articles/list/1495342/princes-20-biggest-billboard-hits, accessed May 11, 2016

http://www.billboard.com/artist/338856/pink-floyd/chart, accessed May 15, 2016

http://www.billmonroe.com/ (accessed July 12, 2007).

http://www.blueoystercult.com/History

http://www.blues.about.com/cs/halloffame (accessed July 6, 7, 8, 2007).

http://www.bobwills.com/history.html (accessed July 12, 2007).

http://www.britannica.com/eb/article-9109660/outlaw-music (accessed July 12, 2007).

https://www.britannica.com/topic/the-Crystals, accessed May 9, 2020

http://www.bsnpubs.com/motown/motownstory.html

http://www.cajunzydeco.net/ (accessed July 12, 2007).

http://www.chuckberry.com/about/bio.htm

http://www.cillablack.com/

http://www.classicbands.com/dc5.html

https://www.cnn.com/2018/01/15/entertainment/gallery/people-we-lost-in-2018/index.html - accessed April 1, 2018

http://www.countrymusichalloffame.com - Roy Acuff (accessed July 13, 2007).

http://www.cowboylyrics.com/tabs/williams-hank/move-it-on-over-524.html

http://www.deadkennedys.com/history.html

http://www.davidbowie.com/bio, accessed March 25, 2016

http://www.dictionary.com/browse/concept-album, accessed May 15, 2016

https://www.discogs.com/artist/573052-Paul-Buff, accessed May 11, 2016

https://www.discogs.com/artist/675606-Jai-Johanny-Johanson. Accessed May 18, 2018

http://www.duaneallman.info/chronologypart1.htm. Accessed May 18, 2018

http://www.eltonjohn.com/about/biography/, accessed April 3, 2016

http://www.elvis.com.au/presley/articles_deathshadow.shtml

http://www.elvis.com/elvisology/bio/elvis_overview.asp

http://www.experiencefestival.com/punk_rock_-_characteristics

http://www.findagrave.com/cgi-bin/fg.cgi?page=gr&GRid=1260

http://www.funandmusic.biz/music-motown-musicians.htm

http://www.geneautry.com/ (accessed July 12, 2007).

http://www.geocities.com/SunsetStrip/palladium/1409/jimparis.htm

http://www.gerrymarsden.co.uk/

https://www.gigwise.com/news/79179/the-killers-hot-fuss-named-best-debut-album-ever. Accessed April 25, 2018

https://www.grammy.com/grammys/artists/allman-brothers-band. Accessed March 30, 2018

http://www.grammy.com/GRAMMY_Awards/Winners/Results

http://www.grammy.com/artist/elton-john, accessed April 4, 2016

http://www.grammy.com/artist/prince, accessed April 28, 2016

http://www.greggallman.com. Accessed May 18, 2018

http://www.grovemusic.com

http://www.grovemusic.com - punk

http://www.grovemusic.com - Liz Thomson (Willie Nelson Biography) (accessed July 12, 2007).

http://www.hermanshermits.com/

http://www.history-of-rock.com/haley.htm (accessed February 4, 2006).

http://www.history-of-rock.com/richard.htm

http://www.history-of-rock.com/spector.htm

http://www.icons.org.uk/nom/nominations/rolling-stones-tongue-logo-1-2-3

https://www.independent.co.uk/arts-entertainment/music/news/eric-haydock-dead-the-hollies-bassist-band-age-dies-died-a8715476.html, accessed May 9, 2020

http://www.imdb.com/name/nm0005002/bio

http://www.ironbutterfly.com/biography.php

http://www.isaachayes.com/

https://www.jambase.com/article/robert-hunter-died, accessed May 9, 2020

http://www.jerryleelewis.com/

http://www.jimfacey.com/Surfarisbio.htm (accessed February 25, 2007).

http://www.jimihendrix.com

http://www.kdla.ky.gov/resources/kybgsong.htm (accessed July 15, 2007).

http://www.kennedy-center.org/pages/specialevents/honors - accessed April 7, 2018

http://www.keno.org/AlbumsRate.htm

http://www.kingstontrio.com/content/bob_shane.htm (accessed February 25, 2007).

http://www.kingstontrio.com/content/the_trio1.htm (accessed February 25, 2007).

http://www.kyleesplin.com/jllsb/JLLSBDIR/pages/72page.htm

https://www.latimes.com/california/story/2021-01-17/phil-spector-dead, accessed March 23, 2022

http://www.louisjordan.com (accessed February 4, 2006).

http://www.mariannefaithfull.org.uk

https://www.macrumors.com/2014/10/14/u2-apologizes-for-auto-downloads. Accessed May 20, 2018

http://www.michaeljackson.com/us/bio

http://www.misfits.com/

https://www.moderndrummer.com/article/january-2016-neil-peart/. Accessed January 2018

http://www.museum.tv/archives/etv/A/htmlA/americanband/americanband.htm

http://www.my-generation.org.uk/Troggs/troggstory.htm

http://www.neilsedaka.com/biography.p1.php (accessed February 11, 2007).

https://www.newyorker.com/magazine/2014/07/07/ambient-genius. Accessed May 19, 2018

https://www.nobelprize.org/prizes/literature/2016/summary/, accessed May 9, 2020

https://www.npr.org/2021/12/07/1062169370/the-killers-new-album-pressure-machine-is-a-deep-look-at-small-town-dysfunction, accessed April 7, 2022

https://www.nytimes.com/2021/01/17/arts/music/phil-spector-dead.html, accessed March 22, 2022

http://www.officialdamned.com

http://www.officialcharts.com/artist/28142/pink-floyd/, accessed May 15, 2016

http://www.oldtimemusic.com/FHOFEck.html

http://www.opry.com/MeetTheOpry/History.aspx (accessed July 13, 2007).

http://www.pbs.org/wnet/americanmasters/database/reed_l.html

http://www.peternoone.com/highnoone

http://www.pink-floyd.org/artint/watleft.htm, accessed May 15, 2016

http://www.playlistresearch.com/recordlabels.htm

http://www.ramones.com/

https://www.reuters.com/article/us-music-bob-dylan-lyrics/dylans-times-they-are-a-changin-lyrics-for-sale-for-2-2-million-idUSKBN2210TI, accessed May 9, 2020

https://www.reuters.com/legal/transactional/beach-boy-brian-wilsons-ex-wife-sues-over-millions-song-royalties-2022-03-29/, accessed March 29, 2022

http://www.rockhall.com/hof/allinductees.asp (accessed February 4, 2006).

http://www.rockhall.com/inductee/ (accessed July 6, 7, 8, 2007).

http://www.rockhall.com/inductee/carl-perkins

http://www.rockhall.com/inductee/isaac-hayes

http://www.rockhall.com/inductee/michael-jackson

http://www.rockhall.com/inductee/parliament-funkadelic

http://www.rockhall.com/inductee/phil-spector

http://www.rockhall.com/inductee/ray-charles

http://www.rockhall.com/inductee/rod-stewart/

https://www.rockhall.com/inductees/rush. Accessed June 2016

http://www.rockhall.com/inductee/the-jackson-five

http://www.rockhall.com/inductee/van-morrison

http://www.rogerebert.com/reviews/great-movie-pink-floyd-the-wall-1982, accessed May 15, 2016

http://www.rollingstone.com/music/albumreviews/lumpy-gravy-19680622, accessed May 11, 2016

http://www.rollingstone.com/artists/carlperkins/biography

http://www.rollingstone.com/artists/michaeljackson/biography

https://www.rollingstone.com/culture/lists/in-memoriam-2017-notable-deaths-people-we-lost-this-year-w512824 - accessed March 14, 2018

http://www.rollingstone.com/music/artists/prince/biography, accessed May 11, 2016

https://www.rollingstone.com/music/lists/30-fascinating-early-bands-of-future-music-legends-w513464/bruce-springsteens-sixties-garage-band-the-castiles-w513505. Accessed May 19, 2018

https://www.rollingstone.com/music/lists/the-100-greatest-debut-albums-of-all-time-20130322/hot-fuss-19691231. Accessed April 25, 2018

https://www.rollingstone.com/music/lists/100-greatest-guitarists-of-all-time-19691231. Accessed May 19, 2018

https://www.rollingstone.com/music/news/butch-trucks-allman-brothers-founding-member-dead-at-69-w462870. Accessed May 18, 2018

https://www.rollingstone.com/music/artists/the-killers/biography. Accessed February 24, 2018

http://www.nme.com/artists/the-killers. Accessed April 24, 2018

http://www.rollingstone.com/news/story/22775018/isaac_hayes_soul_superstar

https://www.rollingstone.com/music/music-news/bob-shane-kingston-trio-obit-945134/, accessed May 9, 2020

https://www.rollingstone.com/music/music-news/gary-duncan-quicksilver-messenger-service-obituary-853829/, accessed May 9, 2020

https://www.rollingstone.com/music/music-news/ginger-baker-cream-dead-obituary-240630/, accessed May 9, 2020

https://www.rollingstone.com/music/music-news/jefferson-airplane-guitarist-marty-balin-dead-76-730912/, accessed May 9, 2020

https://www.rollingstone.com/music/music-news/little-richard-dead-48505/, accessed May 9, 2020

https://www.rollingstone.com/music/music-news/neil-peart-rush-obituary-936221/, accessed May 9, 2020

http://www.rollingstone.com/music/albumreviews/a-saucerful-of-secrets-19681026, accessed May 15, 2016

http://www.rollingstone.com/news/story/5939210/8_little_richard

http://www.ronniespector.com

http://www.royrogers.com/ (accessed July 12, 2007).

http://www.schoollibrary.com/article/whebn0007445107/herb%20cohen, accessed May 11, 2016

http://www.songfacts.com/detail.php?id=432

http://www.songwritershalloffame.org/exhibit_bio.asp?exhibitId=178 (accessed February 11, 2007).

http://www.soul-patrol.com

http://www.steppenwolf.com/

http://www.straightdope.com/classics

http://www.sunrecords.com/_newsite/history.htm

https://www.thedailybeast.com/are-politicians-too-dumb-to-understand-the-lyrics-to-born-in-the-usa. Accessed May 19, 2018

http://www.thebighousemuseum.com/the-band/. Accessed March 26, 2018.

http://www.thebiographychannel.co.uk/biography_story/811:1061/1/Phil_Spector.htm

http://www.theclashonline.com/biography

https://thecreativeindependent.com/people/brandon-flowers-on-ambition/. Accessed April 25, 2018

http://www.thedoors.com/home

https://www.thefix.com/content/all-new-frank-zappa-stories-surface, accessed May 11, 2016

http://www.themanitoban.com/2012/12/free-man-in-paris/13077/, accessed May 9, 2020

https://www.theguardian.com/music/2019/mar/17/dick-dale-dies-aged-81-misirlou-pulp-fiction, accessed May 9, 2020

https://www.theguardian.com/music/2014/jan/15/the-beatles-paul-mccartney-ringo-starr-grammys - accessed April 2, 2018

http://www.titojackson.com/index2.html

https://www.tunefind.com/artist/the-killers. Accessed May 21, 2018

http://www.turnmeondeadman.net (accessed August 25, 2007).

https://ultimateclassicrock.com/judas-priest-lineup-changes/, accessed May 9, 2020

http://www.u2wanderer.org/disco/album.html. Accessed May 19, 2018

http://ultimateclassicrock.com/roger-waters-pros-and-cons-of-hitch-hiking/, accessed May 15, 2016

http://www.waylon.com/about.asp (accessed July 12, 2007).

http://www.zappa.com/fz/discography/, accessed May 11, 2016

http://www.zappa.com/fz/discography/index.html, accessed April 14, 2016

"Ike & Tina Turner: Biography." http://afgen.com/ike_tina.html (accessed February 2, 2007).

"Isaac Hayes." In *Grove Music Online* edited by L. Macy. http://www.grovemusic.com.ezproxy.library.unlv.edu/shared/views/article.html?from=search&session_search_id=1158329224&hitnum=1§ion=music.45925 (accessed May 14, 2007).

"Isaac Hayes." In Wikipedia. http://en.wikipedia.org/wiki/Isaac_Hayes (accessed May 13, 2007).

"James Brown." In *Grove Music Online* edited by L. Macy. http://www.grovemusic.com.ezproxy.library.unlv.edu/shared/views/article.html?from=search&session_search_id=434845381&hitnum=1§ion=music.46075 (accessed May 14, 2007).

"James Brown." In Wikipedia. http://en.wikipedia.org/wiki/James_Brown#Honors.2C_awards_and_dedications (accessed May 13, 2007).

Jan and Dean's Website. http://www.jananddean.com/ (accessed February 2007).

Jimmie Rodgers Museum. "Jimmie Rodgers—The Father of Country Music," Jimmie Rodgers Official Website. Homepage on-line. Available from http://www.jimmierodgers.com (accessed January 21, 2007).

"John Lee Hooker." http://www.johnleehooker.com/home.htm (accessed January 2007).

"Johnny Cash." *The Rolling Stone Encyclopedia of Rock and Roll*, Fireside ed., s.v.

"Johnson, Robert," in *The Encyclopedia of Popular Music*, 4th ed. Edited by Colin Larkin. Oxford: Oxford University Press, 2006.

Jones, A. M. *African Rhythm*. London: International African Institute, 1954.

Jones, A. M. *Studies in African Music*. 2 vols. London: New York, 1978.

"Jordan, Louis." In *The Encyclopedia of Popular Music*, 4th ed. edited by Colin Larkin. Oxford: Oxford University Press, 2006.

"Judas Priest," in *The Encylopedia of Popular Music*, 4th ed. Edited by Colin Larkin. Oxford: Oxford University Press, 2006.

Kennedy, Stetson. "Woody Guthrie." In *Grove Music Online* edited by L. Macy http://www.grovemusic.com (accessed February 24, 2007).

"King, Albert." In *The Encyclopedia of Popular Music*, 4th ed. Edited by Colin Larkin. Oxford: Oxford University Press, 2006.

"Kingston Trio." In *The Encyclopedia of Popular Music*, 4th ed. Edited by Colin Larkin. Oxford: Oxford University Press, 2006.

Koda, Cub. "Biography of Charley Patton." http://www.allmusic.com/cg/amg.dll?p=amg&sql=11:xt7uak4k5m3m~T1 (accessed July 3, 2007).

Laing, Dave. "Four Tops, the." In *Grove Music Online* edited by L. Macy. http://www.grove music.com (accessed May 18, 2007).

Laing, Dave. "The Ronettes." In *Grove Music Online* edited by L. Macy. http://www.grove music.com (accessed February 24, 2007).

Laing, Dave. "Wilson, Jackie (Jack Leroy)." In *Grove Music Online* edited by L. Macy. http://www.grovemusic.com (accessed May 18, 2007).

Lewis, Myra. *Great Balls of Fire: The Uncensored Story of Jerry Lee Lewis*. William Morrow/Quill/St. Martin's Press, 1981.

MacDonald, Ian. "Beatles, the Career." In *Grove Music Online* edited by L. Macy. http://www.grovemusic.com (accessed March 24, 2007).

MacKenzie, Ian. "Big Bill Broonzy: Discography." http://www.broonzy.com/discography.htm (accessed January 28, 2007).

MacKenzie, Ian. "Big Bill Broonzy: The Ultimate Blues Man." http://www.broonzy.com/bio.html (accessed January 28, 2007).

Macy, L., ed. and Joseph McEwen. "Diddley, Bo." In *Grove Music Online* edited by L. Macy. http://www.grovemusic.com (accessed January 28, 2007).

Malone, Bill. "Williams, Hank (Hiram)." *Grove Music Online*. www.grovemusic.com (accessed January 20, 2007).

Marsh, Dave. "Charles, Ray (Robinson, Ray Charles)." In *Grove Music Online* edited by L. Macy, http://www.grovemusic.com (accessed February 2, 2007).

McEwen, Joseph. "Martha and the Vandellas." In *Grove Music Online* edited by L. Macy. http://www.grovemusic.com (accessed May 22, 2007).

McGee, David. "Summertime Blues." *Rolling Stone* 790/1 (1998), 71.

McNeil, Legs, and Gillian McCain. *Please Kill Me, the Uncensored Oral History of Punk*. New York: Grove Press, 1996.

Moore, Allan F. "Rolling Stones, The." In *Grove Music Online* edited by L. Macy. Available from http://www.grovemusic.com (accessed April 1, 2007).

Moser, Margaret and Bill Crawford. *Rock Stars Do the Dumbest Things*. New York: Renaissance Books, 1998.

Moser, Margaret, and Bill Crawford. *Rock Stars Do the Dumbest Things*. New York: St. Martin's Griffin, 1998.

"Motörhead," in *The Encylopedia of Popular Music*, 4th ed. Edited by Colin Larkin. Oxford: Oxford University Press, 2006.

Oakley, Giles. *The Devil's Music*, 2nd ed. New York: Da Capo Press, Inc., 1983.

Oliver, Paul. "Johnson, Willie." In *Grove Music Online*. http://www.grovemusic.com (accessed January 28, 2007).

Oliver, Paul. "McTell, William." In *Grove Music Online*. http://www.grovemusic.com (accessed January 28, 2007).

Oliver, Paul. "Smith, Mamie." In *Grove Music Online* edited by L. Macy. http://www.grove music.com (accessed January 28, 2007).

Patterson, Gary, "The Walrus Was Paul." Nashville: Dowling Press, Inc., 1996.

Peneny, D. K. "Don Kirshner and Aldon Music." History of Rock Online. Available from http://www.history-of-rock.com/kirshner.htm (accessed February 10, 2007).

Pessen, Edward. "The Great Songwriters of Tin Pan Alley's Golden Age: A Social, Occupational, and Aesthetic Inquiry." *American Music 3*, no. 2 (1985): 180–97.

Peter Paul and Mary Website: http://www.peterpaulandmary.com/ (accessed February 2007).

Ralph Johnson Speaks. WOLF.COM. www.jayepurplewolf.com/EARTHWINDFIRE/ralph speaks.html (accessed May 14, 2007).

Rock and Roll Hall of Fame and Museum. "Bo Diddley." Rock and Roll Hall of Fame and Museum Website. http://www.rockhall.com/home/ (accessed January 28, 2007).

Rock and Roll Hall of Fame and Museum. "Bob Dylan," Rock and Roll Hall of Fame and Museum Website. Homepage on-line. Available from http://www.rockhall.com/home/ (accessed February 24, 2007).

Rock and Roll Hall of Fame and Museum. "Elvis Presley," Rock and Roll Hall of Fame and Museum Website. Available from http://www.rockhall.com/home (accessed February 3, 2007).

Rock and Roll Hall of Fame and Museum. "Inductees: Berry Gordy, Jr.," Rock and Roll Hall of Fame and Museum Website. Available from http://www.rockhall.com/inductee/berry-gordy-jr (accessed May 18, 2007).

Rock and Roll Hall of Fame and Museum. "Inductees: Ike and Tina Turner." Rock and Roll Hall of Fame and Museum Website. http://www.rockhall.com/hof/inductee.asp?id=202 (accessed February 3, 2007).

Rock and Roll Hall of Fame and Museum. "Inductees: Jerry Lee Lewis," Rock and Roll Hall of Fame and Museum Website. Available from http://www.rockhall.com/hof/inductee.asp?id=144 (accessed February 9, 2007).

Rock and Roll Hall of Fame and Museum. "Inductees: Martha and the Vandellas." Rock and Roll Hall of Fame and Museum Website. Available from http://www.rockhall.com/inductee/martha-and-the-vandellas (accessed May 22, 2007).

Rock and Roll Hall of Fame and Museum. "Inductees: Smokey Robinson." Rock and Roll Hall of Fame and Museum Website. Available from http://www.rockhall.com/inductee/smokey-robinson (accessed May 18, 2007).

Rock and Roll Hall of Fame and Museum. "Inductees: The Beatles," Rock and Roll Hall of Fame and Museum Website. Available from http://www.rockhall.com/inductee/the-beatles (accessed March 24, 2007).

Rock and Roll Hall of Fame and Museum. "Inductees: The Four Tops." Rock and Roll Hall of Fame and Museum Website. Available from http://www.rockhall.com/inductee/the-four-tops (accessed May 18, 2007).

Rock and Roll Hall of Fame and Museum. "Inductees: The Jackson Five." Rock and Roll Hall of Fame and Museum Website. Available from http://www.rockhall.com/inductee/the-jackson-five (accessed May 21, 2007).

Rock and Roll Hall of Fame and Museum. "Inductees: The Rolling Stones," Rock and Roll Hall of Fame and Museum website. Available from http://www.rockhall.com/inductee/the-rolling-stones (accessed March 31, 2007).

Rock and Roll Hall of Fame and Museum. "Inductees: The Supremes," Rock and Roll Hall of Fame and Museum Website. Available from http://www.rockhall.com/inductee/the-supremes (accessed May 18, 2007).

Rock and Roll Hall of Fame and Museum. "Inductees: The Temptations." Rock and Roll Hall of Fame and Museum Website. Available from http://www.rockhall.com/inductee/the-temptation (accessed May 18, 2007).

Rock and Roll Hall of Fame and Museum. "Inductees: Woody Guthrie," Rock and Roll Hall of Fame and Museum Website. Available from http://www.rockhall.com/hof/inductee.asp?id=115 (accessed February 24, 2007).

Rock and Roll Hall of Fame and Museum. "Janis Joplin." Rock and Roll Hall of Fame and Museum Website. Homepage on-line. Available from http://www.rockhall.com/home/ (accessed May 13, 2007).

Rock and Roll Hall of Fame and Museum. "Jefferson Airplane." Rock and Roll Hall of Fame and Museum Website. Homepage on-line. Available from http://www.rockhall.com/home/ (accessed May 13, 2007).

Rock and Roll Hall of Fame and Museum. "Jimmie Rodgers," Rock and Roll Hall of Fame and Museum Website. Homepage on-line. Available from http://www.rockhall.com/home/ (accessed January 21, 2007).

Rock and Roll Hall of Fame and Museum. "Joni Mitchell," Rock and Roll Hall of Fame and Museum Website. Homepage on-line. Available from http://www.rockhall.com/home (accessed May 14, 2007).

Rock and Roll Hall of Fame and Museum. "The Doors." Rock and Roll Hall of Fame and Museum Website. Homepage on-line. Available from http://www.rockhall.com/home/ (accessed May 14, 2007).

Rock and Roll Hall of Fame and Museum. "The Grateful Dead." Rock and Roll Hall of Fame and Museum Website. Homepage on-line. Available from http://www.rockhall.com/home/ (accessed May 13, 2007).

Rock and Roll Hall of Fame and Museum. "The Rolling Stones." Rock and Roll Hall of Fame and Museum Website. Homepage on-line. Available from http://www.rockhall.com/home/ (accessed April 1, 2007).

Rock and Roll Hall of Fame and Museum. "The Yardbirds." http://www.rockhall.com/inductee/the-yardbirds (accessed April 2007).

Rock and Roll Hall of Fame. Earth Wind and Fire. http://www.rockhall.com/inductee/earth-wind-fire (accessed May 14, 2007).

Rock and Roll Hall of Fame. Sly & the Family Stone. http://www.rockhall.com/inductee/sly-and-the-family-stone/ (accessed May 14, 2007).

Röhnisch, Claus. "JOHN LEE HOOKER The World´s Greatest Blues Singer 1917–2001." http://web.telia.com/~u19104970/johnnielee.html#johnlee (accessed January 2007).

"Rolling Stones." In *The Encyclopedia of Popular Music*, 4th ed. Edited by Colin Larkin. Oxford: Oxford University Press, 2006.

Rolling Stone Magazine - David Bowie: The Ultimate Guide to His Music & Legacy, Special Collector's Edition, 2/2016

Rosenburg, Neil V. "Flatt & Scruggs and the Foggy Mountain Boys." In *The Encyclopedia of Country Music* edited by Paul Kingsbury, 173–4. New York: Oxford University Press, 1998.

Santelli, Robert. Southern Music Network. "Charley Patton." http://www.southernmusic.net/Charliepatton.htm (accessed January 2007).

"Sedaka, Neil." In *The Encyclopedia of Popular Music*, 4th ed. Oxford: Oxford University Press, 2006.

"Shirelles." In *The Encyclopedia of Popular Music*, 4th ed. Edited by Colin Larkin. Oxford: Oxford University Press, 2006.

"Sly & The Family Stone." In Wikipedia. http://en.wikipedia.org/wiki/Sly_&_the_Family_Stone (accessed May 13, 2007).

Smith, Richard R. *Fender the Sound Heard Round the World.* Hal Leonard, 1995, 2003.

Southall, Geneva H. "Jubilee Singers (Fisk)." In *Grove Music Online* edited by L. Macy. http://www.grovemusic.com (accessed January 26, 2007).

"Surfaris." In *The Encyclopedia of Popular Music*, 4th ed. edited by Colin Larkin. Oxford: Oxford University Press, 2006.

Szatmary, David. *Rockin' in Time: A Social History of Rock-And-Roll*, 5th ed. Upper Saddle River: Pearson, 2004.

The Beach Boys. "Timeline." The Beach Boys. http://www.thebeachboys.com/timeline.aspx (accessed October 3, 2007).

"The Beach Boys." The Rock and Roll Hall of Fame. http://www.rockhall.com/inductee/the-beach-boys (accessed October 3, 2007).

"The Meters." In Wikipedia. http://en.wikipedia.org/wiki/The_Meters (accessed May 13, 2007).

"The Neville Brothers." In *Grove Music Online* Edited by L. Macy. http://www.grovemusic.com.ezproxy.library.unlv.edu/shared/views/article.html?fom=search&session_search_id=852771889&hitnum=1§ion=music.46617 (accessed May 14, 2007)

"The Neville Brothers." In Wikipedia. http://en.wikipedia.org/wiki/The_Neville_Brothers (accessed May 13, 2007).

The official community of Buddy Holly." http://www.buddyholly.com/biographies/buddy.aspx (accessed February 2007).

The Official Site of Chuck Berry. Discography. http://www.chuckberry.com/music/discography.htm (accessed February 11, 2007).

The Vocal Group Hall of Fame Foundation. "Inductees: The Ronettes." At The Vocal Group Hall of Fame Foundation Website. Available from http://www.vocalgroup.org/inductees/the_ronettes.html (accessed February 24, 2007).

"The Who." Rock and Roll Hall of Fame & Museum. http://www.rockhall.com/inductee/the-who (accessed April 3, 2007).

TheYardbirds.com. http://www.theyardbirds.com/bio.html (accessed April 2007).

Tyrangiel, Josh. "The Essential Hank Williams Collection: Turn Back the Years" Time Magazine http://www.time.com/time/2006/100albums/0,27693,The_Essential_Hank_Williams_Collection__Turn_Back_the_Years,00.html (accessed January 20, 2007).

VH1's Behind the Music "The Day the Music Died." Interview with Waylon Jennings (accessed July 11, 2007).

Vincent, Rickey. *Funk: The Music, the People, and the Rhythm of the One*. New York: St. Martin's Griffin, 1996.

Wegman, Rob C. "Beach Boys, The." In *Grove Music Online*. http://www.grovemusic.com.ezproxy.library.unlv.edu/shared/views/article.html?from=search&session_search_id=198920287&hitnum=1§ion=music.46067 (accessed October 3, 2007).

Wikipedia. Chuck Berry. Website available from http://en.wikipedia.org/wiki/Chuck_Berry (accessed February 11, 2007).

Wilson, Brian. *Wouldn't It Be Nice: My Own Story*. HarperCollins, 1991.

Trivia Bibliography

http://www.Anecdotage.com

http://www.grovemusic.com

http://www.rockhall.com

http://en.wikipedia.org

Moser, Margaret and Bill Crawford. *Rock Stars do the Dumbest Things*. New York, NY: Renaissance Books, 1998.

About the Authors

Author

Dr. Timothy A. Jones

Dr. Timothy Jones is an Associate Professor of Percussion Studies, coordinator of the popular History of Rock course at UNLV, and is a freelance drummer and percussionist. In addition to performing locally and internationally as percussion soloist and drum set artist, he is the author of *Rock 'n' Roll Origins and Innovators*, a variety of articles for *Percussive Notes* and *Drumscene*, and has performed with the Las Vegas Opera, the Las Vegas Philharmonic, Mary Wilson, Andrea Bocelli, Michael Buble, Sarah Brightman, Josh Groban, Peter Cetera, Kenny G, David Foster, The Killers, Buddy Greco, Natalie Merchant, Don Rickles, the Irish Tenors, The Classical Mystery Tour and Nebojsa Zivkovic. He is the drummer for the Las Vegas based bands, The Wild Celts, and Doors tribute, Mojo Risin'. Dr. Jones is proud to endorse Majestic, Sabian Cymbals, Vic Firth sticks and mallets, Remo drum heads and Grover Pro Percussion.

Co-author

Jim McIntosh has been on the faculty at the UNLV School of Music since 1994. Jim is also a full-time professional guitarist having performed with Lyle Lovett, Slash, "Weird Al" Yankovic, Billy Preston, Sheena Easton and many others. McIntosh was the house guitarist for Penn and Teller's *Sin City Spectacular* television series, Drew Carey's *Mr. Vegas* HBO special, and *The Ron White Show* (WB network). Jim "Jimmy" McIntosh's 2007 critically aclaimed debut record *Orleans to London* includes guests Ronnie Wood (of the Rolling Stones), Jeff Beck and Art Neville, Ivan Neville and Cyril Neville of The Neville Brothers. McIntosh's 2nd album "Jimmy McIntosh and..." released 2014 featuring Rolling Stone Ronnie Wood, John Scofield, Mike Stern and Ivan Neville was *Downbeat* magazine editors pick January 2015.

Jim McIntosh

Index